VOLUME 3
DIGITAL PAINTING
techniques

VOLUME 3

DIGITAL PAINTING
techniques

3dtotal
PUBLISHING

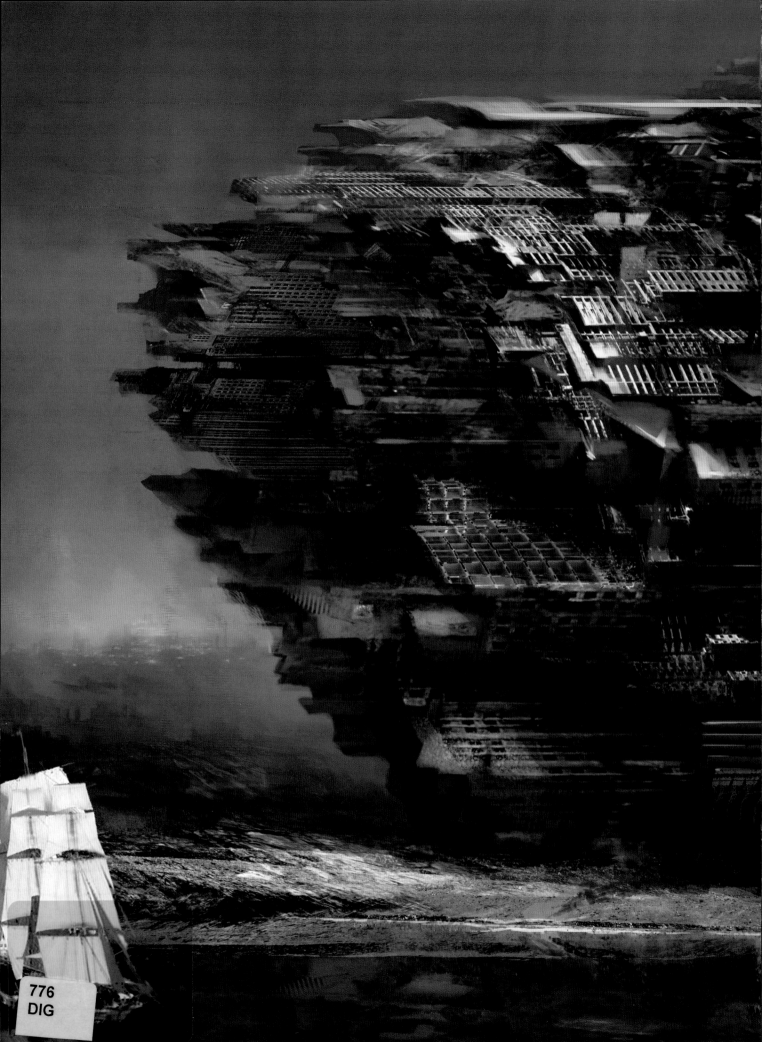

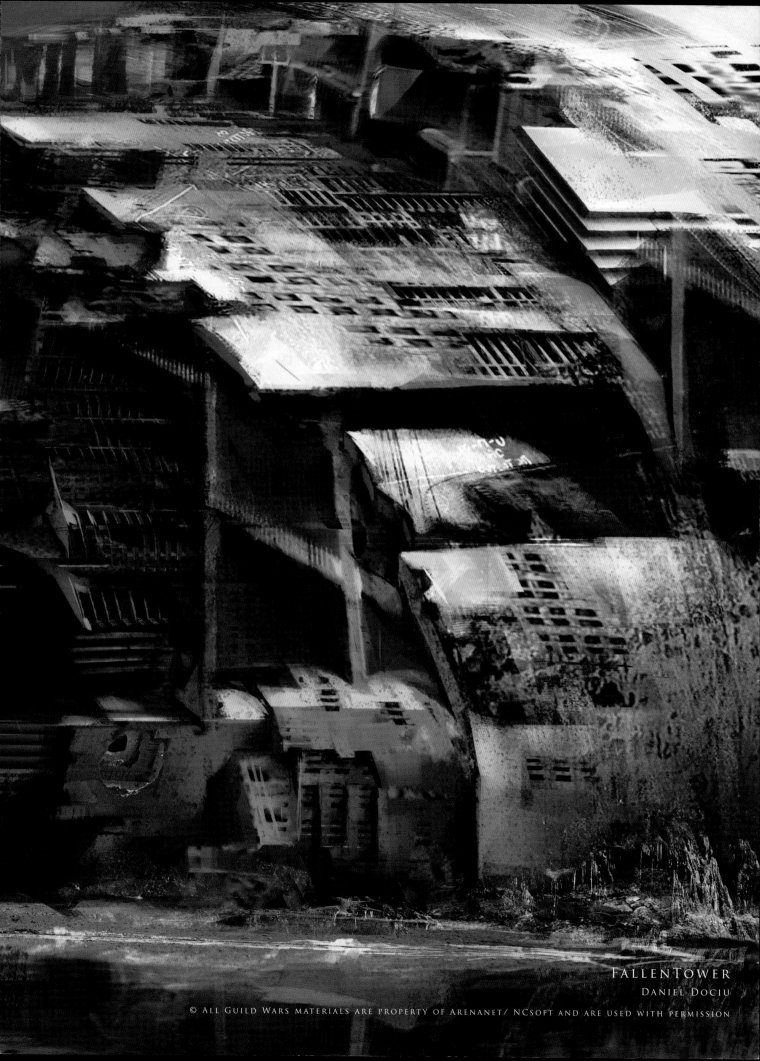

FALLEN TOWER

Daniel Dociu

BONNIE AND CLYDE ©LOÏC E338 ZIMMERMANN

3DTOTAL PUBLISHING

Correspondence: publishing@3dtotal.com

Website: www.3dtotal.com

First published in the United Kingdom, 2011, by 3DTotal Publishing

Softcover ISBN: 978-0-9551530-6-8

Printing & Binding
Everbest Printing (China)
www.everbest.com

Visit www.3dtotal.com for a complete list of available book titles.

CONTENTS

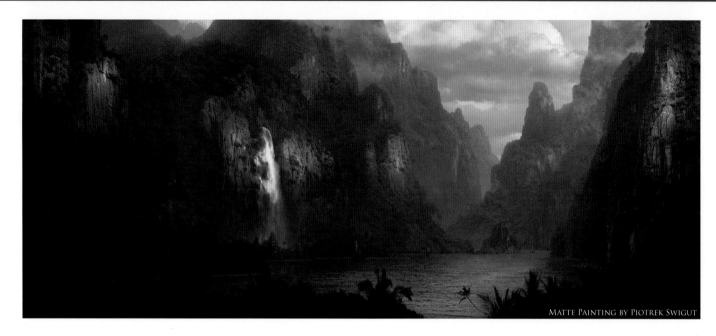

MATTE PAINTING BY PIOTREK SWIGUT

VOLUME 3
DIGITAL PAINTING
techniques

INTRODUCTION

I have lost count of the number of times that I have walked out of a
cinema and heard the words: "the set designs were amazing" or "visually
that film was breathtaking". The sad truth is that a large percentage of
the world's population will never realize that what they were drooling
over was the creative outpourings of a very talented team of digital
painters.

The current generation is immersed in digital media and craves
something new whenever they go to see a movie or buy a computer
game. Therefore the pressure on concept artists is higher than it has
ever been before. They have to create new designs for characters,
landscapes and vehicles that are exciting, fresh and unique. They have
to draw upon a wealth of knowledge, skills, techniques and styles to
create something new and stunning while still meeting deadlines.

You must be thinking to yourself the artists that tackle the daunting task
of creating original concepts must have magical powers that they can
draw upon at will. Well this book will show you that this is not the case.
Whether you are an experienced digital painter or a novice with an
interest in digital art, this book demonstrates a plethora of techniques
and skills that can help you take a step closer to the amazing work
created by these unsung heroes of modern media.

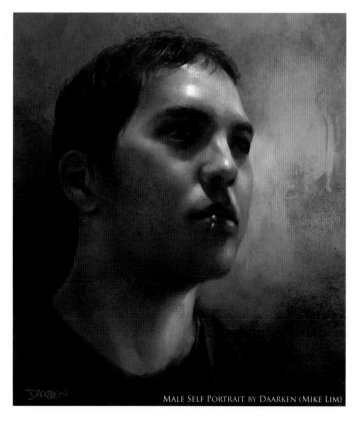

MALE SELF PORTRAIT BY DAARKEN (MIKE LIM)

Digital Painting Techniques: Volume 3 proudly boasts images and tutorials by some of the heavyweights of the concept art industry. Each of the artists approach the task given to them in a slightly different way, which provides a valuable catalog of varying ways for you to create your own illustrations and concept art. You may just find that this book contains the perfect technique for you!

As a source of inspiration *Digital Painting Techniques: Volume 3* is second to none. The final image from each tutorial is a modern day masterpiece and there is also a stunning gallery which contains work of the highest level. Each artist featured is a master of the tools they use, but their skills are also based on an underlying knowledge of the fundamentals of art. Their talent is unquestionable and we thank them for sharing their gifts with us.

SIMON MORSE
CONTENT MANAGER, 3DTOTAL

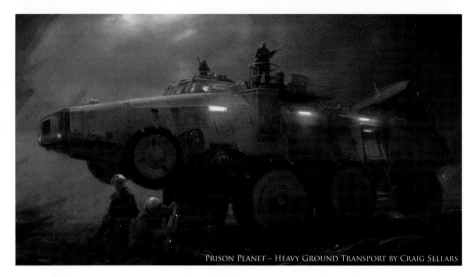

PRISON PLANET – HEAVY GROUND TRANSPORT BY CRAIG SELLARS

COMPILED BY THE 3DTOTAL TEAM

TOM GREENWAY	SIMON MORSE	JO HARGREAVES	CHRIS PERRINS	RICHARD TILBURY

free resources

Some of our *Digital Painting Techniques* tutorial artists have kindly supplied, where appropriate and possible, free resources to accompany their tutorials for you to download to follow along with their teachings. You will find free custom brushes donated by Andrei Pervukhin, Branko Bistrovic, Gediminas Pranckevičius and Svetlin Velinov. On top of these, we have movies by Nykolai Aleksander, a useful steampunk reference guide by Chee Ming Wong and a whole collection of images from 3DTotal's Texture and Reference Library which Richard Tilbury used within his tutorials..

don't forget download your free resources for digital painting techniques: volume 3

All you need to do to access these free resources is to visit the new 3DTotal micro site at http://www.3dtotalpublishing.com/, go to the "Free Resources" section, and there you will find information on how to download the files. Simply look out for the "Free Resources" logo that appears on articles within this book where they are files for you to download.

http://www.3dtotalpublishing.com/

FREE RESOURCES
Download from:
www.3dtotalpublishing.com

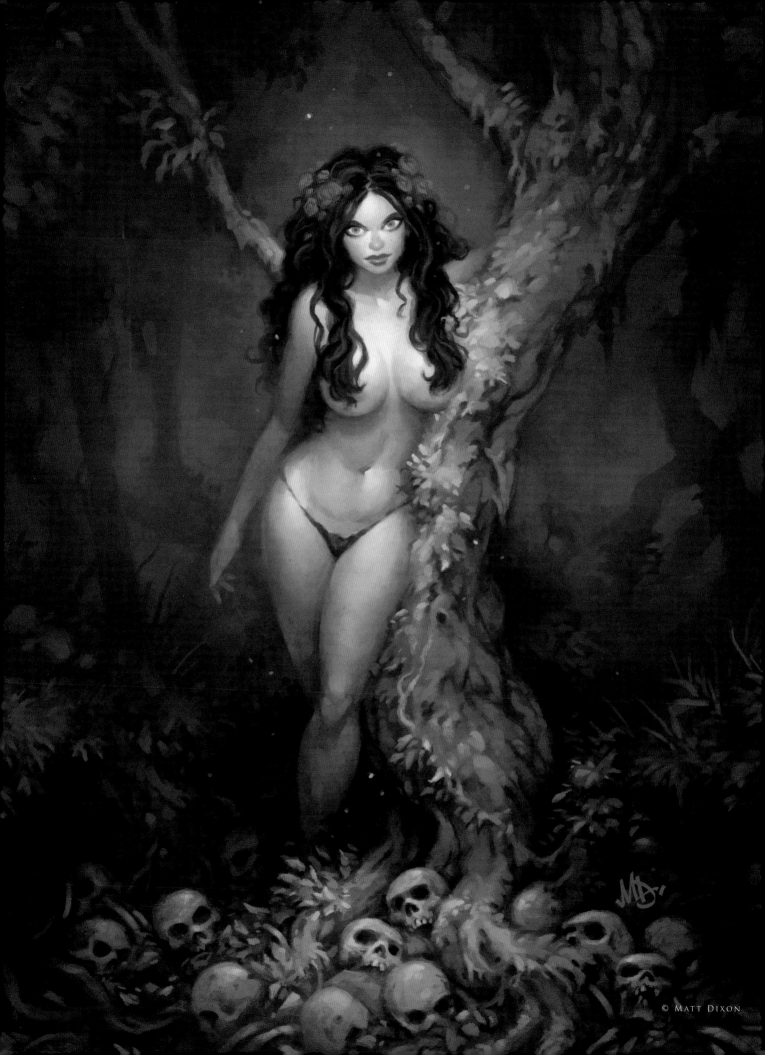

© Matt Dixon

creatures from folklore

Passed down through the generations, tales of folklore are with us from the earliest days of our childhood. But the roots of these stories wind back much further through the years, entwined with the landscape, culture, language and people of their origin. It is this sense of shared history and familiarity that gives folklore such power. Creatures from folklore are so vivid because they live in our own reality. This places great responsibility on the artist; these are creatures we know well and may hold dear, creatures with a past and a story to tell, creatures that our grandparents knew and shared with us in bedtime stories. We all approach these creatures with long-held ideas of how they should look and behave, but we only know what we have been told so far and we all hear these stories differently. The magic of folklore is that the tales can change with every telling. Enjoy the stories that the talented artists on the following pages have to share, and be inspired to tell your own.

MATT DIXON
mail@mattdixon.co.uk
http://www.mattdixon.co.uk

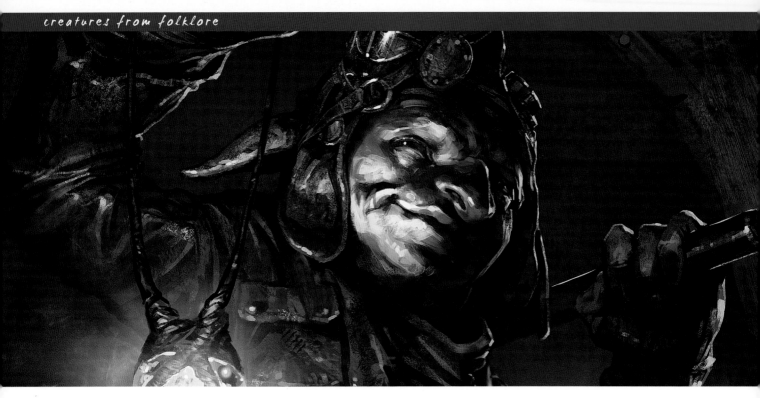

GOBLIN
BY ANDREI PERVUKHIN

SOFTWARE USED: PHOTOSHOP

INTRODUCTION

Hello everyone! When tackling a project such as this one I first think about the composition as a whole. What will the goblin look like? And what kind of environment will he be in? For this project I decided to keep away from the typical J.R.R.Tolkien goblin and make something that looked original and that was closer to the description we are given in folklore. In folklore a goblin or the kobold is the spirit of the mines. He is constantly knocking on the rails and scaring the miners. A lot of characters based on goblins don't seem to reflect this.

MY PAINTING

With this idea in mind, it's time to start creating the image. I'm going to begin painting in black and white because it helps to set out the

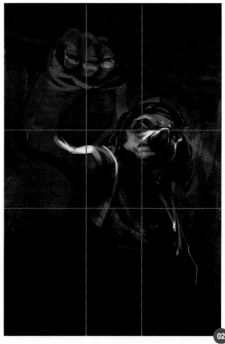

composition, light and design. It also helps me to imagine what the final piece is going to look like. You can use some textured brushes at this stage, like I am, but don't worry too much about the finer details (**Fig.01**).

For the next step I'm going to use the guide called the "golden section". This shows the

centre of the image and helps me to identify where the viewer's main focus will be (**Fig.02**).

Next it's time to look at color. For this, I add an old-fashioned fantasy-looking lamp and some light and glow on a separate layer. I use layer modes to find which light looks best (Soft Light, Overlay, Color). **Fig.03 – 04** show a couple

of the layer modes that I'm trying out. I think **Fig.04** looks the best, so I go with that one.

After establishing the light, I want to start working on detailing the head of the goblin. I find that working on the head of a character will often set the tone for the rest of the image (**Fig.05**).

> START BY REFINING THE DESIGN OF HIS CLOTHING AND ACCESSORIES AND THEN CONTINUE TO DETAIL THE CLOTHING, ALWAYS REMEMBERING THE IMPORTANCE OF THE LIGHT

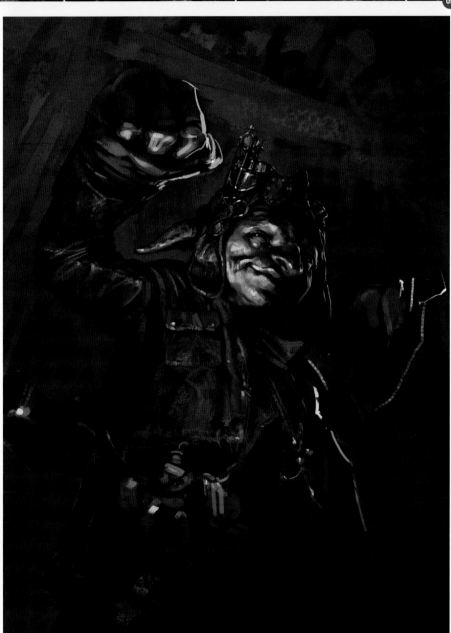

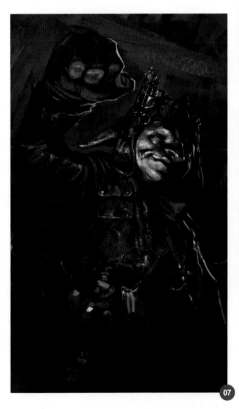

With the head detailed, it's now time to look at the clothing of the goblin. I start by refining the design of his clothing and accessories, and then continue to detail the clothing, always remembering the importance of the light.

I continue to consider this as I move on to working on the hammer on his shoulder (**Fig.06 – 08**). For each of these stages it's a good idea to work on a new layer, adding one on top of the other. To start with I'm drawing on a

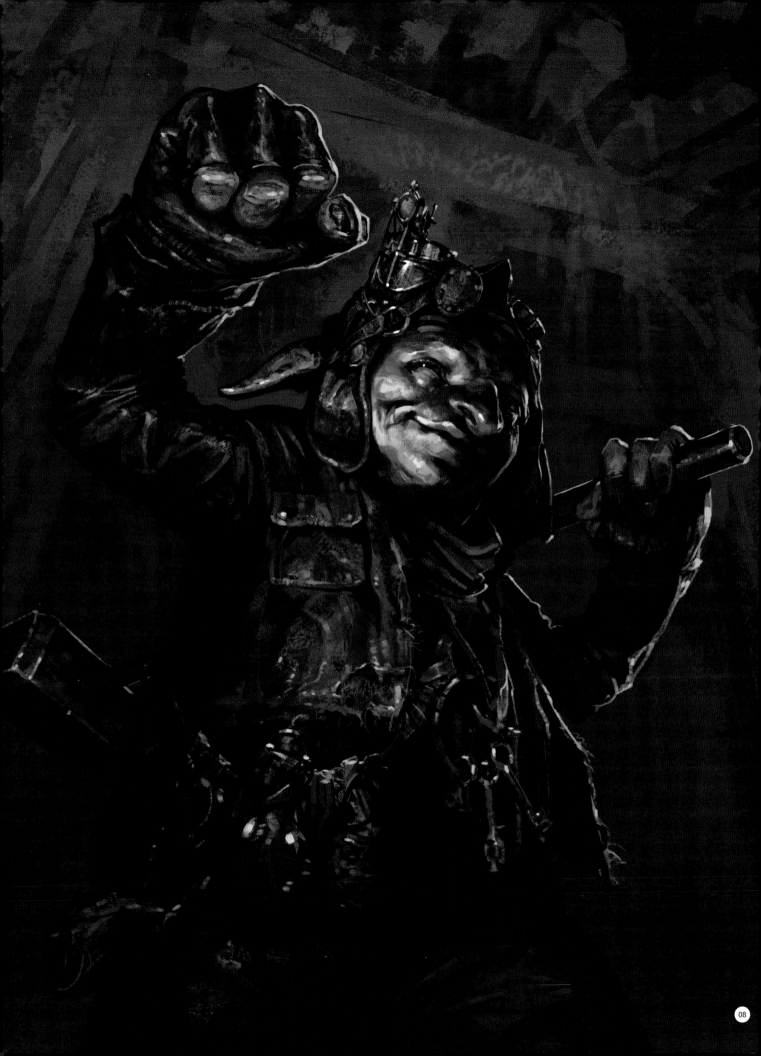

Normal layer, then after that I start drawing on a new Soft Light layer, then Normal again, then Overlay again. Scroll through the layer modes to find which works best for your image.

Next comes the lantern. You can see the layers and settings that I have chosen in **Fig.09**. I create the lamp in black and white, then on top of this add two layers – I'm using Overlay and Color. On these layers I then add a Create Clipping Mask layer called "Lamp" and then paint the lamp.

To create the light from the lamp, I paint in two layers of "hard light" under the lamp. Then I create a layer mask for a few corrections and alterations (**Fig.10**).

In the next step I'm going to carefully cut the goblin from the background and move it to a new layer so that I can start thinking about the background. I'm going to paint the background and then add some textures from 3DTotal's texture library (**http://freetextures.3dtotal. com**). You can see where I've added the photographs and the effect this has in **Fig.11 – 12**.

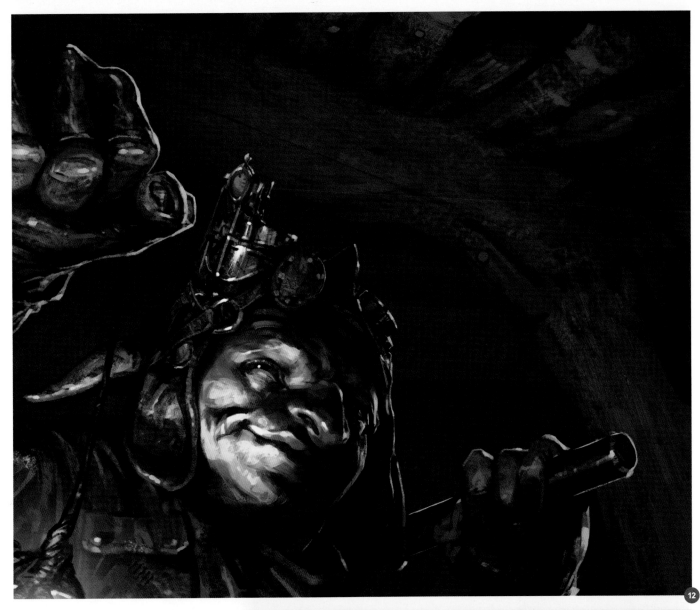

I increase the atmosphere of the image by adding some smoke (**Fig.13**).

Once happy with the overall picture, it's time to string together all the layers from the top. In the resulting layer, I use the filter Sharpen > Smart Sharpen as this will give the completed image a precise look.

To finish, I create a new layer and fill it with a gray color (in the table color picker I'm using the parameter B: 50%). Then I add Noise > Add Noise (400%) and use the filter Stylize > Diffuse, with the parameters of the layer set to Soft Light and opacity to 15%. Finally, on the top, I use Curves to correct the color slightly.

And with that it's done!

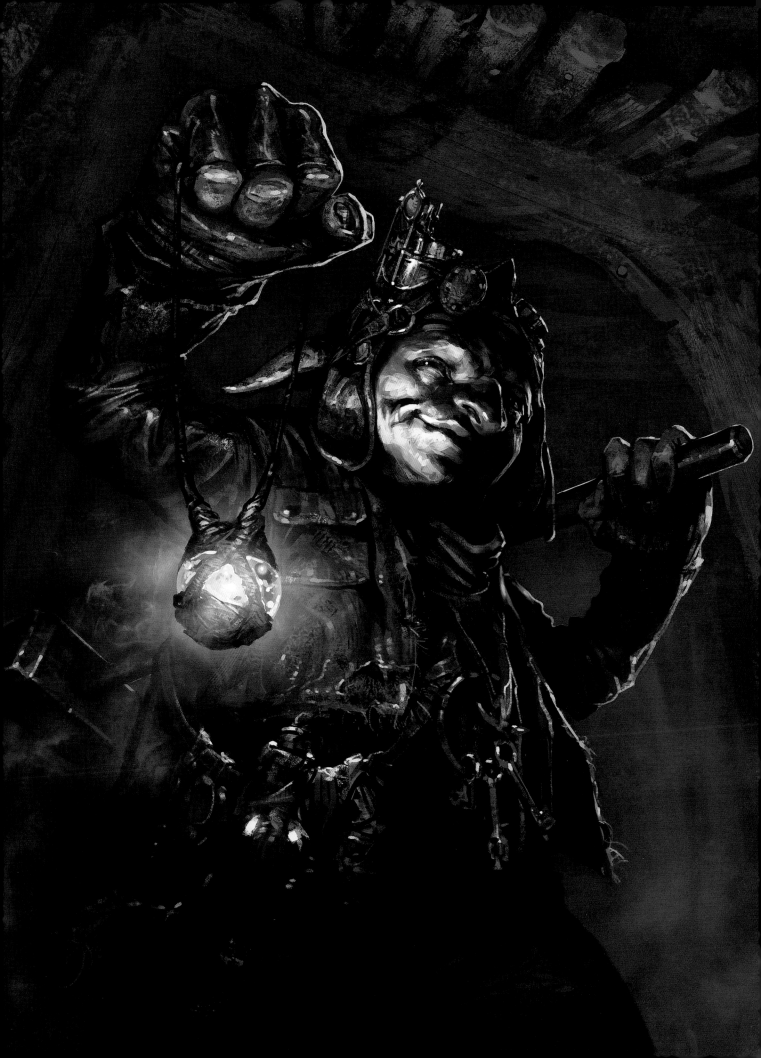

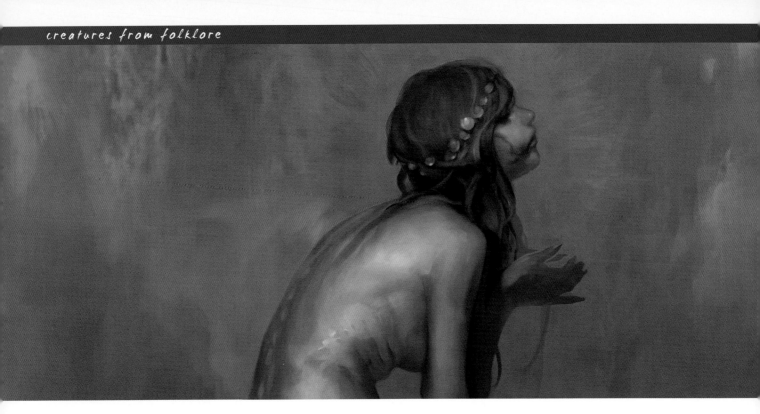

Siren
By Min Yum

Software Used: Photoshop

Introduction

I sometimes start a picture without a strong idea in mind, especially with subjects I haven't dealt with before, and it quickly leads to a research session for a small collection of reference images. Because of this my process usually begins with research. I think it's important to prepare right at the start rather than late in the day as it can save so much time and trouble later on. Good research can

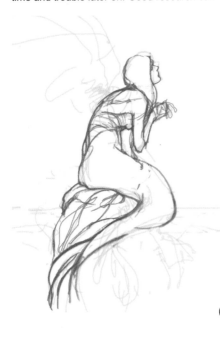

also lead to ideas and inspiration, as well as help you get all the facts right about your subject matter. It turns out that my initial ideas about Sirens were slightly incorrect when I began my research. I've always pictured them more like monsters, ready for battle, but they are actually usually described as beautiful, seductive, bird-like women or like mermaids luring men to the sea.

In this workshop I am going to share my process of creating a painting from a sketch through to the finished piece, as well as share some of the tips and methods I frequently use in Photoshop.

Sketch

I started by roughly sketching out some ideas as small thumbnails. When doing thumbnails

I usually try to arrange the elements whilst focusing on composition. I also avoid focusing on details at this stage; I just roughly put down the ideas and see if they work visually (**Fig.01**).

Refining the Sketch

I decided to go for the mermaid look for my Siren. I like to try something new with every piece of artwork I do, and since I've never drawn a mermaid creature this was an obvious choice for me. I cleaned up the sketch a little here with some minor anatomy details and made a mental note of how the background would be painted (**Fig.02**).

Blocking in

Using some big textured brushes, I blocked in some background colors. There's something about using strong contrasting colors that

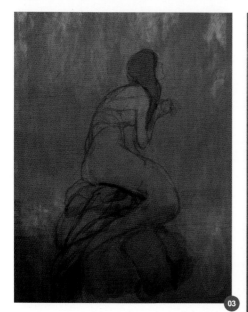

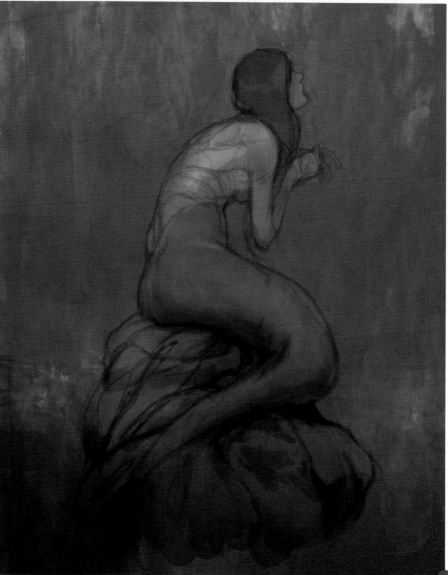

adds to a piece of art and this is no exception. I went for orange and blue. I was feeling a bit adventurous and went with a very bold orange, hoping I could offset this with cool lighting on the character against the warm orange background (**Fig.03**).

> DIGITAL PAINTING "HAS THE ADVANTAGE" OF BEING ABLE TO ZOOM IN, BUT ALSO AT THE SAME TIME IT CAN LEAD TO OVERWORKING AN AREA WHICH MAY LEAD TO INCONSISTENCY THROUGHOUT THE IMAGE.

DEFINING THE FIGURE
I next established the lighting. I tried to keep it subtle by using a slight spotlight from the top left. I also adjusted her skin tone to help her stand out from the background. At this stage I also roughed out the overall form of the figure and the rock (**Fig.04**).

RENDERING
With all the elements in the right places, it was time for the rendering. This process is probably the most time-consuming part. I usually start with the focal point, in this case the figure. My workspace in Photoshop usually consists of two document windows, one zoomed out

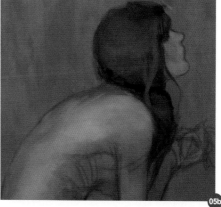

at around 25% and the other with a close-up view so that I can work on the details and check how it works overall in the other window. Digital painting has the advantage of being able to zoom in, but at the same time it can lead to overworking an area which may lead to

inconsistency throughout the image. This can be counteracted by having a second window open showing the whole image. Opening up another window can be done by going to Windows > Arrange > New Window for xxxx. psd (**Fig.05a – b**).

CHAPTER 1

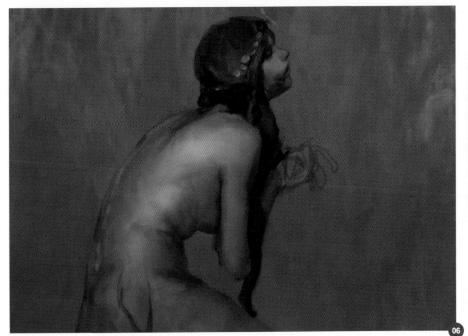

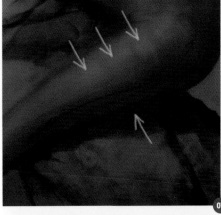

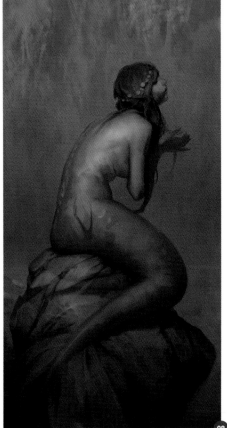

ADDING DETAILS

I started adding the details and worked on the features like her face. I tend to avoid using textured brushes at this stage as they don't give you fine controls. Blending with a low opacity brush can often lead to muted colors as you are painting over semi-transparent colors over and over again. It's good to select the original color again once in a while to bring back the original colors. Another method I use is to overlay brush blending modes to put back some of those vibrant colors that were lost during the blending (**Fig.06**).

RENDERING FORM

If you've tried rendering a simple sphere or cylinder, you may have heard of the term "core shadow". This refers to the region where the shadow starts, shown here with a red arrow (**Fig.07**). This area is darkest because of the reflected/diffuse lighting in the shadow region. One thing I do tend to do is accentuate this area with more saturated colors, usually from the warm colors in the surrounding environment. This works really well with rounded forms but also with the edge of the shadows. A soft edged brush set to Overlay blending mode does the job well.

TIDYING UP

After many hours working on the image the painting was almost done. I added more detail and a warm orange outline around the figure

to help differentiate her from the background. I looked out for any inconsistent brush strokes, which can happen when working on a detailed image. I also got rid of unnecessary details, especially in the background texture.

Quick Tip : Flipping the canvas horizontally is a simple and easy way of checking for any obvious mistakes; I periodically flip the canvas when I'm working to see if anything looks odd. In this image one of the things I focused on was the fact that I wanted to keep the background simple and not conflicting with the main focal point of the image (**Fig.08**).

CORRECTIONS

There were couple of things in the image that didn't seem quite right. The head of the figure seemed a little too small and the tail felt a bit unnatural. A quick adjustment of the head fixed the proportion issue, but the tail needed a bit more work, particularly with the way it rested on the rock. Also it needed more highlights to suggest a shiny texture (**Fig.09**).

FINISHING UP

After adding the final touches and a couple of color adjustment layers, the painting was wrapped up. I was satisfied with the overall feel of the image and the fact that I didn't completely lose all of the bold colors I'd started with (**Fig.10**).

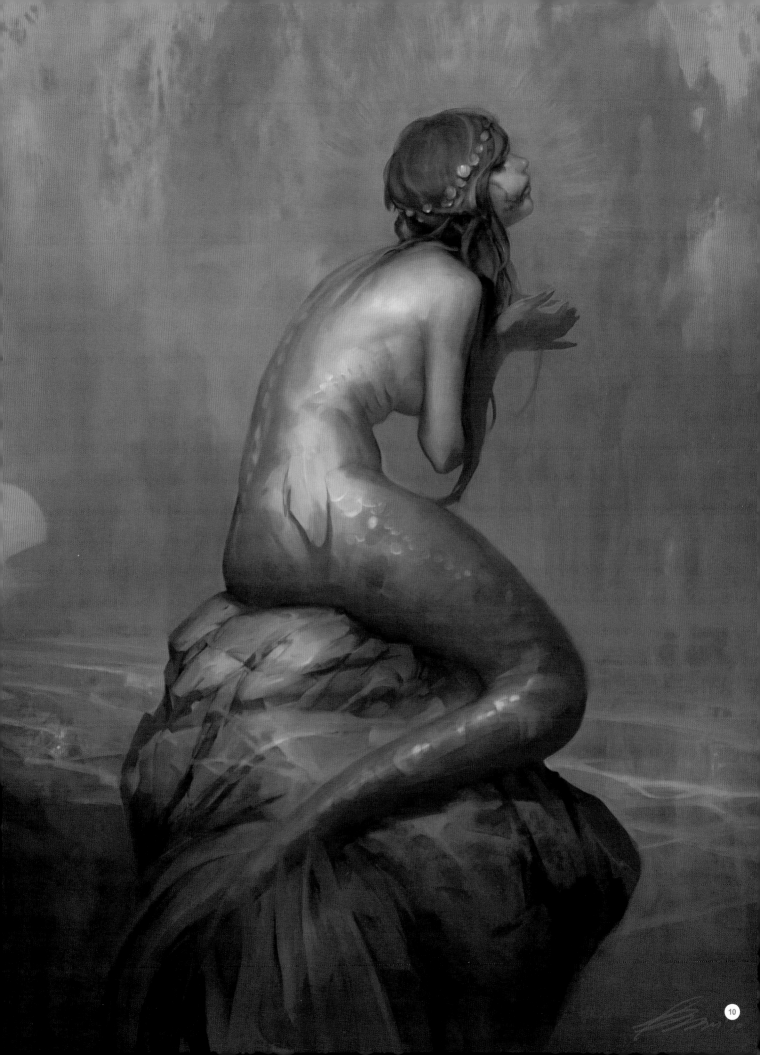

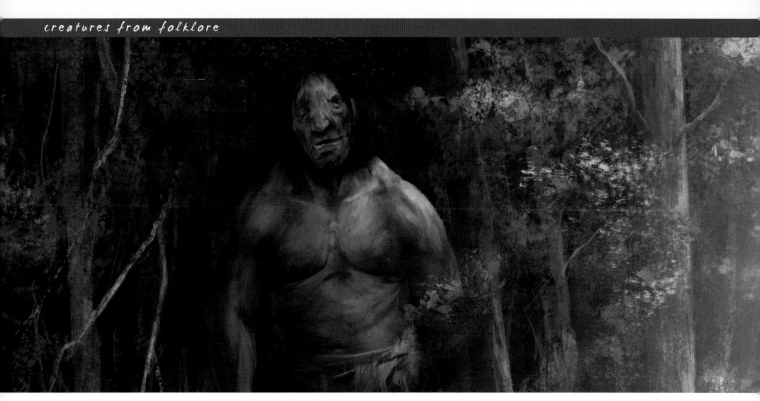

OGRE
BY RICHARD TILBURY

SOFTWARE USED: PHOTOSHOP

INTRODUCTION

An ogre is described in literature as a humanoid monster that is large, hideous and preys on human beings. They often have a large head and strong body, appear hairy, and are disgusting, brutal and closely related to trolls. The word "ogre" has its origin in French but they have featured in mythology, folklore and fiction alike.

> I LIKED HIS EYES AND FURROWED BROW BUT, ULTIMATELY, HE LOOKED TOO HUMAN

When you research the topic you discover a broad range of depictions from various cultures and time periods, all of which look very different. I knew that my version should look hideous and although I imagined him to be a creature to fear, I also felt he should be somewhat unintelligent – more brawn than brains, so to speak.

THUMBNAIL SKETCHES

I had a vision in my mind of a monster that

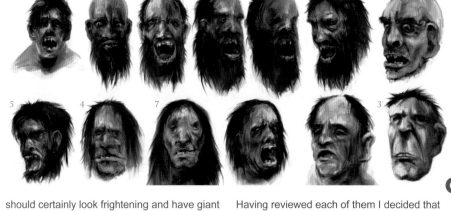

should certainly look frightening and have giant proportions, but I could not picture his face which was the crucial aspect in portraying his character. As a result I decided to create some thumbnail sketches to explore his appearance. **Fig.01** shows a series of grayscale portraits done using a standard hard round brush. The notion that ogres are meant to feed on humans was a trait that struck me as their most fearsome aspect and so I drew some faces with their mouths open. A gaping mouth showing a set of gnarled teeth seemed appropriate to emphasize their cruel intent. As mentioned earlier, ogres have also been described as being hairy and so I added a beard to several versions.

Having reviewed each of them I decided that version 1 reminded me of Rasputin and so was not suitable. I liked his eyes and furrowed brow but, ultimately, he looked too human. Numbers 2 and 3 had less human proportions but seemed too stylized, almost leaning towards cartoons. In contrast, versions 5 and 6 looked more realistic, but had a distinct caveman quality which wasn't what I was after.

Although sketch 1 was not really along the right lines I actually liked the mouth partly open and so did a couple of variations on this. I liked the small eyes in version 4, but his face looked somehow kinder than some of the other versions. His features looked softer by

comparison and almost evoked the quality of a gentle giant. I decided to make the face overtly asymmetrical and with more distorted features (version 7). This sketch certainly seemed to encapsulate a quality I was after and was the version I decided to settle on.

BLOCKING IN

With the decision made on which face to use I started to block in a rough composition. At this stage I was unsure about what I was going to paint, but I imagined the ogre emerging from the shadows towards an unsuspecting foreground character. To have him creeping up on a potential victim was a way of injecting a sense of tension into the image and helping the viewer feel a sense of danger.

Fig.02 shows the initial stages in which the ogre is set within a dark backdrop. I considered having him inside a building or house, but then felt he should be much larger. I thought about predatory animals such as tigers and lions and how they stalk humans who have ventured from settlements and villages. This gave me the idea of a creature that would wait within the cover of a forest and snatch anyone straying too near the tree line. In this way I could keep him partly concealed in shadows.

I added in some trees using a couple of custom brushes, which you can see in **Fig.03**. I used a variation of the same brush to paint both the trunks and the foliage.

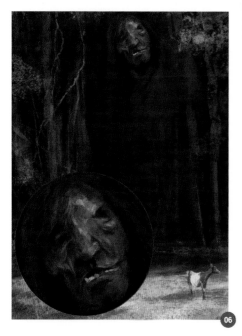

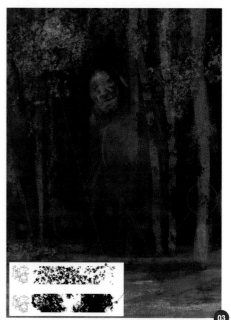

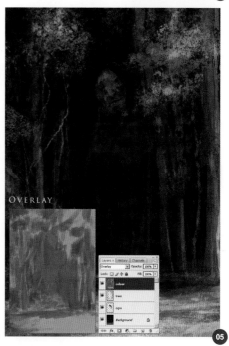

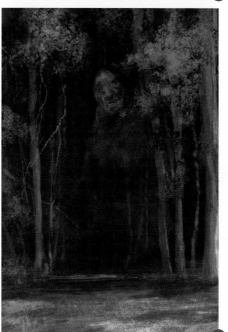

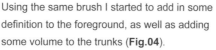

Using the same brush I started to add in some definition to the foreground, as well as adding some volume to the trunks (**Fig.04**).

ADDING COLOR

I added another layer that would be used as the initial color scheme. This layer was set to Overlay blending mode, which means whatever color is applied maintains the tonal range of the layer below. **Fig.05** shows the color layer set to Normal mode in the bottom left and the resultant effect when it is set to Overlay (main image). I started to paint some detail into the ogre's face as well as also adding a goat into

the foreground, which would become the focus of his attention and also a focal point in the scene (**Fig.06**).

At this stage the face now looked a little too bright compared to the previous version; however I knew I could tone this down later and so I left the ogre on a separate layer.

COMPOSITION

The ogre was very central in the composition and so needed to be addressed as the distance either side of his head was similar with respect to the canvas boundary. This doesn't make

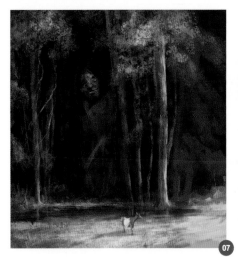

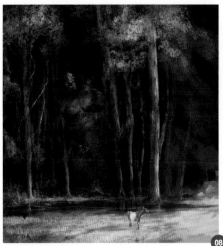

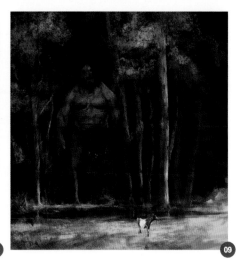

for a particularly dynamic composition and so I opted to extend the canvas as opposed to moving the character. I added a section down the right-hand edge as I preferred the idea of more space devoted to the forest. **Fig.07** shows the newly altered composition with the ogre occupying a more balanced position in

the frame. I also decided to make the darker band in front of the forest into a pond or area of flood water. It made an interesting feature that separated the forest from the foreground.

The next stage was to re-scale the ogre and integrate him into the background. **Fig.08**

shows his new position. I experimented by having him leaning out from behind some cover, watching the goat, possibly waiting to rush out and grab it!

The smaller scale certainly helped the composition, but his leaning posture looked a little awkward. I tried having him stand upright, but with a slight tilt of his head to suggest he is tracking the movement of the goat (**Fig.09**). This seemed like a much more satisfactory solution, although having referred once again to my thumbnails I realized his face was losing some of the qualities I liked in version 7. Using this as a guide I re-painted the features to make them match more closely.

At this stage I had only three layers in my PSD file: the goat, the ogre and the rest of the scene. I wanted to add warmth to the sunlight that was falling across the foreground section and so I first duplicated the scene layer and then went to Image > Adjustments > Color Balance and increased the red and yellow values by around +14 (**Fig.10**).

I then used the Eraser tool to restrict the warmer values to the foreground and to the tree trunks, which can by compared in **Fig.08 – 09**.

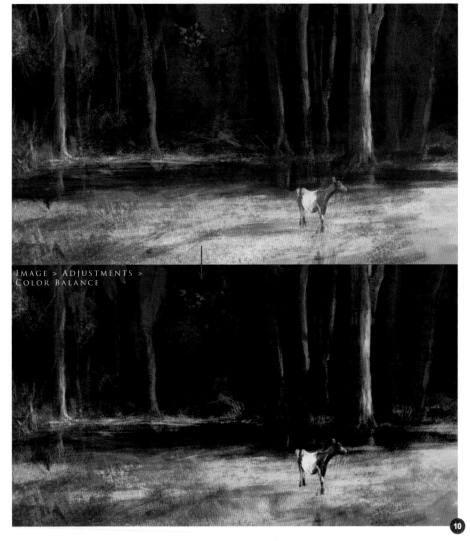

IMAGE > ADJUSTMENTS > COLOR BALANCE

ADJUSTMENT LAYERS

Although the ogre is sheltered by the forest I thought it would add drama to have some dappled sunlight cast across his body through the tree canopy. To do this I created two new adjustment layers: Curves and Color Balance. The Curves adjustment layer was used to

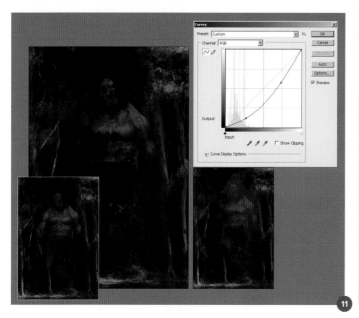

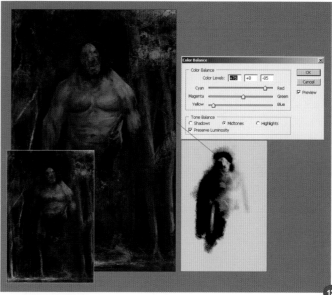

11

12

add a shadow to the left side of the character, which faces away from the light. In **Fig.11** you can see the ogre before this is applied in the bottom left (inset). On the right you can see the Curves adjustment and the mask below this (in red), which restricts the shadow to the left side of his torso and arm. The Curves adjustment is used to darken the entire character and then, by using black to paint into the mask (red area), it is possible to control which parts of the image are left unaffected.

> " I WANTED THE
> OGRE TO LOOK
> IMPOSING AND
> HAVE A POWERFUL
> STATURE, BUT I WAS
> STARTING TO SEE A
> RESEMBLANCE TO THE
> HULK AND SO SCALED
> HIS WAIST AND
> SHOULDERS IN A BIT "

The Color Balance adjustment layer was used to create the warm sunlight cast across his body (**Fig.12**). Here you can see that the ogre has been color tinted with more yellow and red and a slight amount of green (+8). The grayscale image shows the layer mask with the black areas being used to add to the mask and thus hide the color adjustment. You will notice that the area of white on the right side of the face reveals the mask and creates a highlight (ringed in red). The final result of both layers can be seen in the lower left (inset).

The Layer structure now looks like the insert in **Fig.13** with the two adjustment layers at the top of the palette.

FINAL REFINEMENTS

I wanted the ogre to look imposing and have

a powerful stature, but I was starting to see a resemblance to the Hulk and so scaled his waist and shoulders in a bit. I used Image > Adjustments > Color Balance to cool down the color by adding some blue and green to reflect the forest shade (**Fig.13**). I then duplicated the

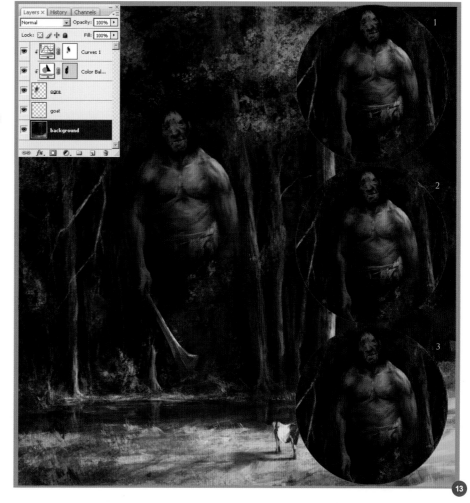

13

> **TO HELP MAKE THIS AREA RECEDE FURTHER INTO THE PICTURE PLANE I PAINTED IN A NEW LAYER TO REPRESENT SUNLIGHT STREAMING ACROSS**

character layer, added some highlights across his right shoulder (1) and also darkened his left side (2). I finished by using a soft eraser to bring back some subtle highlights down his left arm (3).

I wanted the forest to appear denser and so added some extra leaves along the right-hand side of the image (see image 2 in **Fig.14**). This helped make the clearing where the ogre is situated appear more like a cave entrance. To help make this area recede further into the picture plane I painted in a new layer to represent sunlight streaming across from the upper right. Image 3 shows the layer set to Normal blending mode using a lemon yellow and then the consequent result when set to Overlay (image 4).

Once I had added some sunlight catching the canopy in the upper right, I imagined some beams of light falling onto the foreground. To create these I made a rectangular selection area that stretched from the upper right towards the goat (**Fig.15**). Once done I changed the foreground color to a pale yellow and then applied a Foreground to Transparent Gradient, dragging from the upper right down.

I used a soft eraser to create some streaks and break up the consistency somewhat. Here's the finished version (**Fig.16a – b**).

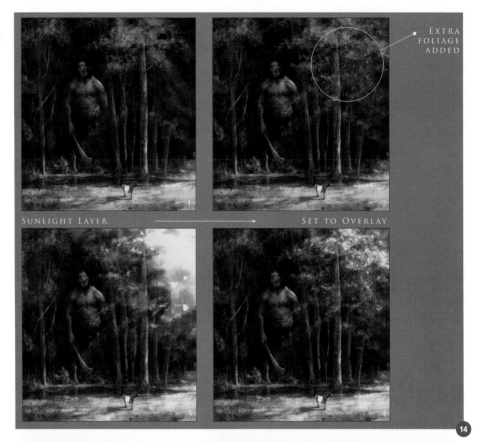

EXTRA FOLIAGE ADDED

SUNLIGHT LAYER → SET TO OVERLAY

14

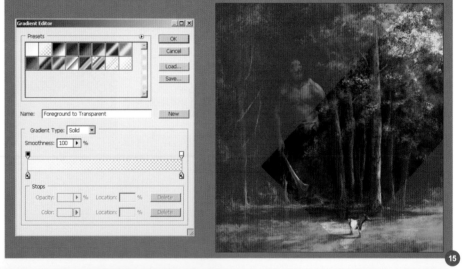

15

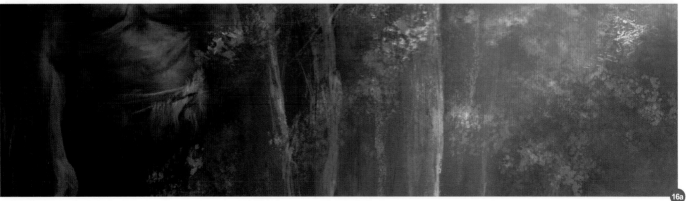

16a

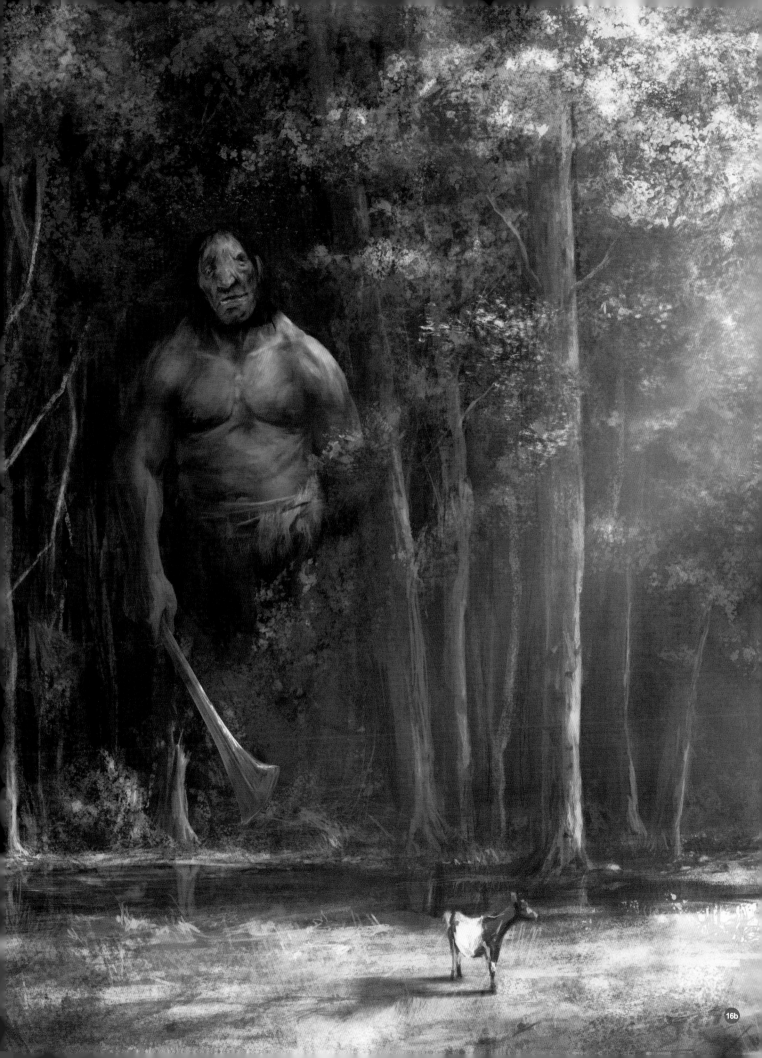

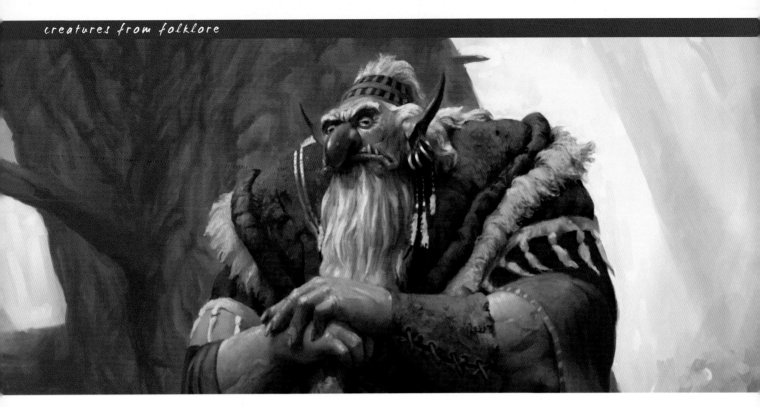

TROLL
BY SIMON DOMINIC
SOFTWARE USED: ARTRAGE STUDIO PRO & PAINTER

INTRODUCTION

One of the most recognizable characters in folklore is the troll, yet ironically they come in all shapes and sizes. Whilst some trolls are depicted as huge and hulking, others are described as being similar to normal folk, distinguishable from humans only by their clothing and habits. Troll tales originate primarily from Scandinavia, although England and Scotland also have a small troll tradition.

For this painting I've decided to paint a portrait rather than an action scene, and to set it in a forest environment. A portrait approach will result in a more formal character depiction, but will allow for full focus on the character.

My troll will be an important personage in the troll community and hence will be dressed more elaborately than his peers. That doesn't mean his clothing will be pristine however, as the forest can be a messy place and trolls aren't renowned for their cleanliness. In terms of weapons I'm going to give my troll a huge, oaken staff that doubles as a club. Trolls tend to make use of the resources around them so I think a basic, natural weapon like a club is more fitting to a forest setting than a sword or a magical item. To complete this image I'll be using ArtRage Studio Pro and Painter 11. I'll do the concepts and sketching in ArtRage and move on to Painter for the coloring and final detail. Either package would be sufficient

to complete the entire project, but ArtRage's strengths are in sketching and Painter's in detailing.

QUICK CONCEPTS

It's often a good idea to knock out some initial sketches before beginning the main work. I actually did this step before I made the decision to create the forest troll portrait as I described.

For this piece I create half a dozen sketches, each depicting a different type of troll (**Fig.01**). The process is very quick as these characters are not intended for display, rather as a decision aid and a catalyst for the creative

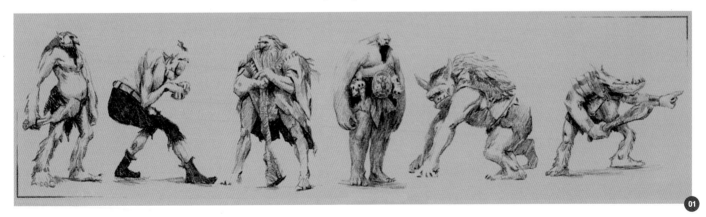

process. I use the default pencil and canvas in ArtRage. I find the rough feel closely mimics using a real pencil. Using these concepts as a guide I choose the third character as the one I want to develop. With this in mind I move on to the actual image.

LINEWORK

My final image needs to be 2480 x 3425 pixels at 300 dpi. However, because I won't be painting fine detail until later on there's no point working with such a large canvas initially. Therefore, still in ArtRage, I create a small canvas with the same aspect ratio as the spec for my final image. I load my concept sketch as a reference so I have a constant on-screen guide as to what I want to achieve (**Fig.02**).

Next I create a new layer and draw a few rough perspective lines to an imaginary vanishing point way off canvas to the left. My troll will be large, maybe eight feet tall, and therefore I want to give the impression that he is looming over the viewer. Rendering the troll against these perspective lines will help in this respect.

I make the outline sketch onto a new layer. This stage is designed to give a basic, clean indication of all the main elements of my character. His clothing is composed of a rag-tag combination of layered clothing, which will have different textures in the final image. The skulls around his waist reinforce the idea that

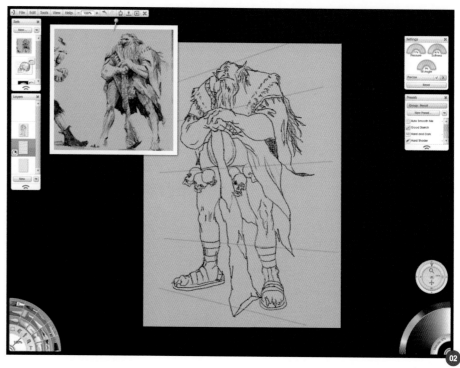

he's a big fella as well as an unpleasant one. When I've finished the line drawing I hold Alt + H (Option + H on a Mac) to view the image mirrored. This helps to identify any anatomical or perspective problems.

SKETCH DETAIL

I increase the size of my canvas to about half the intended final dimensions. This will allow for more detail to be laid down. To compensate for this I also increase my pencil Nib Size to around 200%. I reduce the opacity of my

linework layer to 30% and create a third layer on top. Using the low opacity linework as a guide, I create a detailed sketch of my character (**Fig.03**).

CLEAN UP

The first two layers – the perspective lines and the linework sketch – have served their purpose, so I delete them. This leaves me with the detailed sketch on a single layer (**Fig.04**). I save this as a PSD file because the next time I work on it I'll be using Painter.

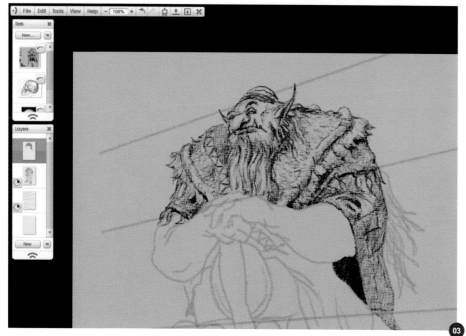

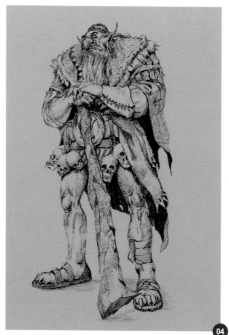

BUILD A COLOR PALETTE

When painting, I find it very helpful to work from a pre-created color palette – a color set. This doesn't mean I'll be choosing every single color from this palette, but it will act as the primary selection tool.

To create the color set I first open a blank canvas in Painter. As in the actual painting stage it's a good idea not to use pure white as the background as it can be overwhelming and make it difficult to distinguish darker colors. I use my Artists' Oils brush to make a sequence of splodges representing the main elements that will be in my image – bright yellows for the sky; deep browns, oranges and grays for clothing material; mid-saturation, mid-value pinks for the skin tone and white for the hair. When I'm happy that those colors will take care of most of my requirements, I click the Create Color Set From Mixer Palette option. This generates a 256-color color set palette, which I save as a PCS file (**Fig.05**).

LOAD THE PSD INTO PAINTER

Because ArtRage processes paint in a different manner to Painter, PSDs that have been exported from ArtRage usually have a number of extra layers. I load the PSD into Painter and see that there are two blank layers and a paper layer in addition to the canvas and sketch layer (**Fig.06**). In this instance I remove both blank layers and the paper layer, although if you prefer the paper layer color to the canvas color you may want to simply remove the two blank layers and drop the paper layer to the canvas.

UNDER-PAINTING

I use my "Under-painting" Artists' Oils brush to lay down a very quick, very rough

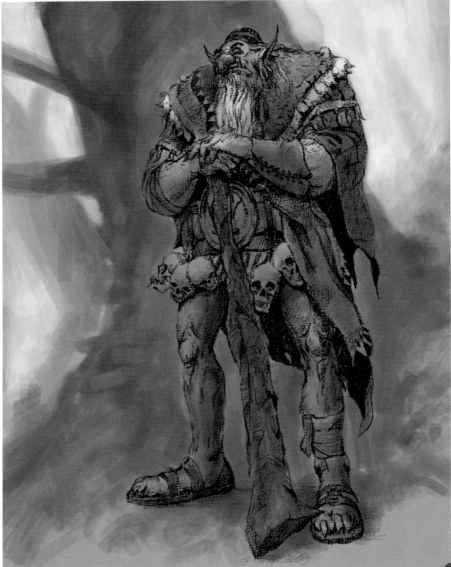

approximation of the colors I'll be using. This is simply to act as a guide to the proper painting. I choose a simple background, which acts as an anchor for the character whilst providing a hint of his environment. I will be painting the background in low-contrast hues so that the main figure stands out (**Fig.07**).

UPSIZE THE IMAGE

I'm ready to begin the final painting process so I upsize my image to its working dimensions using Canvas > Resize (making sure Constrain File Size is not ticked) (**Fig.08**). I actually size it to dimensions greater than the specified 2480 x 3425 pixels, so that I have more scope for

adding fine detail where needed. Because I am careful to maintain the aspect ratio I'll be able to resize to the exact specification when the painting is complete.

BEGINNING PAINTING

Before I start painting I drop the sketch layer to the canvas so that the image is completely flat (in terms of layers). I select the Artists' Oils brush and begin adding rough detail to the troll, starting with the head and face. Because the expression of the troll is important, I work using a relatively small brush, about 10 pixels, with the zoom set at 100% (**Fig.09**).

USE THE LARGEST BRUSH POSSIBLE

When painting larger areas, especially at this stage, it's a good rule of thumb to use the biggest brush possible. So instead of using the 10 pixel width brush on the troll's exposed arms, or flowing cloak, I increase the size to 15 or 20 pixels (**Fig.10**). Of course, as detail increases, the size of the brush will decrease.

USING LIGHTING AND TEXTURE

Understanding the ways different materials react to light is key to creating a believable image. Here I combine a number of different materials to form the troll's garb, ranging from dull drapery to the thick, calloused, fur-lined leather covering his shoulders. I depict the leather as having more surface variations of hue, saturation and value than the thin material of his robe, and also slightly more specularity

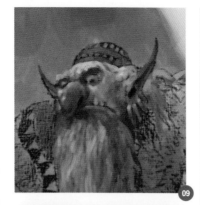

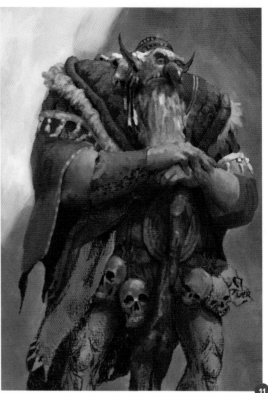

(**Fig.11**). Even more specularity is present on his skin, on the skulls around his waist and also on the monstrous staff he's leaning on, as a result of the wood being worn smooth over time.

ROUGH BACKGROUND DETAIL

To finish off the rough detail work I move on to the background. I increase my brush size to around 30 pixels for this stage. In order to depict bark on the tree I cross horizontal and vertical bark textures so that the tree's bulk is

evident in three dimensions and it doesn't look flat. By easing up on the pen pressure I can blend certain areas so that the texture doesn't overpower the main character. I also darken the area under the troll's feet. This is to anchor the character with the background. If I didn't do this the character would look pasted and it would flatten the image (**Fig.12a – b**).

PAINTING LEAVES

Selecting low saturation colors from my palette, I dab at the ground plane, creating flecks that, from a distance, resemble leaves. I'll be

CHAPTER 1

refining these shapes later on. At the moment it's sufficient that these leafy shapes remind me of leaves and are roughly the right color (**Fig.13**).

USING COLOR VARIABILITY

I'm about to begin the fine detail stage and this involves using the Round brush. One neat trick to improve the painterly appearance of detail is to use the Color Variability settings. I select In HSV from the pull-down (this stands for Hue, Saturation, Value). I then set the sliders to H: 4%, S: 1%, V: 1%. This means that every time I make a mark with the brush, the color hue that I've chosen will change randomly within a 4% tolerance of my original color choice. In the same way, the saturation and value will change randomly within a 1% tolerance. It's a good idea to play around with these settings to see which suits you best (**Fig.14**). A word of warning here: Painter 11 has a bug whereby these settings can spontaneously reset to 0. For this reason I keep the Color Variability panel on my workspace and check it every so often.

DETAILED TEXTURING

With my small, round brush set to between 5 and 12 pixels, I move over the character and boost the detail level. Because our troll is a forest dweller, and likely a bit of a thug too, I add a few areas of scuffing, staining and dirt on his clothes (**Fig.15**).

THE HANDS

The troll's hands, resting on top of his staff, are an integral part of this piece, and they need to look just right to make the piece believable. That means particular attention needs to be paid to the light and shadow, which, broadly speaking, define the form (**Fig.16**). Here we can see the troll's left hand is covering his right, which in turn is wrapped around the head of the staff. The shadows are therefore placed to be consistent with our light source. Where the fingers of the right hand grip the wood I use a slightly desaturated highlight to simulate reflected light from the environment. This helps to give solidity to the hand. A light pressure on the pen will blend paint on the canvas. I use this feature to help stop the texture becoming too "scratchy".

RESIZE THE SKULLS

I notice that the skulls on the left appear smaller than they should, even taking into account the slight perspective we have going on. I select them roughly using the Polygonal Selection tool, then hit Ctrl / cmd + C to copy the contents. I remove the selection area using Ctrl / cmd + D and paste the skulls into a new layer using Ctrl / cmd + V. Using the Edit > Free Transform menu option I enlarge the selection object whilst holding down Shift to maintain the aspect ratio (**Fig.17**). Lastly I choose Edit > Transform > Commit Transformation and then drop the selection onto the canvas. I also neaten the edges a little so it blends with the image.

ROBE MATERIAL

To paint the orange robe material I enlarge the Round brush to between 10 and 20 pixels. Varying the pen pressure is key in this painting process. In the dark shadows I press quite hard so the dark paint is applied "thickly" whilst elsewhere I ease up on the pressure so that the paint is more opaque and bleeds more readily with existing colors (**Fig.18**).

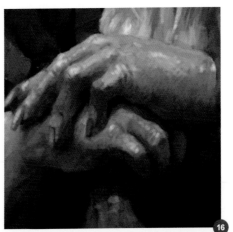

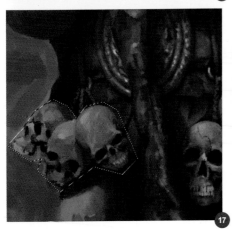

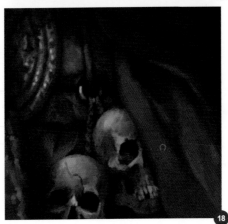

When applying almost no pressure the brush behaves more like a blender and helps to create graduated yet textured blends between light and shadow. To obtain a high degree of control over your pen sensitivity you should experiment with different settings in both your tablet settings application and via your Edit > Preferences > Brush Tracking menu option in Painter.

SCARRED SKIN

It's safe to assume this troll has had a hard life, so the skin around his knees and shins

will be scarred and pockmarked (**Fig.19**). With light brush strokes I make a few dark lines and dots on the skin. To make them appear etched into the skin I make very faint highlights on the edges, especially the lower edges being that our light source is above. As a general rule, if the highlight is on the side of the blemish furthest from the light source it appears like a groove; if it's on the side nearest the light source it appears like a bump and, of course, vice-versa for the shadow. Lastly, I add a bit of dark paint to his knee to represent dirt and scuff marks.

WOOD TEXTURE

If you're not careful the wood texture can easily end up looking like skin or cloth. To avoid this I use darker, more saturated colors for the wood base color (**Fig.20**). I add desaturated specular highlights sparingly to the staff to simulate old, worn wood. Placing some of the bright highlights directly onto the dark areas make it appear as if the wood itself is dark, rather than in shadow. This is a useful method of distinguishing dark coloration from shadowed areas, especially on shiny or slimy items.

AUTUMN LEAVES

I use the Artists' Oils brush to further define the leaves on the ground. At this stage I concentrate on getting the colors right and I leave the shapes quite rough. I use a selection of lighter, desaturated colors for the leaves themselves and dab deep purples and black at their periphery to suggest the shadow and dark earth beneath (**Fig.21**).

FOCUS

When painting the leaves it's easy to get caught up painting one leaf after another and forget the overall image. If you're not careful this can flatten the image due to each leaf being basically the same value and saturation. Zooming out from time to time helps you see how your leaves are becoming part of the scene. Here, I want the leaves in the immediate foreground to be larger, brighter and more colorful than those at the side of the troll, or behind him (**Fig.22**). I also fade out the leaves at the periphery of the piece to create exaggerated focus on the main character. I

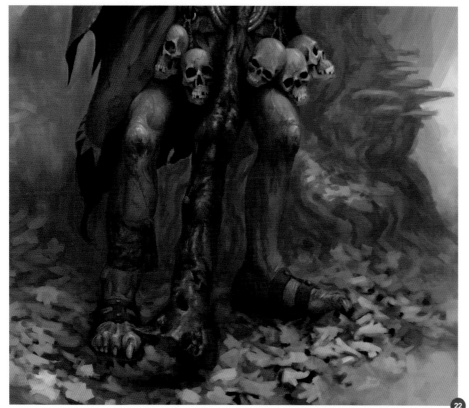

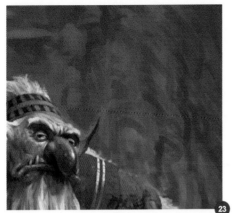

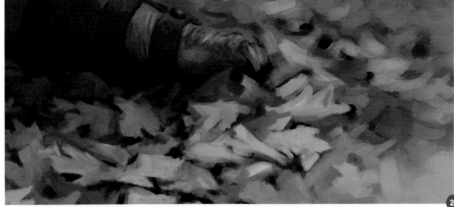

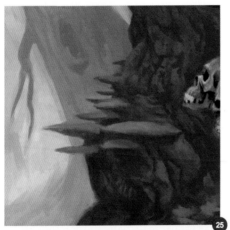

don't use overlays or layers to achieve this effect, rather choose the appropriate color for each leaf and take advantage of the blending function of the brush (Blend increases as Pen Pressure decreases). I also want the troll to appear like he's standing on the ground, not floating in front of it. For this I darken the area below him and to his right to simulate shadow. Again, I try and pick the correct color from the palette or color wheel rather than using layers. You'll see here that I've also flipped the image, which I do from time to time to check composition and anatomy.

TREE BARK

For the tree and the rest of the background I'm careful to use only low saturation colors of mid- to high-value. This is to give a sense of depth and so they don't compete with the main character. Keeping it loose, and still using the Artists' Oils brush, I dab in darker lines that run vertically up the tree trunk. At irregular intervals I sketch small, rough arcs perpendicular to these lines to give the subtle appearance of bulk. This helps give the trunk a 3D appearance and avoids the "stage set" look (**Fig.23**).

FINAL DETAIL – LEAVES

I'm almost finished now so I move around the painting adding some final detail with the Round brush. I don't want to refine the leaves too much so I just spend a few minutes tweaking the brush strokes into more leafy shapes. I don't obsess over each leaf because it's more important to suggest the impression of leaves rather than to painstakingly render each one (**Fig.24**). I also extend the length of the troll's cloak a little, for aesthetic value if not modesty.

FINAL DETAIL – TREE

Using the Round brush I refine some of the tree detail – the fungus and area of discolored bark especially. The level of detail remains much less than that of the main character, so that the background does not compete for attention (**Fig.25**).

A BIT OF TEXTURE

As a final touch I choose the Artists' Canvas Paper from the paper palette (Window > Library Palette > Papers) and, using the Round brush at a large size, dab in a few textures in

the corners of the image, just to make it a bit more interesting (**Fig.26**). As far as I can tell the image is pretty much finished. However, I set it aside for a few days so I can come back to it with a fresh perspective before I do the final submission. Time allowing, it's always a good idea to take a break before formally declaring a piece complete, otherwise there's a danger of getting "too close" to it and allowing familiarity to mask its flaws.

FINAL TWEAKS

When I look at it next I see that the rear hanging edge of the troll's cloak appears too dark, drawing the eye into an unintentional – and somewhat undesirable – focus. I zoom into the shadowed areas and use the Artists' Oils brush to dab in a low value ochre color (**Fig.27**).

RESIZE AND SAVE

If you recall from **Fig.08**, the image dimensions I've been working with are larger than the specified print size. To obtain the print-spec image I save a copy of the main image and use Canvas > Resize to set the dimensions accordingly. Because the large image is the same aspect ratio as the intended smaller one it isn't distorted.

And that completes the picture. During this tutorial Painter has been creating backups of the file every time I've saved (Edit > Preferences > General, tick Create Backup on Save), which I do regularly. I also backed up my files onto a separate disk at the end of every day I worked on the project, using free backup software. For the sake of just a minute or two per day this can save a lot of hassle and stress!

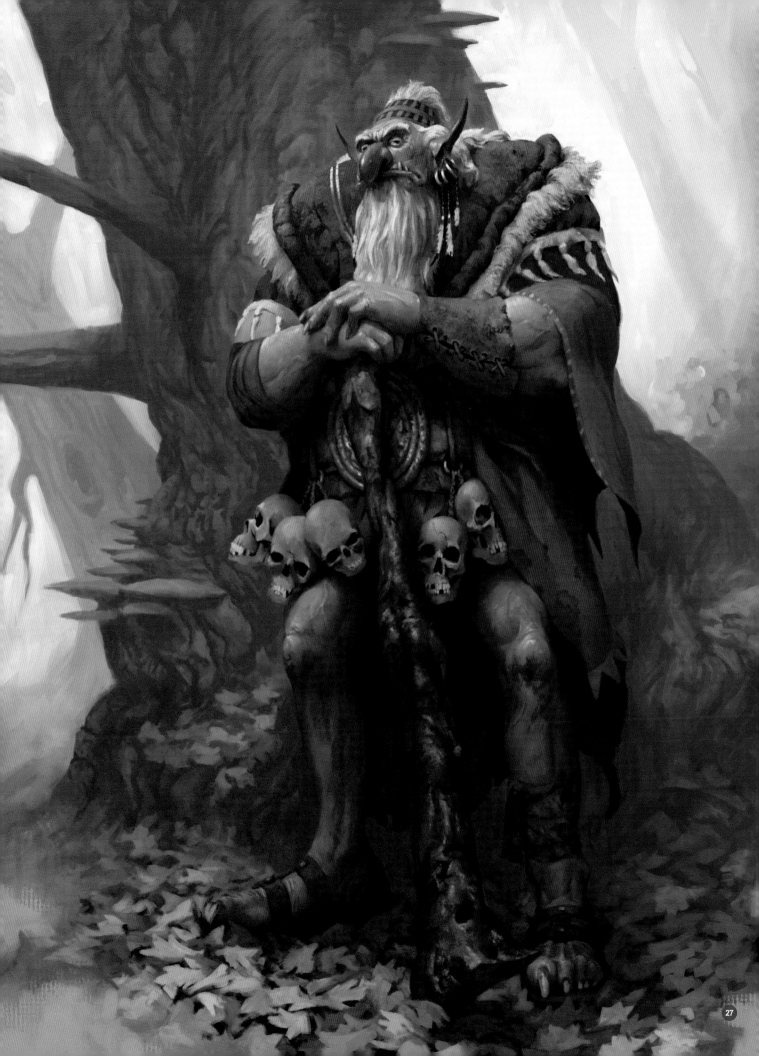

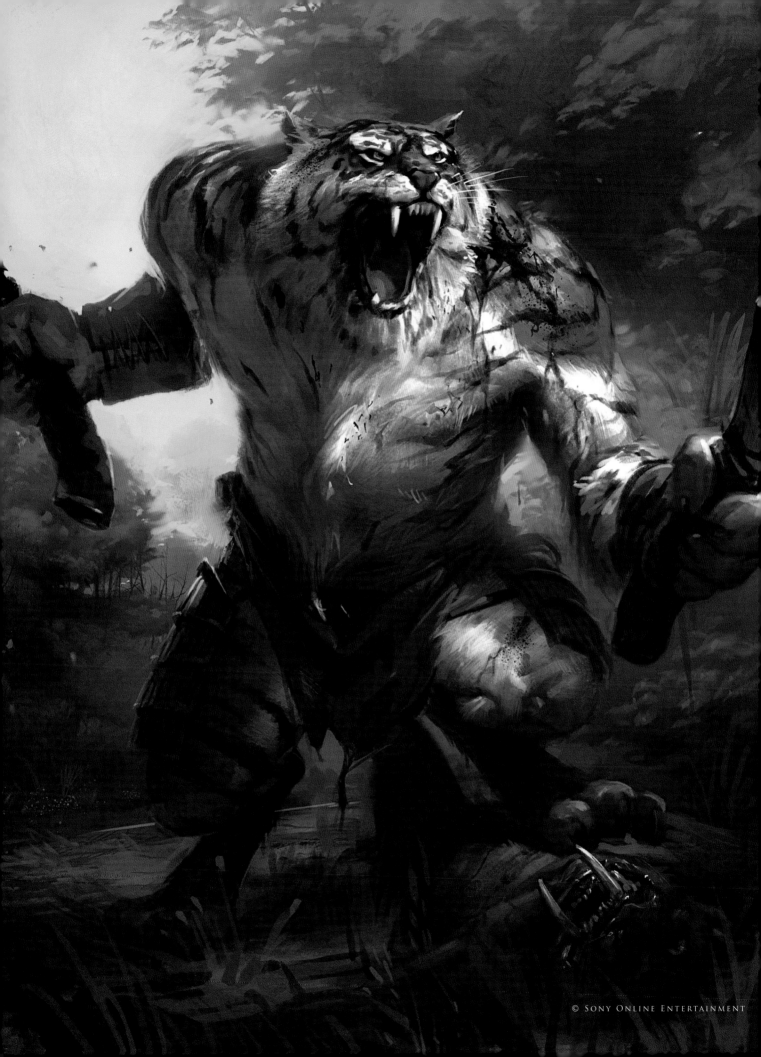

concept art for games

What I like about concept art is arranging ideas and designs. I just love to cut them like vegetables, mix them and then add the dressing. The result is not always tasty, but if you can draw fast (and I think everybody can) it is not a problem. You just start again. What you have to remember is that you should be ruthless when it comes to judging your work. You have to love creating too, and do all the hard work yourself. Never put your pencil down. Always be imagining. Let books, movies, games, music and life all be the sources that provide you with inspiration. If you make concept art an integral part of your life, you will be able to create unique universes.

SLOWAMIR MANIAK
maniak@maniakart.com
http://www.maniakart.com/

PRISON PLANET: THE ENTRANCE
BY THOMAS PRINGLE

SOFTWARE USED: PHOTOSHOP

GAME DETAILS

Game type: First-person shooter
Genre: Sci-fi
Year: 2300

BRIEF SUMMARY

Lex Crane, a former police officer, is now the chief of security at Skye Global, the largest manufacturer of pharmaceuticals on the planet. Lex discovered something about the company he worked for that he shouldn't have, and this starts a chain reaction that causes him to be wrongly accused of the murder of his family and a local politician. He is sentenced to life imprisonment on the prison planet of Asturia. On the prison planet he is constantly targeted by the criminals that he put there all those years ago, along with an unknown enemy within the prison walls hired by Skye Global. Lex was framed by Skye Global's CEO, Lance Shepherd, and Shepherd is now trying to have him killed in a place where nobody will miss him or even realize he's dead. Lex is trying to escape from the prison and back to Earth, where he's convinced he can find the evidence to clear his name. Along the way he forms unexpected alliances and is disappointed by shocking betrayals.

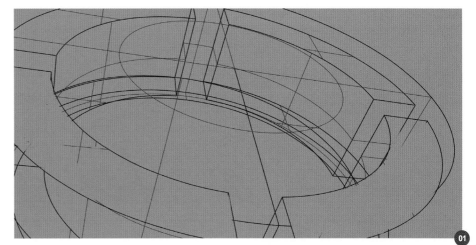

01

THE ENVIRONMENT

The setting is dark and cold. The planet is basically a giant rock. There is no lush foliage or vast bodies of water; instead there are pits of oil and sludge. The terrain has large jagged rock formations jutting out sporadically throughout the landscape. The sky is constantly filled with flashes of green lightning, which brings on poisonous rainstorms.

There is a giant prison facility that has been placed on the planet to house the galaxy's most violent and evil criminal element. Escape is rarely ever attempted because of the sheer fact that outside the walls survival is not possible. The extremely harsh climate, along with the predatory dangers that exist on the planet, make it so that the prisoners would rather stay confined to prison. At least there is food, shelter, warmth etc., inside the jail.

Prisoners are forced to work as part of their sentence. The labor camps are set up throughout the perimeter surrounding the prison. They are forced to mine for the oil that exists deep within the surface of the planet. Along with these intensely laborious tasks of digging and mining, the prisoners are also

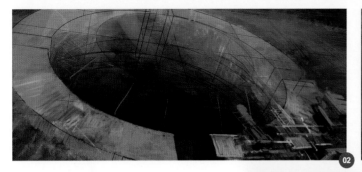

constantly expanding the facility. They are constantly creating more and more buildings to house more prisoners.

THE PAINTING

The assignment for this tutorial is to design the environment for a fictional game universe that takes place on a prison planet. In this first part I will focus on the main shot that establishes the main area. This scene will help set up the tone, style and direction for all the following concepts.

I've decided to design the prison as an underground facility. The prisoners are mining deep within it and the whole structure is shielded from the hostile environment due to the fact it is below the planet's surface. The sharp rock formations, together with the blue tone of the image, will help convey a feeling of tension and hostility.

This scene is very important, as it not only provides a base for the entire concept for the game, but also provides a dark and brooding entrance to the prison, which has potential for a great intro sequence. A descent into hell! For the establishing shot I want to start with a dynamic angle that brings a sense of motion to the scene. I start with a wireframe cylinder

created in a 3D program (**Fig.01**). This is simply to create some basic geometry that I will later paint over. I want this painting to be quite refined and well finished; to achieve this I make sure the underlying perspective is solid, so I won't have to go back at a later stage and correct it. In my experience the more finished the painting, the more solid the underlying structure is required to be.

I start to add color and volume to see if I can trigger the visual direction I want to pursue throughout the environment concepts. Since the concept is that of a prison planet, it is vital that the colors reflect a hostile and cold environment to give the concepts the right mode and feeling (**Fig.02**).

I continue this process until I have established the main distribution of the color and values across my image. It is also important that the direction of the light has been incorporated by now. In these early stages I block everything in before going into any detail (**Fig.03**). This gives me a good overview and allows me to consider the composition as a whole. I can always develop the finer details at a later stage.

I continue this process by further refining the image. I do this by continuing to block in the smaller structures in the foreground and painting the surrounding alien landscape in the background (**Fig.04**). I try to keep the background fairly vague without emphasizing too much detail. I do this as it is important not to divert the viewer's attention from the main focus of the concept.

I decide to shift the colors more towards a shade of blue by adjusting the hue and saturation (**Fig.05**). This again is to push the cold, dramatic feeling. I also paint in fog to certain areas to push the atmosphere further and add a greater sense of depth to the image. I start to wrap up the image by further defining the surface of the prison. To do this I focus on the reflective quality where the light source hits the surface and paint in texture details (**Fig.06**).

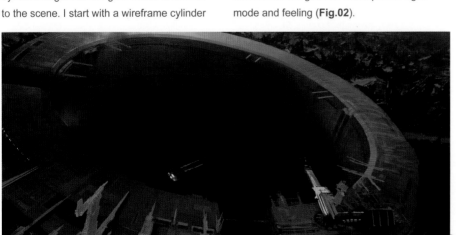

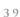

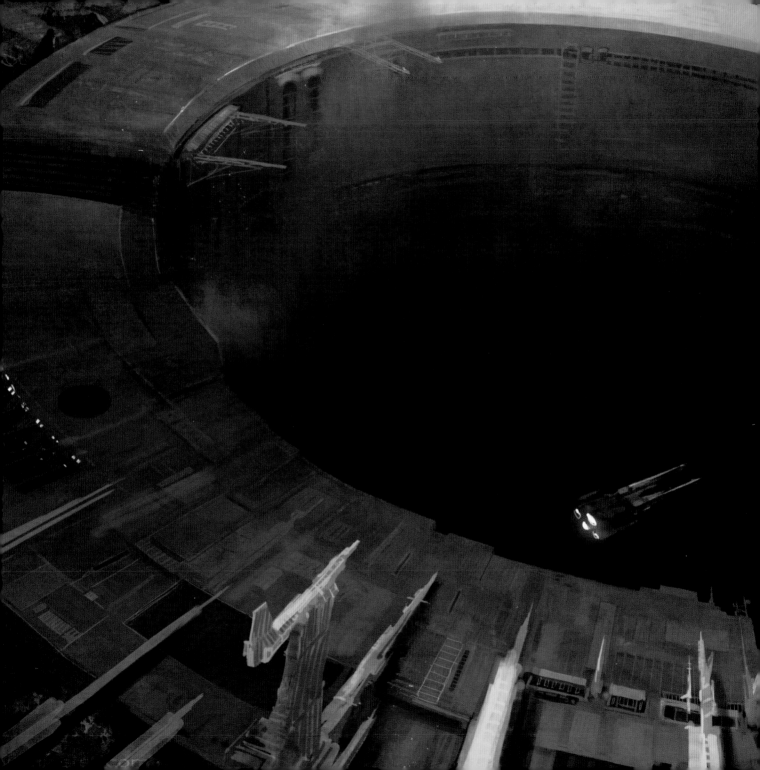

PRINGLE (10)

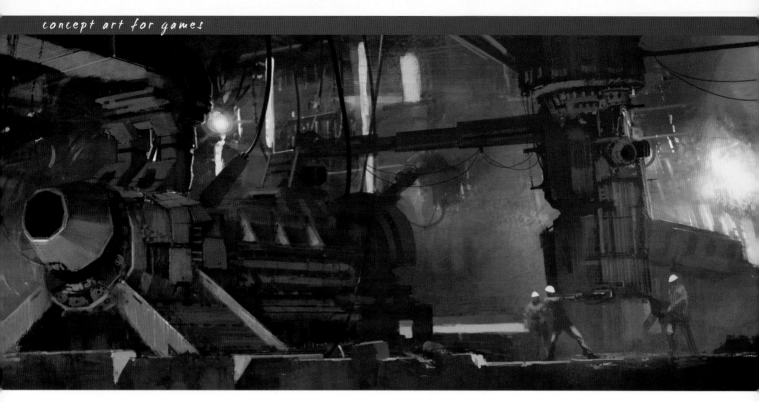

PRISON PLANET: LABOR CAMPS
BY THOMAS PRINGLE
SOFTWARE USED: PHOTOSHOP

INTRODUCTION

In the first part I covered how to create an establishing shot of the entrance to the prison facility. In this second part I will flesh out a concept of the labor camps that are deep down in the planet where they are shielded from the hostile environment on the surface.

THE PAINTING

The main emphasis in this high level concept will be to focus on creating signature shapes that can be used to flesh out the overall look and feel of a level in the game. I start out by establishing my lens and blocking in the overall shapes. At this stage the focus of my attention is on finding an interesting angle to present

the concept from and getting a good contrast going. This will ensure that the image has good readability (**Fig.01**).

Once I feel I have something that will work I move on to adding the bigger elements of the

image. I settle on a blue color, which I treat as a base point that I will start to add local colors to. Sometimes I find it helpful to add bits of some of my old paintings and toggle through the Layers menu in Photoshop. By doing this you will often find an interesting combination of colors that can be very useful (**Fig.02**).

Up until now all I have done is narrow down my selection of color and define the major shapes. Now it's time to select the local colors and design all the different objects at the location. I pick a strong orange for the workers as it gives a good contrast to the blue and helps balance the image. The big machine to the left will be some sort of cooling apparatus for the drill, so I have to make sure to add vents to make it look functional and plausible (**Fig.03**).

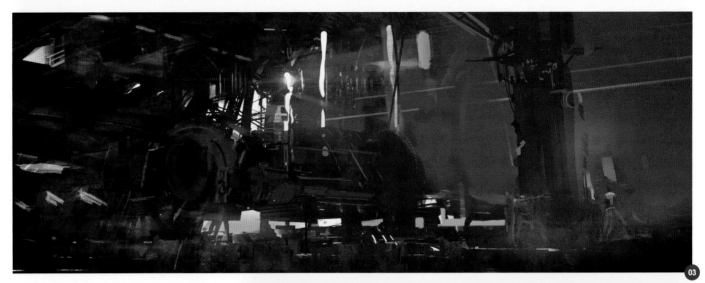

When designing I like to try different things out on a separate layer, or even on paper before settling on a final design. It's always good to do lots of quick variations to get a feel for the object. In this case I tend to focus mostly on the silhouette since I know it will be fairly backlit and have a lot of ducts and pipes breaking out from the core shapes. I always try to push the contrast and, in this case, I make sure to have a round air duct at the front to compliment the otherwise quite blocky design of the machine (**Fig.04**).

At this stage in the painting there's mostly fine-tuning left as everything is already quite well established. The only additions I make to the painting are the overhanging pipes and wire. I like the wires as they give a nice curvature to the horizontally- and vertically-dominated design of the painting. I decide to add white helmets to the workers as they give a nice contrast to the surroundings as well (**Fig.05**).

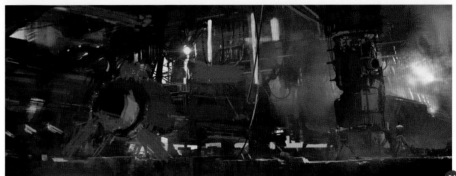

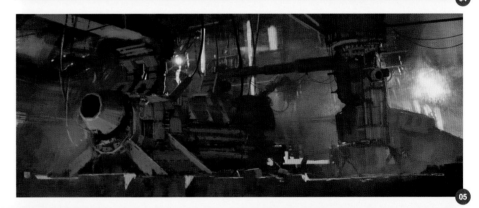

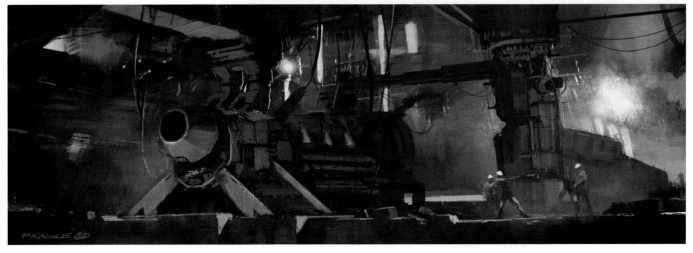

CHAPTER 2

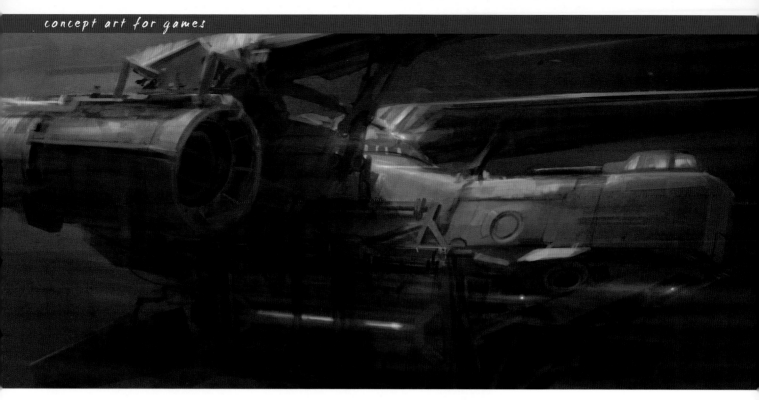

PRISON PLANET: PRISONER TRANSPORT
BY CRAIG SELLARS

SOFTWARE USED: PHOTOSHOP

For my first chapter in this project I want to design a drop ship or prisoner transport for the prison planet Asturia. When I set out to design anything for a game the first thing I consider is how whatever I am required to design can help tell the story and add to the mood.

In this case I'm setting out to design a transport vehicle solely used to ferry highly dangerous prisoners to and from the remote planet's surface. I want the vehicle to feel heavy and a bit clunky – sort of utilitarian, where form follows function (that is to say that the ship's construction is dictated purely by the mechanical requirements, with no thought to making it aesthetically pleasing). I decide it's important to emphasize how inhospitable the planet's environment is so I want the vehicle to look rundown, as if flying in Asturia's atmosphere has taken its toll on the ship.

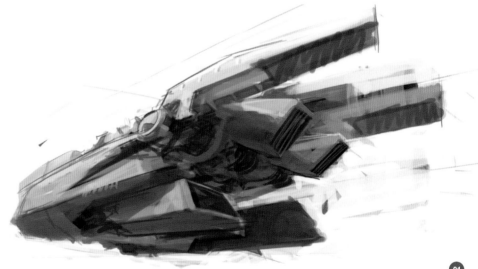

01

When sketching out initial ideas for something like this, I would usually use a blue pencil then markers and a tech pen for cleaning it up, but I have increasingly started to use Photoshop for the sketching process as well as the finished pieces since it is so efficient and versatile.

I'm trying to design something that is heavy yet feels fast, with a lot of control surfaces (**Fig.01**). There is a lot of potential for moving parts constantly adjusting as the ship flies through the turbulent atmosphere. While I like the idea of this design I feel it's a little too bird-like or elegant to be a heavy old prison transport.

02

With this rough sketch I go for a more traditional rectangular box shape, in the spirit of classic shuttles like in *Star Trek* (**Fig.02**). However to make this shuttle look more utilitarian, I add large, oversized engines to the sides, expose mechanical details along the underside and add some less prominent control surfaces for added movement. Whilst I like the heavy feel of this design, I think it lacks a distinct silhouette.

For my third sketch, I try to create a fuselage shape that's more like a tugboat or transport boat with a prominent control room/cockpit

up front for maximum visibility in turbulent atmospheres (**Fig.03**). At this point I realize that this boat theme provides an opportunity to incorporate more "story" into my design, and I place the compartment that the prisoners ride in at the bottom of the vessel. The idea is that since they are so dangerous, the prisoners are kept in the bowels of the ship and as far away from the crew as possible. Also, the fact that they are kind of hanging on the bottom of the ship like cargo reflects how little concern the crew has for the prisoners' lives.

While looking through references of heavy military machinery I come across an image of what I think is a portable bridge. I like the aggressive and unconventional shape so I incorporate this into the design, thinking these large forward projecting shapes could be control surfaces that regulate the descent of the ship as it both flies and falls through the turbulent atmosphere (implausible from an engineering standpoint, but sometimes it's about creating interest above all else). I finish this idea off with a heavy array of engines retrofitted to the sides. At this point it's time to review my sketches. **Fig.03** is the direction I decide to take as it fills all of my design goals.

To start out, I sketch my design on a blank canvas (**Fig.04**). At this point I am carefully choosing an angle that gives the most dynamic

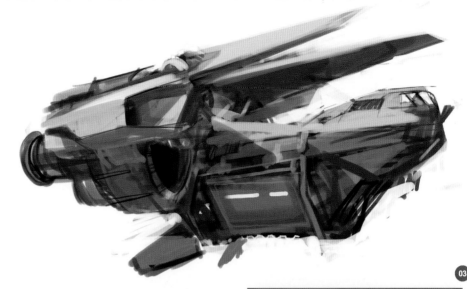

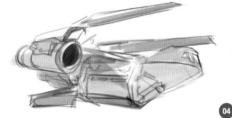

view of the vehicle. Sometimes I'll do this step by creating a simple 3D block model so I can rotate around it to choose the best angle.

Next, I place a background wash of color behind the sketch (**Fig.05**). This is to represent the sky and color of the planet's atmosphere, but more importantly it is the key color for my painting and the base into which I will

paint. I create this "wash" by layering in a couple of nondescript sections of a sky photo, then adding solid color overlays on top and adjusting the transparency so I have some color variety and texture.

Next I start layering in textural images as overlay layers (**Fig.06**). These are made up of photos of metal and rusty surfaces etc., and

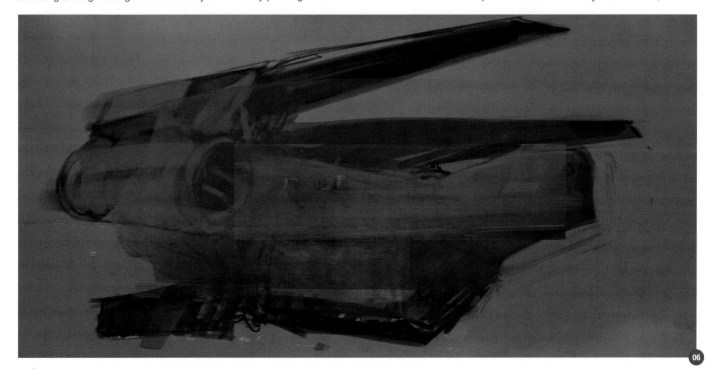

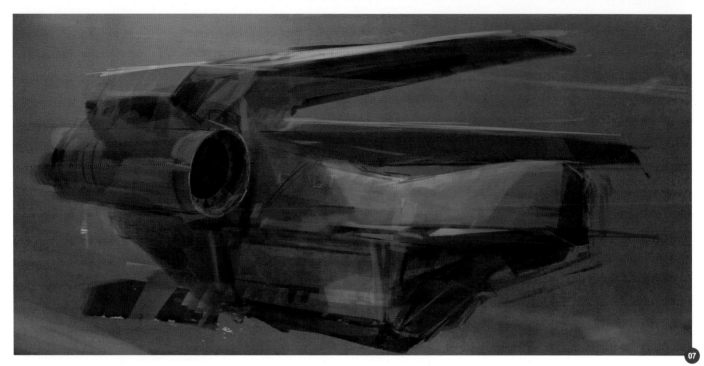

07

provide me not so much with detail, but with local color that I can use to start painting and defining the vehicle. At this point I alter the color and value of the sky to make the vehicle stand out more against the background.

Even during the final illustration stage I am always altering things as I work out what looks best and here I adjust the overall color again

(**Fig.07**). At this point I am mainly drawing into the image and establishing the lighting on the vessel, all to help define the surface planes. I am also starting to think about detail a little and, when looking in my reference folder, I find a photo of a big iron collar fitting on an old industrial pipe. I paste that into my image for the front opening on the cylindrical engine body. I often do this early on not just

to provide detail for a specific area, but I find it encourages me to push forward in defining other things as quickly as possible.

I continue to draw into the ship, conscious of preserving areas of blank or empty surface to compliment the areas with large amounts of detail and "busyness" (**Fig.08**). I always try to make sure I am keeping in mind the

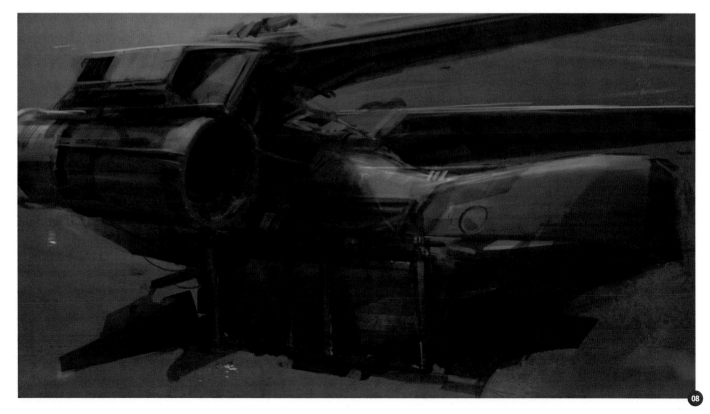

08

purpose of my design within the story. So at this point I add and define a metal framework surrounding the prisoner compartment at the bottom of the vessel. This is a retractable cage that surrounds the prisoner compartment and visually emphasizes the dangerous nature of the characters locked inside.

At this point I am adjusting the values as I go, refining the shadows so they aren't too dark and tweaking the color of the light (**Fig.09**). I also focus on the engine area. The two distinctly different engine housings sandwiched on top of each other feel a little too clumsy, so I paint out the top housing and imply the mechanics of the upper wing base, which is now visible.

I also feel at this point that the nose of the fuselage is a little too organic for my clunky spaceship design so I shave it down a little to be more boxy, then add a glass canopy for the cockpit that is more evocative of an old transport train and more in keeping with my theme (**Fig.10**). It seems that the wings feel a little too flimsy even for my fictional design, so I incorporate some heavy struts that anchor them to the main fuselage and support the overhead wings.

At this stage I am nearing the end, and I work over the whole vehicle adding some details and

removing others. I continue to tweak the overall color and add background flecks and streaks to better imply a sense of motion.

This finished illustration would then be presented to the Art Director and other stakeholders on the projects. If approved,

front, side, top and bottom elevation drawings would be generated for modelers to work from. This type of color illustration is often pivotal in getting an idea approved, as it portrays the concept in a dynamic yet descriptive way that allows everyone to get the feel of the potential final design (**Fig.11**).

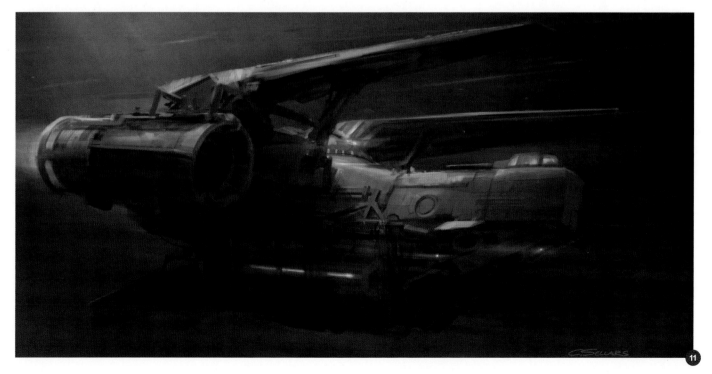

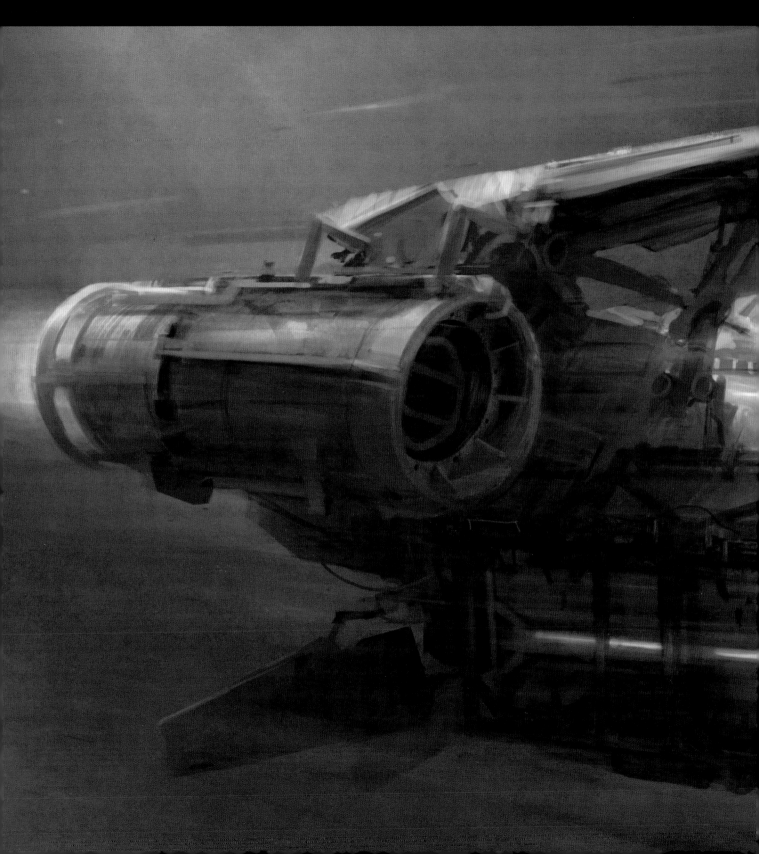

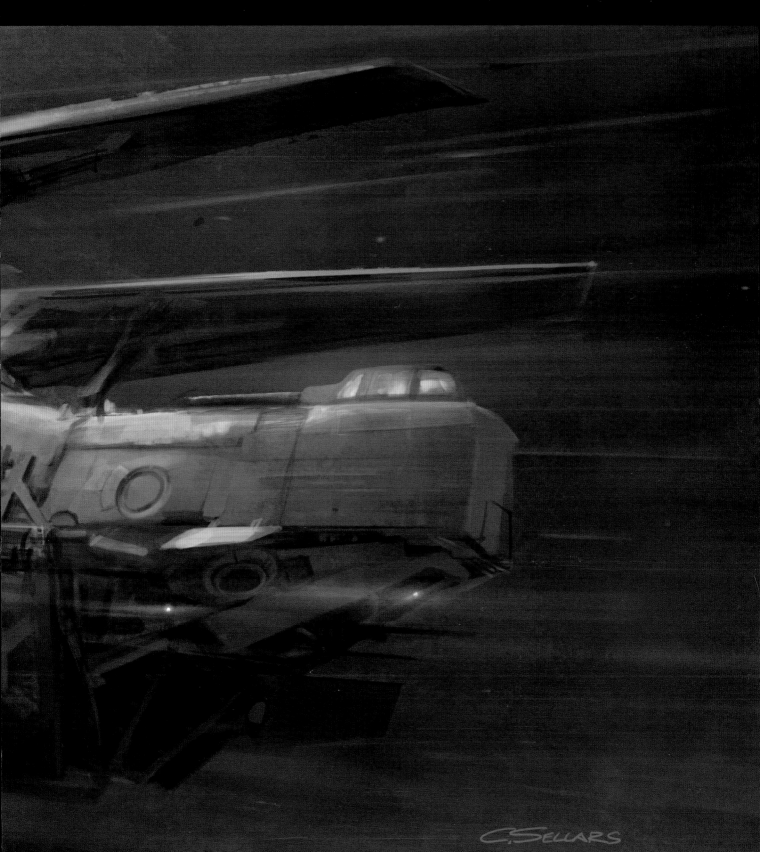

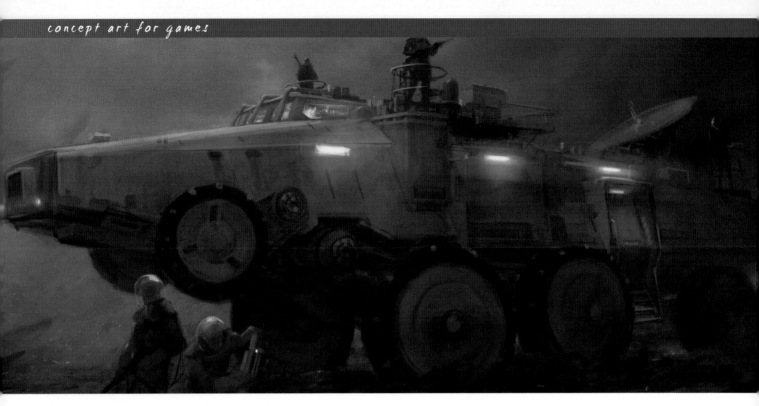

PRISON PLANET: HEAVY GROUND TRANSPORT
BY CRAIG SELLARS

SOFTWARE USED: PHOTOSHOP

For my second and final chapter in this project, my task is to design a heavy ground transport vehicle to be used on the prison planet Asturia. This would be a vehicle used by prison security forces to patrol the surface, transport personnel, track escaped prisoners etc.

Much like the flying transport vehicle I designed, and in keeping with the hostile environment and brutal nature of the prison, I want this vehicle to feel very heavy and rugged. Therefore, I again want function to be the main focus and the vehicle to be very utilitarian.

To speed things along, instead of drawing with pencil and markers I'm again using Photoshop and the Hard Round brush to create my rough sketches. I start out by looking at heavy

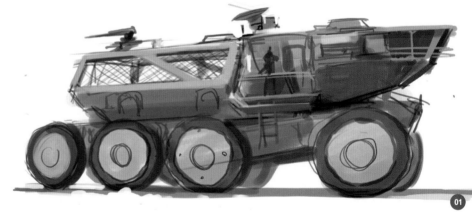

machinery and sketch this idea of a large tractor-like truck (**Fig.01**). I incorporate a cabin that projects forward to create an interesting overall shape, which is functional as it provides the driver with a clear view of the terrain ahead. In order to secure the escaped prisoners after they are re-captured, I add a large, heavy cage on the back of the vehicle. While the overall design has the heavy look I am searching for, I feel it looks a little too conventional and seems more like a piece of agricultural equipment than a heavy prison vehicle.

Next I'm thinking about a more unconventional drive system – tracks (**Fig.02**). But to avoid having the design just look like a tank, I make

the body of the vehicle taller, boxy and more of a classic 70s sci-fi shape. This design has the feel I am looking for – it feels very heavy and would definitely be at home wandering around a hostile planet's surface. However, I start thinking about the speed required to track down the dangerous (and highly motivated) prisoners sent to this high security prison and decide I need something that feels like it could reach higher speeds.

Rather than tanks I start to look at armored transports used by the military. The angled surfaces still have that nice tough feel, and even when I stretch out the shape it still feels heavy, but also looks like it could be fast if

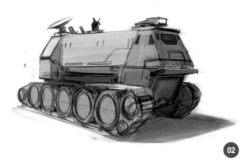

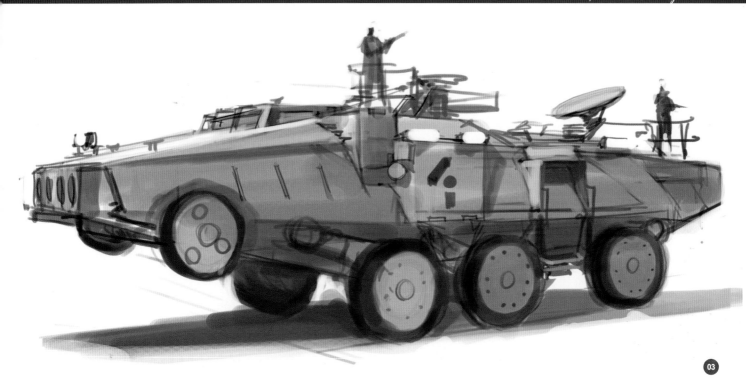

03

needed (**Fig.03**). I incorporate the triple axle as it adds to the sense of both weight and scale. In a bit of pseudo engineering design I add a small, secondary set of wheels to the front end with the idea that they could help the vehicle's long snout over steep inclines in the terrain.

In reality this probably wouldn't help at all, but I like the feel of the wheels up there. Visually, they break up the shapes a bit more and give the sense that this vehicle has been designed

for a specific use and that overrules any aesthetic considerations.

With the hostile environment the vehicle operates in, it has to be pretty self-sufficient in case it loses contact with the main settlement, so I add all sorts of gear to the top. These include a radar dish both because it makes practical sense and because it's a nice distinctive shape to break up the large, boxy shape of the vehicle's exterior. I also think it

would be interesting to perch guards on top of the vehicle who keep watch from up there. At this point I feel **Fig.03** has the most interesting shapes and incorporates all the things I want to achieve in my design so I set about working this up to a finished painting.

In Photoshop, I create a large canvas for my painting and since I like the feel and basic angle of the initial sketch, I paste that in and begin drawing over it (**Fig.04**).

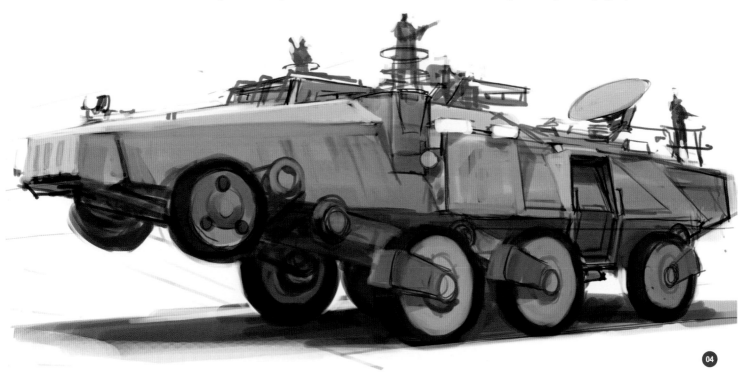

04

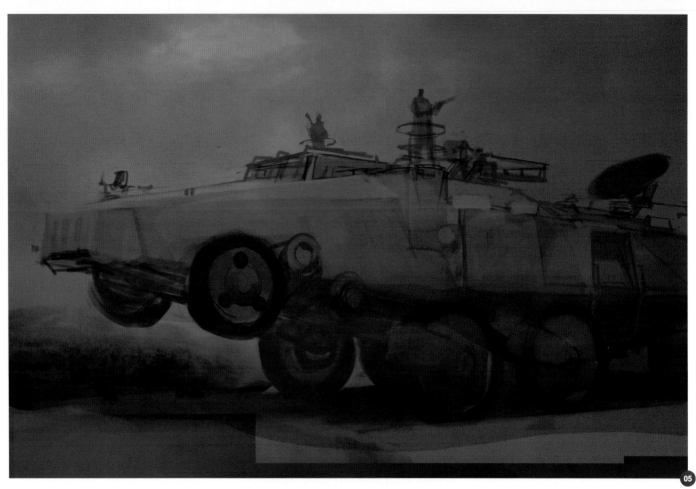

In the final illustration, I want to have a slightly lower angle to give the vehicle a little more scale so I adjust that at this point, drawing into things and tweaking it to achieve the desired perspective.

Next, I jump right into the color by adding a few random sections of sky photos as overlays (**Fig.05**). This quickly establishes value that can be painted into and also defines some of the light early on. I then do an overlay wash to tie the color together and get the muted, desaturated hue I am looking for. This is all done on layers behind the original sketch, which is now on an overlay layer that allows the color of the sky to come through.

Next I start to establish the ground my vehicle will sit on (**Fig.06**). I do this by pasting in photos of rocky ground at various opacities over the top of each other until the density of the texture feels good. I then merge these photo layers together quickly and adjust the color and opacity of the layer until the ground takes on the appropriate hue of the sky and

environment. I then start to paint into the ground, creating different sized shapes to both add interest and reinforce perspective. Behind the truck, I also start to imply the rocky surface of the environment. I find that when designing

a vehicle, structure or even a character, portraying whatever it is in a simulated location is very effective at helping people visualize how the final product will look when everything is put together.

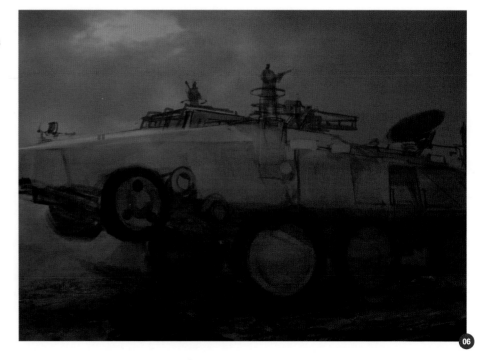

At this point I turn my attention back to the vehicle and start to establish the lighting on the surfaces (**Fig.07**). While I want to illustrate the vehicle as a whole, I also want to create areas of interest in the illustration, so I have the front end of the vehicle catching most of the light, while I let the rear of the vehicle fall into shadow where most of its illumination will be from reflected light to be established later. More details are refined at this point such as surface features and the equipment and guards on top of the vehicle.

I continue to tweak the overall color, such as adding some warmth to the light with an overlay (**Fig.08**).

At the rear of the vehicle I add a little red light with fog around it, which provides some secondary color, and allows me to define the silhouette of the vehicle's dimly lit rear. I also add a little more color by painting flecks of warm light coming out of the ground. Perhaps this is lava or something else – it's not really important. All that counts is the fact that it adds atmosphere and color. More surface detail is established on the vehicle, such as dirt and weathering.

At this point the illustration is well established. The vehicle is relatively well defined, the

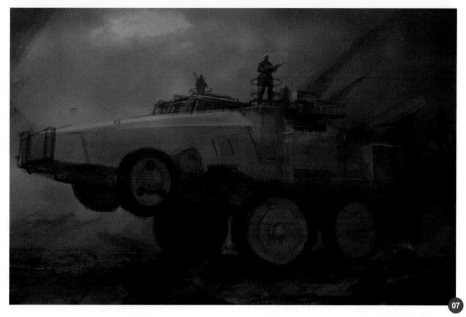

shapes are all working well and I am pleased with the lighting and color. All that remains is for me to add a little more detail to accentuate some things and let others remain undefined and therefore secondary in interest.

I move to the wheels, adding details to their edges to better define them. It seems there could be more focus on the hatch near the rear of the vehicle so I add a small light to illuminate the area, then add details such as railings, steps etc. Considering again the purpose of the vehicle, I add three light strips along the

side which are used for illuminating the dim landscape when in search of missing prisoners.

The image is now nearing completion but because I always like trying to incorporate a little narrative to an image, I am unable to resist adding a couple of characters in the foreground doing stuff on the surface, while their pals on the vehicle stand watch. I then do one last pass at the values, tweaking the levels to make sure everything is how I want it to be and the final image is completed and ready for review (**Fig.09**).

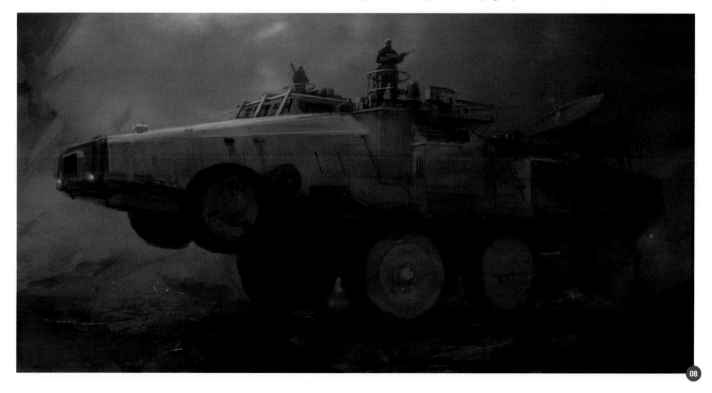

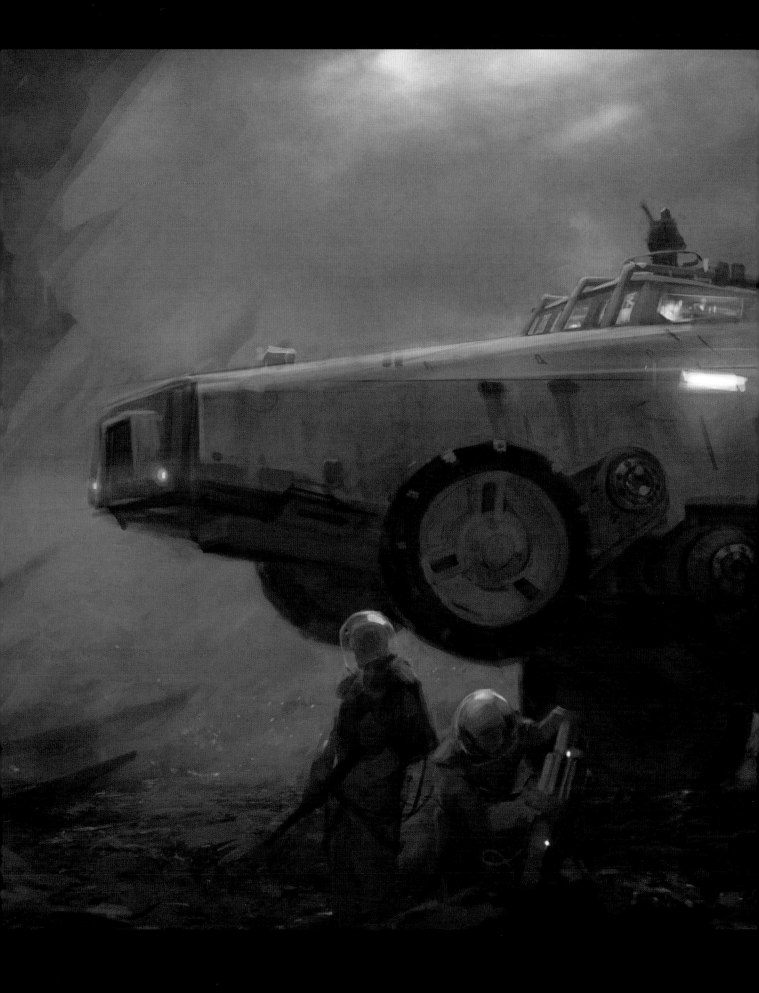

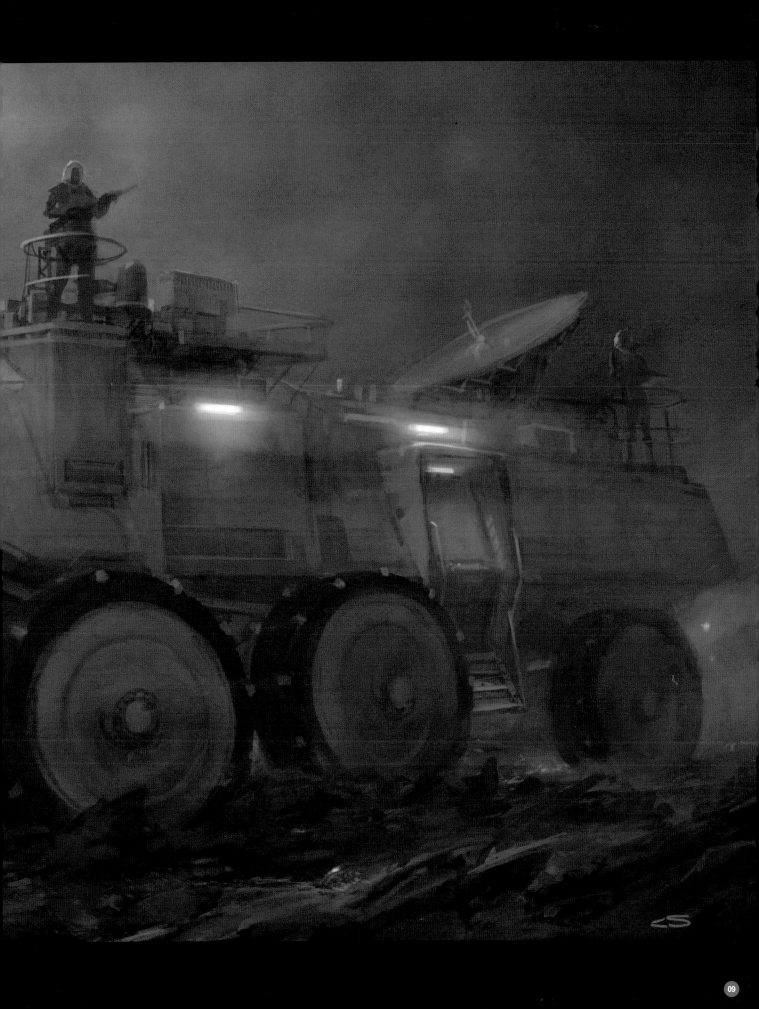

PRISON PLANET: ALIEN PRISONER
BY BART TIONGSON

SOFTWARE USED: PHOTOSHOP

When I create characters I sometimes start by creating a perspective box in Photoshop. To do this I use the Vanishing tool in the Filter tab. A lot of people think that perspective is only important when creating vehicles or environments, but it is also something that should be kept in mind when creating characters. A lot of concepts I see feel flat or unclear anatomically. Various elements can contribute to this, but one thing that is often overlooked is the "broken" perspective. This can affect the anatomy, the costume design and the overall proportions and silhouette of a character (**Fig.01**).

Most artists will create rough thumbnails before getting started on a character design. My process is no different (**Fig.02**). Sometimes I'll do sketches in my sketchbook, but these days it's usually more efficient to use a program like Photoshop, even for the roughs. In this image you can see that I have created blocky, very loose thumbnails to rough out the general shape (**Fig.03**). Think carefully about the personality and role of this character and make sure that the body type fits and feels right. I'm not trying to hammer down any specific design aspects at this point (**Fig.04**). Remember not to

stray too far from the original thumbnails. Stay focused and stay on course. While sometimes the most creative ideas come from thinking outside the box and wandering slightly off of the original path, it can sometimes create more work later on down the road (**Fig.05**). Early on is the best time to let the "wild" ideas take shape, but once you've moved beyond the brainstorming stages, stay on course as much as possible.

Another thing I'll sometimes do, especially with animals and creatures and, in this case, an alien prisoner, is to grab various photos to help create a bit of "noise" and surface texture for the skin (**Fig.06**). Again, think about the personality and role of the character. What type of skin do you want this "person" to have? Is he soft and gentle? Is he cold, dark, rough and ferocious? With Taron Dax, I was thinking of a big powerful and lumbering character with tough impenetrable skin. I thought immediately of a rhinoceros. Here I've downloaded a bunch of pictures that I feel represent the material that I'm looking for. I used the 3DTotal free texture library for these images. It's always nice to have a big library of textures to browse through and their library has some awesome high resolution photos.

After I've detailed the design of the character quite a bit, I start applying some of the photo textures using the different layer options (**Fig.07**). I'm not always sure how a certain layer will affect the image, so it's good to browse through the list and see which one creates the coolest effect. In this case I use Multiply. The photo becomes slightly transparent but doesn't interfere a great deal with the linework that I've already laid down. At this point, I've also decided on a rough color palette that I want to use for the character. I generally keep the colors fairly close in range with a possible complimentary or two. For example, if I want the character to be red I'll often include some other colors that are in the red family but will bleed over slightly into yellow. If I want to add a complimentary color in there somewhere I'll add a subtle splash of blue or blue/green.

Here is a closer shot of some of the detail and texture work. It's still pretty loose, but you

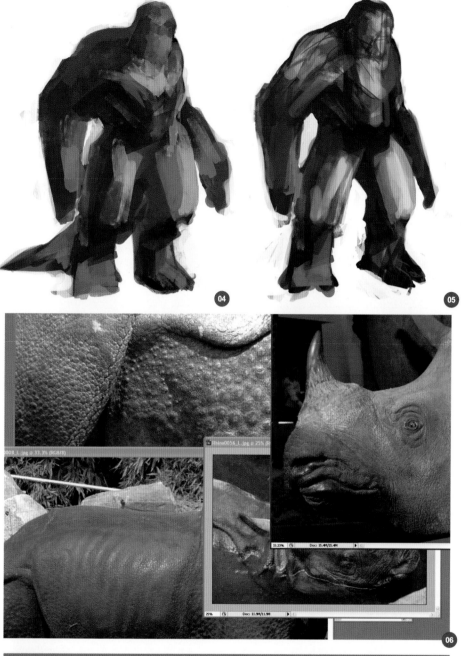

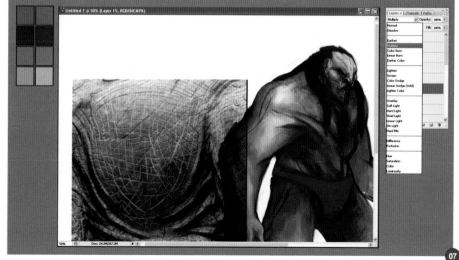

CHAPTER 2

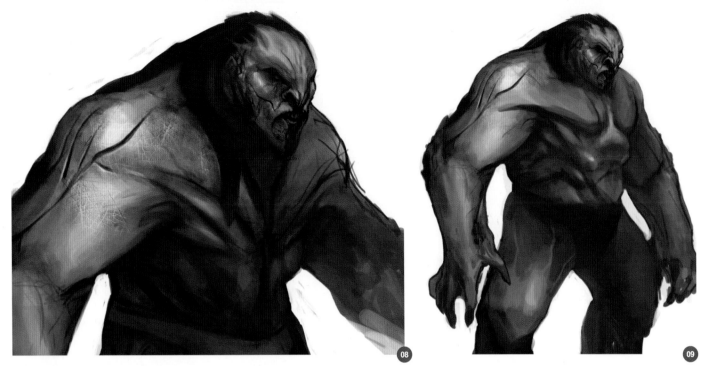

can get the general vibe of the direction of this character (**Fig.08**). One thing to always remember is to do your research, know the story and character, and understand the limitations of your game. You can't always create the most elaborately detailed concept. Sometimes it's necessary to know how and where to put your most important details, and leave other areas less complicated. In this case, since it's hypothetical, the polys are unlimited and we're going for an extremely high resolution, very detailed world.

In this image I've changed the anatomy slightly (**Fig.09**). I've puffed out the chest because I want this guy to feel really big and strong, and at the same time have a very distinct sense of pride about him. I've roughed in some hands as well.

Now that I've got a decent amount designed from the front angle, I create a profile view design using the same basic steps that I mentioned above (**Fig.10**). I jump back and forth between designs to make sure that there's a decent level of consistency between the two. It's not always necessary for the design to be 100% accurate from all angles in terms of consistency, and you don't always have to put in every single detail. You want to leave some artistic freedom for the 3D modeler to work his magic as well. But keep in mind, if there is

an area of the design that you want to remain absolutely true to the concept, you need to be sure you make it crystal clear in the drawing as to how it should look! Also in terms of the polish and rendering, don't lose sight of the fact that you are not creating an illustration; it's first and foremost a concept design. However, you also want there to be enough rendering and color information to leave as few questions as possible for the modeler or the client.

I'm pretty close to the final image at this point and I make some minor tweaks to the saturation levels (**Fig.11**). The mood of this game is dark and gloomy, and the same goes for the character so I bring down the amount of color a tad. Of course art is subjective and an artist's personal tastes will always inevitably shine through, so it's the concept artist's job

to try and use his talents to create a character that suits the game design whether or not it's your preference.

Quick Tip : It's pretty important to save different versions of your work just in case you end up wanting to go back and use a previous version. Save and save often. A good rule of thumb is to save whatever you're not willing to lose.

The best way to learn this lesson is the hard way! I can't count the number of times when I've lost a ton of work due to a program crash or computer crash. Even during the course of this tutorial, I experienced a power failure, but luckily I had saved the file and didn't lose too much work. So save often and also take the time to occasionally step away from your work.

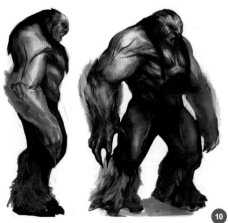

Here, I use a vector mask on a new layer so that I can bring back an older saved version of the face and shoulder area (**Fig.12**). With the mask layer, I'm able to "erase" what I don't want from the layer, but I can also bring it back at anytime without losing the actual information. Vector masks are a very valuable tool that I use all the time. It's far better than simply erasing elements from a layer.

> " I WANTED THE
> PRISON JUMPSUIT
> TO FEEL SCI-FI AND
> SLIGHTLY FUTURISTIC.
> AT THE SAME TIME,
> I WANTED TO USE
> A COLOR THAT FELT
> ICONIC TO PRISONERS "

At this point in time, when you are very close to finishing the final image, it's crucial to stay focused and not become complacent. Don't be lazy. Almost 100% of the time when I see something that doesn't seem right or the design could have been better in my work, I realize that it was most probably because I was being lazy and not wanting to put in the extra time to fix it. Now, it's not always possible to do this since time is an artist's enemy, but I think that an even greater enemy of an artist is laziness.

This sheet is now a presentation ready to hand off to the modeler (**Fig.13**). Its purpose is to get the tone and character of Taron Dax across while at the same time clearly showing the design aspects. A side, front and ¾ view is usually enough. If the back has some extremely specific designs then that should be included as well.

This is a full body front, ¾ shot (**Fig.14**). Again, all the specific details should be included here so that the modeler, as well as anyone else who looks at the image, will have no questions about the design and the personality of the character.

I found it necessary to show the side view of this particular character, not for the details as much as for the thickness and depth of his body (**Fig.15**). I wanted to make it clear just how beefy I wanted him to be.

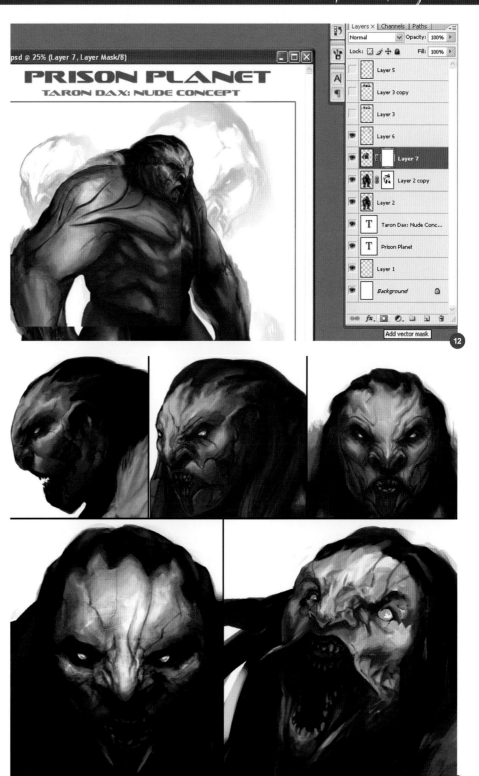

Here the back is rendered out in detail for the anatomy and design (**Fig.16**). I've shown the costume as well as the nude for this angle.

This image shows Taron Dax in full prison gear (**Fig.17**). I wanted the prison jumpsuit to feel sci-fi and slightly futuristic. At the same time, I wanted to use a color that felt iconic to prisoners. I didn't like the super bright orange usually associated with prisoners, so I toned it down slightly and went for a "blood red". I also played around quite a bit with the shackles and mouth restraint. In the end I wanted them to be very bold and heavy. I wanted it to look like they needed some massive chains to keep him restrained. I think it came across that way!

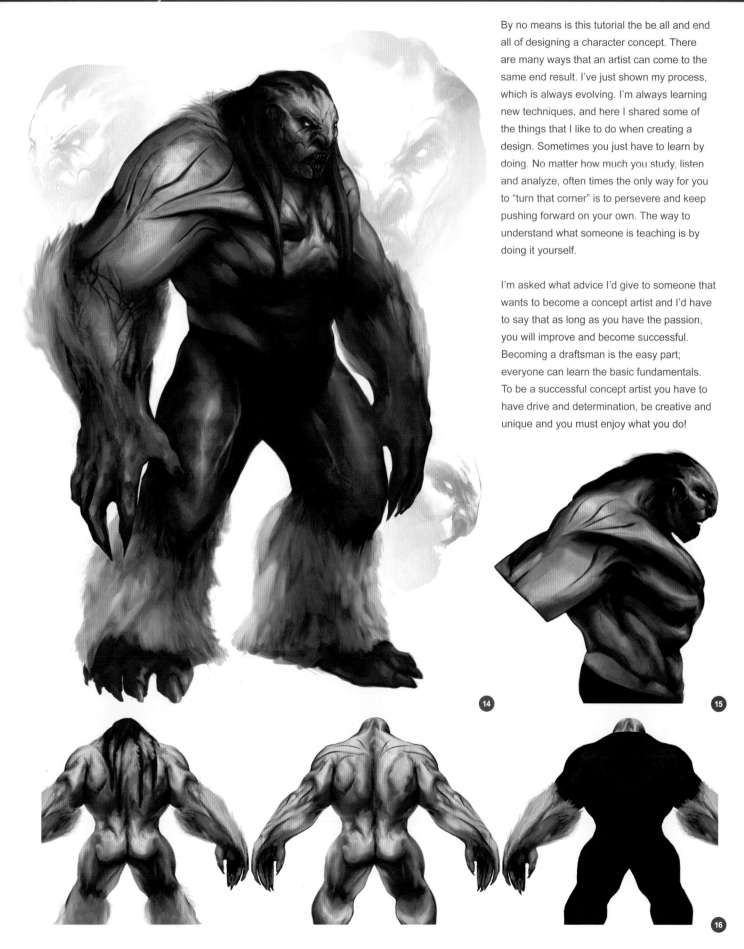

By no means is this tutorial the be all and end all of designing a character concept. There are many ways that an artist can come to the same end result. I've just shown my process, which is always evolving. I'm always learning new techniques, and here I shared some of the things that I like to do when creating a design. Sometimes you just have to learn by doing. No matter how much you study, listen and analyze, often times the only way for you to "turn that corner" is to persevere and keep pushing forward on your own. The way to understand what someone is teaching is by doing it yourself.

I'm asked what advice I'd give to someone that wants to become a concept artist and I'd have to say that as long as you have the passion, you will improve and become successful. Becoming a draftsman is the easy part; everyone can learn the basic fundamentals. To be a successful concept artist you have to have drive and determination, be creative and unique and you must enjoy what you do!

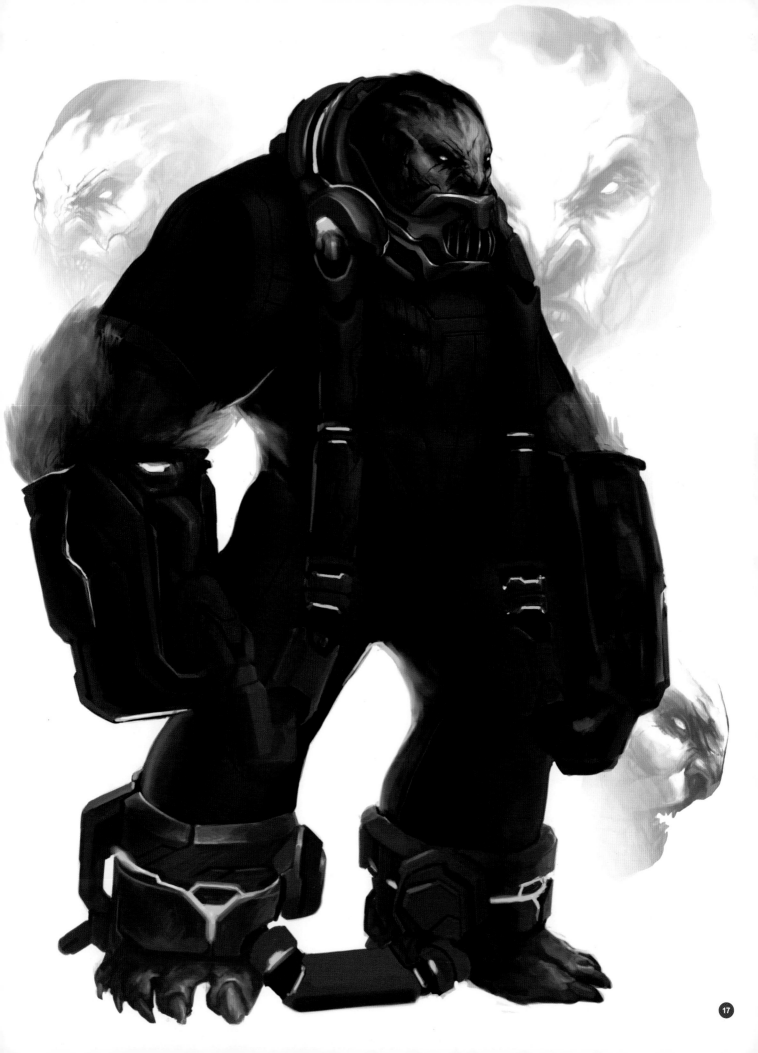

PRISON PLANET: CHIEF OF SECURITY
BY BART TIONGSON
SOFTWARE USED: PHOTOSHOP

There are various methods that I use to create characters. It all depends on the subject matter, the specifics of the character or even just the mood that I'm in at a certain time. But whether I'm using markers or graphite on paper, or working digitally with Photoshop, one thing remains constant: I always do rough thumbnails to start off. It's important to keep

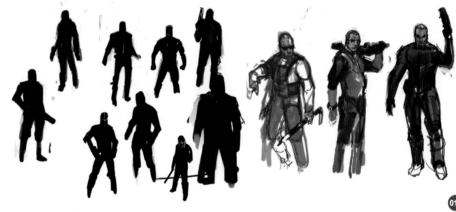

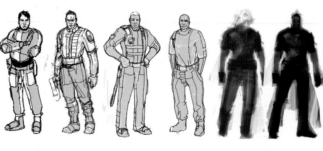

things loose and gestural in the initial sketches. Here I have used a few different ways to create thumbnails (**Fig.01a – b**).

Sometimes I'll just "ink out" black solid shapes, while other times I'll use a very light gray as an "under layer" and ink out the linear details. On another occasion I might start off smudgy and

just roughly fill in the areas of the silhouette until I feel that I've nailed a decent initial design.

In this image I've narrowed down several of the thumbnails that I feel are not only cool designs but also suit the personality of the character (**Fig.02**). I want to keep each of these "finalists"

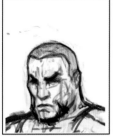
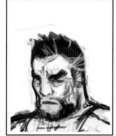
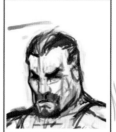
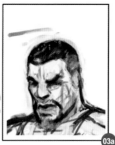

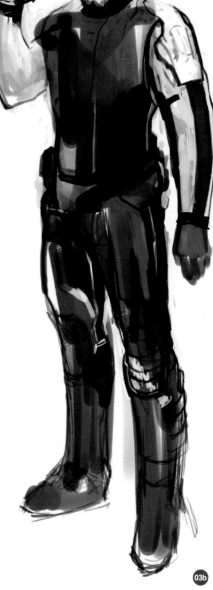

> I ALWAYS TRY TO IMAGINE HOW THE CHARACTER WOULD BEHAVE IN CERTAIN SITUATIONS. THIS HELPS ME TO VISUALIZE THE DIFFERENT PHYSICAL ASPECTS OF THE PERSON I'M DESIGNING

was Cadillac Crane) is a man in his mid-40s and is very strong willed and stubborn. He is haggard and cold, and while good hearted at his core, he has an exterior that would lead people to believe otherwise. Keeping this information in mind is very important. You can never lose sight of the personality of the character. I always try to imagine how the character would behave in certain situations. This helps me to visualize the different physical aspects of the person I'm designing.

as different from each other as possible; this way it makes it easier for me to choose one specific design to go with.

I end up using elements from each design to come up with the final choice (**Fig.03a – b**). I like different things about each and the end result merges them all in some way. I start thinking more specifically about the face and hair specifics. Lex Crane (Lexus is his full name and he has always hated the fact that his father named him after a car. His father's name

With this in mind I commit to a specific face and decide to run with it (**Fig.04**). I can very easily spend too much time on any given design, whether it's the face, the costume, a weapon etc. That is why it's important to do various thumbnails then choose one and confidently move forward. Once you've decided which design to go with, do your best to make it as polished and cool as possible. Whilst I work out the details of his uniform as Chief of Security at Skye Global, I am also thinking about and polishing the specifics of his face. I

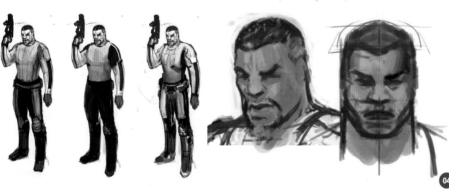

go back and forth between the two concepts to help keep my mind fresh, as well as allowing one design to affect the other.

In these four images you can see the progression from a loose thumbnail to the final concept (**Fig.05**). I use pretty dramatic lighting to accentuate his bone structure. Lex is a very strong individual, both in mind and body, and I feel that this has to be reflected not only in his body, but also his face. I draw very light construction lines to begin drawing the face. I break up the face into thirds, keeping the eyes roughly in the centre.

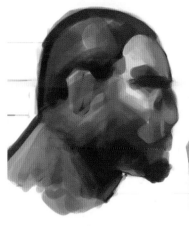
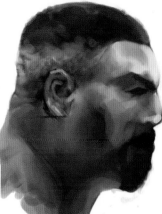

When I first begin a front view of a face, I will rough out the area of the eyes, ears, nose and mouth. I'll then get a little tighter on the details on one side, then copy and flip the drawing to mirror the other side. This is for placement and proportion only. Nobody's face is exactly identical on both sides, so it's important to paint in the "imperfections" to make it feel more realistic and believable. This is also how you show the character in one's face.

After I've basically solidified the front view, I'll use the same steps to create the sides and the ¾ front view as well (**Fig.06**). Unless there is something very unique and specific in the design of the rear view, it's usually not necessary to draw this for most 3D modelers. It's important not to spend time on unnecessary concept drawings, and it helps to know the ability and/or style of the modeler that will be building from your concept. For example, some modelers will need more information than others, while other artists work far better if you leave some room for interpretation. As a concept artist it's crucial to be able to recognize when you need to do more or less work, and you have to be ready and able to draw out as much detail as the next artist may need.

This is the final image of the three angles of Lex's face (**Fig.07a**). I've added some final touches like scars, and a robotic eye. This adds to the sci-fi vibe as well as emphasizes the fact that Lex is no ordinary individual.

This is the final image of Lex Crane as Chief of Security at Skye Global (**Fig.07b**).

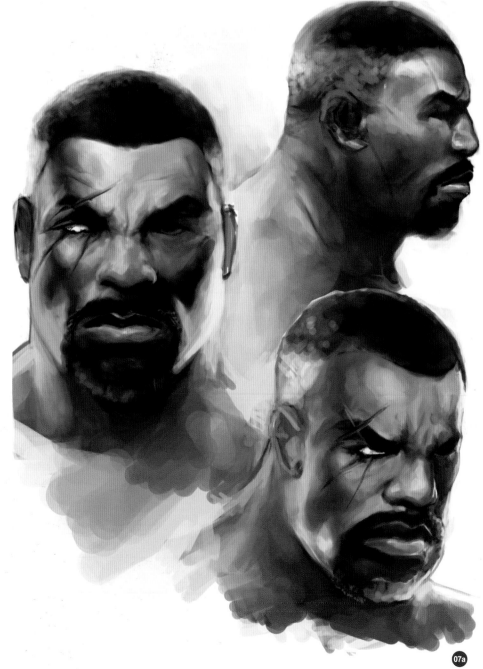

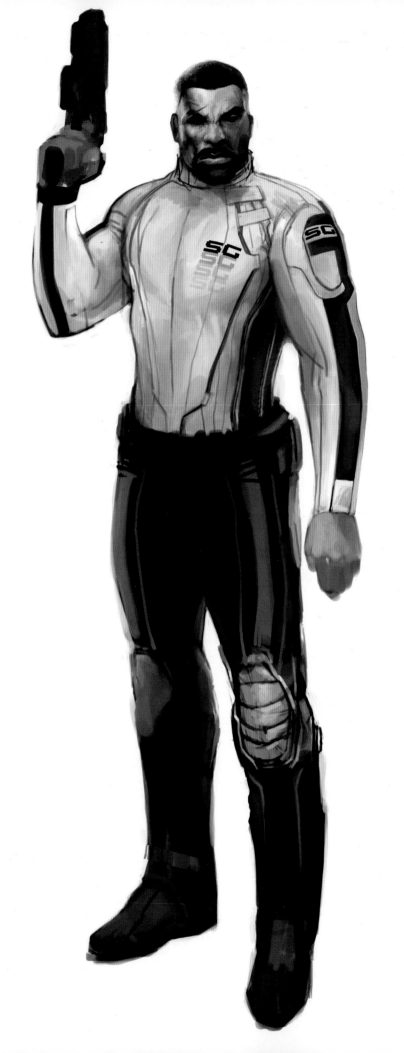

I ALSO TRY TO "SHOW THE PHYSICAL" STATURE OF LEX. I WANT TO SHOW THAT HE IS VERY STRONG AND MUSCULAR, EVEN THOUGH HE HAS THE BODY OF A MAN IN HIS MID-40S

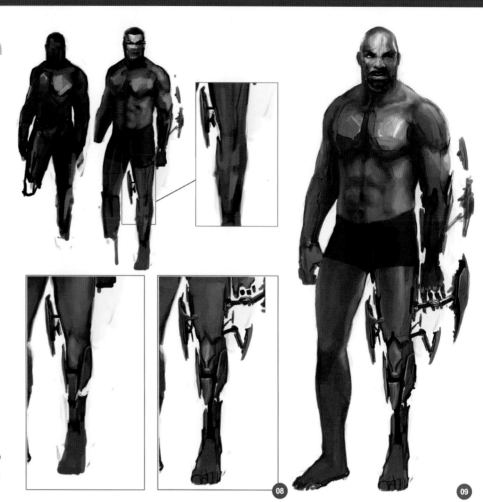

I want to accentuate the fact that Lex is not your average "Joe". So in this picture I am creating some rough elements of design on his nude body (**Fig.08**). I want to show that he is partially robotic. Maybe he was injured in the line of duty during planetary wars or during his stint as a global military soldier (Shock Troopers).

I keep these drawings very loose since I feel that they are more for mood and tone. At this point it's not certain whether or not we would even see Lex in this "mode" during the game. I feel that it's still important to include these types of drawings because it helps the fiction to evolve. In the end there can never be too much information.

I render out the half human, half robot body a little bit further (**Fig.09**). In this picture I also try to show the physical stature of Lex. I want to show that he is very strong and muscular, even though he has the body of a man in his mid-40s.

Much like the previous images showing the nude front, I don't spend too much time detailing the back (**Fig.10 – 11**). The idea being that we will most probably never see Lex completely naked. While this is the case, it's still important to show what he would look like underneath his clothing to help the modelers,

art director or game designers to understand your thought process and how and why the character looks like he does. Sometimes I'll paint a grayscale gradation bar that goes from dark to light. This helps me keep in mind that I should include different values. I want there to be a successful amount of contrast in the

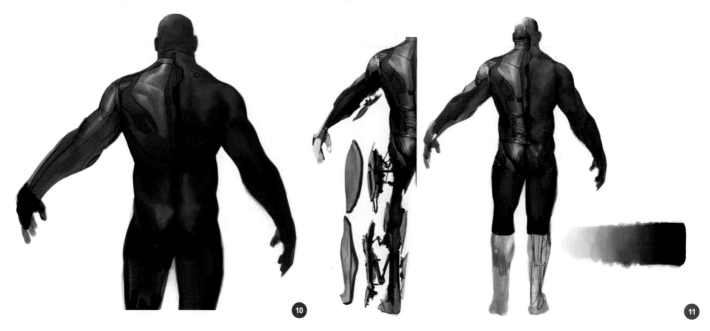

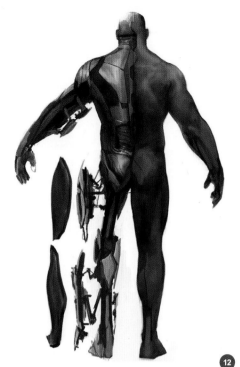

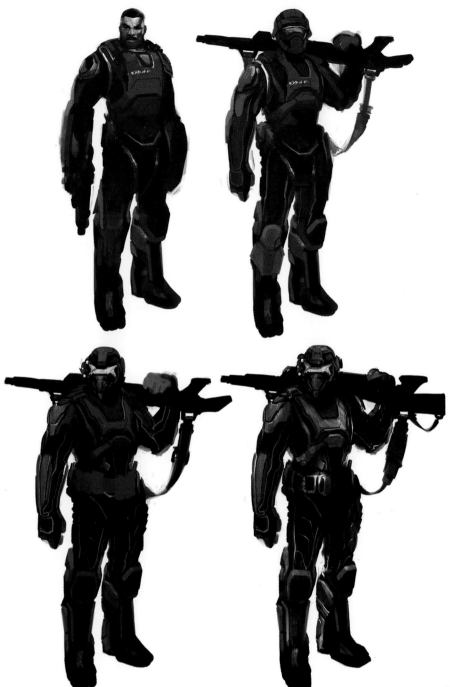

design. I don't usually want any design to be overwhelmingly dark or light. Of course there are always exceptions to this rule depending on the specific design.

The final pose and design for the rear nude view (**Fig.12**).

I imagine that a large majority of the game will be played with Lex in his Combat Gear (**Fig.13**). Before Lex was wrongly imprisoned he was a decorated Shock Trooper, leading forces against enemies that threatened Earth's security. I wanted to make sure that this armor and gear felt close enough to current day military wear so that the viewer would be able to relate to it, but at the same time have the design different enough and far enough

removed so that it conveyed a science fiction feeling. I started out with a blocky rough silhouette, like always. It's much easier to move forward with this design now that I have already created the body type and face of the character. Since we already have his face designed I decide to make this concept full gear, including a helmet and face mask.

I usually work initially in black and white. This helps me to focus primarily on the design without having to worry about color early on.

I'm also able to keep a good degree of value range, which I feel is very important when designing characters (**Fig.14a**). Once I'm happy with the grayscale concept, I'll put a subtle color overlay on it using either a color brush or the Color Layer option. This way I'm able to preserve the original black and white design without the risk of losing it due to my color additions.

Once I have my color wash in there I also work on specific little details, like the scratches in the

armor (**Fig.14b – c**). This helps to show he's been in many battles. I also want to include not only contrasts in values, but also in the shapes of the armor. I like to have small, medium and relatively large shapes in the designs. Again, this isn't always going to be the case with every character.

These show more images that focus on attention to detail. Every little bit helps to make the final "sell" successful (**Fig.15a – c**).

Here is the final design of Lex Crane in his Battle Gear as a Global Shock Trooper (**Fig.16**).

Ultimately there are many different ways to achieve the same goal. From a lower level, the goal of the concept artist is to convey and create an image that fits the description of the game designer. You must be able to visualize and bring to life the ideas of people that often are not imaginable beyond the written word. It's important to be able to do this in a quick and timely manner as well as creating as many different ideas as necessary in order to satisfy the "client".

From a higher level the concept artist must be able to create imagery and concepts that stand out from what has already been seen. Being unique is very difficult in today's very competitive games industry. If you want your game to stand out visually from the rest of the games that are out there, it all starts with the concept. You are laying down the foundation of the entire game and your designs are responsible in a large way for deciding if the game is inviting or not. Of course the entire art team plays a crucial role in developing the look and each artist is equally responsible, but if the artwork from the concept side starts out bland

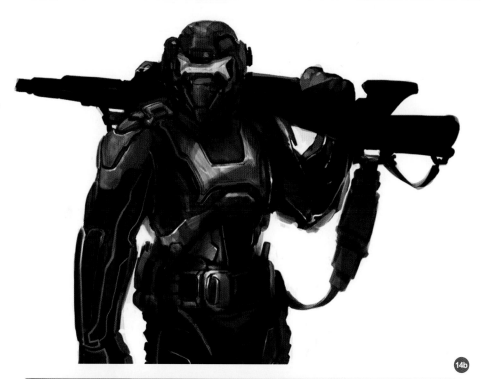

14b

14c

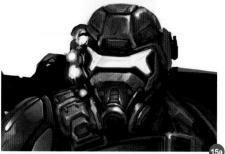

15a

15b

15c

or forgettable, then it makes the tasks much more difficult for the rest of the team.

I hope that I was able to give you some insight into the pipeline and development of characters from the concept level of video games. While many different artists have different techniques and tricks of the trade, I always have and will

maintain that the only thing that you truly need to succeed as a concept artist is hard work, dedication, an open mind and a passion for the craft!

Thanks for checking out my tutorial and please feel free to contact me with any questions or comments.

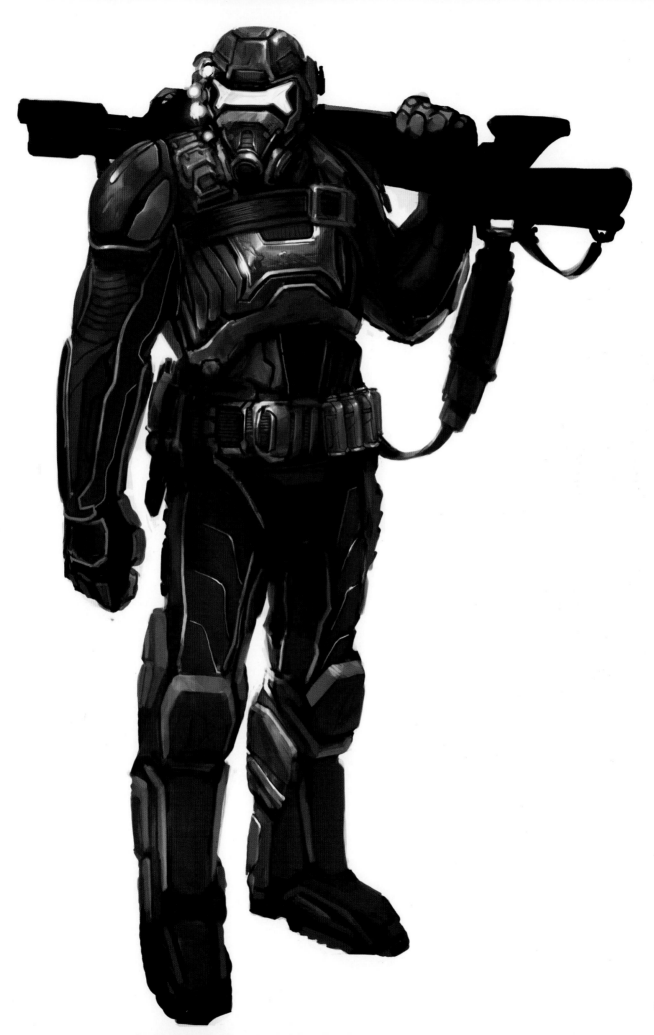

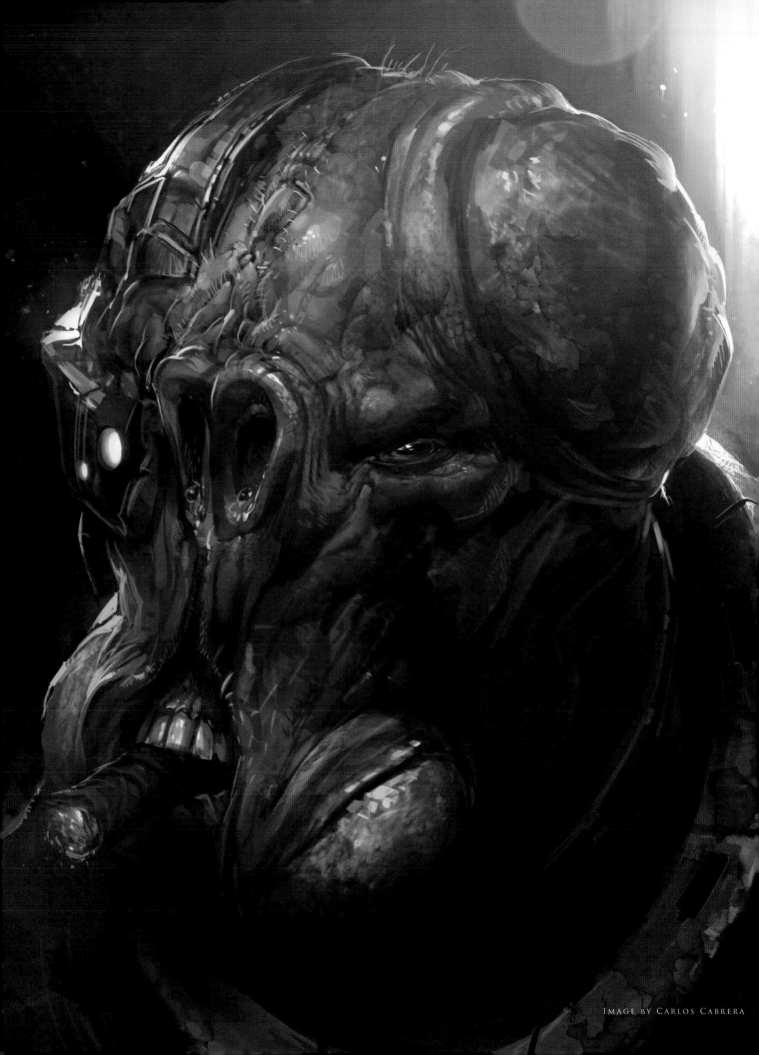

IMAGE BY CARLOS CABRERA

monsters

This illustration was based on a short story that Juan Cubas (an amazing writer, artist and game designer) wrote for me.

"Mklarth likes his mercenary job. He does it well and that's why he is well paid. His job allows him to travel from one reality to another, which he enjoys more than vaporizing a complete gang of Pinilla's neobikers. And although 80 human years ago he lost one of his four lungs, he still loves to smoke pure Ghlodiana-skin cigars.

Mklarth is also earning enough to move out of his mother's house. Not because he doesn't love her, but because he is getting older and is allergic to his mother's Dhamaris. Also his girlfriend, Ashajagha, pressures him as she is now at the age where she wants to incubate."

CARLOS CABRERA
carloscabrera@gmail.com
http://www.artbycarloscabrera.com/

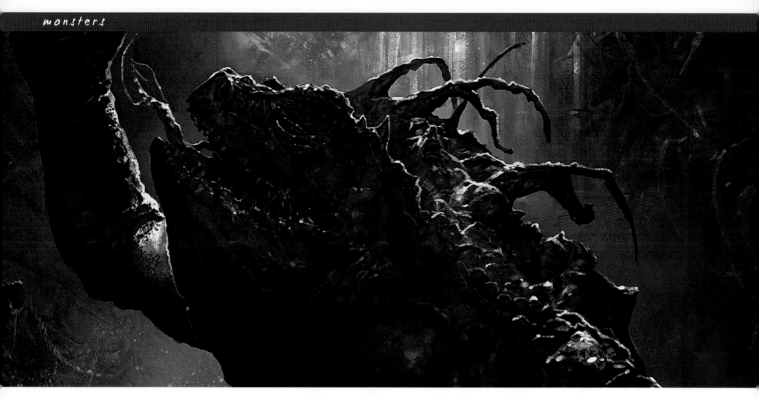

Sewer Monster
By Andrei Pervukhin
Software Used: Photoshop

I would like to start my tutorial by looking at all the brushes that I'll be using to create my Sewer Monster. Brush 2 is my favorite and the one I use most of the time (**Fig.01**).

Firstly I consider the composition as a whole: what will the monster look like and what kind of environment will he be in? When I have an idea I start to create my piece by working in black and white. I do this because it's much easier to see how the final image will work and it gives me another opportunity to think about the overall composition: where will the monster be and from where will the light source be coming? I use brush 1 only to create this first image (**Fig.02**).

I continue to think about my overall composition, and try a few different things to find out where I am going to put my detail. At this stage I am mainly defining the silhouette of the monster and thinking more about its final design. For this image I use all of the brushes apart from brushes 3 and 6 (**Fig.03**).

The main point of this tutorial is to design a monster for the environment, so as I continue to think about my monster design I go back

| 1 | 2 | 3 | 4 | 5 | 6 |
| SQUAROT | OIL PASTEL | ROCKY | HARD ROUND | SOFT ROUND | SPLOUCH |

01

02

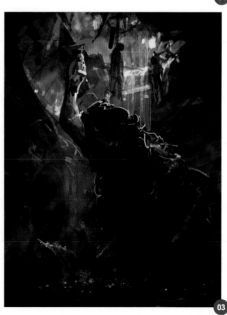

03

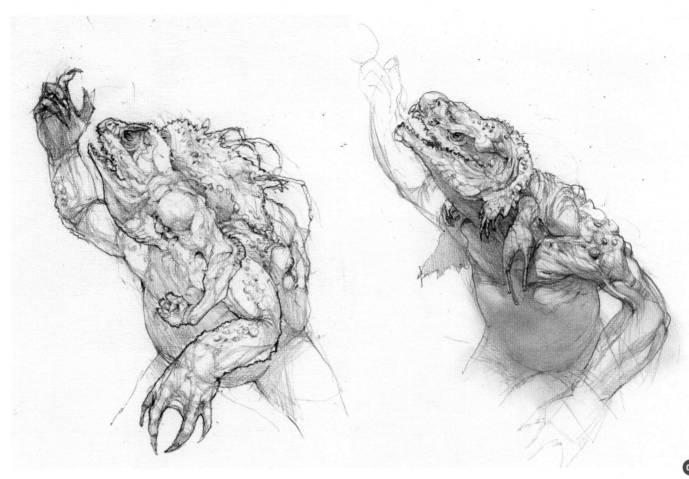

to traditional paper and pencil to develop my ideas. I do this in quite a lot of detail. This will help me as I continue to develop my piece. I also find that the texture of pencil on paper helps too (**Fig.04**).

Next, I scan in my pencil sketch and put it into my digital painting where the silhouette I've previously created is. I change the settings from Normal to Multiply for this layer. Under it I

create a new layer with the normal settings and start to carefully fill it in without going beyond the pencil sketch. To help me do this I create a mask with clear boundaries around the monster and then I correct the contrast using levels (**Fig.05**).

The next stage is to select the appropriate color scheme. I make three versions in a variety of colors and I really like the third option, which

I created by adding several layers above the image and using the first layer for the casting color and the second layer for the soft light (**Fig.06a – c**).

Now that I have determined the color and the composition for my monster and the environment he is in, I make a new layer to add some soft light. I then use brush 3 to give the monster texture (**Fig.07**).

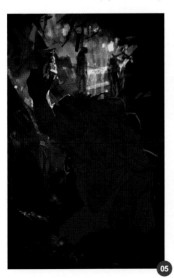
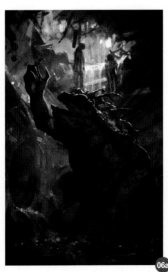

CHAPTER 3

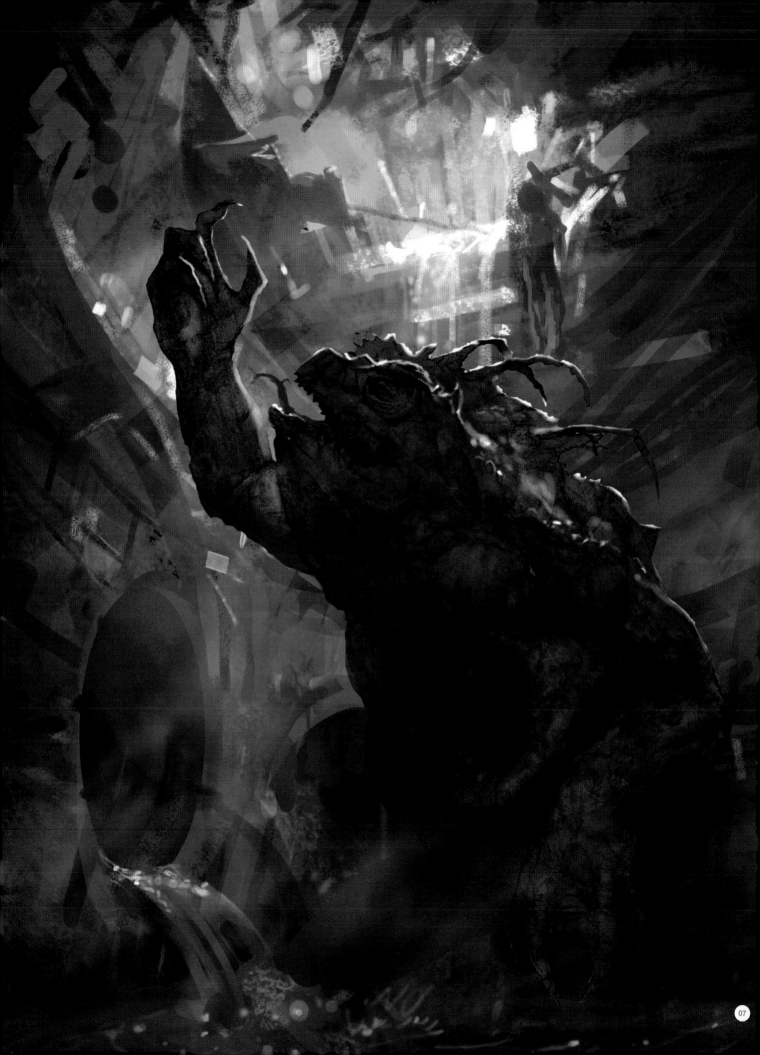

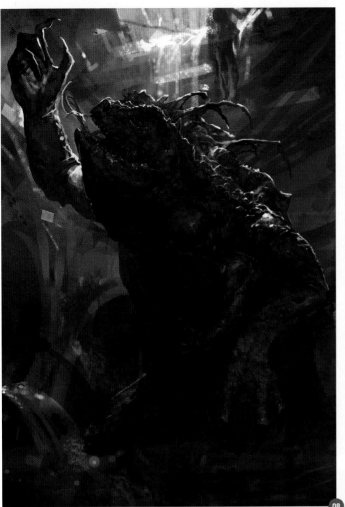

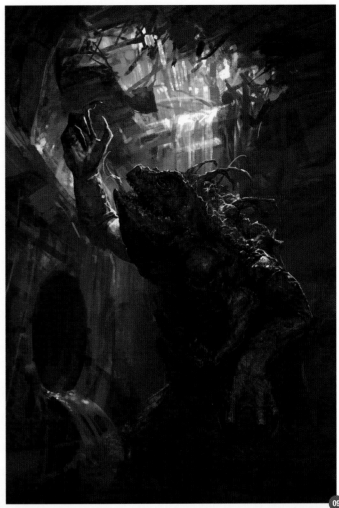

I create a new layer on the top and start working on the monster by adding more detail. The reason I work on this first is because the monster is the main focus of the image (**Fig.08**).

When I am finally happy with the development of the monster I turn my attention to the environment (**Fig.09**). As I continue to work on the environment and develop the desired atmosphere, on a separate layer I paint evaporation and some light which I can then disable or change later in the process if I wish (**Fig.10**).

When I am happy with the painting of the environment, to add some detail I start using some textures that I found on: **http:// freetextures.3dtotal.com/**. Before I add them to the main image I bleach them out a little bit, set the layer type to Soft Light and transform and delete the parts that are not required (**Fig.11**).

CHAPTER 3

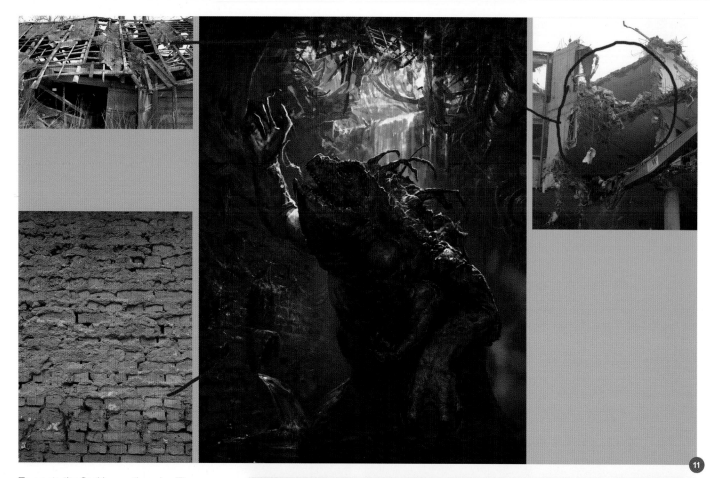

11

To create the final image there is still more painting that needs to be done. To finalize the image I use all the brushes I listed at the beginning. I start by adding the evaporation and the dust that you can see in the light; to do this I use brush 6. I think this helps to give the final image much more of an atmosphere. When I am happy that I have finished this picture I put together all the layers from the top and in the resulting layer, I use the Sharpen > Smart Sharpen filter. This gives the completed image a more precise look. Finally, I create a new layer and fill it in with a gray color (in the table color picker I make the parameter B: 50%). Then I add a Noise filter (amount: 400%), use a Stylize filter called Diffuse, and set the layer mode to Soft Light with 15% opacity (**Fig.12**).

You can download a custom brush (ABR) file to accompany this tutorial from: **www.3dtotalpublishing. com**. These brushes have been created using Photoshop CS3.

12

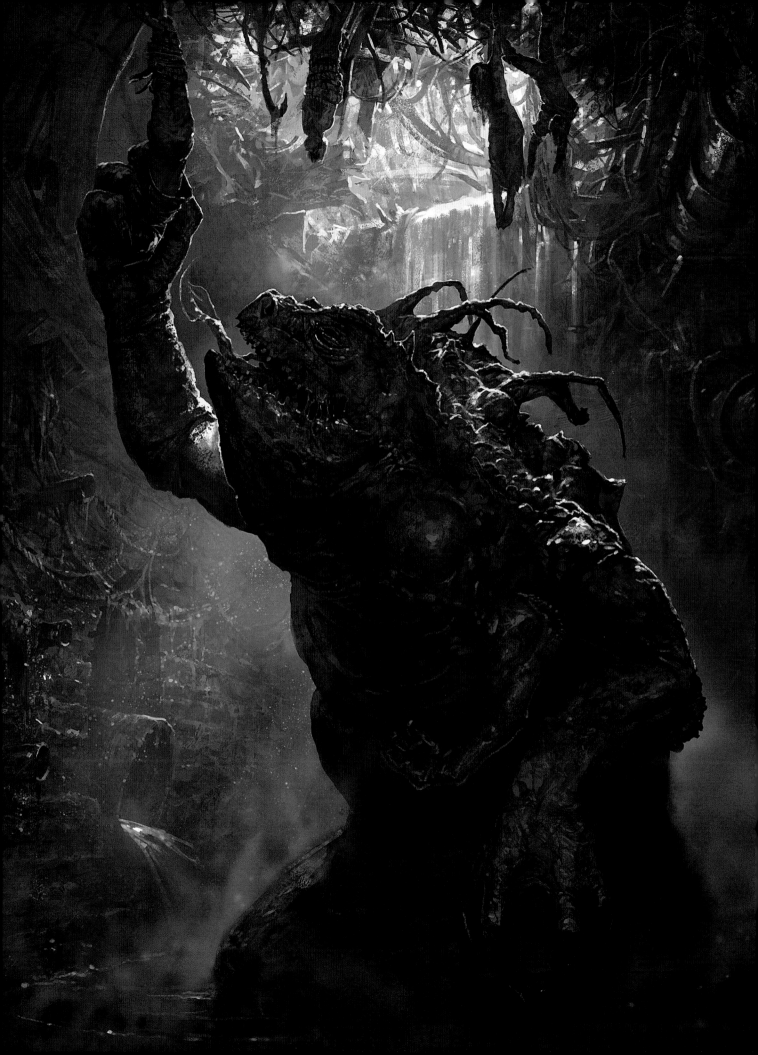

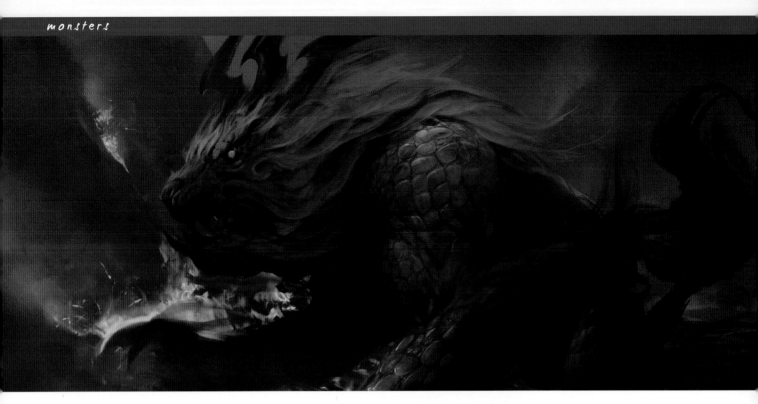

VOLCANO MONSTER
BY JASON WEI CHE JUAN

SOFTWARE USED: PHOTOSHOP

To make a convincing creature, good anatomy and a good dynamic pose will help a lot. In this tutorial I'm going to cover eight steps that explain the different stages of this painting. I'm working in Photoshop for this design, which has the great advantage of the Brush panel, and while the program can't handle hard and soft edges at the same time, you can combine two or more strokes to achieve the same thing.

Color and composition (if it is for a creature it will be a silhouette) are the first things people see when they look at an image, and the silhouette is the key to defining a creature or

monster early on. A good way of doing this is to create several different small thumbnails and pick one from them, which you will see many concept artists or illustrators doing. It's a good idea to keep working in grayscale at this stage, since it is easier to deal with form, lines and shapes (**Fig.01**).

There are two types of brushes involved in the sketch. One has texture and a rough edge,

and one is the default Round brush, which is good for blending and soft lines. There is no detail or much lighting as the silhouette should have enough information to indicate what the creature looks like and give an impression of its movement.

Keep refining the silhouette until it looks right (**Fig.02**). I add more details and define the face and feet more. It is very important to place all

the parts in the right perspective. Rotate the canvas, or even turn it upside down; this will help you to get a fresh look at the image and the problem areas will show.

This image and the concept remind me of the ancient Chinese creatures called Kirin and one of the types of Kirin lived in volcanic areas, so I start to research some reference images of Kirin to help me define the detail and shape more. I find some interesting things from reference photos, such as how they define the scales on the Kirin's skin, and which color they apply on the surface. However I won't start the color version just yet, so for now I continue with the sketch, correcting some proportion and anatomy problems. I also keep the creature on a layer that is separate from the background since this will make it easier for me to paint the background later.

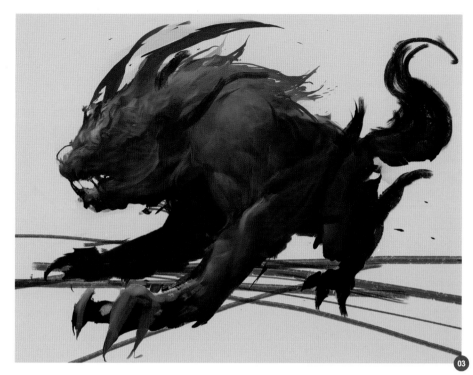

Besides the shape and design of the creature, lighting and value are the focus of this step. Just a couple of simple perspective lines help to make the space clearer. Lighting is all about rendering skills and the only way to get better is to do more long pose drawings or paintings from life, which can be still life or human figures. By doing more drawings and observing life you can make the lighting in your work more realistic. The perspective lines also show the right leg of the creature was off in Fig.02 so I fix that too (**Fig.03**).

The next step focuses on the background and for this background I create a special brush. The base image of the brush is a cloud, and so I call it the "Cloud brush". Since the environment is supposed to be hot lava and smoke, the Cloud brush is perfect. In this step

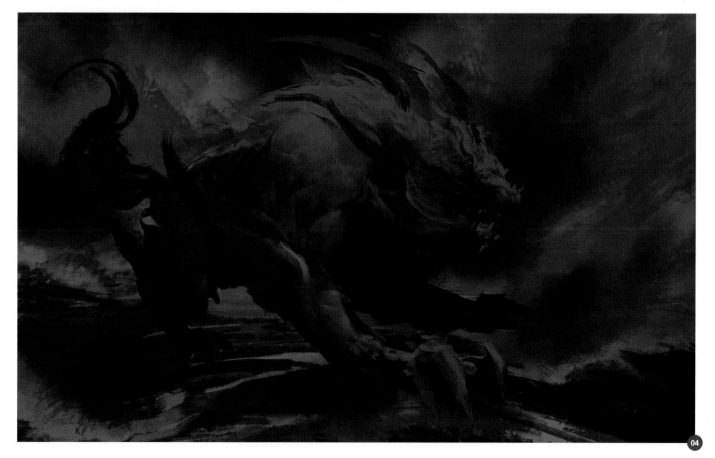

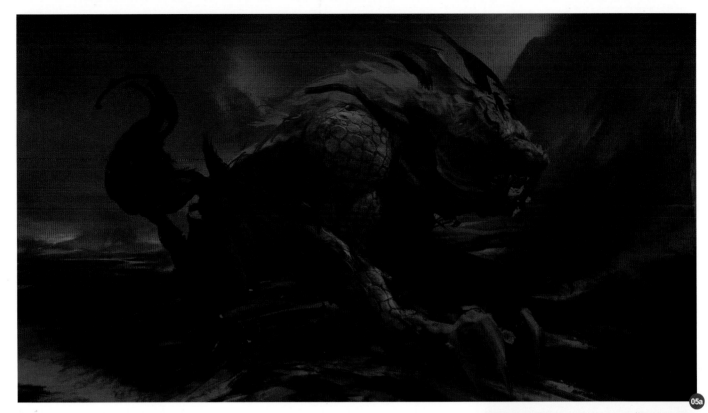

the image flow and composition are what I really care about, since this will change the whole painting dramatically. No matter how good the silhouette is, if the background is not handled well the foreground creature may become lost in its environment. This step basically defines the whole look of the final image. The only missing part now is the color, so color is the next thing I'm going to focus on (**Fig.04**).

Like traditional painting, before moving on to the processes like under-painting etc., the first step is to fill the color without modifying the value too much. The majority of the color will be black, dark blue and red. A good fire color involves hue changes, which are from red and purple to light yellow (dark to light) (**Fig.05a**). I also add scales onto the Kirin. I do this by using a reference image of a crocodile (**Fig.05b**) which I took in a museum in Chicago.

The High-Pass filter in Photoshop can filter out large color and value changes, and keep the small details – this is perfect for overlay. In the left side of the painting I also add the dark blue sky and some landscape shapes, which can help the depth of the scene and also help the scale of the painting.

Here is another way of using layer blending and "lighten" (**Fig.06a**). Since the painting is very dark, any fire reference photo can be used directly on top of it and the fire will be seen and anything darker than the painting will be ignored. The fire layer is another big change for the whole painting since the hue and the brightness are very intense. This will change the composition of the whole painting again. It is always good to compare what you are

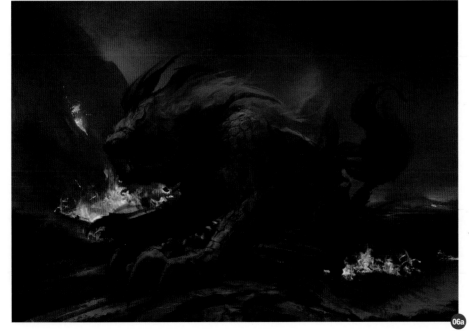

working on to the previous incarnation of the painting, and Fig.04 is a good reference image for me if I choose to adjust the composition back to the way it was (**Fig.06b – 06c**).

The fire added in **Fig.07** changed the composition a lot, so in this step I focus on the fire itself (this is kind of similar to when I used the Cloud brush earlier, apart from the fact that then it was in black and white). In this stage, red, yellow and dark blue are the major colors involved. Sometimes it is hard to see the color and value at the same time. Specular is also another cool technique for the final touches. It cannot be used everywhere, but can be used for the most important areas, such as the eyes and the scales in the highlight area. One thing that is easily ignored when people start to put detail on is that when we put detail on highlights or shadows, sometimes it changes the value of a big portion and loses the volume of the main object. Here I can

see that the detail which I'm painting on the creature is making the Kirin become a little bit flat so I brighten the centre of body to make the creature look more solid and 3D.

Usually I won't go back to the final touches phase, but with this image I found details everywhere that lacked interesting shapes and details, such as the background, the scales on the shoulder and the Kirin's face. Putting higher

contrast lines in works, and more rendering work on the face enhances the face of the creature and I also flip the image upside down to make sure the elements I just put in actually help.

For me all the processes I did here and there were more like a balance game and the more elements I put into the painting, the harder it was to make everything balance (**Fig.08**).

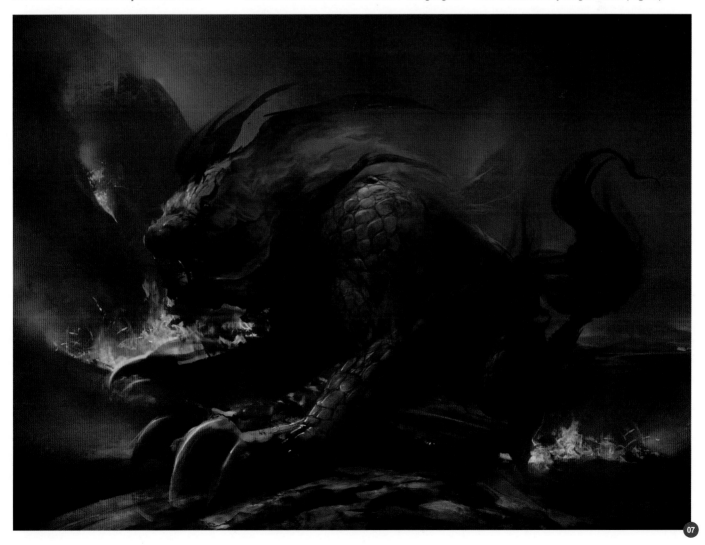

CHAPTER 3

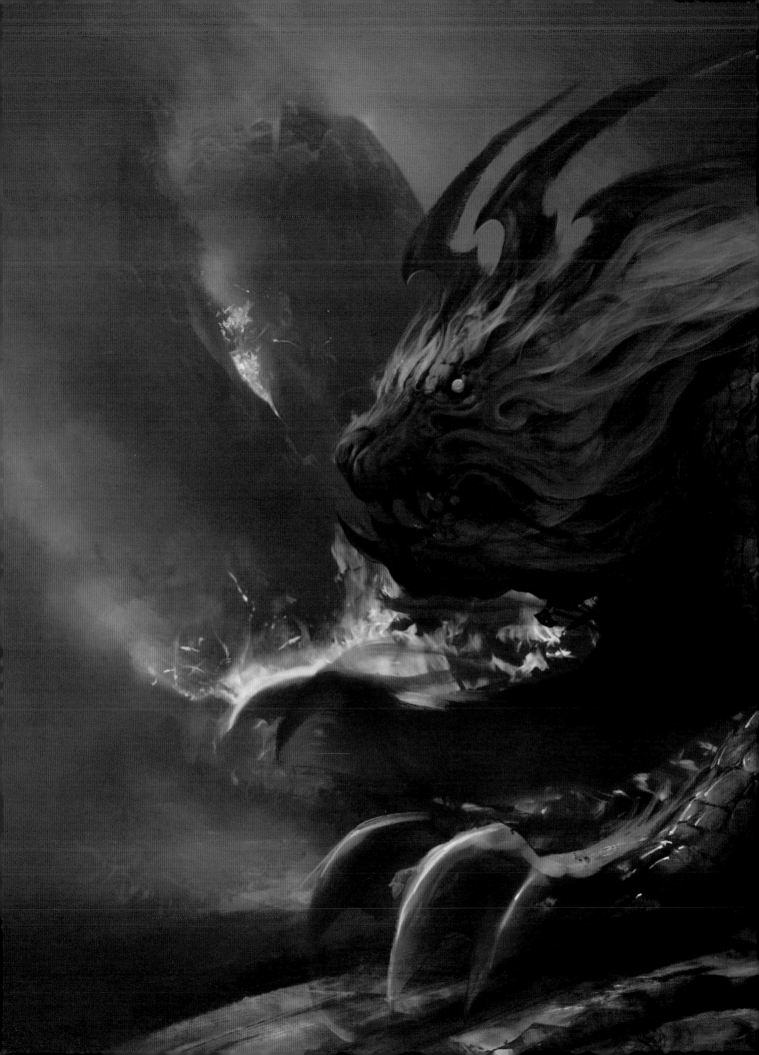

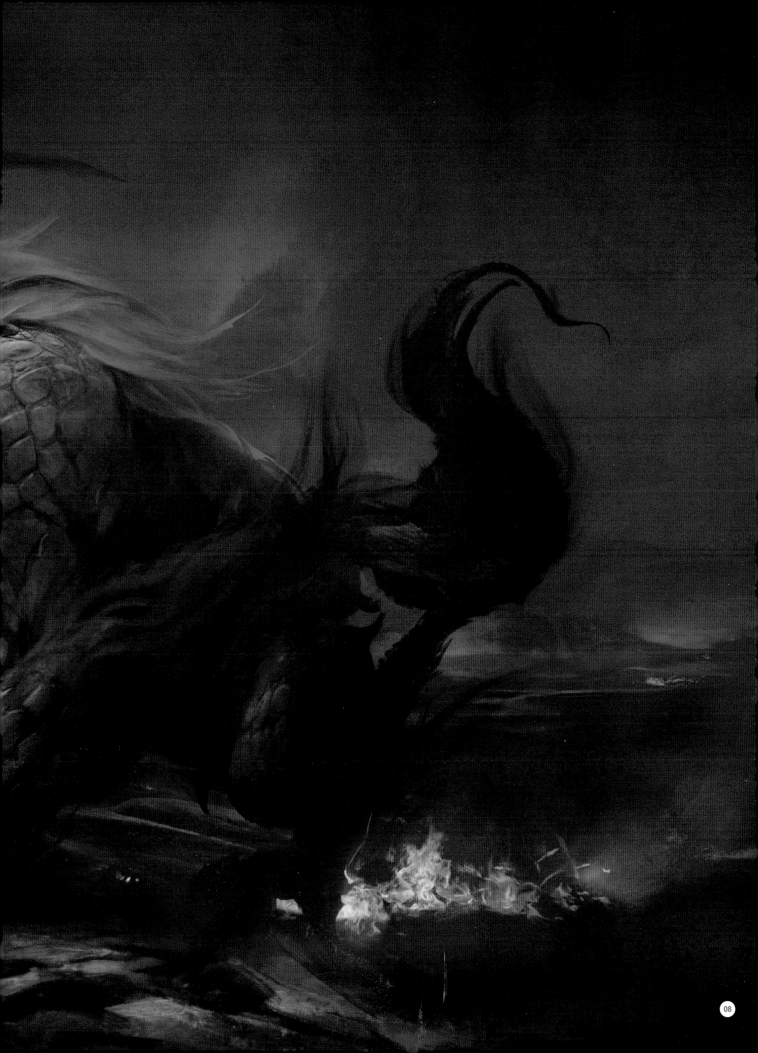

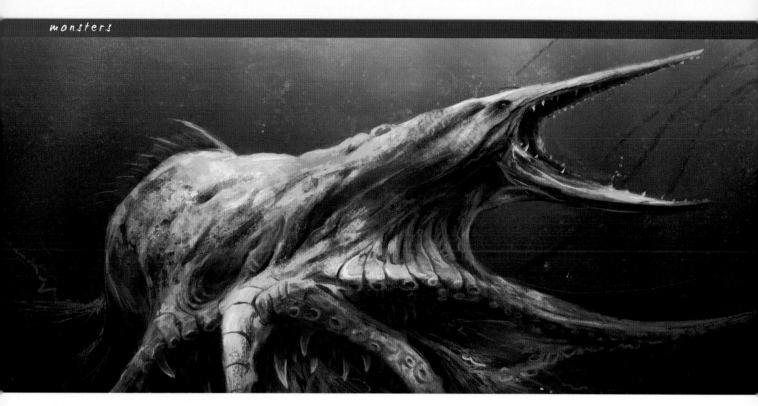

Sea Monster
By Richard Tilbury

Software Used: Photoshop

Introduction

Before starting this tutorial I decided that whatever topic I settled on, it would focus on the actual creature itself and not on any environment or context. Because of this it also made sense to place it against a simple background.

I've chosen to go with an aquatic theme as this is a subject I have had little opportunity to explore in the past and hence will make an interesting challenge. The fortunate aspect of this particular creature also means that I can place it in its natural, underwater context and still keep the background simple due to the habitat. This certainly was not my motive for choosing the sea monster but it sure is nice when things work out like this sometimes!

> **I START BY LOOKING AT SOME REFERENCE PICTURES ON THE INTERNET, MAINLY FOR HOW LIGHT INTERACTS WITH THE SEA AND ILLUMINATES SUBMERGED OBJECTS**

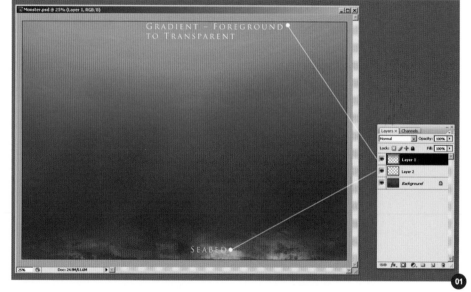

As per usual I start by looking at some reference pictures on the internet, mainly for how light interacts with the sea and illuminates submerged objects. As opposed to having a plain blue background I think it would be more interesting to show the creature near the surface with evidence of the waves above.

Creating an Underwater Habitat

To start to create a very simple underwater environment I first of all fill the canvas using a blue color with a little variation (**Fig.01**).

You will notice that the scenery comprises of three layers, the first of which is a lightly modulated blue which you can just make out in the thumbnail. Above this background layer is the seabed, which is simply a band of abstract shapes which I've painted along the bottom edge (Layer 2). The final layer represents the light filtering downwards from the sun and has

been created simply by using a Linear Gradient with a Foreground to Transparent preset (Layer 1).

I opt to remove the seabed as this implies a shallow section of water and therefore a smaller sea monster. On separate layers I then paint in the surface along with some light beams filtering downward. The sunbeams are painted using the Soft Round airbrush and then have the opacity reduced to around 40% (**Fig.02**).

The creature is then blocked in on a separate layer in case I want to change the color scheme or lighting at any point. Keeping elements separate like this can ease experimentation, which is something I like to do throughout the painting process.

You can see on the right how the file is currently structured into five layers. The lighter gradient along the upper section of the canvas has been set to Screen mode at 89% opacity. The reason for this can be seen much more clearly in **Fig.03**, where it serves to create a smooth transition from the surface to the mid depth.

CREATURE EVOLUTION

You have seen the initial creature sketch in Fig.03 and, with the basic environment underway, it is time for me to focus on developing the animal. I often start this process with some thumbnail drawings, but in this case I am happy to start doodling and see what develops.

I begin with some random shapes and non-descript brush strokes and start to develop these into a more fish-like form, as shown in Fig.02 and Fig.03.

I quite like the beak-like shape in the upper right and think this may make a good mouth and so decide to keep this feature. The curved body reminds me of a seal or dolphin, which is not alien enough for my taste, and so I mould this into a more amorphous shape (**Fig.04**).

Part of the design is inspired by jellyfish, which have always fascinated me due to their strange and unconventional form, and so I

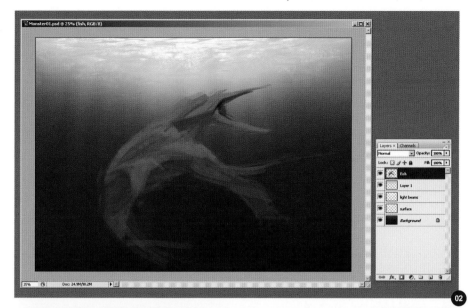

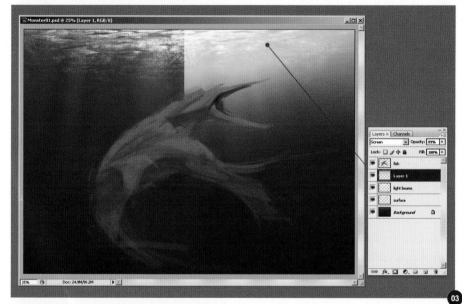

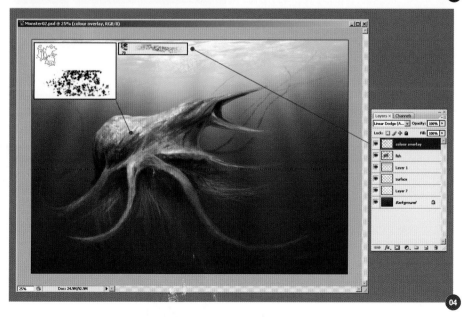

include some tendrils and a bulbous shape. I then marry these ideas with the tentacles of an octopus.

I like the idea that this creature is quite slow moving but uses its tendrils and tentacles to sting and trap prey, similar to a jellyfish. I add in some long tendrils disappearing into the distance to suggest that this beast could catch its prey even if it were not within close proximity. I use a custom brush to create a pattern across its body, which is done on a separate layer set to Linear Dodge.

> ## TO CREATE ANOTHER DIMENSION I OPT TO ADD SOME LUMINESCENT LIGHTS BELOW ITS BODY WHICH IT WOULD USE IN SIMILAR FASHION TO THE ANGLER FISH

I then begin developing the head by adding in the eye and teeth along with some detailing around the jaw. I also use another custom brush, which incorporates an image of broken glass, to create a variation to the skin pattern (**Fig.05**).

Because the creature is quite near the surface I decide to add some more contrast to the caustics across its body as it is looking a little flat. To create another dimension I opt to add some luminescent lights below its body, which it would use in similar fashion to the Angler fish. The glow from these would attract smaller fish towards its tendrils and keep it fed in between feeding on larger prey (**Fig.06**).

To create the glow I use the Outer Glow layer style, which can be accessed by clicking on the FX icon at the base of the layers palette (highlighted in red). This brings up a dialog box similar to **Fig.07** where you can see the settings I have used.

As this creature now uses glowing tendrils I think it would be both interesting and weird to give it a second mouth through which smaller prey could be digested. An octopus has a body integrated into its head with no distinct

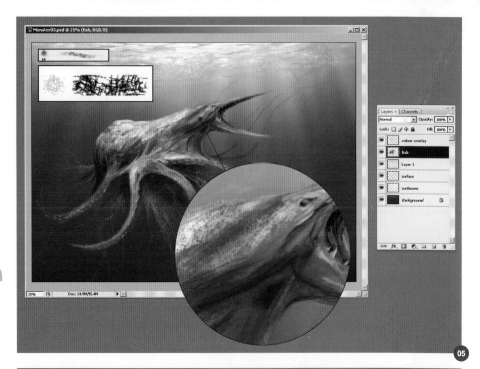

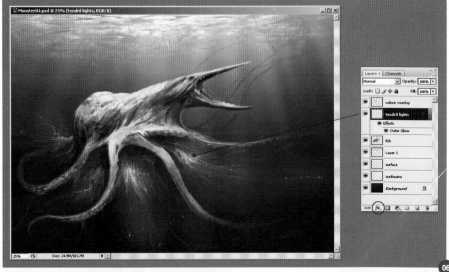

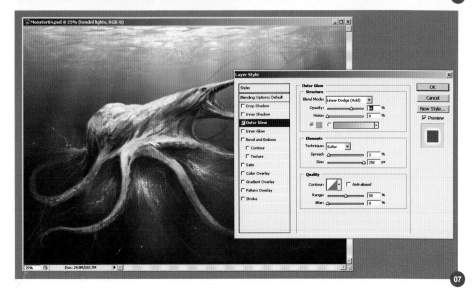

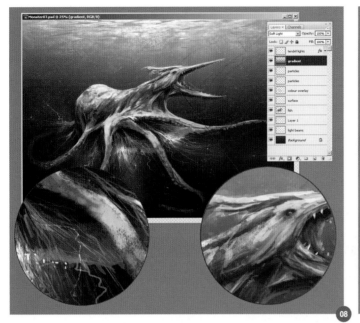

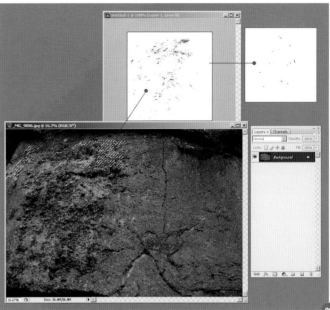

difference and likewise I think that a mouth section as part of the body would make this creature look even more unusual. I therefore decide to add a membrane that connects the tentacles as well as forms a mouth cavity (**Fig.08**).

This can now be used to engulf potential food. I also experiment with a different head and body shape, giving it a crest and a more pronounced neck section.

One other aspect that is missing is some evidence of scales, plankton and some general particles in the water. The best way to create this is through a custom brush which can be based upon a range of different sources. In this case I use an image of a moss-coated rock from the free online photo library at 3DTotal. com. You can download this image via the link at the end of this tutorial.

I first make a color range selection of part of the moss and then copy this into a new file with a white background. Once desaturated, I then scale it down and use an eraser to reshape it into a few sparse dots which become my eventual particle brush (**Fig.09**).

As I look through some of the earlier versions of the creature that I've saved, it strikes me that the original shape from Fig.04 was somewhat more unusual than its current state and so I resort back to this design (**Fig.10**).

You can also see how the particle brush helps to add some detail in the water (inset). Because the creature has a second mouth I feel it needs some teeth reminiscent of squid or octopus and so create a series spanning the underside, which also helps lend it a more menacing aspect.

ADDING FINAL DETAILS

Usually once the painting has reached a reasonable stage I flatten it and then begin adding some of the refinements on a new layer. In this instance I add two new layers. The first one is set to Overlay mode in order to add some passages of color to certain sections,

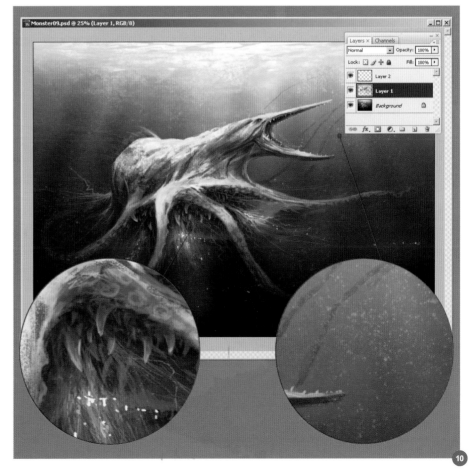

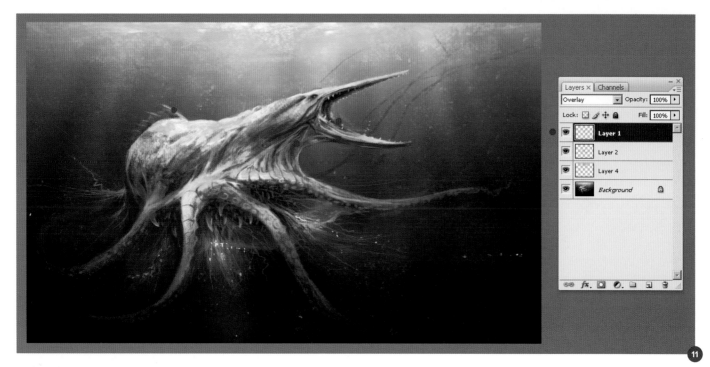

such as those highlighted in red in **Fig.11**. These comprise of a red tint along the jaw and tail fins, along with a blue shadow beneath the lower jaw.

I use the remaining layer to add the segmented sections along the tentacles. The picture is almost complete now, but a few adjustment layers will further help tie the image together once all the layers have been flattened.

The first one I apply is Curves by going to Layer > New Adjustment Layer (**Fig.12**). I use this layer to darken the overall tonal range by adding the two points and dragging the line down slightly. Once done you can use black to paint into the mask and reveal the original stage if need be.

The next adjustment layer is Levels – again this is used to darken the image so that I can

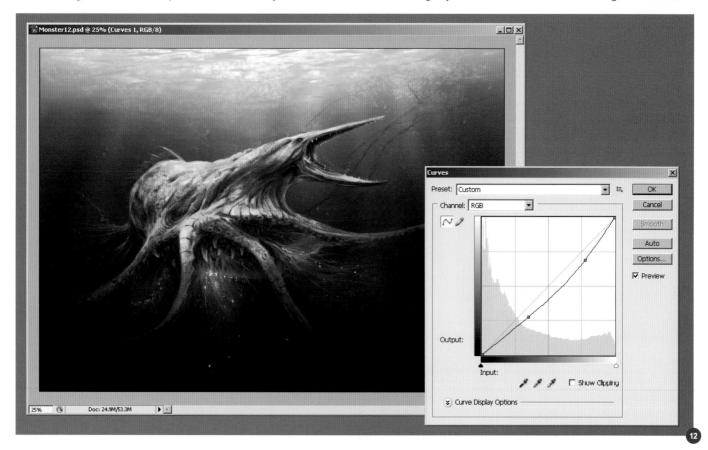

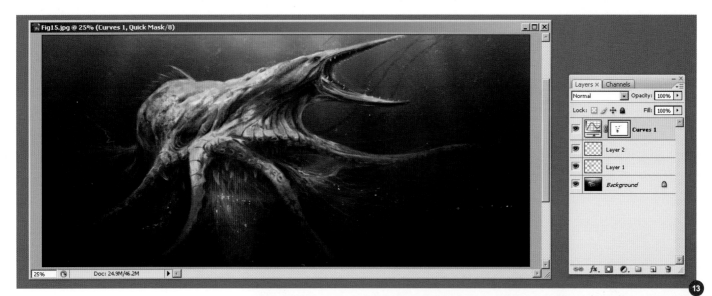

then paint into the mask and reveal a few bright highlights in specific areas as shown by Quick Mask in **Fig.13**. The red areas in the image correspond with the black areas in the small thumbnail at the top of the layers palette. The next adjustment layer I use is Levels; again to darken the overall image before once again painting into the mask (**Fig.14**).

The last and final adjustment layer is Color Balance and is where I add a greenish tint (**Fig.15**).

The final image can be seen in **Fig.16**.

CONCLUSION

This has been an interesting tutorial and has certainly been fun to do as it is not a subject I have tackled before. I try to vary my approach to painting and apply different techniques each time I start a new piece. Sometimes I work in grayscale to begin with and then add color later in the process, and at other times I make a series of thumbnail sketches beforehand. In this case I jumped straight in without any preconception of where the journey would take me, developing the design along the way.

You can download the resource image (JPEG) file to accompany this tutorial from: **www.3dtotalpublishing. com**.

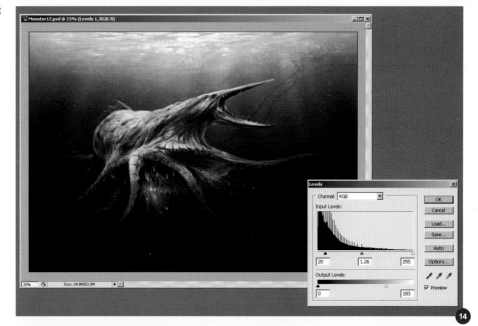

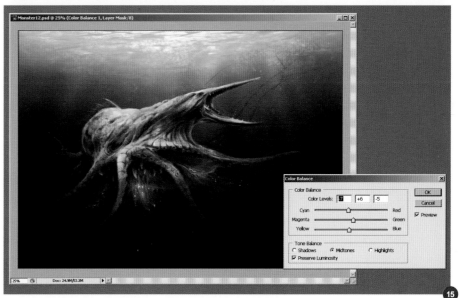

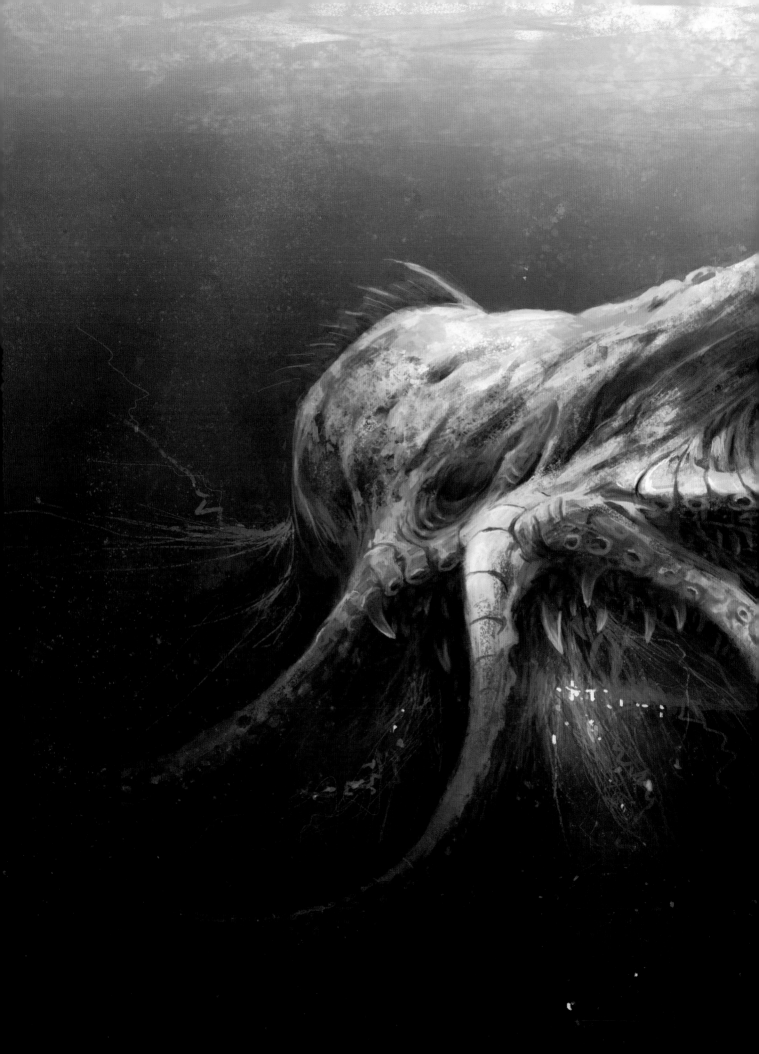

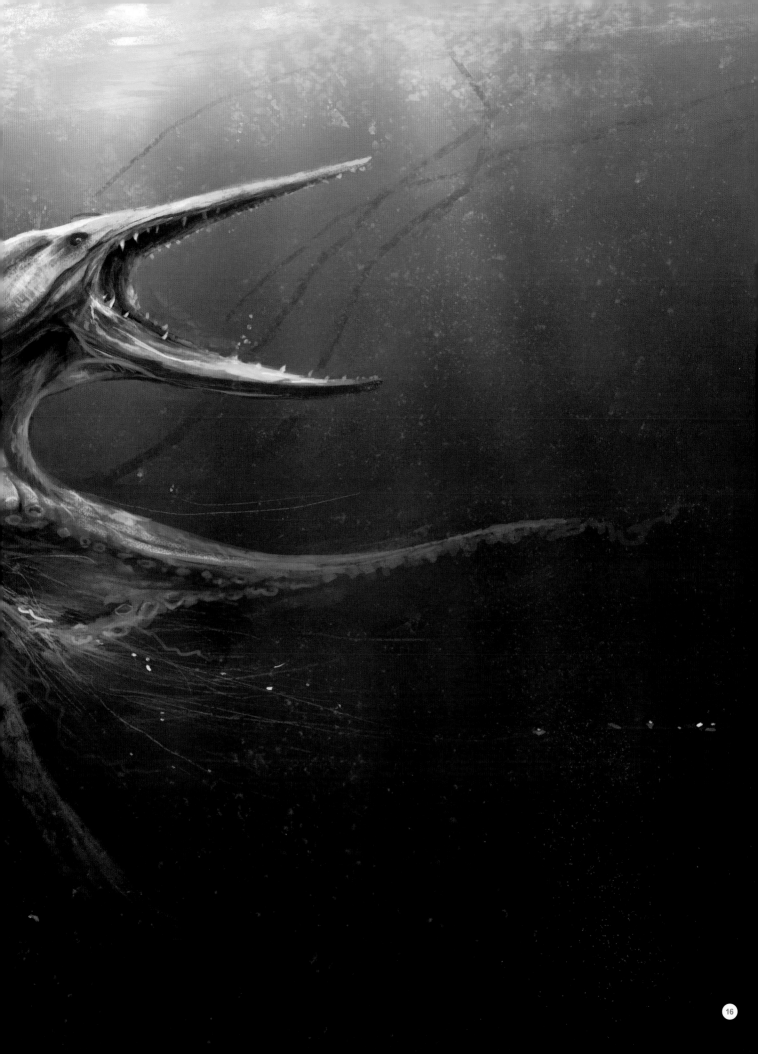

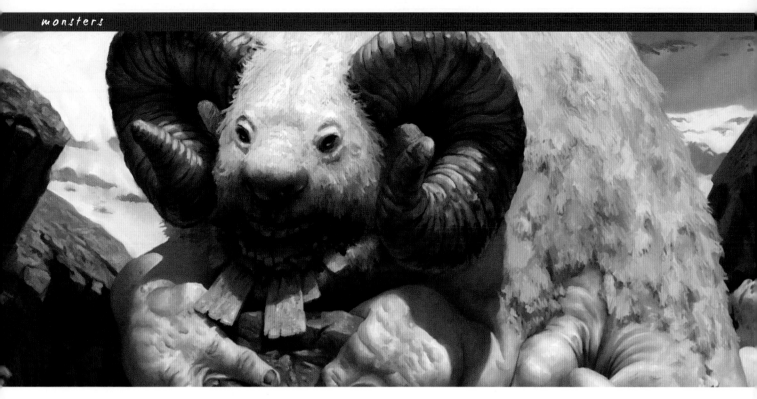

MOUNTAIN MONSTER
BY SIMON DOMINIC
SOFTWARE USED: ARTRAGE & PAINTER

INTRODUCTION

In this tutorial I'll be designing and painting a fantasy mountain creature. I'll be doing the first half in ArtRage 2.5, and the rest of the image in Painter X. Both of these packages have their strengths and weaknesses and by using them together I can combine their best features.

Before I start I need to get some idea of what attributes my creature will have. I find the best approach is to jot down the key points about the environment and use them as a guideline to building our beast. We know he lives in the mountains so I'll be using this as my starting point.

The first thing about a mountain environment is that it's cold. Therefore our creature will need fur and thick skin. Mountain air also tends to be thin so this suggests our creature might possess a hefty set of lungs and consequently a large upper body.

Mountain terrains are rocky and frequently covered in snow, so we'll give our creature three sets of powerful legs in order to cling to the rocks and a pair of strong arms with shovel hands to dig through the snow in search of

vegetation. We'll also give him a couple of tusks for uprooting tough mountain plants and bushes.

In order to give him some camouflage we'll make him white, but in case that isn't enough and he's discovered by a fiercer mountain beast he can have a fine set of horns. So that concludes our creature spec; all we need to do now is draw him.

SET UP THE CANVAS

I start off using ArtRage, so first off I create a new canvas. My final canvas will be 2480 x 3425 pixels, but I don't want to start that big so let's go with 827 x 1147 pixels (dividing both dimensions by three). Later I'll set my dpi to 300 for print. If you're just going to be displaying on the web, however, it doesn't matter what dpi you use. I choose a slightly rough canvas and give it a light tan color – I find white can be too overpowering and it scares me!

ROUGH SKETCH

I create a new layer – let's call it "rough layer". I'm using a new layer rather than the canvas because in the next step I'll be deleting it.

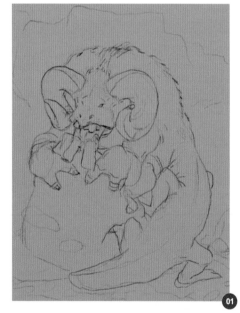

I select the basic Pencil tool (Size 150%, Pressure and Softness 50%) and draw a rough sketch of my creature. I set the color to black, RGB (0,0,0) – this is very important. If a lighter color is used it will cause problems when under-painting (**Fig.01**).

REFINED OUTLINE

I set the opacity of the rough layer to around 40% and create another layer called "outline

layer". On the outline layer I trace my rough sketch to give a more refined outline. Then I delete the rough layer because I don't need it anymore (**Fig.02**).

FINAL SKETCH

I set the opacity of the outline layer to 40% and create another layer: "value layer". This layer is for shading the sketch in black and white, alternatively known as a value study. As well as giving me the form of my creature it allows me to see how the values of a piece – the lights and darks – fit together prior to painting.

Using the same pencil settings I apply shading to the creature, paying particular attention to the dark shadows and light skin and fur. I keep in mind the position of my main light source in order to achieve accurate shadows. The result is still very sketchy but that's OK; it's just a guide for my painting.

When I've finished the shading I delete the outline layer so all I'm left with is a blank canvas and the value layer (**Fig.03**).

COLOR PALETTE

ArtRage 2.5 has a fairly limited color palette facility so I prefer to use Painter's Color Set function. Unfortunately I can't import a Painter color set palette directly into ArtRage so I create the color set in Painter, capture it using a screen capture utility, save it as a JPEG

and import it into ArtRage as a reference image. I create the color set palette in Painter by dabbing my chosen colors into the mixer palette and then choosing "New Color Set from Mixer Pad".

UNDER-PAINTING

Painting directly onto the canvas I quickly lay my colors down, color picking from the referenced color palette. I spend no more than 15 minutes on this stage. I use a medium-size Oil brush at 100% Pressure, 30% Thinners and 40% Loading. I'll leave these settings unchanged for the rest of the session, only altering the brush size when needed.

Because the value layer is still present it overlays my colors so that the general form of the creature is not lost. When I've completely covered the canvas with color I merge the value layer with the canvas.

Note that I've made my sky a very dark blue. The reason for this is that the higher you are, the darker the sky dome. In this instance it helps reinforce the idea of an elevated mountain location (**Fig.04**).

BLOCKING IN THE COLOR

Painting directly onto the canvas (we're finished with layers now) I do another pass of the painting and dab color over the areas where the pencil shading is visible. I also put a bit of detail in there and coarsely refine the shape of the head and rocks (**Fig.05**).

RESIZE UP

I rescale the image to its final size. When resizing up make sure you do it at an early stage or else blurring of detail will occur. This painting contains none of the final detail so it's fine to resize up.

> **Quick Tip:** Sometimes you may want to resize up beyond your final size and then resize down for your final image. This is handy if you want to add very fine detail, assuming your computer can handle it.

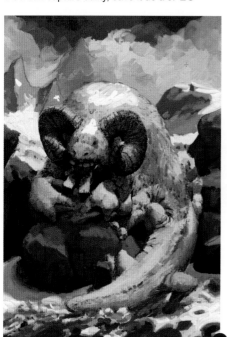

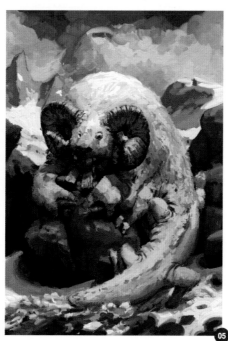

Of course you could start off with a large canvas in the first place and not bother with resizing at all. I just find it quicker to sketch and block in color on a small canvas first (**Fig.06**).

ZOOM IN

Zooming in at this stage is somewhat disconcerting and results in a screen full of ragged blotches and unrecognizable fuzzy shapes. This is good because it means things can only get better. Working at between 50% and 100% zoom, I start with the creature's head, refining the shape and pushing the lights and darks to simulate three dimensional form. Although the sun is the main source of light we also need to take account of diffuse light from the sky and reflected light bouncing from the surrounding snowy landscape. When you consider too that the creature is white this means there will be very few areas of darkness on its fur and skin. I do darken the area around the creature's mouth, although that's more to do with its eating habits than anything else (**Fig.07**).

> ## NO TWO WAYS
> ## ABOUT IT: SHADOWS
> ## ARE BORING. BUT
> ## THERE ARE WAYS WE
> ## CAN JAZZ THEM UP A
> ## BIT

FIRST DETAIL PASS

I work outwards from the creature's head – the focus – doing much the same thing as in the previous step. I loosely reference the horns from a photo of a goat I found on the web in order to get the shapes right.

It's important when drawing a figure or creature to depict it interacting with the environment rather than the landscape being pasted in as

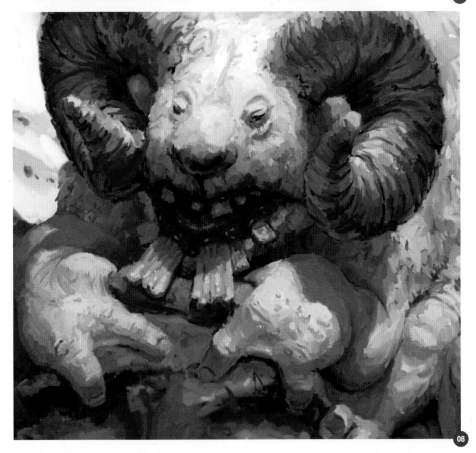

an afterthought, like the backcloth to a stage. Here much of the interaction comes from the creature's hands and feet, which are gripping the rock. Normally when you grip a rock the shape of the rock will dictate how your hands grasp it. However, in this instance we have the luxury of a virtual rock that can be shaped to

our needs, so we can draw our hands first and fit the rock around them, which is much easier (**Fig.08**).

MAKE SHADOWS INTERESTING

No two ways about it: shadows are boring.

But there are ways we can jazz them up a bit. Here I'm painting the shadow cast onto the creature's right leg by its horn. Notice I've given it a distinct blue tint. Although the shadow is formed due to that portion of the leg being shaded from the direct sun there is still diffuse light falling in that area. The majority of that light is reflected from the sky, which happens to be blue, hence my color choice. In real life this blue tint would be nowhere near as pronounced but I find that exaggerating these things can give your painting a certain extra something (**Fig.09**).

PAINT THE ROCK

I add texture to the rock, always bearing in mind the location of my primary light source – the sun. This particular rock is weathered and full of cracks and crevices, which need to be colored very dark. I leave the sides of the rock, those exposed parts in shadow, much lighter as they are catching the light rebounding from the snow and the general environment.

If these rocks were by a stream or in a forest it would be good to include some moss and vegetation, but seeing as this is a harsh mountain location I'm leaving them bare (**Fig.10**).

OOPS

Something has been bugging me for a while and I've just seen what it is. The creature's head is too far over to the right (it's left). Unfortunately ArtRage 2.5 doesn't have cut and paste functionality, and exporting to

another application would lose the paint depth information, so I need to make the correction another way.

What I do is duplicate the canvas to a new layer and set the paper opacity of that layer to 0 via the Paper Settings option. I turn off the visibility of the canvas and on the new layer I erase everything but the head. I turn visibility back on for the canvas and reposition the head in the correct place using Transform Layer Contents. Then I merge the layer with the canvas, tidy up the rough edges and hope that the next ArtRage comes with cut and paste (**Fig.11**).

DISTANT MOUNTAINS

Although I'll be doing most of the fine detail in Painter, the ArtRage Oil brush is great for texturing craggy, sharp rock. This means I can do most of the distant mountain detail in ArtRage, using a small brush of around 9% (**Fig.12**).

START DETAILING IN PAINTER

I export the image from ArtRage as a PSD then load it up into Painter. For fine detailing I use a small, soft, grainy brush with pressure dependant opacity and re-saturation plus a small amount of bleed. When I press hard

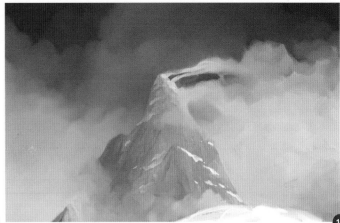

13

14

the brush delivers solid color to the canvas, but when I ease off the pressure it acts as a blender, smoothing my paint into the existing colors.

I work at a high zoom, normally 100%. I start by applying final detail to the mouth, hands and horns (**Fig.13**).

BLEND THE SKY

Not being one to work logically, I take a break from the creature and blend the sky and clouds. I already have my colors in place so all I need is a big Blender brush. For this I use a brush with almost identical settings to my detail brush except it has 0% re-saturation. This means it won't put any new paint down, just blend what's there (**Fig.14**).

SMOOTH THE SKIN

Using a combination of the small detail brush and the blender I smooth out the creature's skin whilst accentuating the edges and folds. I also use the small detail brush on the fur to give the impression of the thick coat of fur becoming more ragged and patchy towards the midsection (**Fig.15**).

SPLASH SOME MUD

Underneath all that snow is a nice layer of mud, so I splatter some onto the creature's feet and tail. Again, this helps with the impression that the creature is part of its environment and not just pasted on top of it (**Fig.16**).

BLEND THE SNOW SURFACE

For the open areas of snow I mainly use the blender brush with an occasional dab of the

smaller detail brush. Note that the distant snow in the shadow of the gray cliff is slightly lit from below, with soft shadows being projected upwards. This is because the sunlight being reflected from the snow slopes below would, I reckon, be slightly stronger than the light being reflected from the clouds and sky (**Fig.17**).

FINAL TWEAKS

All that's needed now is to put in those final tweaks, neaten up the edges and make sure

no areas have been overlooked. I don't need any color correction and that's one of the advantages of using ArtRage early on. Mixing colors on the ArtRage canvas often results in hues of higher saturation being produced and this helps in retaining a vibrant look and stops the colors becoming muddy (**Fig.18**).

All that's needed now is to add my sig and it's done! Thanks for following my tutorial and I hope it was helpful.

15

16

17

18

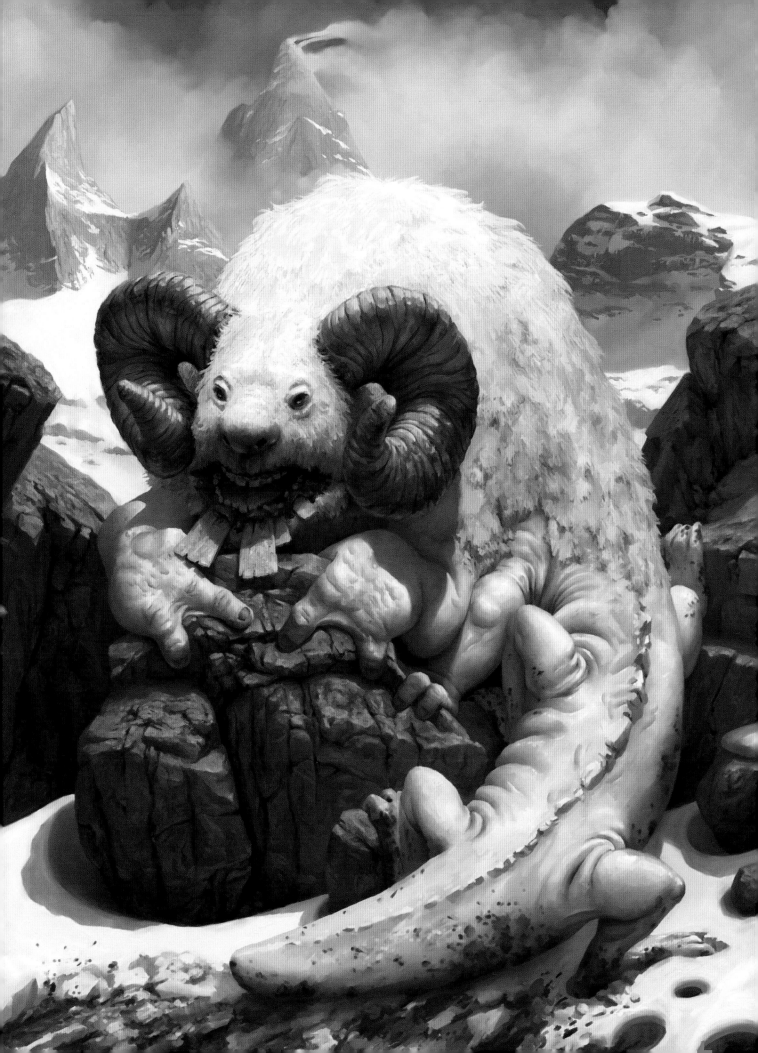

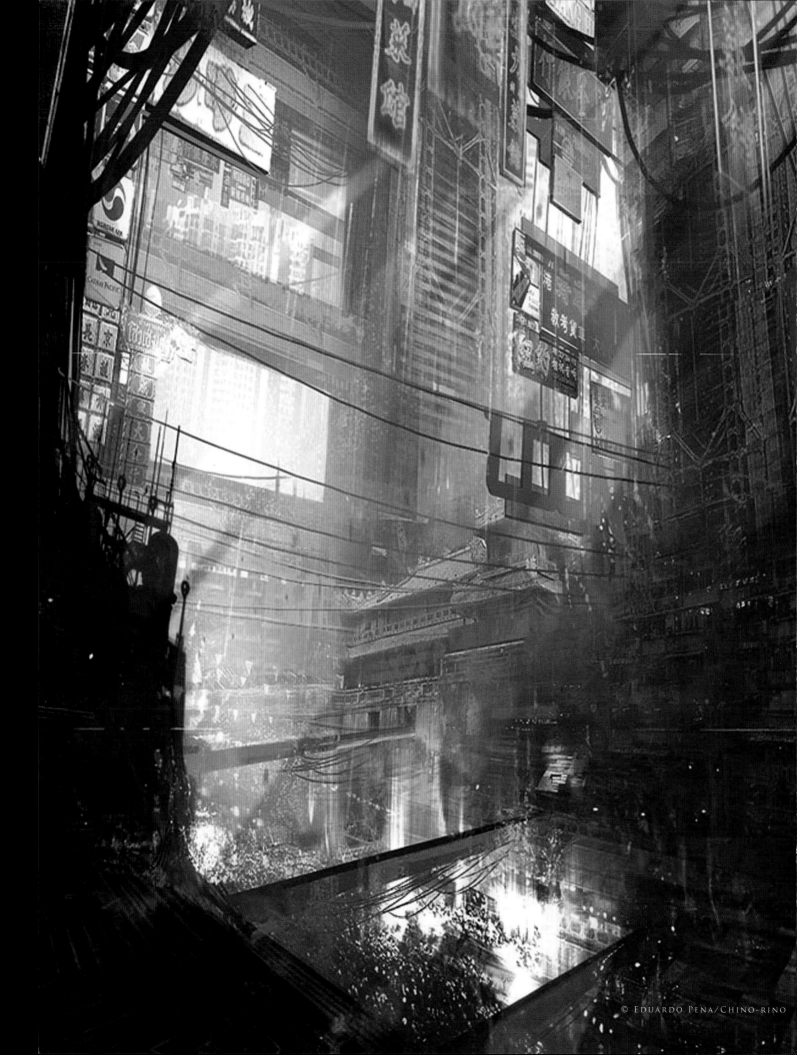

sci-fi cities

Sometimes when designing something that reflects our vision of the future we have to find a different way of understanding the present. We have to try to imagine a future adaptation of the world we live in now, showing an alternative reality that is influenced by the science-fiction genre. Then we must paint this and reveal our thoughts in a visual language.

The most important thing to remember when tackling a project such as this is that you must completely involve yourself in the theme and topic. You should make yourself an adventurer in a future world in your imagination and take all the visual experiences with you.

The technical representation of these things will come in time; what is important is that you spend time exploring your imagination.

EDUARDO PENA
caareka20@hotmail.com
http://chino-rino2.blogspot.com

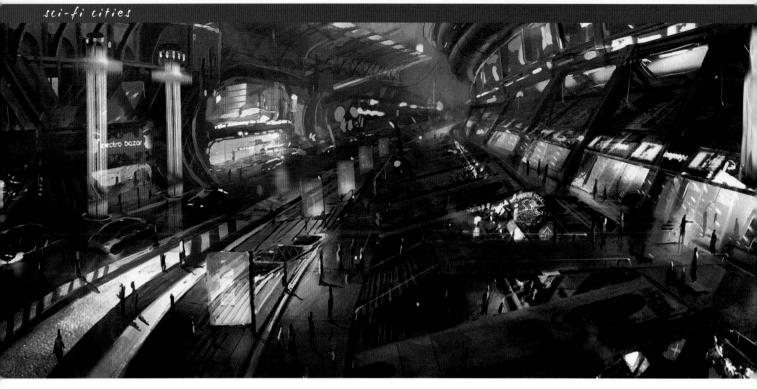

FUTURISTIC MARKET PLACE
BY IGNACIO BAZÁN LAZCANO
SOFTWARE USED: PHOTOSHOP

INTRODUCTION

The aim of this tutorial is to tell you some "tricks of the trade" and techniques that you can use to obtain a good perspective and composition. These tips should help you to be able to create an attractive image and detail it quickly.

When thinking about this tutorial, my first thought was to create a market or futuristic bazaar scene that contained a commercial center, and a zone full of shops and shoppers. It was quite difficult though to think of an

original idea, because there is so much art dedicated to science fiction and films like *Star Wars*, *Aliens*, *Avatar*, *Blade Runner* etc. It can be difficult sometimes to paint something that hasn't been done already.

Thus, to come up with "the idea", I made several drawings. I later discarded the first two because neither seemed convincing. Nevertheless I've included them as an example so that you can see the idea process (**Fig.01a – b**).

I started over again and made four new sketches, but this time I did not give them color or detail. I made thumbnails so I could see the general idea better. I decided that I liked the third option (**Fig.02**).

THE PICTURE

Once I had chosen the thumbnail to develop, I polished the idea and added more detail to it. I then had to recreate the thumbnail at a

larger scale and in greater detail. To start with I raised the vanishing points, and defined the forms and structures by adding further detail. It is important to maintain the correct perspective and composition; to do this the first thing I do is to define the horizon, as this depends on where we are viewing the scene from. Depending on where the horizon is located, what we show or tell will change. For an aerial shot it is better to place the horizon higher, but if you are trying to show how an ant would view the scene the horizon needs to be lower (**Fig.03**).

> ❝ WHEN I WORK ON AN IMAGE THAT HAS A DEGREE OF COMPLEXITY, I DO NOT ADD ANY COLOR UNTIL I HAVE AT LEAST 60% OF THE DETAIL DONE IN GRAYSCALE ❞

However in this scene there is more than one vanishing point and the horizon is twisted to give the scene a greater sense of action and movement (**Fig.04**).

At this point I need to say more about composition. To compose is to order, balance and locate the elements of a drawing in an attractive and interesting way. To create an interesting composition we have to break down the symmetry and find balance by means of shapes and perspective. If you center the vanishing point, everything will become symmetrical and boring. However, if you twist it clockwise then the balance and symmetry becomes far more interesting (**Fig.05**).

STEP BY STEP
Once the composition was ready, the next step was light and shadow. When I work on an image that has a degree of complexity, I do not add any color until I have at least 60% of the detail done in grayscale (**Fig.06**). I started this process by masking the buildings' silhouettes and giving them shape and color that contrasted with the rest of the image by using much lighter or darker grays (**Fig.07**). Once the general shape of a scene is clear you can give it more detail by starting to add textures (**Fig.08**).

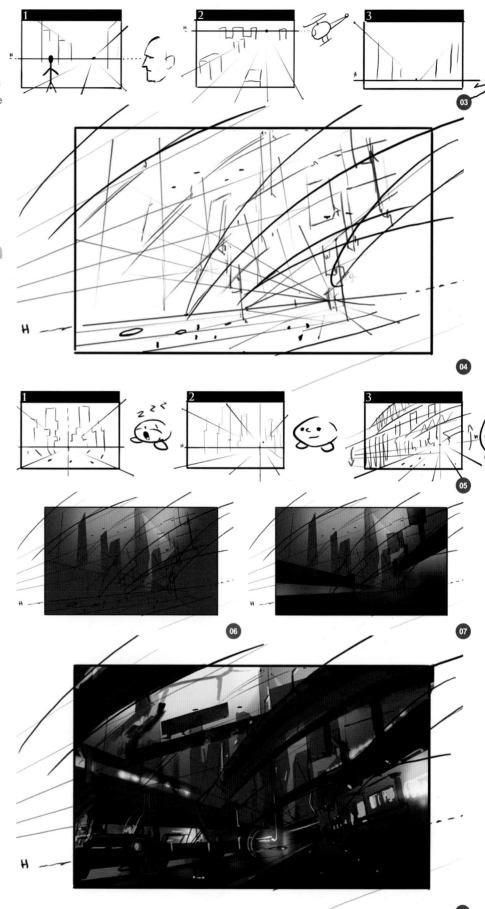

CHAPTER 4

TEXTURES

What I usually do with backgrounds to save time is to draw a texture and repeat it several times using Photoshop tricks. As an example to show you how I do this I have drawn a basic structure in perspective that leaks away to a single point.

Step 1: Draw a texture or design on any surface of the drawing. In this example I have chosen the end of the wall (**Fig.09a**).

Step 2: Once the texture is ready, mask it and copy it to a new layer (Ctrl + C and Ctrl + V), then press Ctrl + T. You will see that the selected texture has a frame to allow you to adjust the size. In the middle of the frame you will find a circle with a cross in the middle of it. Move that to the vanishing point (**Fig.09b**).

Step 3: When steps 1 and 2 are done, place the mouse cursor on the left superior angle of the frame that contains the texture, and press Shift + Alt to move the texture to the left, while pressing both mouse buttons. This way we can repeat the same previously drawn texture and transfer it, keeping its perfect form and perspective (**Fig.09c**).

I've noted the areas where this technique has been used with red marks (**Fig.09d**).

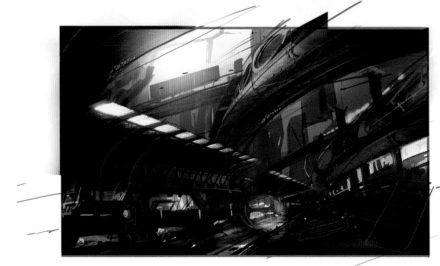

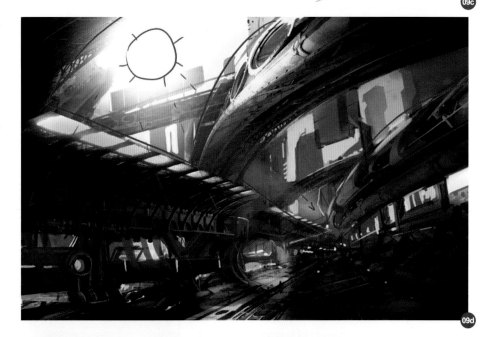

COLOR

To give color to the image I distinguished each element step-by-step by using color

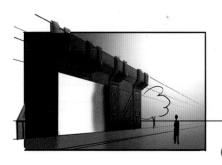

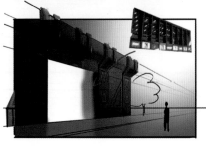

contrast. Sky on the one hand, the street and the buildings on the other. Light is always an important element (**Fig.10**).

WINDOWS

Here I will show you step-by-step how to get the "glowing window" effect by using textures:

Step 1: To get a realistic effect, draw rectangles on each building, using only one color (**Fig.11a**).

Step 2: Place a texture over this color. It can be taken from any photograph where light can be seen through a window. Then place the photo

in the windows area and select the Linear light option from the Layer options (**Fig.11b**).

Step 3: To light the window even more, use an almost white yellow color and create a new layer. Paint it using the Overlay option (**Fig.11c**).

POSTERS

Step 1: Draw a poster, or some kind of rectangular, square or circular surface.

Step 2: Texture it with a photograph or something that will attract attention. So that it fits on the image, use it on Overlay (**Fig.12**).

CONCLUSION

When it comes to making work for a client or to sell, knowing how to compose the image and use perspective correctly makes a big difference.

It is very difficult for me to tell you step-by-step how I created the final image. If I had to, I think it would be very tedious for readers, so I did my best to explain the most important steps. The search for ideas, composition and perspective are crucial when it comes to creating an interesting image. I hope you have liked this tutorial and can benefit from it. To have good ideas is what really matters.

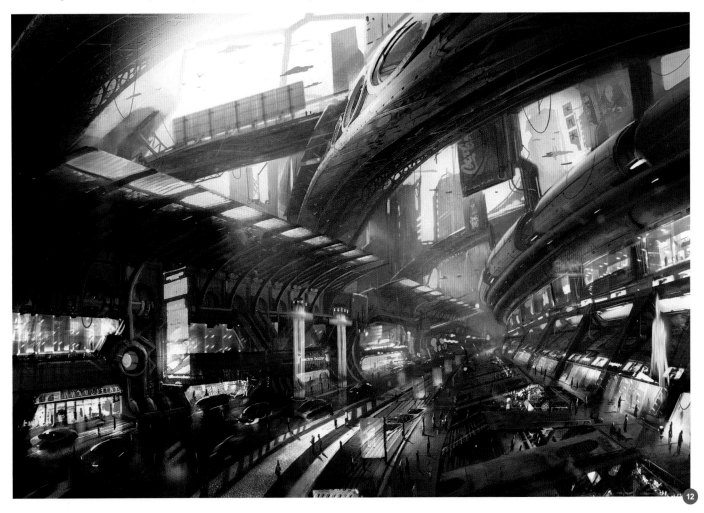

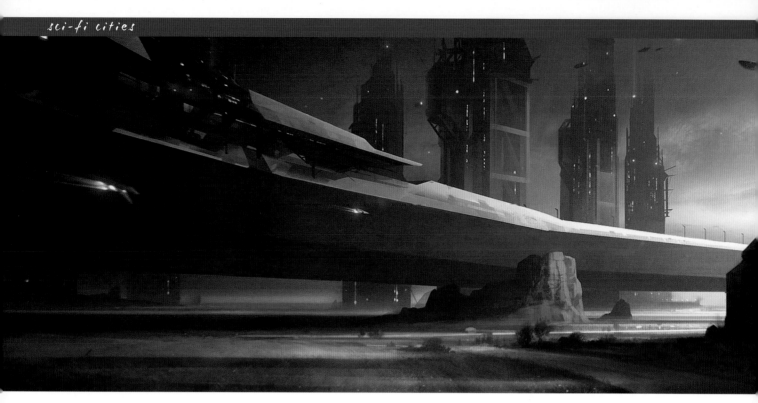

DESERT CITY
BY JAMA JURABAEV

SOFTWARE USED: PHOTOSHOP

INTRODUCTION

In this tutorial I am going to show how to create a scene with some air traffic and skyscrapers. Of course, before I start to draw or paint anything I try to think about the theme and form some basic ideas in my mind. People have seen enough of various cityscapes with flying aircrafts and cars in films like *Star Wars*, *Star Trek* and other epic movies. I think recreating these scenes would be unfair and I wanted to create something a bit different, but I was still unsure what exactly I wanted to create. I think it is sometimes good to start with some uncertainty because it can give some unpredictable and pleasant results.

> " I THINK LEARNING PHOTOSHOP AS A TOOL IS A TECHNICAL ISSUE, BUT LEARNING TO CREATE SOMETHING CREATIVE AND ORIGINAL DEPENDS ON THE ABILITY TO IMAGINE AND DROP THAT IMAGINATION ONTO THE CANVAS "

On the other hand, I wanted this tutorial to be concentrated more on the procedure of creation rather than on the painting process and Photoshop tools, because I think learning Photoshop as a tool is a technical issue, but learning to create something creative and original depends on the ability to imagine and drop that imagination onto the canvas. And I also want to talk more about the procedures that can boost your imagination. Anyway, time to start.

SKETCHES

When it comes to sketching I try to do it in different ways and to explore. I remember

watching one of the tutorials made by the great artist Nick Pugh. He really opened my imagination. Nick showed different sketching techniques trying to show how to work with abstraction and unpredictable designs and so on. Sometimes he draws with his left hand to obtain different shapes and forms. After watching those tutorials, I tried to plug this abstract thinking into my workflow and my sketches. I mainly use Photoshop in my paintings, and everything done here was in Photoshop. For this one I started to paint using the Lasso tool (L) and Gradient Fill tool (G). Both these tools are great to create basic shapes and form. The Lasso tool allows you to

keep sharp edges while the Gradient Fill tool brings nice gradient color transitions and color variations.

At this stage I try not to think about perspective, colors, light and other things. I just relax and paint. I start by selecting some regions with the Lasso tool and filling them with color gradients. Some regions become flying ships, some of them skyscrapers. Some may be land or sky. I just create abstract forms that will inspire me to think about the final composition.

After playing around a bit, I created these sketches (**Fig.01 – 03**).

Hmm, I liked them, but they were nothing that I wanted to finish. So I copied all the images into

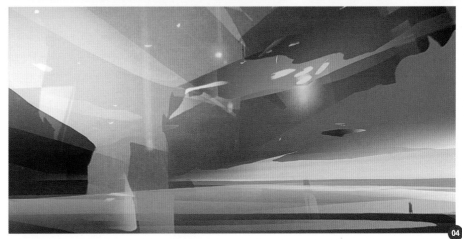

one file and started to adjust layer modes in Photoshop. Layering images in different ways can create really unpredictable results and **Fig.04** was one of them.

I started to see this gigantic shape that was hovering above the landscape and I thought that could be a great shot. After detailing it a bit I came up with this image (**Fig.05**).

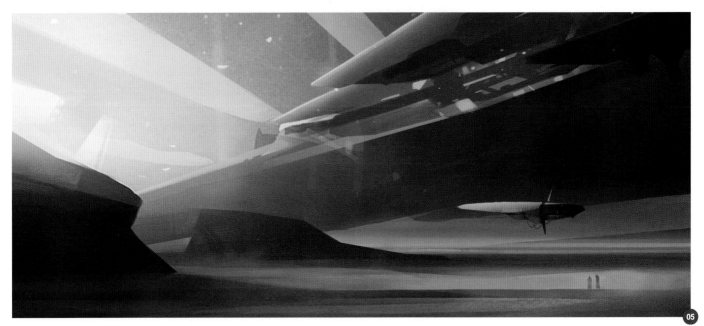

CHAPTER 4

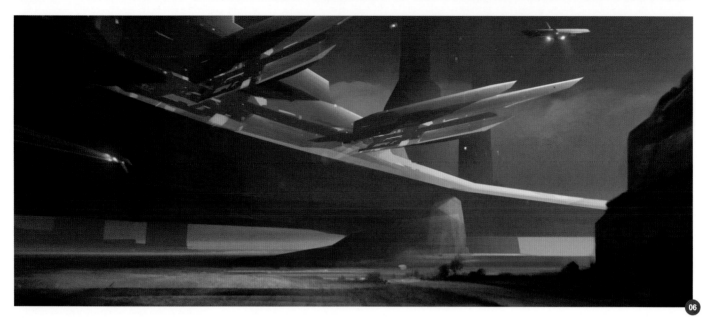

Everything was working fine for me at this stage, except that the image had a slightly different mood. To set the mood and feel that you would like, it is good to look through different references. It can be photos, paintings, drawings, or even the weather out of your window. I used one of my own studies that I did not so long ago (**Fig.06**).

When I had decided on the mood I started to refine my image, and at this stage I refined some compositional issues too (**Fig.07**).

The key tip here is constantly flipping the canvas to refresh your view point. It helps a lot to correct the composition and perspective. It is really surprising that there are no shortcuts for flipping the canvas in Photoshop, so don't be lazy and set up shortcuts for this operation. It saves a lot of effort!

Another thing that I refined here is the foreground. I started to think that making a kind of desert landscape would create a good contrast with the futuristic buildings. I also thought that it would be interesting to show that humanity had eventually started to care about our beautiful mother Earth, and stopped destroying everything to build cities.

COLORS

For me, the best way to learn about colors is to study the masterpieces of great artists of the past such as Isaac Levitan, Aivazovsky and other masters of traditional paintings. By looking at their paintings you can observe and learn how to work and manage color. Not being a master of color myself, I am still learning and have a lot more to learn.

One thing that I can say for sure is that color variation is the thing that makes things look realistic. There are no plain colors in nature; they all contain some kind of tint and hue. And in my paintings I try to insert those variations.

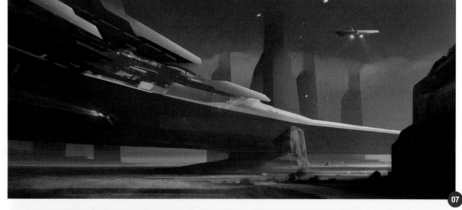

If I paint grass, I introduce different colors than just green and this makes my grass look more realistic. I think the best way to learn about colors is to paint things from nature. Don't be lazy, go outside and paint. It will help a lot!

DETAIL

By refining a bit more, I came up with this (**Fig.08**). I blocked the main skyscrapers and the rest was detailing the picture to head

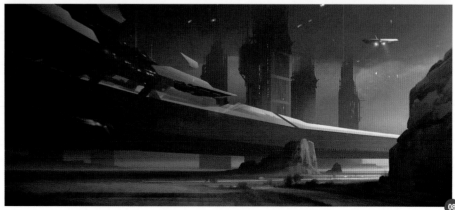

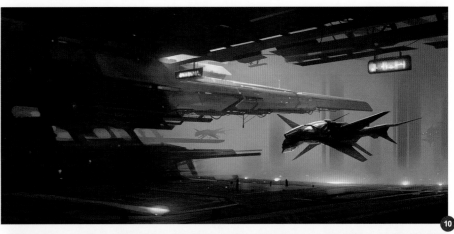

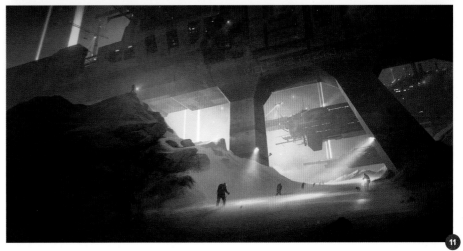

towards the final look. There are several ways that you can do this. You could paint all those details, or use photos and textures to imply the details. Both ways are good.

I used some of my previous paintings to create the details (**Fig.09 – 11**). Why not? If Photoshop allows me to cut out some regions of my previous paintings and paste them into the new one, I will definitely go ahead and do it, especially when it comes to concept art, when everything has to be done in the most efficient way. It's a good way to create details quickly.

After that it took me some time to refine everything in the image and add the air traffic to the sky. And here is the final image (**Fig.12**). Hope you like it.

CONCLUSION

As I said at the beginning of this tutorial, I wanted to share my process of creation. Being a self-taught artist I have encountered many problems from the time I started working digitally. I looked through tons of articles and tutorials which taught Photoshop as a tool. After I had learned all of those useful tools and instruments, I realized that it is not enough at all! What is more important for me is to use those tools to bring my imagination to life. That is why I decided to share the methods that help me to imagine.

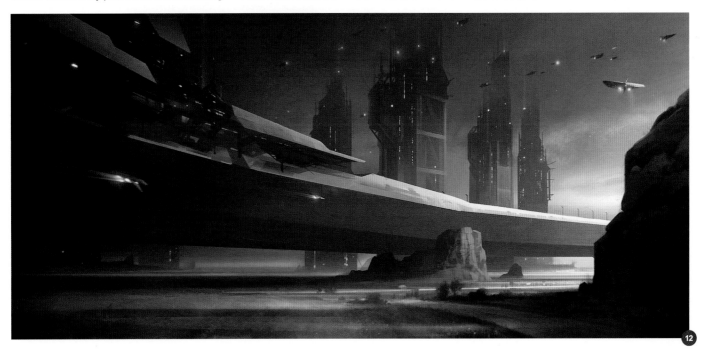

CHAPTER 4

FUTURISTIC DOCK
BY RICHARD TILBURY

SOFTWARE USED: PHOTOSHOP

The first stage in this tutorial was to do a little
bit of research by looking at images of docks
and different types of ships on the internet.
From the outset I wanted to create an image
that had a large sense of scale, mainly
because of the size of ships when viewed
up close. Any large vessel has an imposing
quality that is immediately impressive due
to the strong sculptural form and sheer size
compared to the average person.

The grandeur of the early cruise liners was
something that I had in mind when considering
the type of composition and I decided that the
eye level should be low down to emphasize the
vast scale of the ship that would form the focus
of the image.

I decided that I didn't want to stray too far from
the general design of ships for fear that it would
look unconvincing. Any waterborne vessel
adheres to a few basic principals regarding the
shape so that it can effectively move through
water and so given this long established
tradition I thought it would be best to stick to it.
I find that with any interpretation of a subject it

is better to start with what you know and then
modify it in order to create a more plausible
concept.

Due to the low eye level I decided to build
a simple ship shape in 3D to give me an
accurate starting point with regards to the hull
in perspective.

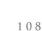

Fig.01 shows the basic shape that was created in 3D. I then added in some perspective lines to act as a guide and a framework along the left which would create depth in the scene. This device of repeating a motif or shape can be used as a gauge to measure scale and perspective in a scene (Fig.02).

With the perspective and basic 3D shapes in place it was time to start blocking in some of the tonal range (Fig.03).

I usually use some textured brushes at this stage and apply some random strokes and marks which often suggest a direction or help describe details. I used the Lasso tool to create some hard edged shapes along the ground which would also help convey the perspective. In Fig.04 I darkened the sky and boat as there was too much white in the image, and made sure that the back of the boat blended into the background less abruptly. The right side of the boat at the bow also looked too bright even though it was reflecting some light and now looked far more convincing.

After establishing the basic composition I created a new layer set to Overlay blending mode, which would represent the color scheme. I painted in some provisional colors here, which you can see in Fig.05. By setting the blending mode to Overlay it is possible to add color without affecting the tonal range. Some artists use this method whilst others prefer to use color directly as they feel this approach produces a muddier palette.

You will notice that I have also added some structures on the deck and two large vent shapes at the front to create a slightly odd feature that helps make the boat look less contemporary.

Fig.06 shows the structure of the layers palette with the tonal composition at the bottom called "Main" and the color layer directly above it set to Overlay.

Using the perspective lines as a guide I created some simple shapes on the right using the Lasso tool and then filled them in with a light gray (Fig.07). They automatically appear blue due to the color layer above.

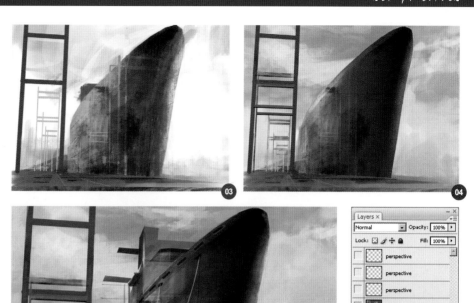

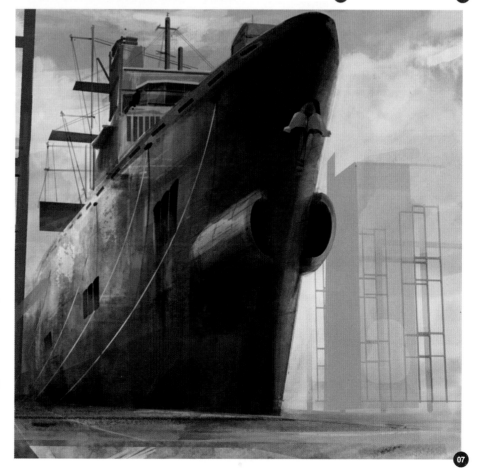

I continued working on the base tonal layer and began adding in some detail along the ship with some structures on the deck and rigging. I added in some shapes that could become crates or platforms, but at this stage I was not sure.

Quick Tip: When painting in symmetrical detail along the hull it is best to create some shapes on a new layer and then use the Transform tools to match the perspective. Scale and Skew are the two common ones I use, but Warp was particularly useful in this instance due to the curvature of the hull.

Fig.08 shows the Transform tools under Edit and, in this case, Warp has been used to curve the vents along the side of the ship. I made one group first and after duplicating it twice used the Scale and Skew tools in conjunction with the perspective grid. Once done I then warped each set individually to align with the hull.

At this stage I began looking through some of the free photos available at 3DTotal which I could use to paste into the image and help add a sense of realism. Photos that are carefully used and color corrected can help an image immensely and suggest all kinds of textural detail and subtle effects.

Whilst sifting through the library I found two photos that caught my eye and which can be

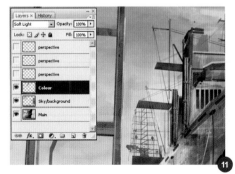

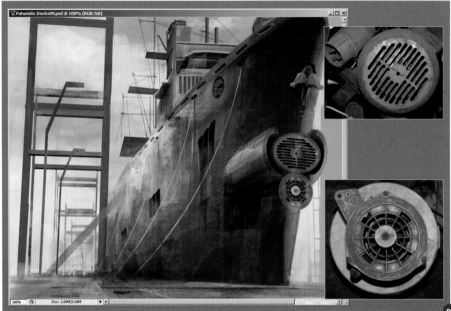

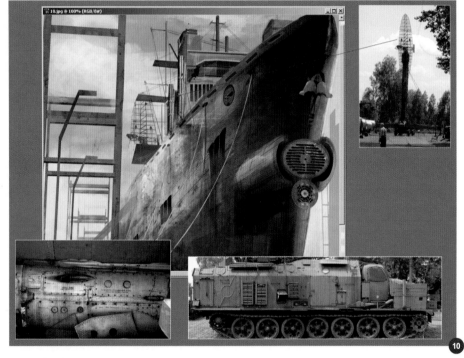

downloaded by following the link at the end of this tutorial. I imagined them fitting somewhere and so dragged them into my image, scaled them and started to experiment (**Fig.09**). I finally decided that they looked quite interesting at the bow and fitted in with the vents so I skewed them accordingly and blended them in using Image > Adjustments.

I found a few other useful references In the library which I used to add further detail and realism to the image (these can also be downloaded by following the instructions at

the end of this tutorial). I copied and pasted in some aircraft panelling along the hull and on the girders on the left, and set the blending mode to Soft Light (**Fig.10**). The other two components taken from the radar and tank were simply color corrected and set to Normal blending mode.

After all of the detail had been added from photos I decided to flatten many of the layers to keep the file from getting too complicated. These were then merged with both the color and also the original tonal layer (**Fig.11**).

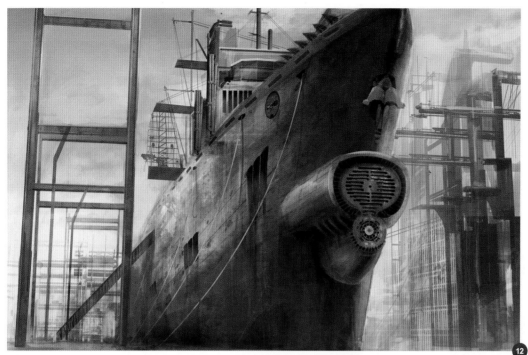

The background on the right was looking a little empty so I created an abstract shape that could represent a large crane or something similar and then duplicated it twice before scaling it to match the perspective. I kept this on a separate layer for the time being as well as adding a new color layer set to Soft Light to change the hue of the top of the boat which was too blue.

With a little more refinement to the background and a better integration of the vents on the front of the ship, I once again flattened all of the layers except for the perspective ones. I then added two adjustment layers: Curves to darken everything slightly and Color Balance to add some warmer tones towards yellow (**Fig.12**).

You can see the layer structure here with the adjustment layers and a further sky layer which I used to add a blue mainly to the upper left (**Fig.13**).

At this point the detail in **Fig.14** was at a reasonable stage, however the color scheme seemed a little drab and washed out; fine for a foggy day, but not what I had in mind. The composition was also troubling me because the ship seemed squashed and had no space to breath so to speak. I altered the canvas size by increasing the height and also added a

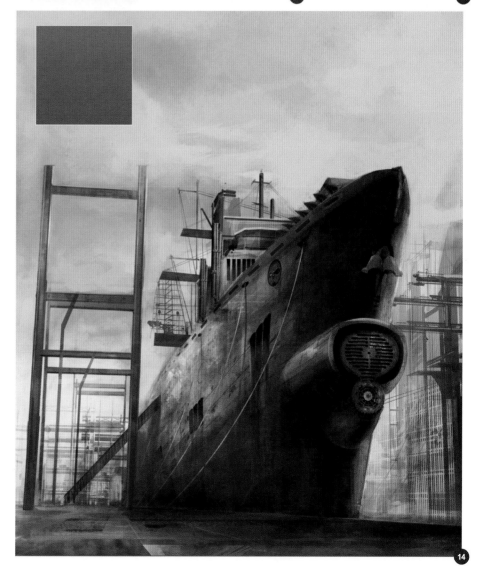

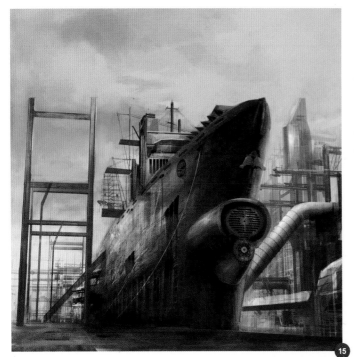
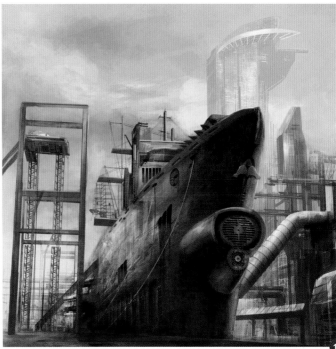

15

16

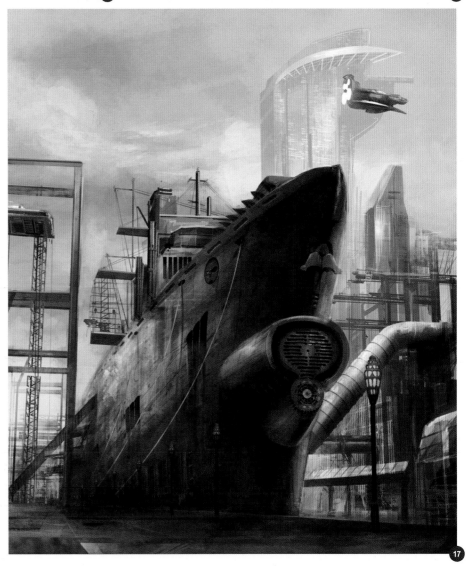

17

Gradient layer set to Overlay using the colors in the small inset upper left. I then used a soft edged eraser to delete certain sections that coincided with the ship.

This area of space above the ship helps balance the composition, which I feel is much better. With this new injection of color I started to build on the level of detail on both the ship and background (**Fig.15**).

I continued adding further refinements to both the background and foreground. Small highlights on some of the ship's details made a big difference overall and the panels along the lower side of the hull were warped to better match the curve (**Fig.16**).

A gigantic building in the background helped add some extra interest along with a spaceship flying over the docks (**Fig.17**).

Some lamps and a character placed in the foreground completed the image, and with a few more embellishments the picture was complete.

You can download the resource image (JPG) file to accompany this tutorial from: **www.3dtotalpublishing. com**.

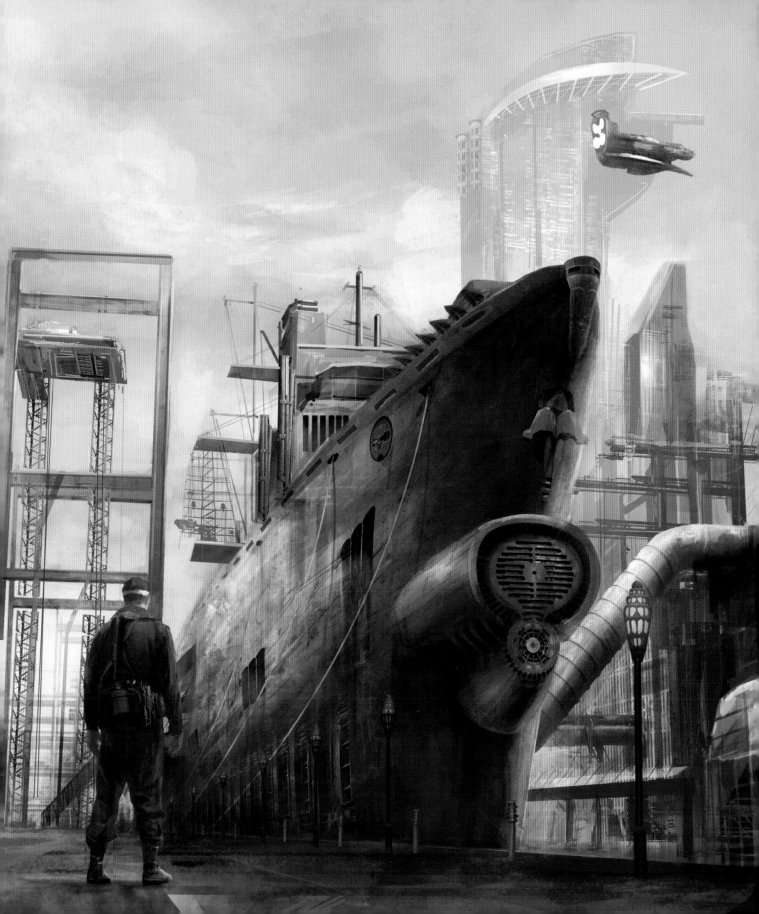

WEALTHY CITY
BY ROBH RUPPEL

SOFTWARE USED: PHOTOSHOP

I always start with a simple abstract composition when developing a sketch. This helps in that if it's not working with a few simple shapes and a few simple values, all the rendering in the world won't save it. This design suggested the possibility of a futuristic city to me (**Fig.01**).

> ## SHOOT YOUR OWN REFERENCES WHEREVER YOU TRAVEL

Next I found a few random images from my photos (shoot your own references wherever you travel) and overlaid them to specific layers. I kept the background and foreground on separate layers so I could link the photo to the foreground shape. That way it only affects that layer. There are several photos and I kept repositioning them until something clicked. I don't usually hit the reference this early, but I was looking for something to suggest itself. Since it's a personal piece it's more fun to see what develops rather than planning it (**Fig.02**).

Now the heavy lifting. I had to establish some larger planes and how they relate to the

> **I OVERLAID SOME MORE PHOTOS TO START MAKING IT LOOK LIKE THE NIGHT SCENE I WAS IMAGINING. YOU MIGHT THINK IT'S "CHEATING" BUT THESE ARE ALL TIPPED IN PERSPECTIVE TO CONFORM TO MY VANISHING POINTS**

horizon/perspective. Photos are merely a start. Without the understanding of perspective and tone you'll always be a slave to your reference, which isn't being an artist (**Fig.03**).

Here are some big changes! I started carving up the larger planes with detail. This was all made up and hand done with a simple round brush (**Fig.04**).

Let there be light! I overlaid some more photos to start making it look like the night scene I was imagining. You might think it's cheating, but these were all tipped in perspective to conform to my vanishing points. You always have to do this because rarely do you get a photo that perfectly conforms to your painting. I used Free Transform and Perspective with the keyboard shortcut cmd + T, which brought up whichever function I needed, with Perspective and Free Transform being the most used (**Fig.05a – b**).

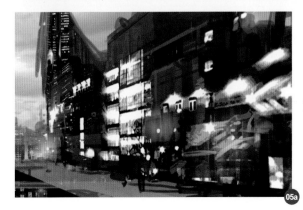

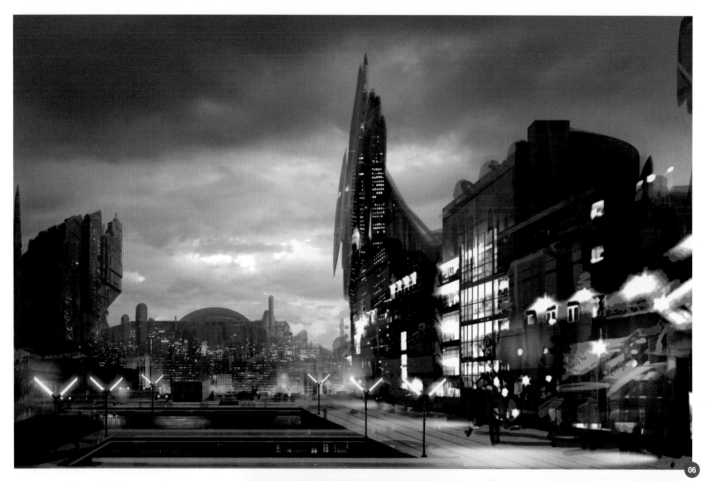

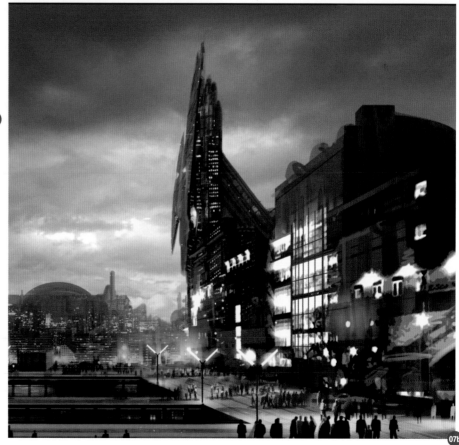

The next step was to clean up some edges and add the street lights for scale. I made one light, duplicated it and then repeated, using Free Transform again for the size and perspective. I also started adding some more complex frames to my lit windows on the right. Again, and I cannot say this enough, the photo will only get you so far. You've got to be an artist and get in there and change it to suit your design! This is the skill that separates the photo collage artists from the rest. Everyone does it, but with the best you can't tell where the reference ends and the overpaint begins (**Fig.06**).

Next I moved on to people. It was always my intention to have people milling about. I made three different custom brushes that I used to quickly populate the ground (**Fig.07a – b**).

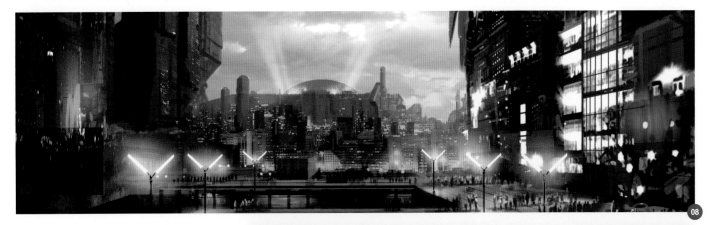

Some subtle lighting emanating from the dome in the distance added a little more "coolness" (**Fig.08**).

I then added more detail to the mid-ground structures on the left. I brought shapes forward, defining slight overhangs and adding lights to the side plane. The image needed all these small touches to bring it to life (**Fig.09**).

The final step was to add a lot more to the lower right structure and some clouds to obscure the tops of the buildings on the left. It wasn't the focal point so a few soft edges would keep the eye from wandering off the page. Signed and done. I considered this a sketch so I only took it this far (**Fig.10**).

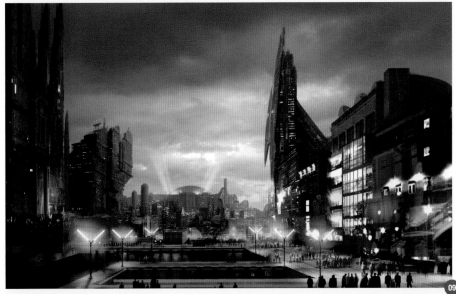

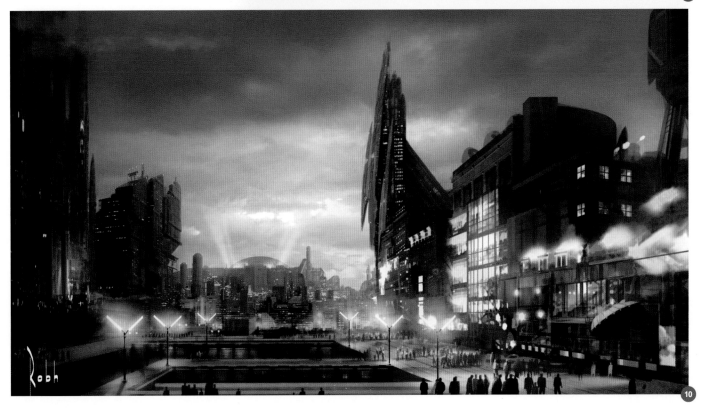

CHAPTER 4

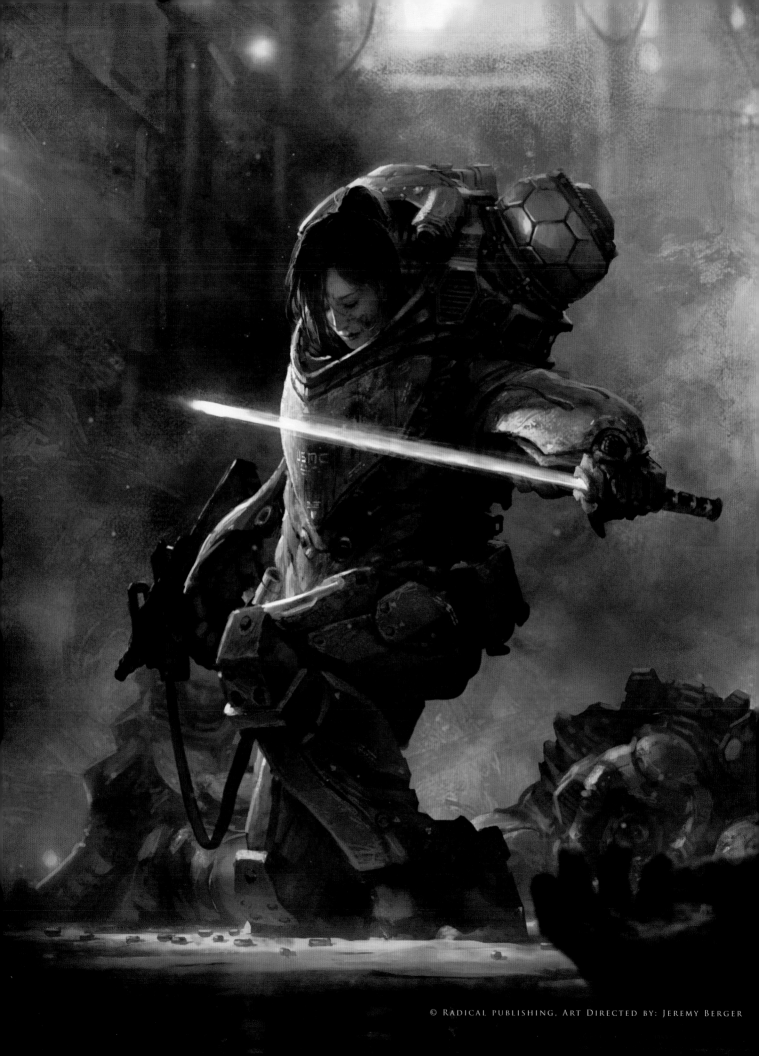

futuristic marines

Futuristic soldiers are a fantastic subject to paint, especially for a military fan. It's also a great way to let your design and innovation shine through, combining existing solutions with your imagination in every accessory, piece of armor and weapon you paint. No matter if you are designing a space marine with cybernetic implants and a plasma rifle, or a more contemporary army man with equipment that reflects current trends in warfare technology – you should remember one thing: military equipment must be useful! It might be simple and minimalistic or ornamental and decorative, but first and foremost it must have a purpose. Just keep that in mind and your futuristic soldier will look more believable

MAREK OKOŃ
omen2501@gmail.com
http://okonart.com/

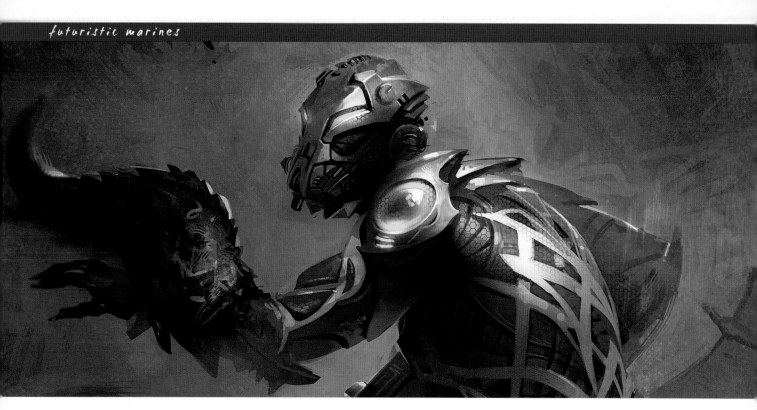

FUTURISTIC MARINE
BY SVETLIN VELINOV

SOFTWARE USED: PHOTOSHOP

INTRODUCTION

Hi. I'm very glad to have this opportunity to develop this idea and show the different stages behind creating a futuristic marine. I hope this tutorial will be useful to everyone and will give helpful advice and knowledge to those who still want to learn and advance in the field of concept art. The purpose of such work is mostly supporting the film and game industries. It makes the work of the concept artist very important because you need the right vision and to create an original product, as this is what makes it successful. The final result is the fruit of the work of many people, but the artist always has an important role and is crucial for the project.

The theme of this tutorial is a futuristic marine. This made me think of a scene with a soldier who is being ambushed by flesh-eating worms.

SKETCH

A serious production requires a lot of preparation before the real creation process starts. Lots of different possible thumbnails are outlined. Positions are sketched; diverse visions and designs are tested. In this case we don't have the necessary time for this step, nor is it the tutorial's purpose.

My first task is to make the concept for the composition clear. I use a Hard brush to build the silhouettes and to compose their elements (**Fig.01**). The masks are chaotic and expressive as, in the beginning, I'm not searching for a distinctive shape or volume – I'm just experimenting (**Fig.02**). When I was a child I enjoyed staring at the textures of flooring and the objects around me. Looking at the structure and the patterns of the stones, the wood and any other surrounding things is

01

a nice way to develop one's imagination. You start seeing interesting shapes and volumes; faces and figures; people and animals. This is why my first task is to chaotically sketch masks and lines until I see a definite shape that could become the frame and structure of the image. Achieving a good end result might be pure coincidence but the satisfaction you can get from using this kind of process is huge, and the development of a character in this way is pretty fun.

02

MAIN COLOR AND LIGHT

This is the stage where the basis of the color is lain down and the light is built up. It is quite a rough version of the final vision of the character. After having built up and structured the composition in grayscale, we define the color range for the illustration on a new layer (**Fig.03**). For this we can use a picture, an old drawing or a texture. We place the selected image above the sketch and from the drop down menu select Blending Property Color. Later we can add or remove colors by using Selection or by moving certain parts to other places, or you can just fill in with the brush. This is the stage where the contrast and the intensity of the colors are set, as well as the light source.

> ❝ AFTER TAKING THE CHARACTER TO A FAIRLY ADVANCED LEVEL, WE MUST DO OUR BEST TO THINK ABOUT HOW WE MIGHT FINISH THE PIECE ❞

COMPLETING THE CONCEPT

Next we're going to develop the character and all the other details, like the weapons and the armor, but this time with color. Actually this process ends when the picture is completed because there's always something to be

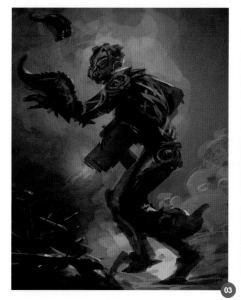

corrected or added to the initial idea (**Fig.04**). The deadlines are quite often very tight in this field. At this stage we set the direction for the further development of the character.

OVER-PAINTING AND RENDERING

After taking the character to a fairly advanced level, we must do our best to think about how we might finish the piece. As we have the luxury of time, we can develop it even more by finishing the main idea and adding the details to the materials. It is now that we have real creative freedom (**Fig.05**).

The details are an important element of completing the character. They are what make

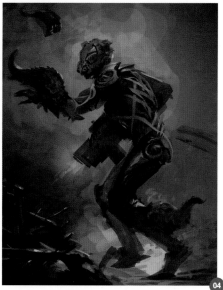

it unique and original. The more original the concept, the better and more successful the end product is. This is what every artist aims for in order to keep at a consistent level that shows quality and ensures the success of the studio, as well as getting the artist larger and more interesting projects.

LIGHTING EFFECTS

When painting futuristic armor it is absolutely necessary to add something that shows how the armor fortifies the character's strength. There must be something that translates the force and abilities it gives in a visual language. As the action takes place in the future, it must show a futuristic level of technology as well. This can be shown by including glowing

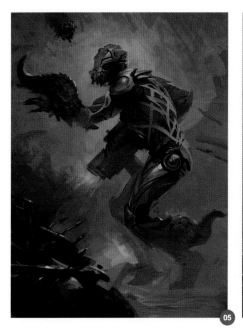

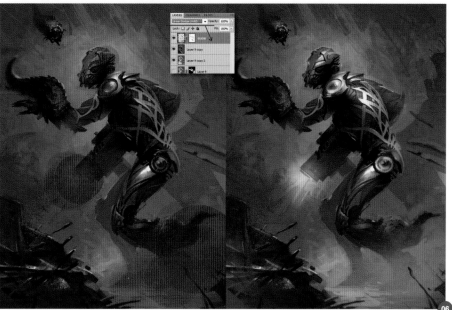

elements to the armor. The typical elements of the armor are now set in place. On a new layer we define the areas where we want to make the glowing effect stronger (**Fig.06**). I've marked these areas in red in order to make it clear how to reach this effect in your own work. We use Gaussian Blur to disperse the light and get the desired glow effect, and finish off by setting the layer to a new blending option (Linear Dodge).

TEXTURE

In order to give a futuristic appearance to the armor, it is necessary to use a texture that reflects a futuristic effect. For this we need to try different materials and underline their structure. We create a new layer and change the blending mode to Linear Dodge. Then

use a Hard brush, which you can select as a "texture" from the Options menu. I've marked the areas where the texture is applied in red in **Fig.07**. After reaching the desired effect we create a layer mask and define the areas where we want to use the pattern.

The second stage is to texture the whole picture, and then finalize it by adding Soft Light to the blending mode of the layer (**Fig.08**).

COLOR CORRECTIONS

The last stage before praising ourselves and finishing the work is the color correction (**Fig.09**). We create a new adjustment layer and use Curves to set the desired corrections (Ctrl + M). Strengthen and define the intensity of the contrast and, for better control over the process, paint in the mask for the layer. This almost ends our work on the concept. The last stage is the artist's signature.

Now we can praise ourselves! The character is complete and developed, and we can move to the next task. For me it is drinking a very cold beer. To those who enjoyed this tutorial, I hope you were inspired and learnt something new. Pleasant drawing!

You can download a custom brush set (PSD) file to accompany this tutorial from: **www.3dtotalpublishing. com** .

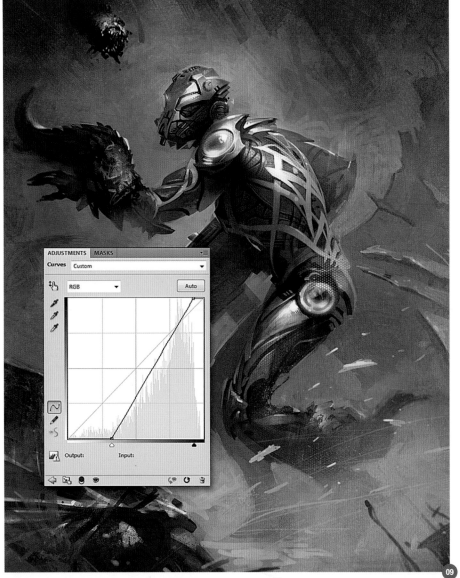

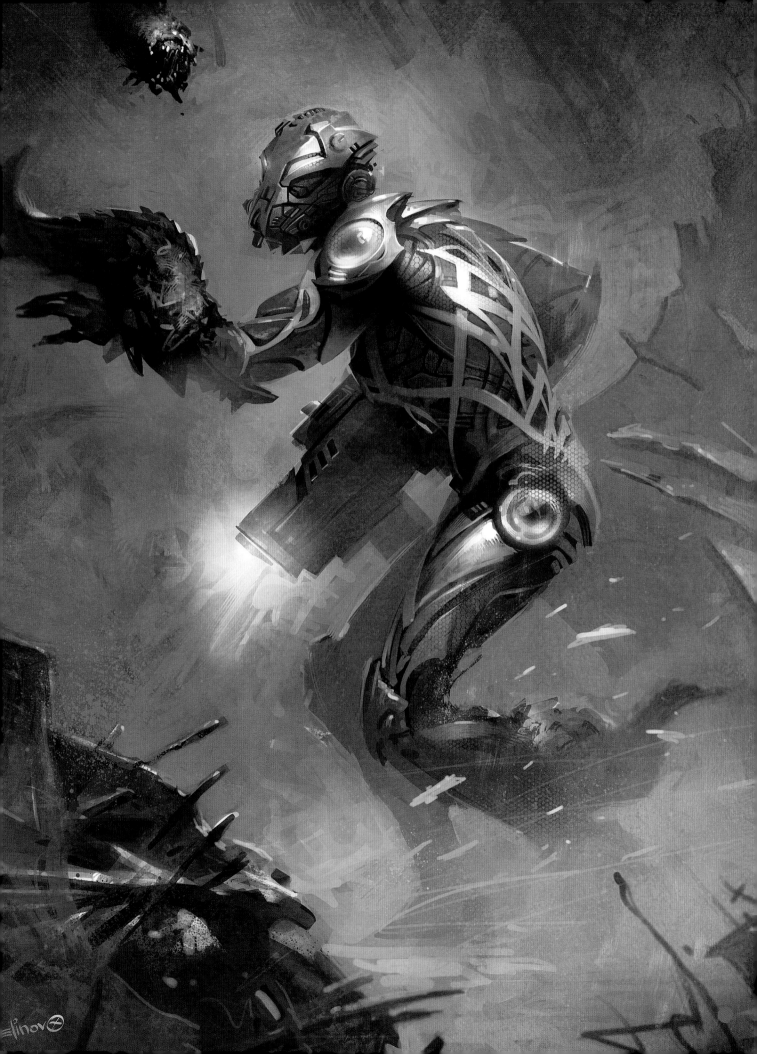

ALL-TERRAIN MARINE
BY RICHARD TILBURY

SOFTWARE USED: PHOTOSHOP

INTRODUCTION

The task for this tutorial was to paint a futuristic marine/soldier, which initially conjured images of bulky, heavy armor typified by certain games such as *Warhammer*, *Starcraft*, *Gears of War* and *Halo*. There are some films that also seem to have established an iconic vision of a space marine, such as *Aliens*, *Starship Troopers* and, of course, *Star Wars* with the classic Stormtrooper. The subject has definitely spawned some memorable designs over the years in both game and film, and has been explored extensively. As such it is hard to extinguish all of this imagery from one's mind when it comes to designing something original.

The first step with any creative task is to research the material and find references. In this instance I typed Space Marine into Google and found all the usual pictures of heavily armored characters. I liked this approach as opposed to one that might look more like a stealthy assassin, such as the *Crysis* character with his nano-suit or Solid Snake from *Metal Gear Solid*. These character designs are very strong, but they seemed too elite and specialised to represent an average soldier of the future.

With this in mind, the main thing I'm going to focus on is the heavy armor and the rest of the design will be established during the painting process.

BLOCKING IN

Start by filling in a background layer with a solid color and then create a new layer in which to block in the character. I'm using a grey blue to begin with, although this is only provisional. **Fig.01** shows the initial block-in

of the character that you should be aiming for, with some loosely painted sections of armor. The design at this point is far from finalized, with this just providing a rough template from which to work. I find that it is easier to experiment on the canvas and explore various ideas as I go along, which often leads to happy accidents. I suppose it is a bit like sketching and painting at the same time, but sometimes the image will suggest a direction to take and give the process a sense of spontaneity. Use a

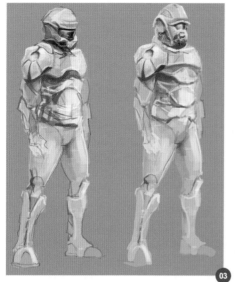

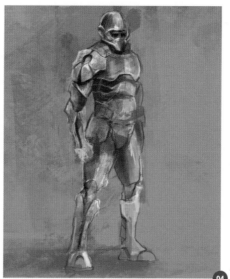

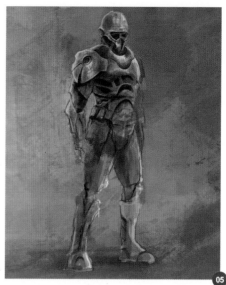

standard Hard Round brush, such as the one shown in **Fig.02**, with just a minimal number of tonal values to add volume.

In **Fig.03** you can see two variations where I've added in some rough shapes and linework to flesh out a general design. At this stage the process is very fluid, incorporating simple strokes to sketch out the main volumes and shapes of the armor.

Fig.04 shows another version with some color added on a separate layer. I prefer to keep the

color on a different layer so that I can change it easily and try different solutions. I usually flatten the layers later on when I have decided on the final palette. For this stage I'm using a custom brush with some texture, but a textured Chalk brush also works well for general use.

The image is looking too monochromatic so let's add some more color across the character. Feel free to use random strokes as these can be tidied up later and once unified will help add some variation to the armor once it is refined. This process of adding in some color variation

will help create a more realistic surface. Also add some highlights along the left side using a bluish hue to help reflect the background and give it a little more drama (**Fig.05**).

DEVELOPING THE DESIGN

At this point it's time to start adding more definition to the character, using the standard Hard Round brush together with a textured brush. Next let's modify the design of both the armor and the helmet – you can see the changes I've made in **Fig.06**.

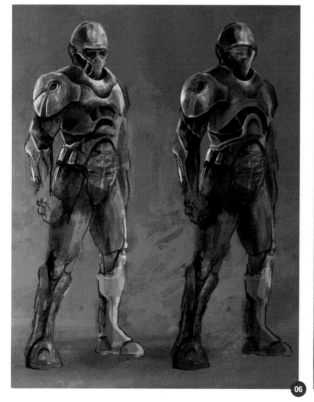

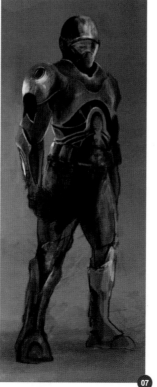

The perspective on the shoulder armor looks incorrect and needs to be altered, particularly on the small hole. The best way to draw this shape is to create an ellipse on a new layer and then rotate and scale it so that the perspective is correct, which is how I've added both this and the ellipse on the chest (**Fig.07**).

When trying to draw any sharp edges the best way is to either use the Pen tool, which is arguably the most accurate method, or alternatively the Polygonal Lasso tool, which is quicker but maybe not quite as flexible. With a selection area you are assured a clean edge when painting and we can use this to get the dark curve across the upper chest.

The helmet and visor look a little uninteresting and more like something a high altitude skydiver would wear. Some of the most memorable head wear that have stuck in my mind are the older gas masks from the 1940s

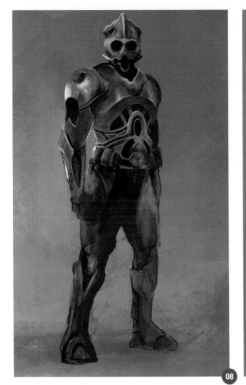

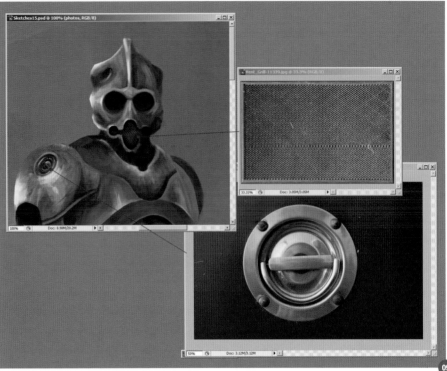

and Roman gladiatorial helmets, so we're going to combine the two, giving the helmet both a futuristic and antique quality.

In **Fig.08** you can see the initial block-in, which adopts the eye shape from a gas mask and the upper part from the Roman helmet.

We're going to look at the texturing next. I'm using some photos from the Industrial and Urban Objects sections in the free library at 3DTotal (**http://freetextures.3dtotal.com/**) so

I would suggest you do the same if you don't already have any appropriate images.

My photo choices can be seen in **Fig.09**. The round cap has been skewed to match the perspective and the vent was scaled down accordingly. Once added in the images need some color correction and a little desaturating. Continue to add some more photographic elements from images – I'm using a picture of an engine, which can be seen in **Fig.10**. To help add some wear and tear to the armor, let's

use another photograph. We could create a similar effect using a custom brush, but as I've already got an appropriate reference to hand, I'm going to use that instead. Once it's pasted into the painting, use the eraser to focus the dirt in certain areas and then desaturate it (left inset). Once you're happy with the composition, change the blending mode to Overlay (right image) (**Fig.11**).

Next create a new layer, call it "highlights" and set this to Vivid Light at 77% opacity. Using a

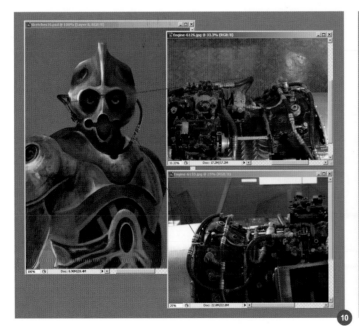

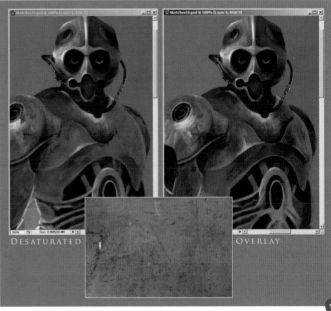

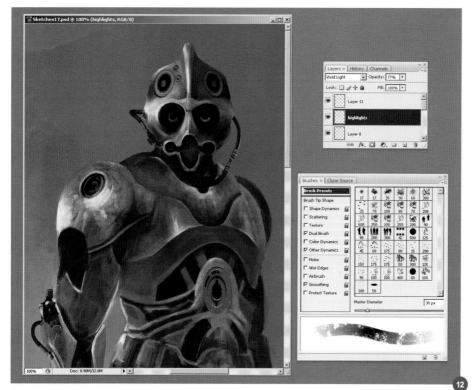

12

13

textured brush paint in some reflections across various parts of the armor (**Fig.12**).

Also modify the layer mentioned in Fig.11 by altering the Color Balance and shifting the slider more towards yellow.

To better show how this highlights layer looks, here is a "before" and "after" image in **Fig.13**. The "before" image is at the top and shows the layer set to Normal mode at 100% opacity using the color seen in the small square. Once the blending mode and opacity have been altered, we have the "after" image, which can be seen underneath.

There are already some highlights painted onto the main layer but with this new layer they have been emphasized and also help add some subtle reflections on those areas facing away from the light. By creating this new layer the highlights can be toned down and controlled independently, which is always useful if you wish to make the armor look more battle worn, for example.

REFINING THE DESIGN
With the helmet alteration, we can now build on what we have so far. Start by making some selection areas using the Elliptical Marquee

tool and then use Edit > Stroke to create some accurate seams across the body armor. Finally we want to use the Rectangular Marquee tool to delete the teeth across the chest torso (**Fig.14**).

To add some further wear and tear, pick a worn metal texture from the 3DTotal texture library and copy this into your file. Use the Warp tool to stretch it across various sections of the body and then set the blending mode

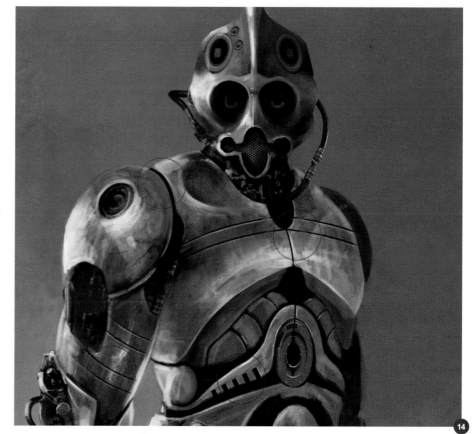

14

to Overlay. Make some color adjustments where appropriate and reduce the saturation somewhat until it matches the color scheme more accurately (**Fig.15**).

On a new layer, paint in some lights within the sections that were erased earlier. To enhance this add an Outer Glow layer style – the

settings and effect of which can be seen in **Fig.16**. You can see how this compares to the other orange sections that are devoid of the same glow.

Two more additional photos that I've sampled to help add more realistic detail can be seen in **Fig.17a – b**. Again these were taken from the

library under a search for aeroplanes, so you should be able to find some equivalent images easily enough.

With some further enhancements and some readjustment to the posture the marine is now complete! In **Fig.18** you can see the final image.

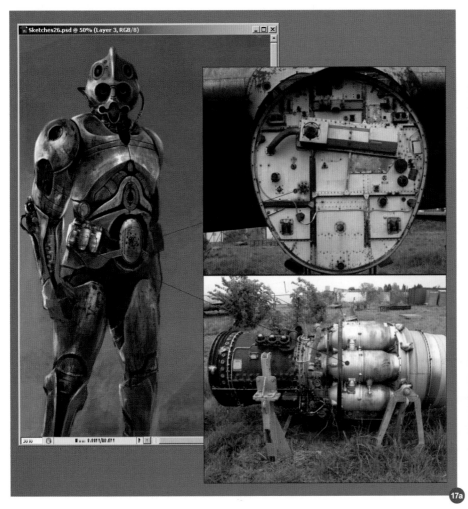

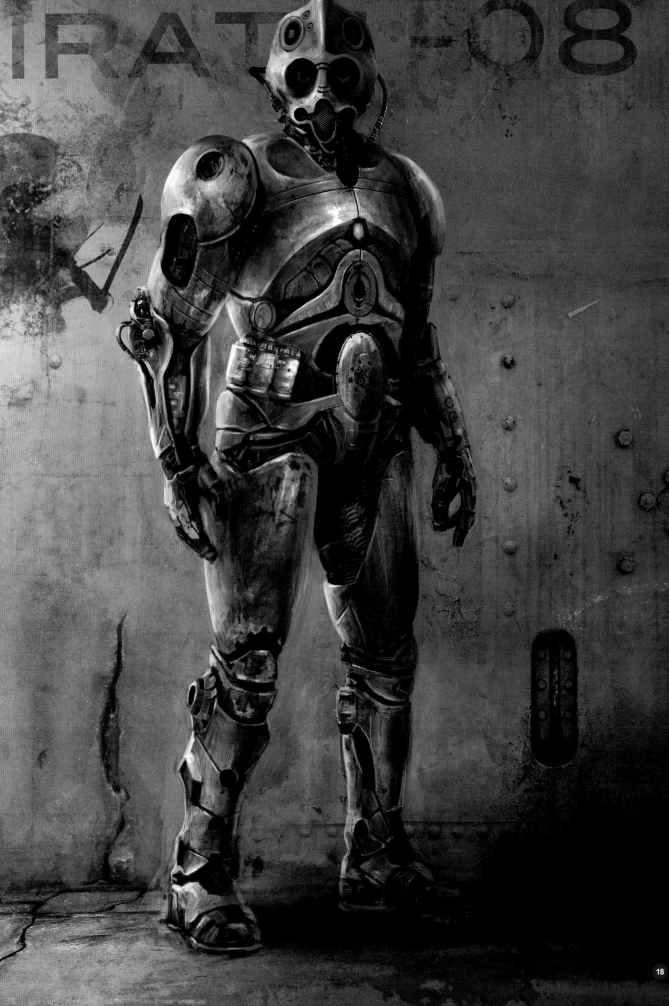

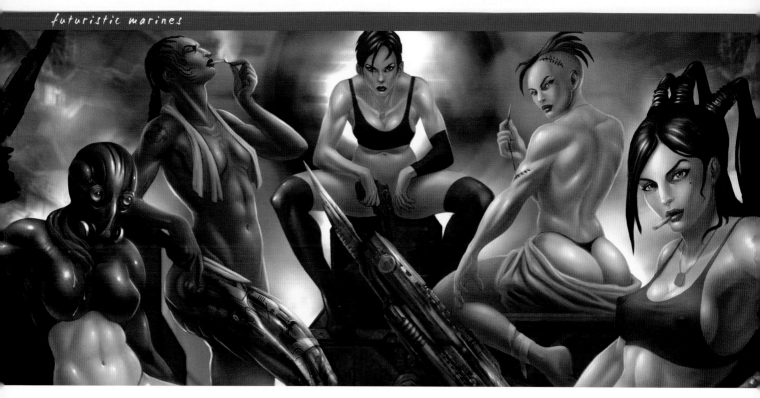

FEMALE MARINES
BY ALEX RUIZ

SOFTWARE USED: PHOTOSHOP

INTRODUCTION

First let me say that it was a pleasure doing this tutorial for the great team over at 3DTotal. Creating a tutorial can sometimes be a very easy thing for an artist, assuming they're creating art that they've done many times before. This was not the case for me on this one!

I was asked to do a tutorial, the theme being "Futuristic Marines". At first I thought, "Cool, I'll just create some badass marines, no problem". Then I saw what the other artists were doing and well, the slightest bit of intimidation set in. Then I thought, "Damn, I better do something real original or else this isn't going to work!"

Thankfully, the gang at 3DTotal let us come up with our own vision of a futuristic marine. So one idea I suggested was, "A badass, post-apocalyptic, super-hot female marine". They loved it, and I loved them for that, because I don't do many finished pieces with females in, so this would certainly give me the opportunity.

This image was to be first and foremost, super sexy! Anatomy was going to play a big part, as I wanted to show as much of it as possible.

As I progressed, I decided on a locker room feel, perhaps a post-battle hangout. But I also wanted it to have a model shoot vibe as well, hence the "posed" poses. I used no references for the females except my trusty male anatomical sculpture (**Fig.01**).

SKETCHES

As with most of the art I do, I create sketches first. Most of the time I sketch right into Photoshop, but this time it was basic pen on paper. There's definitely a freedom in that – no layers, no fancy brushes; just you, one tool,

and your imagination. Since I already know my subject – a badass female marine – it's easy to come up with several ideas. As I'm sketching away, I start thinking maybe I should do two characters, and after some more sketching, I think, "Why not a group of hot badass girls?" (**Fig.02 – 06**).

> CLEANING UP
> A DRAWING IN
> PHOTOSHOP CAN
> TAKE A WHILE AS
> OPPOSED TO DOING
> IT ON PAPER, BUT
> YOU DO HAVE A BIT
> MORE CONTROL

DECIDING ON FINAL SKETCHES

In **Fig.05** you can see the direction I'm taking the piece in. The sketch is not pretty, but at

this point it is all about ideas and the overall concept. It has that locker room feel that I want. It's also a little bit playful and, of course, very sexy!

SCAN AND CLEAN UP

After scanning the drawings in and compiling them, the arduous clean up process begins!

Cleaning up a drawing in Photoshop can take a while as opposed to doing it on paper, but you do have a bit more control. I'm using a regular brush with a tapered edge to do the clean up on all the characters. This is not my usual process, as I like to go right into painting, but I want this tutorial to reveal more of my thought process.

CHAPTER 5

SEPARATION USING LASSO/PATHS

I've got each character separated on their own layer, so I can't compose the image by moving the characters around as I go along. During this process, I'm making paths for the characters as well, to further fine-tune the edges and overall silhouettes. When you make a path, you simply select the image either with the wand or by hand with the Lasso and, in the paths palette, click on Make Work Path from Selection. Once you've done that, you can now edit that path using the Pen tool to refine the path. I'm editing the paths all the way through the painting process so I have precise control over edges and silhouettes (**Fig.07**).

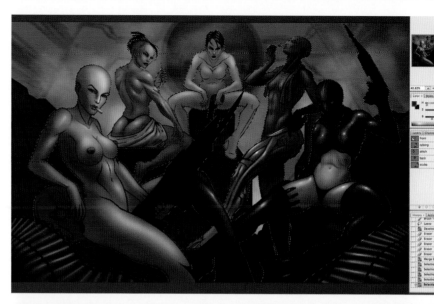

QUICK VALUE STUDIES

When I'm working on a piece, I like to jump ahead using values (black, white, gray) and see how the composition reads. You can find mistakes in your drawings and composition by doing this. This also helps break up the mundane clean up phase (**Fig.08**).

ADDING COLOR

This can simply be done by using Overlay and Soft Light layers over your values. But you want to build up the color, because it can look very fake if you overdo it at the beginning. It's better to start with very low saturation for the base color, and gradually build on it from there (**Fig.09**).

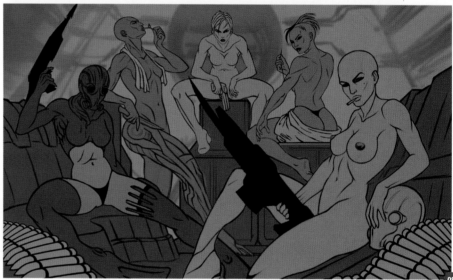

PAINTING/RENDERING FORMS

This is where you take lines and turn them into forms. This is the main difference between drawings and paintings. Both have unique qualities about them, but just because you can do one, doesn't mean you can do the other.

ANATOMY

The one thing I stress to all my students (and myself as well), is that learning anatomy is key to becoming a good artist. It's important to understand where things connect, how they move, and the overall form of the bones, muscles etc. This is the one area that, if you get it wrong, can throw the whole painting off, which is why you have to put the time into taking life drawing classes and studying and copying from books to get to grips with the

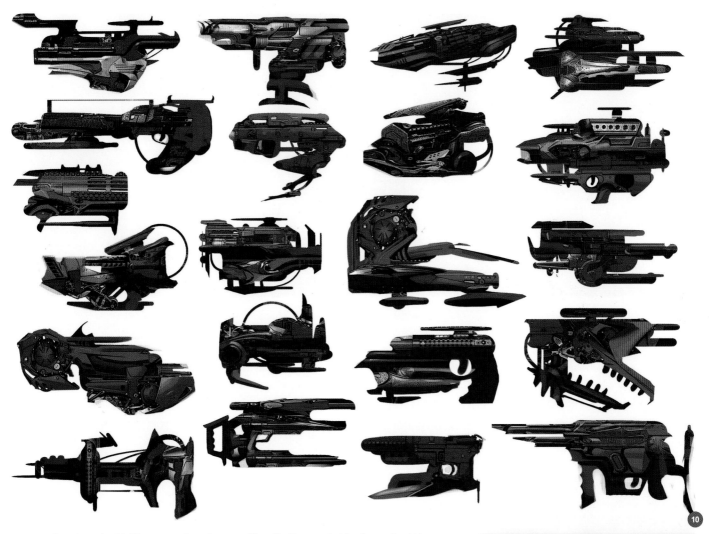

basics. I've always said, "If you can draw the figure well, then you'll be able to draw animals well". From there, creatures and robots will come much, much more easily.

DETAILS

This part of the process can be very fun, assuming you've done most of the hard work! The dog tags are a fun little detail that I have created in a separate file. You can then play around with Drop Shadow effects and Bevel/Emboss effects.

The rifle I've created for the main girl is composed of various machine and weapon photography that I've compiled into a weapon asset sheet (**Fig.10**). You can add the marine tattoos by using a clipart of the standard marine tattoo, and setting the layer blending mode to Overlay (**Fig.11**). I've brought in a few other images of mine to add subtle technology around the image (**Fig.12**). Finally, adding little things like highlights and reflections can really bring a piece to life, so remember to experiment!

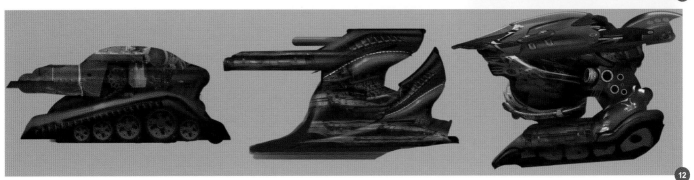

CHAPTER 5

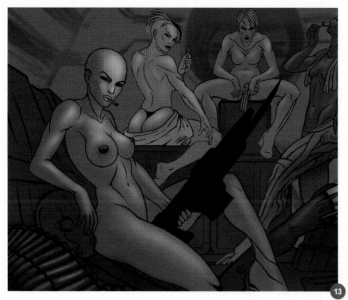

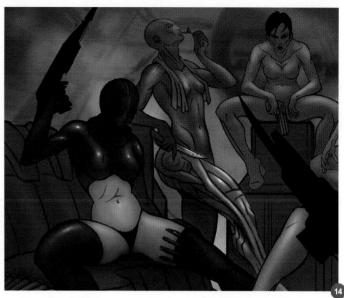

TEXTURES/FINISHING TOUCHES

I'm looking for a subtle "grungy" quality to this, so let's bring in grungy textures and set them to Overlay and Soft Light blending modes, erasing what you don't want (**Fig.12 – 18**).

I've also decided to create an alternate image to make it look like an old vintage postcard, basically by taking it back to grayscale, and adding a subtle sepia tint. This can be done by using adjustment layers, found at the bottom of your layers palette.

CONCLUSION

I had a great time working on this, and as I mentioned before, this image was somewhat unusual for me. Most of my work is very conceptual; the artists I'm most compared to being H.R. Giger and Andrew Jones (which is

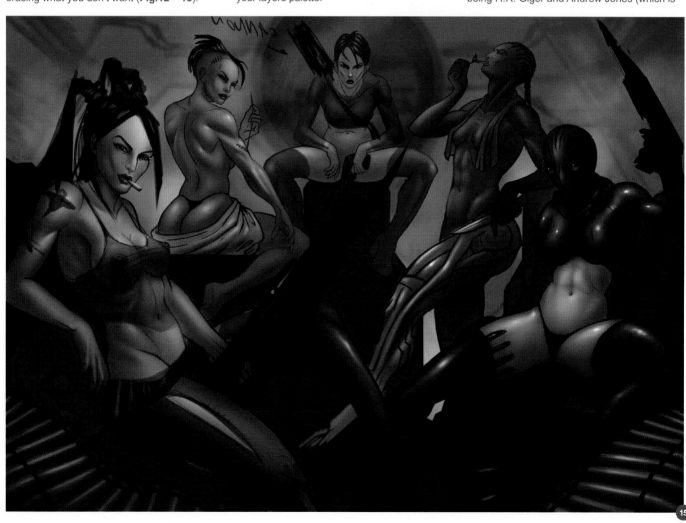

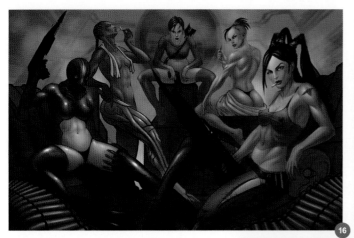

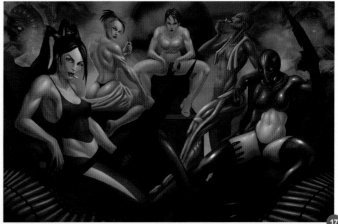

an absolute honor), though we see none of that sensibility here as I wanted to try something different. My point being that you must challenge yourself as an artist, and that means as a human being as well. Try to incorporate new ideas all the time, study things like history, engineering, philosophy and apply some of those concepts in your work. And of course, don't forget to draw sexy ladies from time to time (**Fig.19**).

Now get back to creating art, my friends!

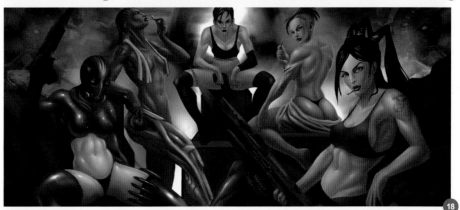

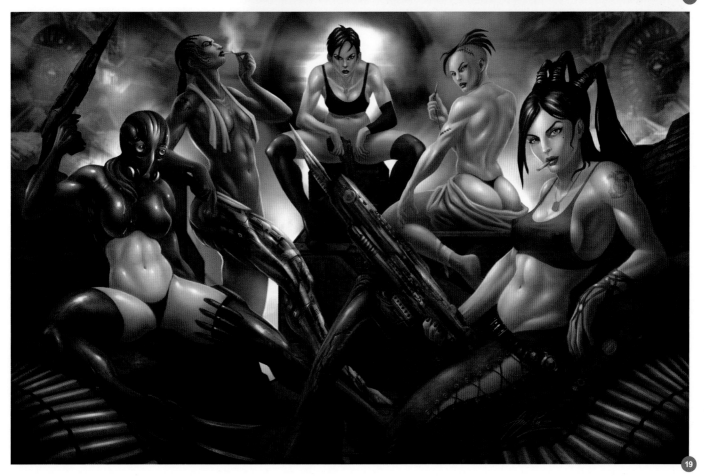

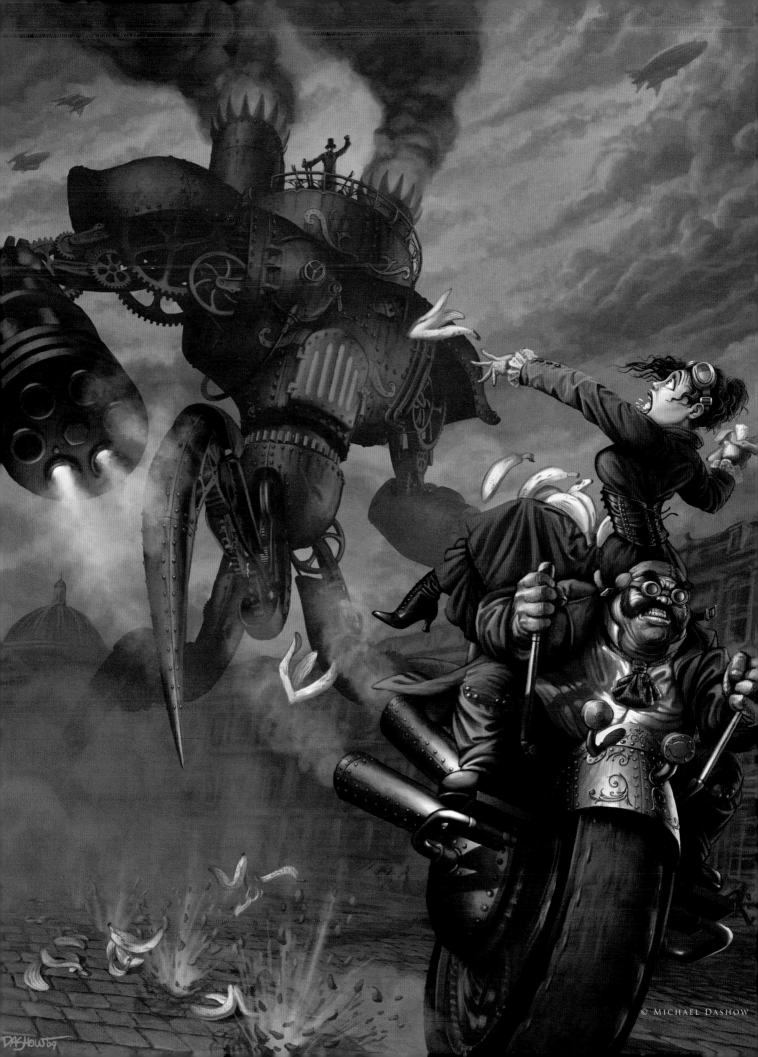

the five ages of steampunk

Steampunk is science fiction as seen through the retrospectacles of the Victorian era. It is an alternate history with a can-do attitude, an age of hope and wonder in which amazing devices could have been hand-crafted by anyone using the technology of the period. For me, steampunk holds a strong appeal due to its wonderful contrasts: genteel manners with a rough-and-ready pioneering spirit; bustles and top hats together with brass goggles and leather; intricate ornamentation combined with worn metal and bolts; amazing robots, walking tanks, and soaring airships driven by the gears and steam power of the past. The juxtaposition of romantic nostalgia with futuristic vision, underscoring the resourcefulness and ingenuity of mankind, makes steampunk incredibly fun to paint.

MICHAEL DASHOW
mdashow@michaeldashow.com
http://www.michaeldashow.com

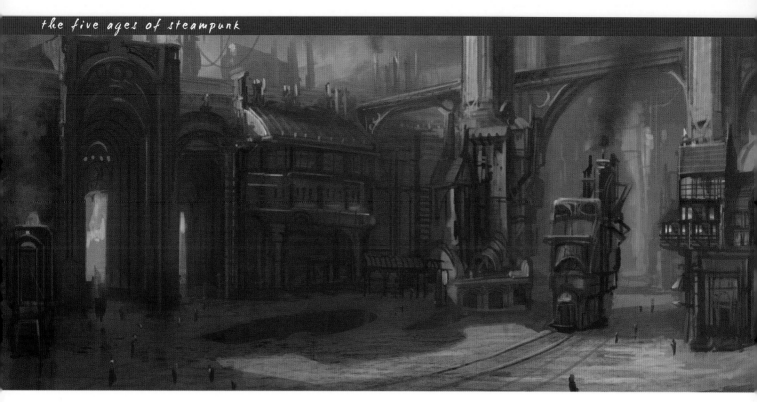

HISTORICAL PERIOD
BY CHEE MING WONG

SOFTWARE USED: PHOTOSHOP

D'TOUR

Over the next few pages, our tour will encompass different eras and themes within the interconnected districts of the Steamworld (D'Inginis , D'Vinci, D'Metronomus and D'Automobilis). The central hub of D'Machinis serves as both the administrative sector and self-contained machine engines of the Steamworld, and it's through here that travel between the districts/transitions occurs, via the convenient and yet unrealized Automobilis public transport system featuring steam trains and various automation.

Thus, let us begin our tour of the arts, science and practical applications of the sub genre of steampunk, via the exploration of the brilliant inventions and great feats of engineering this realm has to offer (and where all things, though improbable, are possible).

ESSENCE OF VICTORIAN STEAMPUNK

On our first stop of the tour, we will be taking a look at the basic transportation manufacture and design that is at the heart of the various districts of the realm. In essence, the main thrust of the Steamworld transport is inspired

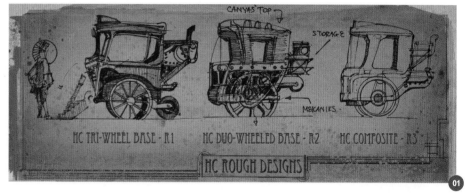

by the discovery, utilization and subsequent daily use of steam technology epitomized by the scientific and global influence of the Neo-Victorians. For here, at the D'Automobilis TCEECT Workshops (The Centre for Extraordinary and Everyday Conventional Transport), we can freely share in the basic principles of steampunk transport design. Victorian England in the 19th century represented the height of a technological and cultural worldwide revolution that helped herald society into the modern age. One of the technological advancements of this time, was the refinement and advancement of steam power in all sorts of mechanical, industrial and scientific endeavours, which helped to improve the overall quality of life of the day.

DESIGN & SKETCH YOUR OWN STEAM TRANSPORT

Now that we have talked briefly about the origin of steampunk, let us consider modifications and improvements that we could make to a conventional horse-drawn carriage to fit this genre.

A good way to approach this is a "mash" approach through which you can think about and explore the design aspects of the horseless carriage. On one hand, over-analyzing the design may produce a stilted design without much exploration and, in contrast, sometimes it is worth exploring the existing design and its variations without worrying about the technical aspects (e.g.,

technological limitations, gameplay, texture budget, VFX budget). After all, the main end objective would be to reach your "high concept" design and then adjust and tailor accordingly for the required situation.

Thus, in that regard one should look at the steampunk genre as an unlimited delightful exercise where the realization of the realms are unbounded.

THE HORSELESS CARRIAGE

So, let us consider the carriage (**Fig.01**). From a visual artistic development point of view, one should initially consider its method of propulsion. Assume for a moment that transport had reached a state whereby the steam engines were sufficiently compact enough to be partly integrated within a carriage. Visually this has positive ramifications and immediately allows us to develop a one or two seater transport carriage that can be equipped with a discreet steam engine, as well as various attachments and paraphernalia to various gears, pistons and belts.

Next consider the functional aesthetics and overall form. With reference to Fig.01, the designer has considered approaching the carriage design with a tri-wheeled and duo-wheeled approach. For access, the operator would enter via a frontal hatchway system which self folds and unfurls ingeniously using slats and hinged joints to provide good reliable access into the carriage. The final phase

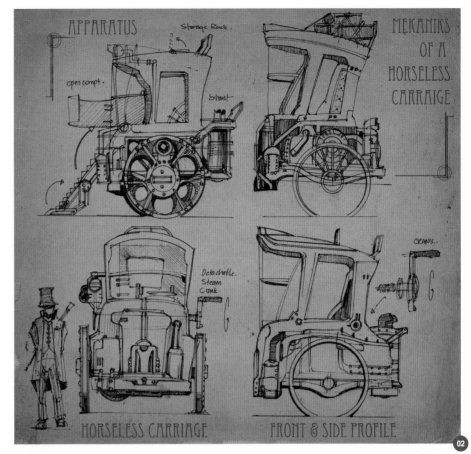

would be to combine the elements that best fit a working design of both, and subsequently experiment using this composite cleaned up design as a base.

Carriage Schematics

Once a clean-line base design is decided upon, the next aspect is to consider how the HC transport design would appear from various angles. These can be achieved via a

set of plan drawings commonly featuring the orthographic front and side views (**Fig.02**).

During this stage there is an opportunity to explore the inner mechanics of a steam engine. This can range from exploring different wheeled spokes, the application of a small fly wheel/gear belt pulley system or even a partial exposure of a miniature boiler/engine system. In addition, exposure of a simple (fishbone) suspension system can help demonstrate its functionality.

Additional details to consider are:

- **Hand Crank**: Once the general shapes were determined, attention was paid to smaller details, such as the use of a detachable hand crank to help start the ignition of a external pressurised starter motor, which would subsequently release a burst of highly pressurised gas into the compact steam boilers.
- **Luggage Rack**: Further thought went into considering a foldaway luggage rack system. Initially, this was located towards the rear of the overall apparatus where

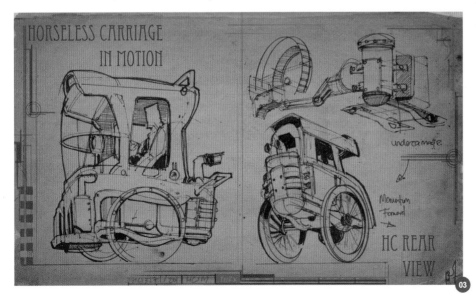

the external boiler and exhaust pipes are housed. Upon the third and fourth trial, it was felt that a roof-based rack system would work better with an overall vertical design.

- **Alarm and Lighting Rig**: To further reflect an unconventional bolted on look, it was felt that a combo Klaxon-Lantern amalgamation mounted asymmetrically towards the side of the carriage would fit well (as opposed to conventional forward mounted lamps).

The Steampunk Look

The thing to appreciate is that a steampunk look works best when there are two or more layered pieces joined together by bolts and rivets. Elements of brass, copper and wood are a marked difference from worked aluminium and steel. Even the type of rivet determines the overall final look.

Up to the 1950s, great sea ships utilized "clench bolts", whereas flushed rivets such as those seen on a WW2 Supermarine Spitfire required skilled training and advanced production techniques, which almost resulted in the cancellation of this 60-year-old legendary fighter. This sort of thing should be considered in your design.

> **THE CARRIAGE IS LIKENED TO A SELF-PROPELLED RICKSHAW, AND THUS WOULD ONLY WORK IF THERE WERE GYROSCOPIC ELEMENTS FACTORED INTO THE EQUATION**

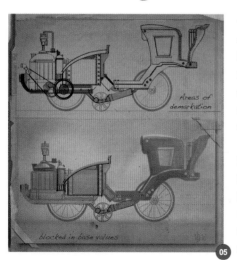

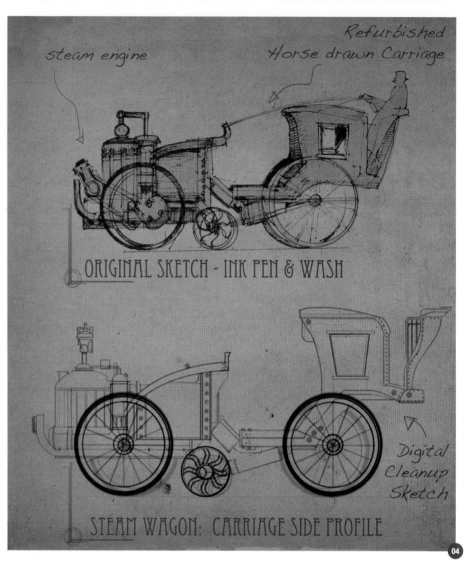

steam engine

Refurbished Horse drawn Carriage

ORIGINAL SKETCH - INK PEN & WASH

Digital Cleanup Sketch

STEAM WAGON: CARRIAGE SIDE PROFILE

Carriage Motion

Once a set of orthographic plans are produced, the next step is to imagine a 3D representation of the vehicle in a 2D drawing (e.g., via a 3/4 perspective view (**Fig.03**). In this instance, the carriage is likened to a self-propelled rickshaw, and thus would only work if there were gyroscopic elements factored into the equation. In contrast, one should also consider how this transport would appear when its resting – perhaps a third rear wheel pops out, or the forward aspect of the transport detaches and provides some rudimentary support and stabilization.

By utilizing a 3/4 perspective view, the designer is able to visualize the design as if it were to be produced as a miniature model or 3D object. In terms of visual troubleshooting, now is an opportune time to explore various functional shapes that may have appeared promising in

a planer/side profile, but may cause various teething issues in a solid 3D form. Lastly, whilst it is useful and commendable to take into consideration all these aspects of rigorous industrial design and functionality, perhaps a fine balance of sufficient believability, aesthetics and functionality offers the best marriage of the trio.

STEAM WAGON
Sketch and Clean-up

Returning once again to the horse and carriage concept, it seems like a good idea to replace the horse with a steam horse (**Fig.04**). The initial ink sketch features a carriage piloted by a driver sitting high at the rear. In contrast to the horseless carriage approach, this concept features a wagon that has no combustion/mechanical aspects and in all intents and purposes is merely a simple carriage. This is linked to a small compact steam engine

consisting of a boiler, piping and exposed gear shafts/pulleys and belts. A mid set of support iron wheels are attached in the middle to add more stability and fine control. These are relayed via a set of pulleys and controls that allow the driver in the rear to manoeuvre properly. Subsequently the initial impetus of these designs is used as a template to provide a clean line sketch.

Work-up

The clean-line sketch of the steam wagon is utilized as a base from which to work it up further. In this instance, we will only focus on a side profile version. These can be blocked out to accentuate areas of volume (**Fig.05**). This allows you to focus on the textural aspect of the materials. For example, a transport that utilizes wood and metal can expect to have a level of matte finish and specularity. Being able to denote and show these material differences (e.g., leather, polished wood, exposed steel, riveted boilers) using just pure values can often be a challenge and offer a high value concept from which to derive other designs.

Values

The next challenge is to transform a line drawing into a semi 3D image using just pure grayscale values (**Fig.06**). Popular car magazines can help with regards to lighting approaches – and, quite simplistically, a top down lighting situation is often sufficient to provide some believability in a side profile view.

Additional Design Elements

To continue the aspect of believability, the designer can add further design elements such as an exposed steering system.

Touch-up

Once the general lighting issues are sorted, the final aspect to consider is improving readability, bounced lighting, and material texture and feel (**Fig.07**). This image should serve as a good starting sketch from which to work up a more refined painting/illustration at a later junction.

STEAMPUNK REFERENCE: VISUAL ART DIRECTION

This next segment deals with visual art direction and reference. A good artist and illustrator should have a reasonably well-

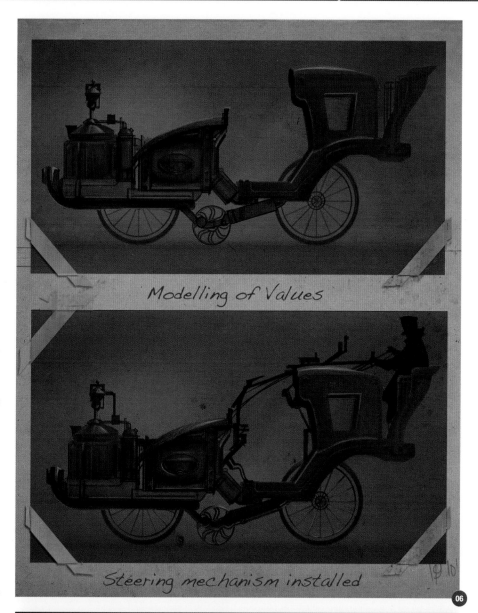

Modelling of Values

Steering mechanism installed

06

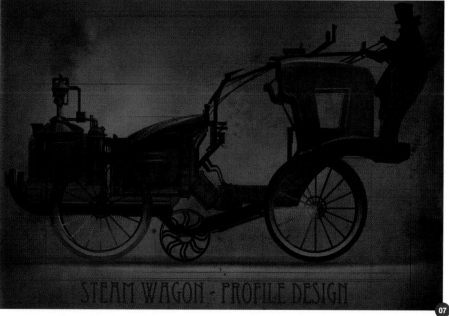

STEAM WAGON - PROFILE DESIGN

07

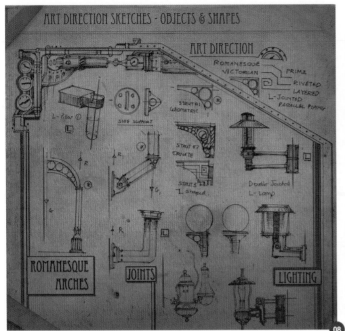

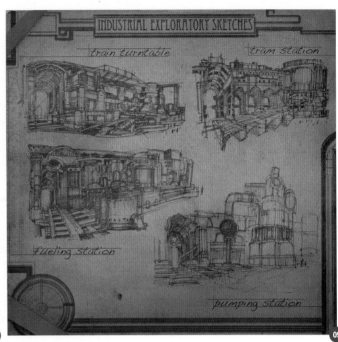

developed methodology of collecting, classifying, analyzing and applying references. Well, you would expect at least the more successful artists to have developed a coherent system to help bring realism and authenticity into their work.

VICTORIAN-ESQUE

To develop a steampunk universe, you should set about analyzing and collecting various bits, aspects and forms from the Victorian period (**Fig.08**). These tend to comprise of jointed shapes featuring L or D shapes (perpendicular 90 degree joints). These can subsequently be applied on lighting, joins, geometrical supports and arches. A lot of the characteristics of British arches are left over from the Romanesque period. Unlike Europe, which tends to favor a more Gothic and Art Deco/Nouveau styling.

Industrial Exploratory Sketches

Applying this approach, one can explore various elements of construction as simple, small thumbnails – featuring basic composition, readability and layering of objects. In this instance, these sketches feature elements of a train turntable, tram and fuelling station, and a pumping station (**Fig.09**). We will later apply these sketches in a pen and ink wash collage.

Townhouse Exploratory Sketches

Lastly, we can zoom in and consider the more minute aspects of a set of buildings

> ## ONE CAN EXPLORE VARIOUS ELEMENTS OF CONSTRUCTION AS SMALL THUMBNAILS – FEATURING BASIC COMPOSITION, READABILITY AND LAYERING OF OBJECTS

by considering a building, for example a townhouse (**Fig.10**). On the far left are various elements of Victorian townhouses such as a Romanesque doorway, window and triple-storied flat. Extrapolating this one can outline the overall form and accentuate this further to create your own unique steampunk townhouses at will.

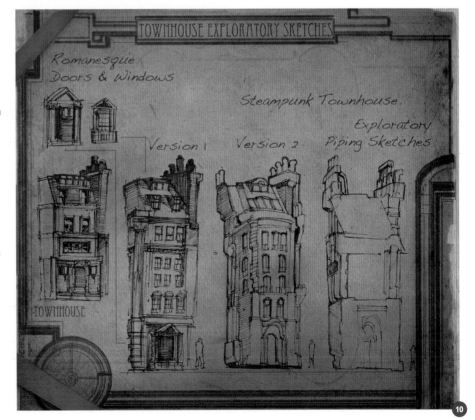

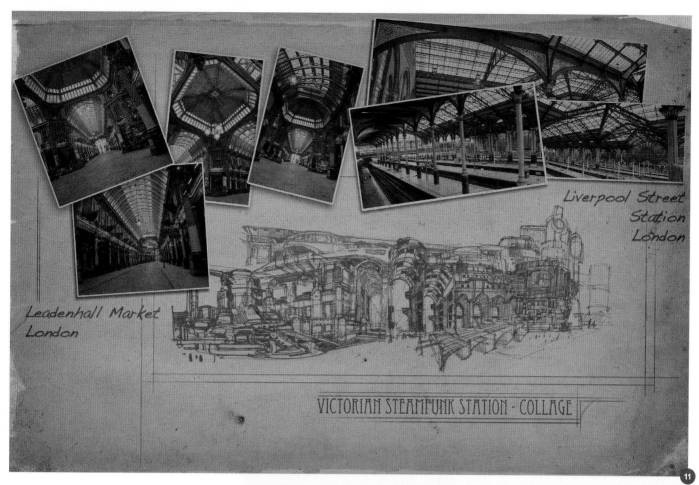

Leadenhall Market
London

Liverpool Street
Station
London

VICTORIAN STEAMPUNK STATION - COLLAGE

11

D'AUTOMOBILIS TRANSIT CENTRE: INK AND WASH

Collage

In this last segment of the tour, we will look at a quick digital ink and wash approach towards our onsite sketching of various steampunk buildings. (**Fig.11**) By amalgamating the various sketches and unifying the various vanishing points into an overall whole, this can provide a rapid and satisfying collage of sketch work provided as a joint sketch collage.

As an accompaniment, various photograph depictions from old market halls and rail stations in Victorian London are researched to provide a believable reference point.

Digital Wash

Upon completion of the sketch collage, the next step is to apply a weak unifying wash (**Fig.12**). This allows you to explore various shapes and structures with similar values and distances from the viewer. Areas and foreground objects that may have potential core shadows can also be marked out (**Fig.13**).

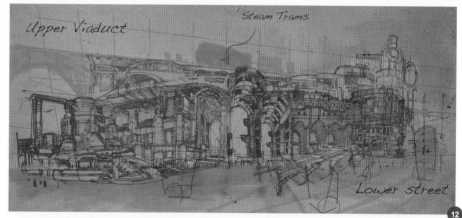

Upper Viaduct

'Steam Trams

Lower street

12

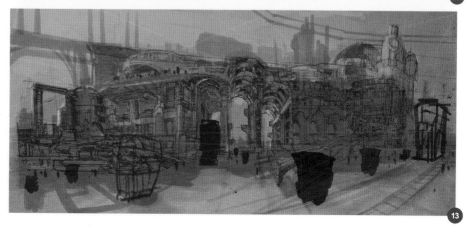

13

Background Plate

For this particular image we can now work in a methodical fashion starting from back to front. We can firstly work out the main color of the image, which features warm yellow clouds on a backdrop of gray/blue ambient skies. This particular approach will allow us to paint against the daylight as favored by plein air artists when sketching/painting (**Fig.14**).

BLOCK IN AND WASH

The next step is to bring these separate images together in a layered format, whilst observing the various value relationships of one another (**Fig.15**). I started by constructing a multi-arched viaduct in the rear. This was then followed by the mid-ground elements of central arched buildings and foreground elements. The various elements are separated onto different layers to be composited together. However, when you do this there is a problem that tends to occur – namely, the overall image may become too diluted or overwhelmed by the various separate elements. A quick composite of the various elements proves that the overall composition is flawed in terms of composition, elements and rendering (**Fig.16**). When you come to a point like this you have to decide on the next course of action.

Murder or Persevere

About one and a half hours later, there are just too many issues to tackle. It would be far better for me to choose the "murder" approach.

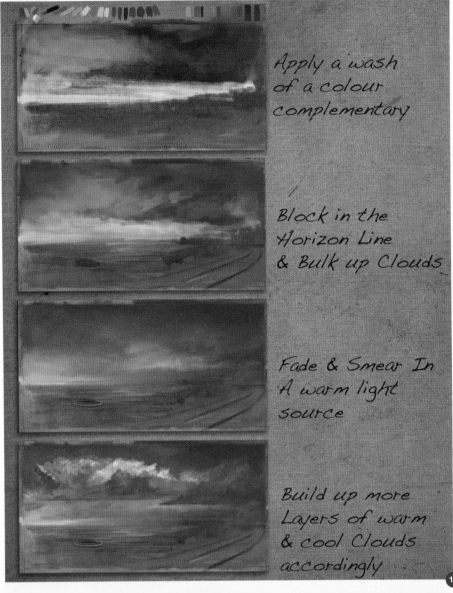

Apply a wash of a colour complementary

Block in the Horizon Line & Bulk up Clouds

Fade & Smear In A warm light source

Build up more Layers of warm & cool Clouds accordingly

14

15

In that regard, the Crop tool can be a handy aid, allowing us to split the overall image into a portrait view (A) or landscape (B).

It is these decisions and being able to develop various strategies that is one of the everyday challenges facing an artist and illustrator. Even the best laid plans may have to be abandoned for a simpler approach sometimes. Ultimately I opt for the landscape format of B, which allows for a more intimate crop that focuses on the buildings, town and transport.

END OF D'AUTOMOBILIS TOUR

Welcome back to the D'Automobilis transit centre and I hope you have enjoyed our brief tour of the steam transport design workshop.

You can download a document (TXT) file to accompany this tutorial with handy references from: **www.3dtotalpublishing. com**.

16

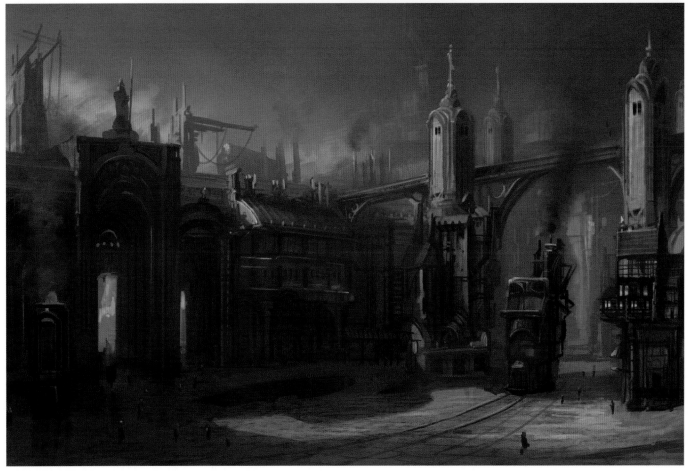

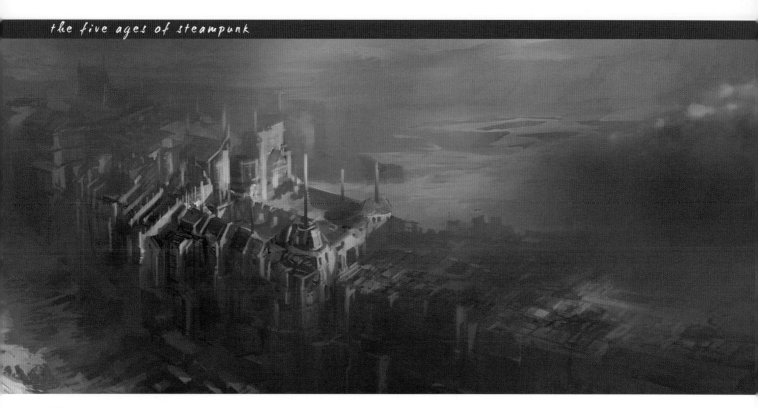

TRANSPORTATION
BY CHEE MING WONG

SOFTWARE USED: PHOTOSHOP

D'TOUR

In the first leg of the tour we started within the Victorian Era of D'Automobilis, where we had the opportunity to briefly discover how transport became the mainstream thrust of the Brittanic Victorians, starting with the steam engine. Our tour also looked into designing and developing steampunk transport and environments using a themed period as a starting basis.

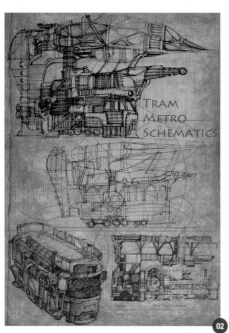

D'VINCI: ESSENCE OF RENAISSANCE/MIDDLE AGED STEAMPUNK

Returning to the Transit Centre where central public transportation is governed, we discover the tram metro responsible for our next leg of the journey, which is still being retrofitted with the appropriate apparatus to enter and co-exist within the D'Vinci realm.

In **Fig.01** the tram metro is being retrofitted with D'Vincian equipment and Renaissance technology, vital for the safety of inter-realm travel whilst travellers adjourn to the nearby café. The physical and inter-realm energies of each era are entirely unique, and thus require careful measurement, calibration and maintenance via the vast might of the engines of the central administrative hub of D'Machinis. Thus, without the right outfitting and maintenance of the tram metros, our tour may veer off course or even overshoot into the inter-realms of the physical worlds, resulting in malfunctioning of the steampunk technology, or even worse, being marooned to a indeterminable existence. In **Fig.02** we

can see the schematics for the tram metro, showing its various modes of deconstruction and retrofitting.

Apologies dear ladies and kind sirs whilst we adjourn for tea in the nearby Transit Café, to allow for the completion of the retrofitting. Meanwhile, one of our plein air artists has taken the opportunity to produce a rapid sketch for completion at a later juncture.

JOURNEY TO D'VINCI
Finally, our tour has taken off safely via the Transit Arch, towards the mountainous village of D'Vinci. For it is here that all the brilliant advances in astronomy, mining, sail barges, noble gasses and so forth were pioneered.

I forget to add that on occasion strange elemental hazards of nature do visit this strange village in the mountains. It is not unusual to have both a beautiful verdant spring morn, followed by hail and snow at noon that rapidly melts into a warm summer rain and ends with a perfect golden glaze of sundown, and sometimes all of the above in a flash. We can see in **Fig.03** a value sketch of the

approach to D'Vinci produced in sepia washes featuring the vast looming relic that both serves as a haven for D'Vinci engineers, the power source of its amazing technologies and natural aberration of its local weather and more unusual levi-stone properties.

TRAM RETROFITTING
During our short break within the town of D'Vinci, one of the artists has just completed

a painting consisting of the scene at the tram metro. Thus, we have time to share a brief dissection of the painting produced. In **Fig.04** we can see a sketch of the tram metro being worked up into a full painting.

EN PLEIN AIR
En plein air is a French expression, meaning "in open air", which is used to denote the study of light and shadow on location. It was a

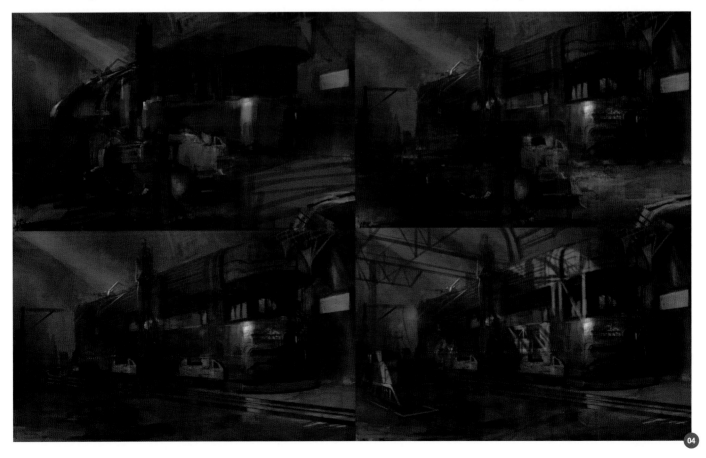

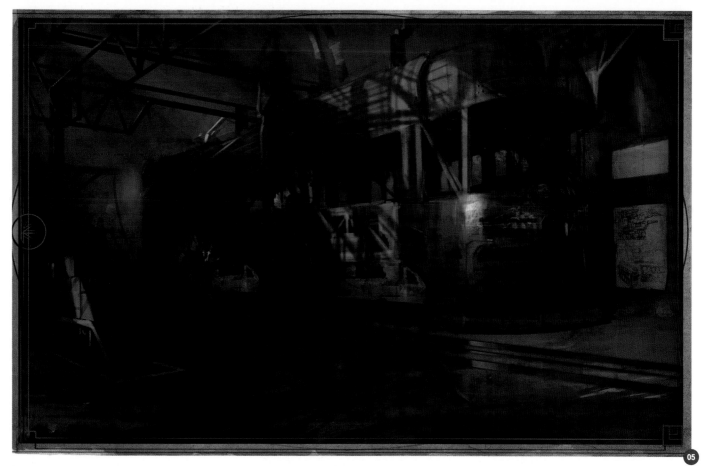

05

revolutionary art style utilized by 19th century Realists to Impressionists. They believed that rather than relying on various formulas, you should trust your own eyes and paint what you see and perceive from life. Thus, for environment and landscape artists, this practise of studying from life is fundamental in evolving and growing as an artist, as well as painting with light. With reference to the image, the painting can be distilled into a four part process:

> ## THE FIRST STEP IS TO REARRANGE THE VARIOUS ELEMENTS INTO A COMPOSITION WHICH WILL BOTH ATTRACT AND APPEAL TO THE INNATE SENSIBILITIES OF THE VIEWER

• **Block-in**: The initial image comprises of main tones and shapes worked into a plein air sketch. Diffuse lighting and various bits

of machinery are seen throughout and all the key features of the subject matter should be noted. A rapid 30-40 minute color sketch such as this is sufficient (with additional linework/information such as that gleaned from the tram metro schematics – see Fig.02).

• **Arrangement**: Once within a studio (or a quiet area to work) environment, the first step is to rearrange the various elements into a composition which will both attract and appeal to the innate sensibilities of the viewer. The diffuse lighting is strengthened to provide focal direction whilst still retaining the soft overall ambience. In addition, various objects within the scene can be grouped and arranged in a complementary manner.

• **Setting**: Sometimes to complete a painting, one needs to remove all foreground objects to paint various elements in the background and to consolidate the overall design. In this case, various wheel and brake clamps are implemented onto the transport and elements of a oil spillage can help gel the horizontal plane. Rail tracks are also

implemented (featuring a middle track for electrical conduits in areas utilizing/ receiving electrical power sources).

• **Completion**: The painting is finalized with diffuse lighting and atmosphere, as well as various crates and cargo being loaded whilst bands of light and shadows are cast across the transport. This helps to provide contrast and relief, thus accentuating the transport's overall form as it is retrofitted with technology suitable for its onward journey (**Fig.05**).

Visual Art Direction

In the development of the D'Vinci township, various options and approaches come to mind. As such, for the sake of brevity we will cover three approaches towards building a believable fictional ecosystem by covering life in a medieval town, textural building materials and constructional methods, sketch work and ending with a map view to help aid in its development. It is via these various steps that a richer visual asset for film, animation and games can be approached.

VILLAGE OF D'VINCI - CREATING YOUR OWN VILLAGE

As a designer responsible for the inter-realms of Steamworld, often the various realms grow and expand with the linear progression of time. As such, there is a need to step in as town architect/builder and manager.

Well, you are in luck. It just so happens that at this very moment the town folk of D'Vinci are in need of a new expansion in the area earmarked for expansion within the empty areas of the D'Vincian map. Various town builders and residents are in favour of a new sister township. Thus, let us visit the Guild of Architects to help oversee the necessary ingredients of building a successful town.

D'TOWN RECIPE

- **Ingredients**: Town Hall, Village Square, Central Water Reservoir, General Goods store, Transport Centre.
- **Additional Ingredients**: Bakery, Tannery, Inn/Pub, Hopper, Blacksmith, Armory.

VIEW OVER TRAFALGAR SQUARE
NATIONAL PORTRAIT GALLERY
LONDON

06

GUILDHALL, LONDON

07

STONEWORK

08

- **Resource Points**: Sawmill, Watermill, Windmill, Ore Mine and Refinery.
- **Alternate Local transportation**: Airways, Waterways, Pneumatics.

Over at the local Guild of Architects, within the Department of Logistics and Access Ways is a local master mason/builder. He explains that the main architect is away on travels at present and any help with the half finished plans would be much appreciated and ably executed by his team of assistants and master builders.

Using such a basis, one can approach the construction and development/layout of a city/township as a living/breathing ecosystem rather than one or two unique art assets. As such, this will help the artist develop an integrated and functional living space that can be especially useful for level design within games and augmented in reality developments.

VISUAL DIRECTION: STYLE AND MATERIALS

D'Vinci is a fictional blend of medieval/high renaissance. As such, one approach is to perhaps look at existing architecture and re-imagine such time periods within an alternative setting.

We will start with a look at rooftops. This often forgotten element of a township/city is the quintessential character of any medieval township as the overall forms and shapes seen from within and without form the overall horizon and landscape when approaching a township. In **Fig.06** you can see a study of various rooftops at Trafalgar Square, London.

Another approach is to consider the primary function of medieval life. Such time periods often consist of main central areas of worship and congregation such a town guildhall, cathedral/church or town square interspersed with various allotments for housing. We can see some of the main shapes and forms of medieval D'Vinci in **Fig.07**.

In addition, one needs to consider the building materials used for such buildings/constructions

TOWNHOUSES

09

SIDE VIEW
ELEVATION
SKETCH

GRAN CATHEDRAL
TOWN OF D'VINCI

10

– a mixture of stone, recovered wooden ship timbers, slate, granite, decorated marble and stone. Take, for example, the use of stone. This can often be quite varied, especially where such stone cladding is more decorative than functional, which tends to be more limited by regional and transportational limitations (**Fig.08**).

Larger constructions such as fortresses and administrative constructs can often go to great lengths to obtain rare soap stones, decorated marble/granite/stone relief panelling and exotic woods/materials to cater towards the more extravagant and lavish tastes of a region's ruler or administrator.

> "ONE HAS TO RECALL THAT FOLKS IN ANCIENT TIMES WERE MUCH SHORTER AND SMALLER THAN OUR CURRENT MODERN WEIGHTS/SIZES"

BRIDGE
TO
D'METRO
NOMUS

PORT OF D'VINCI

11

DESIGN: SKETCHING MEDIEVAL LIFE

The next aspect of developing and designing a township is to imagine life within a medieval (steampunk) township.

Using **Fig.09** as a main reference point, of particular interest are various bridges and connections between townhouses within a medieval town. Notice how narrow the alleyway appears to be; in ancient times such a passage would be the norm as the main street (whereas in Roman times, the main road would be foursquare the size and width of the alley above). For even narrower back alleys, imagine more congested and narrower alleys 1/4th the size of the alley depicted above (often around 5-7 feet in width). One has to recall that folks in ancient times were much shorter and smaller than our current modern weights/sizes.

The next aspect Is to perhaps explore the main areas of congregation, such as a place of worship. As such, let us re-imagine the grand cathedral of D'Vinci (**Fig.10**). For this

section, blending Romanesque roofs and pillars, interspersed with grand statues and Gothic arches, helps provide a larger than life sensation whilst the inhabitants walk up these elaborate stairways – filling them with awe, piety, humility and reverence.

From the elaborate grand buildings, let us next re-imagine utilitarian areas such as the port of D'Vinci (**Fig.11**). For such an area, a good aspect to explore would be the various buildings and materials used in their construction. In addition, let us imagine that this port had to be built towards a reclining topography. Townhouses would tend to be narrow, with tall townhouses with two to three levels, high ceilings and elaborate frontages for the more well to do. Stone bases and slate roofs are the norm, often using local resources and materials. In addition, recovered ship timbers are incorporated within the various roofs and we will explore this element further.

Imagine that the industrious builders of D'Vinci can often be short of local resources. However,

what is available in large abundance are various ships that are too heavily damaged, or shipwrecks that have been recovered within the region. Thus it is a simple progression to sketch and develop housing and transport designs built purely from the hulls of ancient ships and wrecks (**Fig.12**).

In this instance, we can conveniently utilize the main hull of a small trading ship for the roofing of a mill workshop and construct it from steel, stone and recovered ship timbers. In addition, a small black iron reinforced forge is attached and therefore, should be well built and ventilated.

Lastly, let us incorporate all these elements into a simple town sketch down the main street (**Fig.13**). The view includes a look out onto the various rooftops, ship-hulled buildings and tall narrow townhouses that can serve as a template for future paintings.

AERIAL VIEWS

The best and simplest way to build a city is perhaps by drawing a plain old map. Many successful and well loved stories involve a crude map from which a grand epic world begins and serves as a base for lost treasure, high adventure, dark fantasy and epic greatness. In the beginning, there was the map, and from this map grew a city. And so on.

One thing that often features prominently in fantasy novels and games of yore is the world

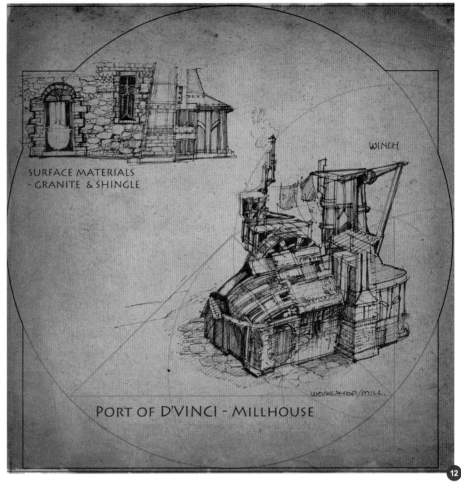

SURFACE MATERIALS – GRANITE & SHINGLE

WINCH

WORKSHOP/MILL

PORT OF D'VINCI - MILLHOUSE

map. If you had to develop your own world, it is probably both logical and prudent to start by laying out the key areas of interest and prominence on a map, followed by any gaps in between them that are occupied by secondary and tertiary structures, and a hodgepodge of filler inhabitations in between.

If you look at any old world city in the current day, the layout of streets and squares and buildings may not have any coherent structure at first glance. However, there will be a logical practical basis underneath. Inhabitants build for absolute practicality and convenience. Therefore most farmsteads would have logs stacked within easy reach, but not next to a fire hearth as this would be dangerous. Also a consideration is where to site stables, livestock and such; their locations would be dictated by practical considerations, experience and even previous accidents.

The location of townhouses and streets were often dictated by allotments and located near local watering holes and wells. How well off one was in society determined various other considerations such as decorations, stronger robust construction materials, and so forth.

HISTORY: D'VINCI EARLY-MID PERIOD

The preliminary steps are best explored by sketching out how such a township could

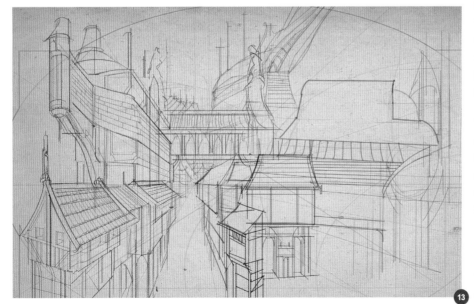

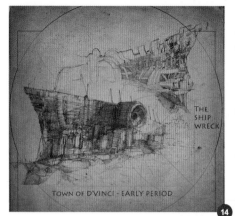

THE SHIP WRECK

TOWN OF D'VINCI - EARLY PERIOD

14

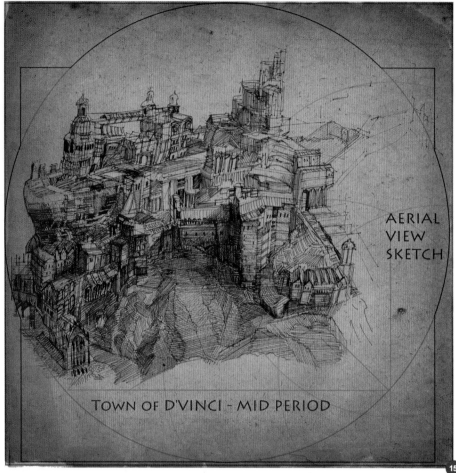

AERIAL VIEW SKETCH

TOWN OF D'VINCI - MID PERIOD

15

have evolved. These can be rapid sketches with ink and quill (or pen) on various pieces of parchment.

In the realm of D'Vinci, it was originally said that the first inhabitants espied this relic from ancient times and decided to build an abode upon it. Upon further exploration, the first inhabitants found all forms of tools, technological wonders and automatons that helped provide bountiful harvest, food, water and a safe haven from the extreme weather conditions.

In time, their first civilization of engineer inventors came to inhabit this realm and established a society of high arts and craftsmanship, featuring intense studies and philosophy into sacred geometry, arithmetic and astrology. Being within the mountainous regions near the roof of the world, the inhabitants of D'Vinci felt they were closer with the oneness and thus initially built vast vertical temples and areas of worship dedicated to sacred geometry.

Fig.14 shows the early period township of D'Vinci – illustrated as a gigantic ship relic within the high mountains with a few grand structures and houses built into it.

This soon grew into a thriving village and subsequently a powerful small trading community filled with exploration into the machines of the various realms, and all things arts and mechanical.

Fig.15 is an example of a mid-period township of D'Vinci – featuring improved battlements, fortifications, buildings and transformation of a Victorian relic into a useful fortress township.

AERIAL ILLUSTRATION

Saving the best for last, we can establish this scene with a bit of moss and snow (**Fig.16**). Let me explain.

With limited resources, one has to be a bit creative, and take the approach of studying miniature moss gardens and such when approaching an aerial perspective view. This view was taken during one of the many winter showers we get here in London, during a walk through the London Guildhall and high gardens of the Barbican.

Using your imagination and a simple camera you can scout various locations which can then be featured in your high mountain city (much like a location scout) and thus plan accordingly. Pebbles become mountain peaks and moss becomes vast plains of forest covered with ice

16

fields. Therefore the next step in this process comprises of two parts.

Step 1: Layout sketch (**Fig.17**). This is fairly straightforward and involves a layout of various shapes and buildings relative to an established perspective and needs not be an intricate prolonged affair.

Step 2: Is a bit wordy and involves a four stage process (**Fig.18**):

• **I – Block-in**: A low saturated wash of gray/ blue/purple tones are roughed in over the preliminary linework, with various shapes and buildings blocked in relative to the general lighting (two o'clock). Rocks that protrude and areas with significant snowfall are blocked in. And far off mountainous regions are planned out.

• **II – Texture and Details**: One way could be to paint every single village/hamlet/ roof in, or perhaps to initially layout everything on a square grid and paint in the general shapes, lakes, gardens and squares and subsequently transform it onto the illustration. For this, various colored roofs, cobbled roads and garden paths were painted. Subsequently, small village squares and town allotments were built and arranged accordingly.

• **III – Color Grade**: Subsequently, a colder green blue overcast sky predominates and helps to gel the overall scene. Areas of light and shadow are demarcated, with areas in relief receiving a cold blue tone for snow, and lit areas a warmer yellow-tinged cast.

• **IV – Mood and Atmosphere**: Lastly, aerial perspective, low lying clouds, rain, mist and fog are all added to sell the sense of being within this large aerial scene.

To complete the illustration, all that is required is a large frosted frame within which to display this scene.

END OF D'VINCI TOUR

Welcome back to the transit centre, and I hope you have enjoyed our brief tour of the quaint fortified town of D'Vinci and a visit through the various plazas and workshops.

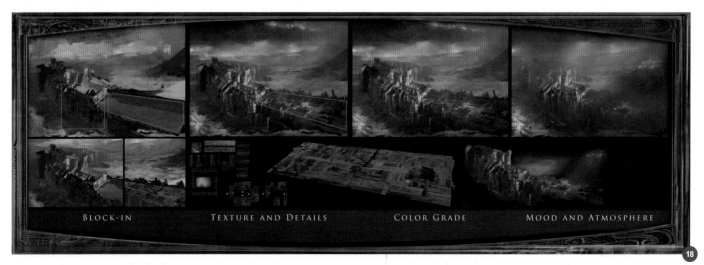

BLOCK-IN TEXTURE AND DETAILS COLOR GRADE MOOD AND ATMOSPHERE

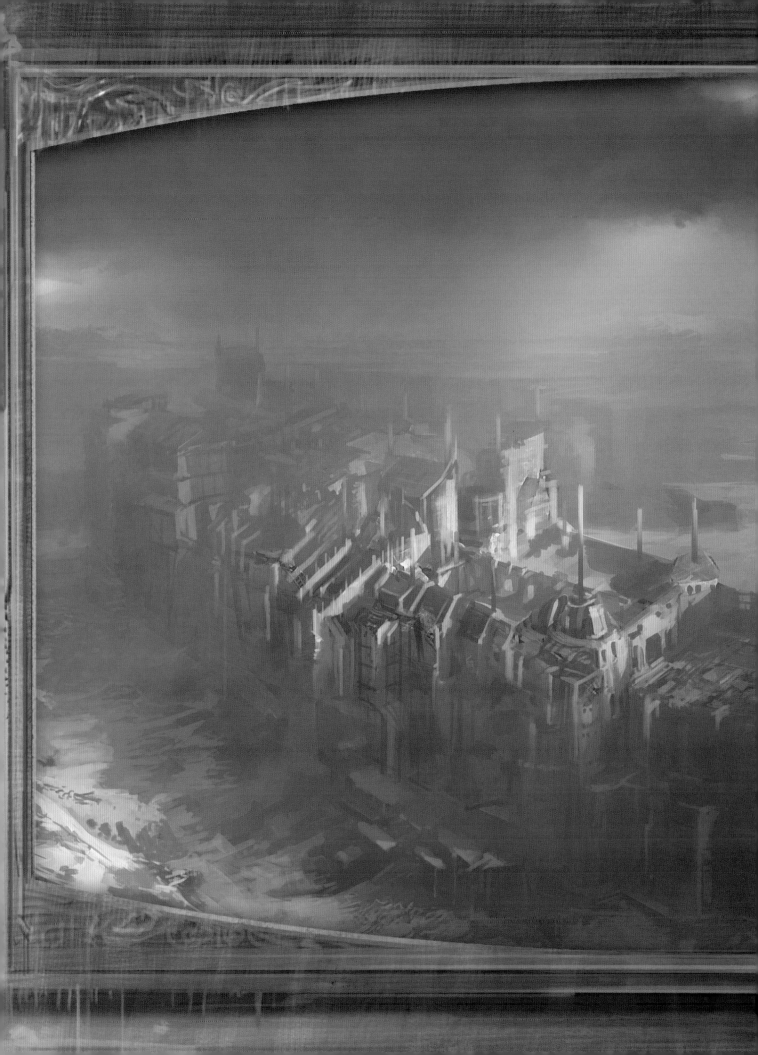

INDUSTRIAL
BY CHEE MING WONG

SOFTWARE USED: PHOTOSHOP

D'TOUR

Our tour is now midway through the inter-realms and encompasses different eras and themes within the interconnected districts of Steamworld, administered by the central transit and engineering hub of the Guild of D'Machinis.

Let us leave our transport behind for now and continue the journey on foot. For it is on foot that the realm is best seen, felt, heard and appreciated with the artist's eye, so let's partake in the Walk of the First Sone. This is experienced via the crossing of one of the vast sky bridges (an amalgamation of the disciplines that have fused these constructs together with the great sky port) into the realm of D'Metronomus. For here is where the first Sones discovered the realm's raw potential for artifice, and sought to fuse ether with the raw metals and ore mined within to form the five principles of Alchemical Mechanics (A'Mekhanos).

D'METRONOMUS: ESSENCE OF FANTASY STEAMPUNK

The realm of D'Metronomus is old. By far the

> THE VAST INHABITED ARC BRIDGES AND INTRICATE WEAVE OF LEVI-STONES ARE SAID TO HAVE BEEN LITERALLY SUNG INTO EXISTENCE BY THE VAST GUILD OF SONES

oldest of the realms, it was once quiet, desolate and derelict before the arrival of the bustling ports that grew up around the sky bridge.

Indeed, a journey deep towards the old quarter still reveals the raw energies that suggest the mysteries of how this realm came to be. For you see, much of D'Metronomus failed to exist when it was first inhabited. That is, the vast

inhabited arc bridges and intricate weave of levi-stones are said to have been literally sung into existence by the vast Guild of Sones.

Legend foretells of the first Sone, an explorer known as D'mar Sonas who discovered the strange qualities of this isolated, mineral rich landmass (**Fig.01**). Some experts predict when delving into the legend that once there

was an ancient sea in this region and over the millennia periodic shifts in land plates and multiple land quakes resulted in the draining of this ancient sea and leaving behind the impossibly saw-toothed land struts and bridges jutting out of the entire region.

ART DIRECTION

For the art direction, a decision was made to implement an oriental twist within the steampunk genre. In part, this is reminiscent of the travels to the realms of the Bund, Shanghai, which combines the aesthetics of Art Deco west with Oriental construction, materials and shapes.

In that regard, it also allows for an exploration of an overgrown, derelict, aged process combined with strong graphic design visuals, thus reflecting the eastern art styles of saturated bright colors.

OLD QUARTER

As one enters the Old Quarter of the Sones, of particular interest is the old warehouse district. For it is here that in its heyday the first sky bridge pier-point was established. This port provided trade and commerce in gears, ancient constructs and barrels of raw refined etherium to all the realms. Whereas, over time the needs of the realms have expanded and the great

sky port and a gigantic construct of seven arc bridges form the gravity defying construct of the sky port. Held together by the fusion of both Sone and Alchemical Mechanics, it is here that old and new technologies lead the way to new constructs, and possibly also new realms (**Fig.02**).

Nowadays the raw etherium has been mined to depletion and it is within the partially submerged realm of the master pumps and gears of D'Mechanis that various caches of etherium may be located that allow for inter-realm maintenance, and construction of future constructs.

SKY BRIDGE PIER-POINT

Finally, our journey takes us into a clearing from which we can take a short break for lunch and enjoy the view. So, let us take the opportunity to review the first two sketches and deconstruct how our group of artists developed these paintings.

For this sketch (**Fig.03**), the composition and finish was approached as a four stage process.

1. **Block in Large Forms**: Key forms are blocked in with one value, whilst areas in relief (receiving direct light) apply their own singular value in contrast. Lastly, the background has a low contrast monochromic value approaching neutral gray.
2. **Perspective Guide and Focal Interest**
3. **Color Grade and Atmosphere**
4. **Contrast and Details**

Once the core elements are in place, the next step is to take the sketch and turn into a fuller painting.

MOSS AND LICHEN

Thus lighting, ambient light, bounced light, and local set dressing, moss and lichen are applied

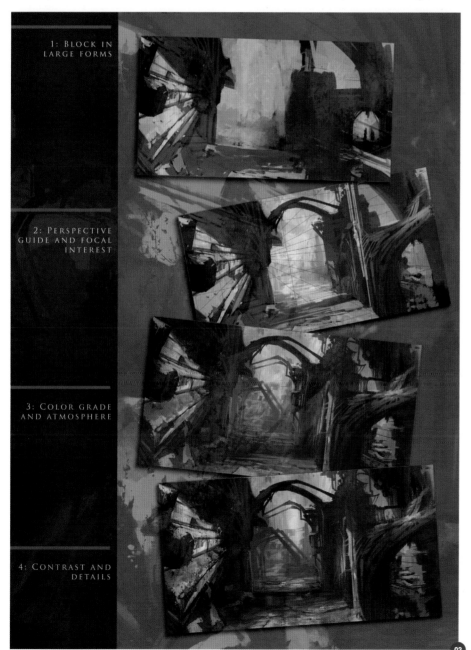

1: BLOCK IN LARGE FORMS

2: PERSPECTIVE GUIDE AND FOCAL INTEREST

3: COLOR GRADE AND ATMOSPHERE

4: CONTRAST AND DETAILS

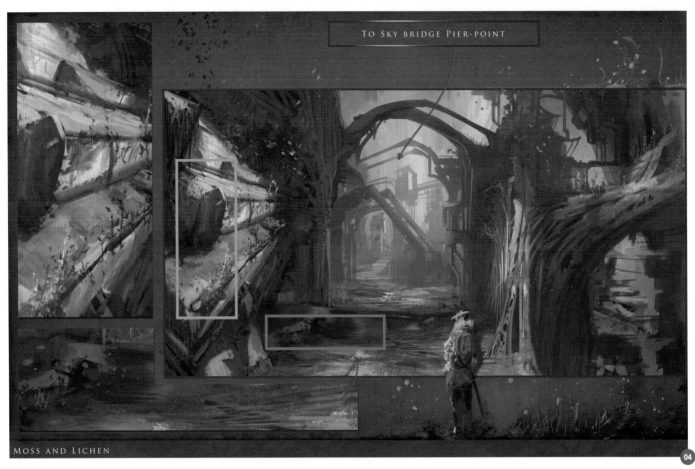

TO SKY BRIDGE PIER-POINT

MOSS AND LICHEN

04

on various elements of derelict equipment and pipes that, through sheer age, weathering and time tends to form semi-abstract shapes akin to naturalistic roots and tree branches (**Fig.04**). Certain machinery takes on a fossilized interlocked stony appearance akin to that of basal columns seen spectacularly within the Giant's Causeway (Antrim, Northern Ireland) or similar igneous rock formations of the Devil's Mountain (Wyoming, USA).

This aged effect has to be applied meticulously throughout the whole scene and, suffice to say, a rainforest featuring a mossy forest is the best real-life reference for such a scene. Moss and lichen are an interesting pair (**Fig.05**). They are a composite of a fungus and a photosynthetic partner (green algae or cyanobacteria). Lichen comes in all shades, ranging from grayish blue-green, to yellow-green. It derives its color in part from its enslaved photobiont, of which there are over 13,500 species! In terms of shapes they can be leafy, crusty, flaky, branched, powdery or gelatinous and are extremely hardy, often being found living in extreme weather conditions.

In contrast, moss is a soft small plant. It germinates as spores sexually in the presence of water. It is often found in colonies and prefers damp and low light conditions. Aesthetically, moss is cultivated to recreate forest carpet scenes and is said to bring a

feeling of Zen calmness and peacefulness, which is especially appreciated within Japanese moss gardens. In terms of art, moss forms brilliant saturated hues of vivid greens and viridians, and is suited for use when you're depicting rich, damp forest scenes.

MOSS & LICHEN TYPES

05

OLD QUARTER WAREHOUSE

To carry this theme on further, we choose a top down view overlooking the Old Quarter warehouse.

In this instance, we will try a different approach to painting. The importance thing here is to establish a tonal contrast between various shapes, and allow the various abstractions to appear accordingly. Due to the loose manner in which these paintings progress, it is vital to have a back story or designed element prepared beforehand so as to steer the end result into the required direction (**Fig.06**).

The advantage of this approach is that the images tend to have a richer, more vibrant end result. The offset of this is that as your own art direction, artistic execution and innate painting aesthetic offer various options and possibilities, it may tug you in opposing directions and can end up looking horrible (whereby certain parts of the image look good and, on the other hand, certain parts look very subpar).

Thus, once you have a vague notion of the direction your painting is headed it develops a life on its own. Allow for some happy accidents and a gentle nudge here and there should see you in good stead for the end result. Almost as if you had planned it all serendipitously.

Indeed, an element of intuition is crucial for the successful outcome of such a painting. One could argue intuition is part of the knowledge of art theory, emotional intelligence and

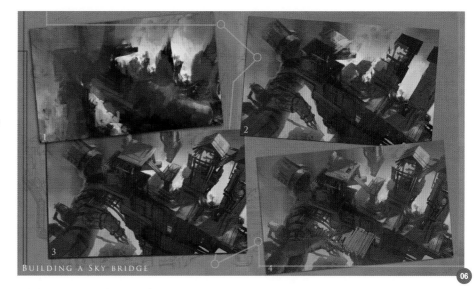
BUILDING A SKY BRIDGE

artistic insight manifests itself as an almost preternatural instinct of where to lay one's strokes economically, and that a element of abstraction and focal detail provides continued contrast and delight to the viewer.

In the right hands this can often lead to reliable, spectacular results, and in the hands of a novice sometimes you win, sometimes the piece is better left unfinished to join the vast ranks of storage where stillbirth paintings go to rest and retire until a later date and perhaps until their resurrection.

In brief:

- Large shapes and tonal contrast allow for domination of the scene. In this instance, a diagonal shape suggests movement that leads the eye to the far left (**Fig.07**).
- Akin to moulding clay, one can nurture and

mould the shapes to form pipes, cylindrical forms interspersed with rigid rectangular blocks of wood, metals and various architectural constructs. Some suggestion of strong lighting from the top right is cast upon the forms, to aid in a sense of three-dimensionality. Shadows or bands of light across forms can often be pleasing to the mind's eye.

- Additional shapes and secondary details are etched in to provide support to the main shapes.
- To create mood and atmosphere some slight atmospheric perspective is added, accounting for humidity and the amount of "air" between the viewer and the end object. It helps provide welcome relief and softens the overall painting.

Once all the main elements are in place, we can apply the same aging and weathering process that we used with the painting before. We have to ensure that the moss and lichen read well in both light and shadowed relief to ensure a believable read. Lastly, some slight color adjustments and balancing will ensure that the overall image is presentable and reads well.

SKY-BARGES

As we continue onwards from our short lunch break, we step through a shadowed arch onto a bustling port powered by gears, globes and mechanical wonders of all assortments. On to Pier 39, we see a gigantic levi-stone barge coming in to dock upon the great stone piers

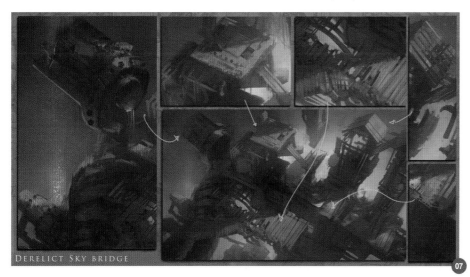
DERELICT SKY BRIDGE

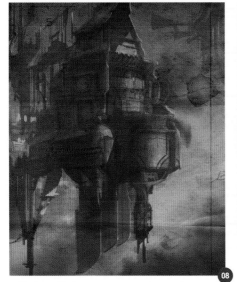

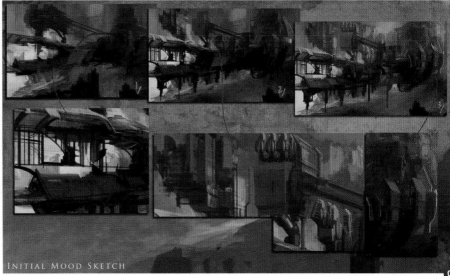

08

INITIAL MOOD SKETCH

09

(**Fig.08**). Comprising of a amalgam of levi-stone, etheric sails and vast storage facilities to contain the rare etherium, these behemoth ships ply the high air currents from realm to realm and slowly but steadfastly navigate the trade winds to capture and harvest the fine microscopic etheric dust that permeates the upper atmosphere. Much like vast shipping fleets of the sky, these barges may take weeks to months on end to accumulate a significant amount of etherium before pulling into dock. It is here, within the high, thin altitude and climes that navigational and astrological equipment can have the best view of the stars and orbits above. Thus, these barges are often occupied by a swarm of academia and astronomical instruments to better divine the meaning of life or the birth of the heavens.

> **NOT ALL SKETCHES GO ON TO BE SUCCESSFUL ILLUSTRATIONS, AND IT IS CERTAINLY WORTH GOING THAT EXTRA MILE OR FURLONG TO DEVELOP MORE CONSISTENT ILLUSTRATIONS WHICH CREATE AN IMMEDIATE IMPACT**

BUILDING SKY PIER 39

Let us reconstruct a sky pier as it looked in its heyday. In the initial instance, we can use the same approach as we did for the Old Quarter district by using a modified three-part process:

- **Large Forms and Contrast**: Block in large forms and establish tonal contrast in the initial instance (**Fig.09**).
- **Lighting and Supporting Forms**: Mould in supporting details and cast directional and ambient lighting.
- **Grade**: Grade the overall sketch to unify (Note: There is a trade off between overall cohesion versus the loss of detail/contrast/ distinctive elements within a sketch).

Once the initial sketch has been established, the next aspect is to deconstruct it to generate a more refined illustration.

Note: Another trade off in refining an image is the slight loss of spontaneity and immediacy generated in a mood sketch. Nevertheless, not all sketches go on to be successful illustrations, and it is certainly worth going that extra mile to develop more consistent illustrations that create an immediate impact.

CONSTRUCTING AN ILLUSTRATION

With the initial sketch as a base, the next crucial step is to provide critical analysis to deconstruct the image into its main components. To keep things simple, this image can be broken into the background vista and the foreground sky pier.

Starting with the background element, all foreground elements are selectively removed and stored away. Next, the main background is reconstructed to be re-imagined to what it could

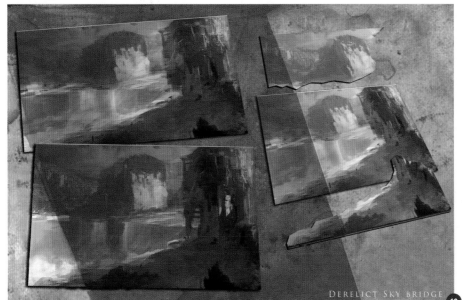

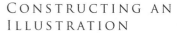

DERELICT SKY BRIDGE

10

be without any obstructions or overlapping elements. And finally, the focal detail, lighting and a background grade are applied to form a overall background plate (**Fig.10**).

Going forward, we can develop the foreground elements of the pier. Utilizing repeatable shapes and elements, one can align these components to a perspective grid (**Fig.11**).

Drafting a simplified perspective grid by hand each time can allow you to think through the image beforehand, and thus help aid that intuitive process when you paint. Much like visual troubleshooting, each illustration has its unique challenges and rewards.

Subsequently, the task now involves rejoining all these separate elements into a more cohesive whole (**Fig.12**). In addition, each block element should relate to one another, so as to visually appeal to the viewer and clearly show its innate purpose and function.

In addition, use the perspective guide as a subtle visual aid for the viewer via the use of color temperature contrasts and shifts. In the perspective guide comparison (**Fig.13**), various objects that recede towards the vanishing point form positive or negative shapes; some are placed utilizing the guidelines of the golden ratio, whilst the rest according to various nexus points along the three-point perspective grid.

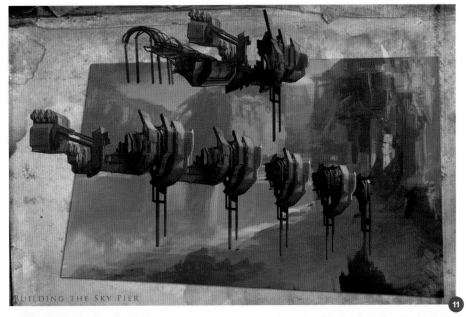

BUILDING THE SKY PIER

11

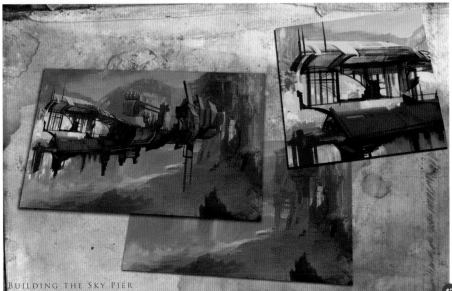

BUILDING THE SKY PIER

12

DERELICT SKY BRIDGE

14

13

Lastly, the final image can be color graded and some focal interests added according to the desired finish and stylization. It is often best to leave the visual effect manipulations towards the end, thus allowing the core underlying structure to remain unchanged, should at a future point such changes become necessary (**Fig.14**).

As a final design element, interconnecting pipes and vents are added alongside the whole sky pier, to reflect the mechanical steampunk nature of this large construct.

And with that, our day trip of the mechanical realms of D'Metronomus comes to an end, and we shall reconvene at the local transit centre.

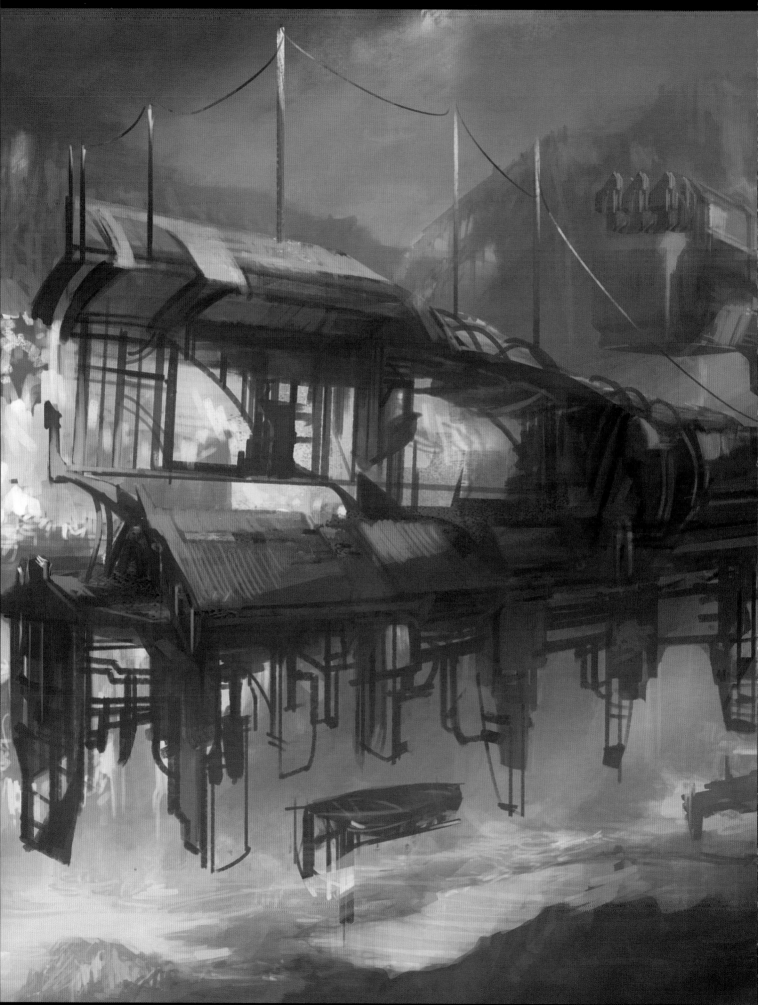

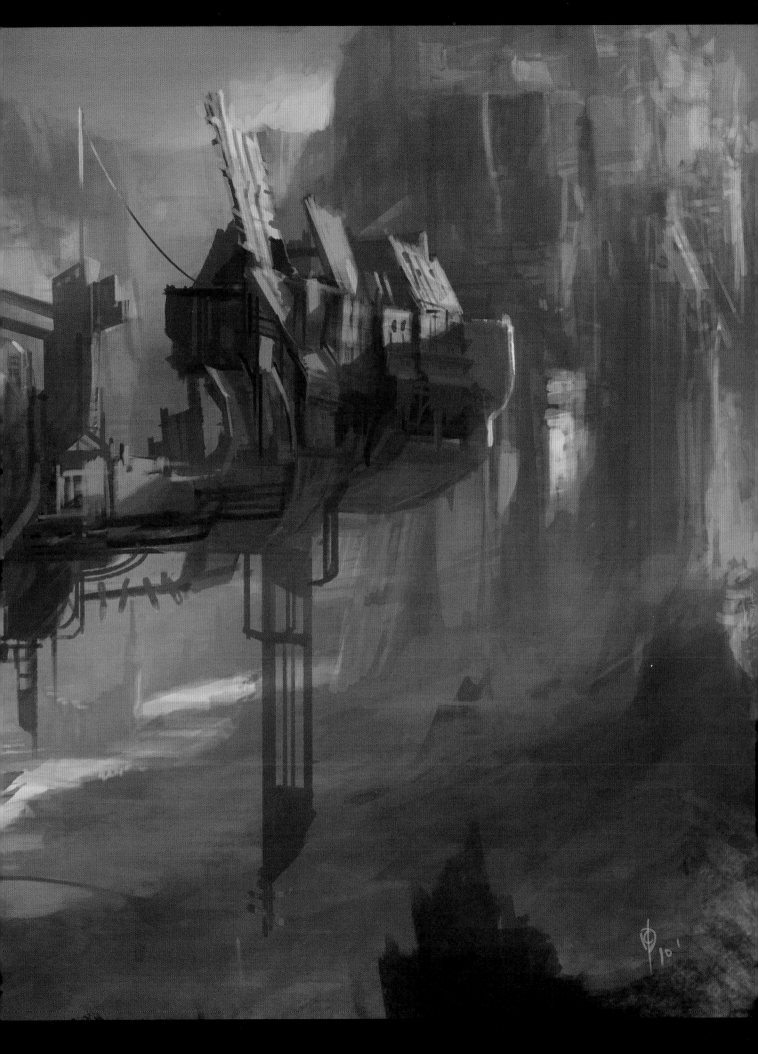

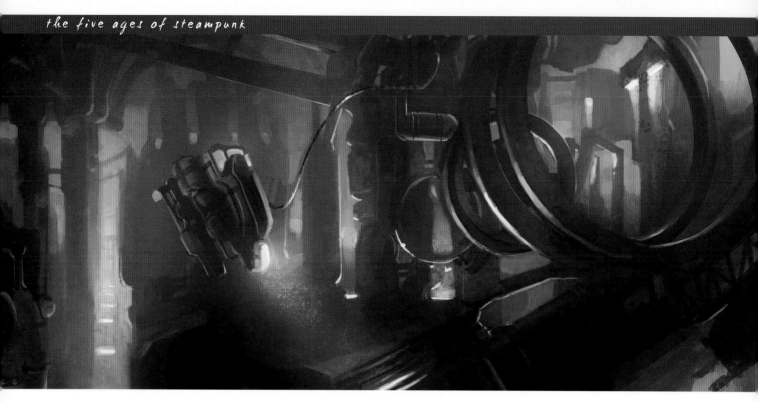

MECHANICAL
BY CHEE MING WONG
SOFTWARE USED: PHOTOSHOP

D'TOUR

From the ancient heartland of D'Metronomus, we continue on our journey into the inner workings of the fourth realm of D'Inginis. It is here that the tireless powerhouse of Diesalis powers the various furnaces and etheric energies of the Steamworld. Key to this distinctive realm is the usage of industrial pipes, welding, bolts and engine components. There is a minimalistic feel when it comes to aesthetic considerations.

And thus at the magic twilight hour, we finally reach the border of "The Drop".

THE DROP

The Drop represents a sharp demarcation between the cloud and mist of the ancient overgrown heartland of D'Metronomus, and the pipe laden, humid underworld of D'Inginis Diesalis. It is from here we have to continue further afoot towards a lower vantage point of this chasm whereby we come across the derelict scrapyard of The Drop.

It is here we can choose a suitable location to set up an evening composition from which to depict the merging of two styles, that of a

diesel steampunk style, and that of overgrown nature. The first thing to note is that with such a twilight scene, one needs to work fast. For there will barely be half an hour to an hour before the light fades fast. It is also during this time that lighting can be at its strongest – providing strong contrasts and saturated lighting (**Fig.01**).

The initial canvas should be quickly prepared with a rapid block out of all the strong key forms and objects we want, thus providing a strong read (and contrasts). Two similar compositions are explored initially to depict a naturalistic harmony between a strongly lit scene and one that depicts its steampunk nature (**Fig.02**).

The Composition

Following the initial sketches, one can combine the best of the sketches to form the "bones" of the composition (**Fig.03**).

One thing to note is a level of readability, whereby the background is clearly separate from the foreground objects. In addition, the main lighting direction should be determined in order to plot the core shadows and local ambient occlusion.

Roughly translated into plain speak, this means a depiction of hard and soft forms, angular and curved shapes and lastly low contrast values (objects in the distance) and higher contrast silhouettes (foreground). This methodology requires the usage of the canvas to provide a monochromic tone from which to build positive and negative shapes.

Shape, Form and Texture

Subsequently, we can start bulking up the sketch with some early introduction of

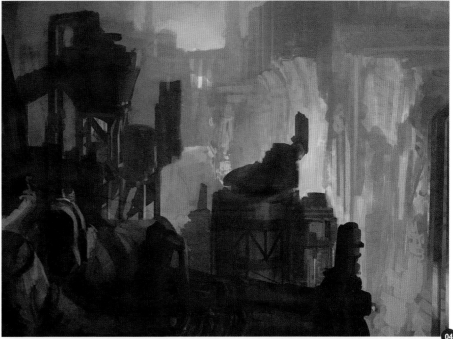

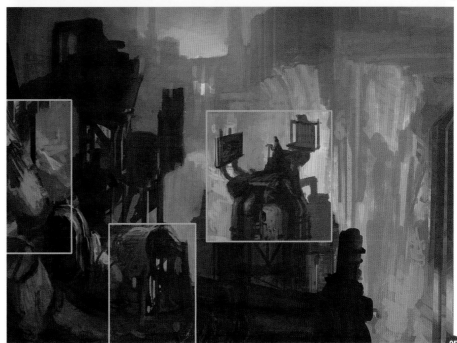

warm tones throughout. This both provides an opportunity to unify various foreground objects with the same core shadows, and a textural warmth of a lower contrast and unified background shapes (**Fig.04**).

The next stage affords one the opportunity to work rapidly by bulking the main meat of the image with further focal details, whilst still keeping a loose energetic hand. Strokes and brushwork can be confident and assured, reflecting a conscious choice to simplify

certain details into a few strokes, denoting both textural quality, specularity and tonal form (**Fig.05 – 06**).

Reference: Art Direction

To aid with the depiction of such objects, it can be useful to observe various construction scenes such as the references provided. Note the regularity of large bold shapes and pipes within the photo (denoted with a yellow circle) – these linear shapes help anchor the

main super structure towards the ground plane and thus reflect the need for solid, believable foundations (**Fig.07**).

In terms of style, it is particularly useful to observe first=hand an industrial complex (if possible). Here we see the Lloyds building at 1 Lime Street, London, which aptly depicts the strong diesel punk theme of this workshop. Note the strong use of parallel shapes, piping and the reflectivity of its surface material in relation to the ambient (blue sky) surroundings (**Fig.08**). The ability to depict such similar shapes in various lighting conditions will greatly aid in the depiction of a dramatic steampunk artwork.

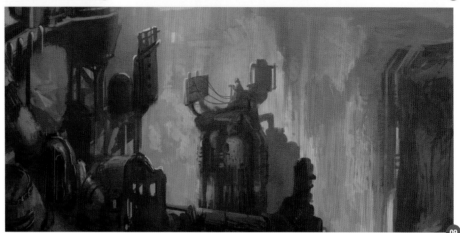

Lastly, a warm pinkish atmosphere is added to the overall scene to capture the lasting rays of twilight and thus soften various mid-ground shapes, and unify the overall background (**Fig.09**).

UP-LIGHTING

Up-lighting can often be used to increase the dramatic effect of a low light scene. This effect is often prominently used within theatrical or museum displays, upon listed historical buildings and deco-styled monuments and buildings (**Fig.10**).

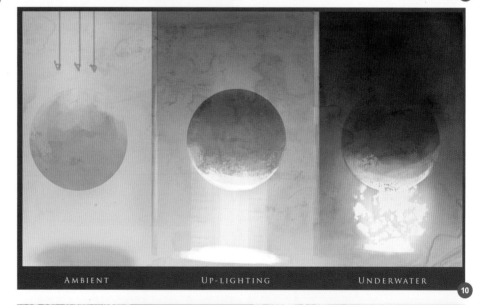

AMBIENT UP-LIGHTING UNDERWATER

However, to show that it is a night-time scenes, one needs to be particularly observant of local lighting. Notice how various forms have a strong edge, with saturated bold tones and forms. In addition, objects in the distance tend to fade rapidly into black, which is quite a contrast to phased falloff gradient in daytime (**Fig.11**).

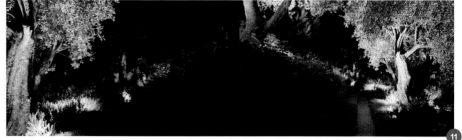

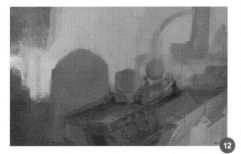

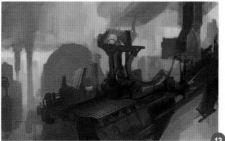

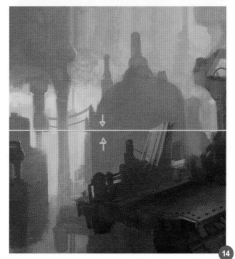

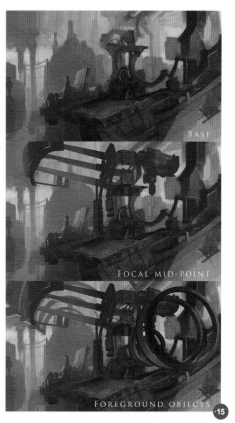

BASE

FOCAL MID-POINT

FOREGROUND OBJECTS

THE ENGINE ROOM

Having traversed towards the edge of the chasm, we can see the hybrid Deep Cable Express hidden within. Utilizing this mass transport we take the five mile journey into the heart of the engineering marvel of the Steamworld. Powered by a massive set of diesel-powered levers, pistons and flywheels it is here that sufficient heat and power can be generated to distil the etheric power source that provides free lighting, heat and energy for portable and general usage throughout the Steamworld.

To capture the look and feel of the massive engines herein, let us start by preparing a fresh canvas and blocking in all the main primary shapes using large broad strokes via a simple Chalk brush (**Fig.12**).

The next step is to provide immediate focal detail. In this instance, we depict a massive angled elevator used to ferry large tunnel boring machines and supplies into the heart of this realm (**Fig.13**). Subsequently, we help

unify the overall image with elements of lost edges and grain to provide a better overall read of the composition (**Fig.14**).

DETAIL

This next step is the more formalized aspect of blocking in forms and designing elements so they fit perspective and proportions, and communicate effectively as a solid set of objects to the viewer (**Fig.15**). In addition,

surface materials are provided with the appropriate treatment – such as providing reflective mirror-like surface materials for smooth metallic surfaces (**Fig.16**).

COLOR GRADING

Once the formalized aspect of firming up the details is complete, the next task is to provide a color grade for all the objects and scene. Firstly, the composition is skewed slightly

towards a hazy, tan and yellow feel to provide us with a colored monochromic base. This is followed up with the addition of localized reddish hues and complimentary dark greens (to denote different surface materials) (**Fig.17 – 18**).

Lastly, localized up-lighting and reflected surfaces are rendered accordingly with small minor tweaks to represent the hot, humid atmosphere of being enclosed within a furnace-like ambience (**Fig.19**).

THE FLOOD
Lastly, we will depict how to convert an existing image towards a more flooded feel, by literally

flooding it. Firstly, let us briefly discuss a mode of railed transport that would allow for such an undertaking.

In essence, a dual-mode hybrid that is a cross between a tram and a submersible would be required. As such, it is simply a straightforward case of designing a plain bulkhead in the initial instance, without any additional distinguishing forms. Central to this is what I'd liken to a horizontal waistline that denotes a separation between the lower ballast/cargo of such a transport, and the upper division that would safely encompass our artist explorers. The next step is to incorporate elements of a mass transport.

Elements that can be incorporated include a rear propulsion system, a local ambulatory set of paddles (resembling flippers) and a top mounted, overhanging grapple pulley system. This hybrid system would comfortably traverse the depths and above water realms with comparative ease (**Fig.20**).

Quick Tip : Red and yellow colors have the shortest falloff underwater, followed subsequently by cyan and blue. Thus, everything underwater will tend to have a cyan/bluish color reflected back towards the viewer's eye. In addition, over a certain distance, everything else fades into a grayish black – and thus objects lose their details fairly rapidly.

Having objects lose their detail is not a great prospect for artists. To help prevent this we bring in local lighting and spotlights (of epic luminosity). By utilizing up-lighting and local lighting, the artist can create a dramatic depiction of structures underwater – and thus fire the imagination of the viewing audience.

UNDERWATER CONVERSION
Taking the above elements in mind, let us undertake the conversion of the existing scene into an underwater one.

The first thing to note is the need to eliminate a majority of the yellows and reds, and

A MIXTURE OF SHARPER EDGES AND CONTRASTS BETWEEN LOCAL LIGHTS AND LARGER SPOTLIGHTS MAY EITHER MESH TOGETHER OR PROVIDE A CONFLICTING READ

subsequently unify the image with a slightly saturated cyan feel. Doing this helps to group various complex shapes into core shapes and objects. This also eliminates various details due to a sharper falloff, (let us say arbitrarily) from the mid-ground onwards.

To provide a more underwater feel we are required to unify the image further, akin to peering through a green fog (**Fig.21**). This further eliminates focal detail, and we will have to bring certain features back to the fore, via the judicious usage of local lighting (**Fig.22**).

Utilizing up-lighting can help create a more dramatic scene. Sometimes one can also try to paint such a scene upside down. This may help the artist plot various light rays and falloffs with relative ease – however once you are attuned to painting above water and utilizing up-lighting for night scenes, the brain can develop a dual switch (to a certain extent).

Lastly, to complete the underwater conversion one can add various underwater submersibles and transports to the scene, as depicted in **Fig.23**. A mixture of sharper edges and contrasts between local lights and larger spotlights may either mesh together or provide a conflicting read. Therefore ensure the placement of foreground objects and lighting can complement one another for a more harmonious and involved feeling.

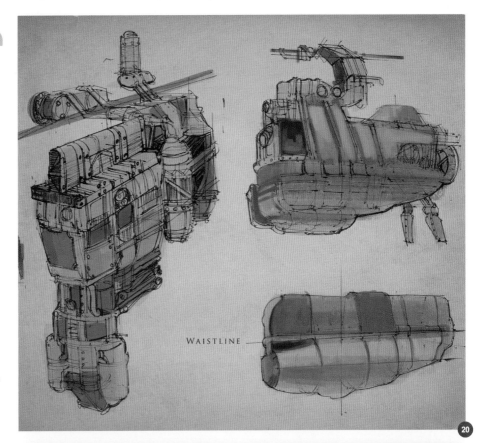

WAISTLINE

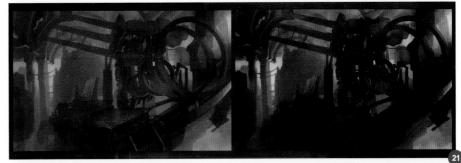

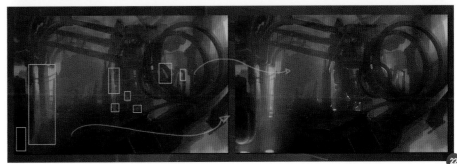

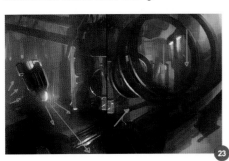

END OF D'INGINIS TOUR

Welcome back to the central hub of the Steam world where our tour moves towards its penultimate end.

Within this tour we took a more naturalistic approach towards depicting an everyday scene, by setting down tones and strokes rapidly using a mixture of softer broad strokes and firmer (more detailed) strokes for areas of focal detail. The setting of a diesel-powered realm run by engines allowed for the introduction of theatrical up-lighting. In addition, we also looked at adding some underwater elements to see how this can work brilliantly to good effect in an image.

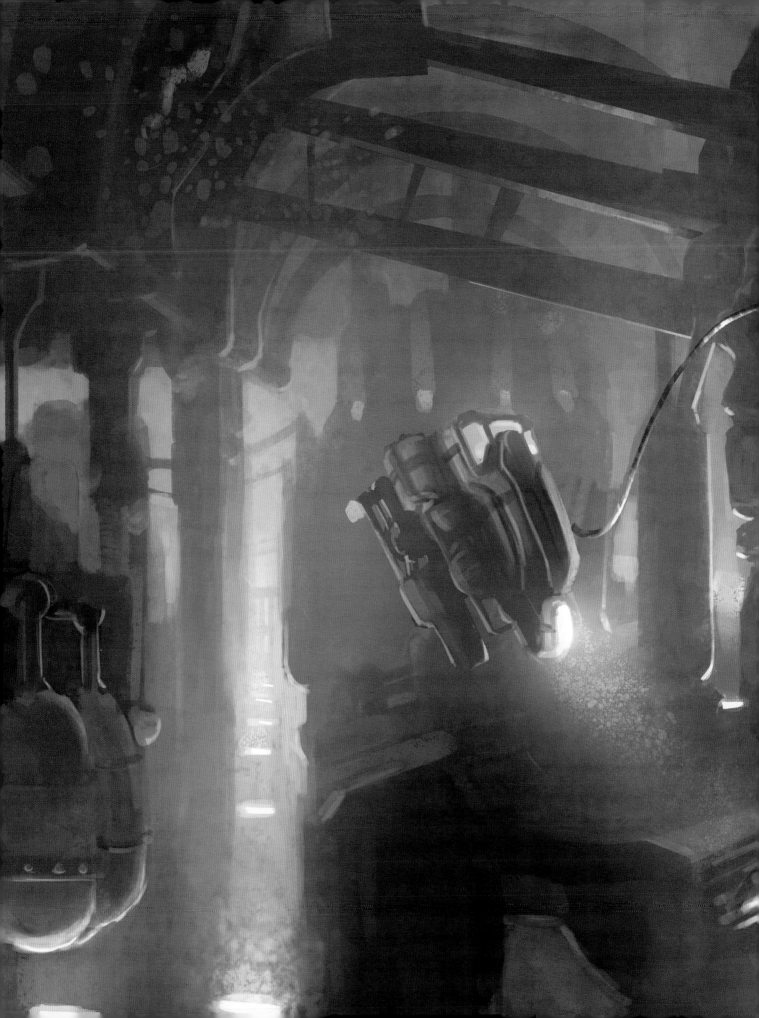

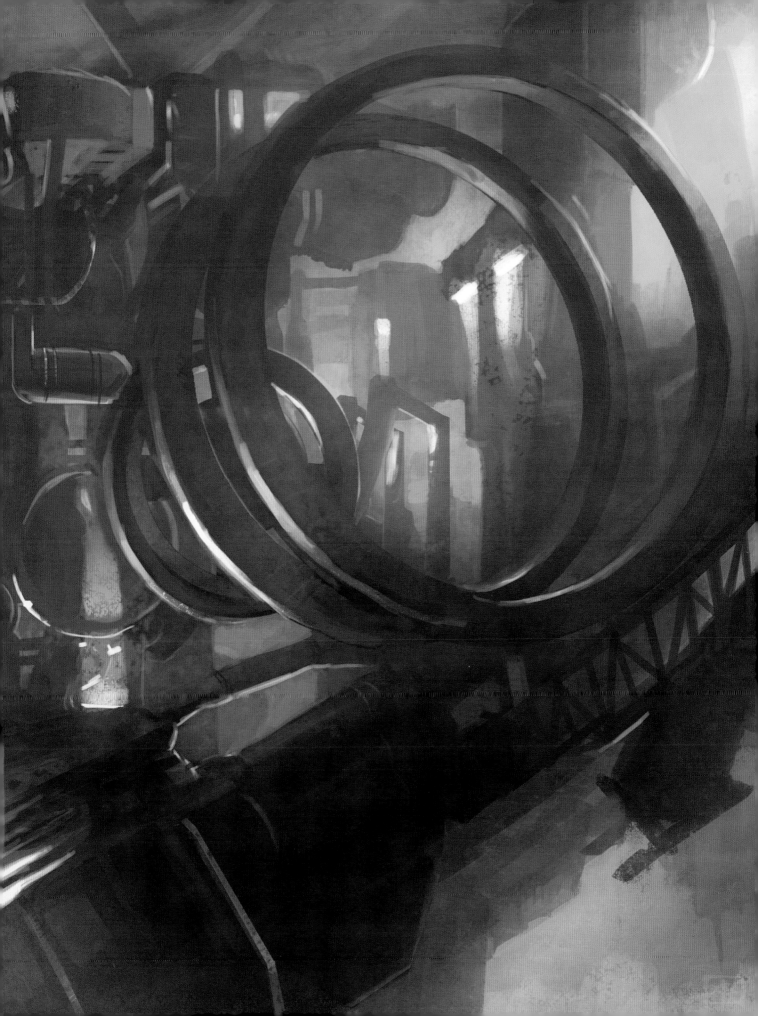

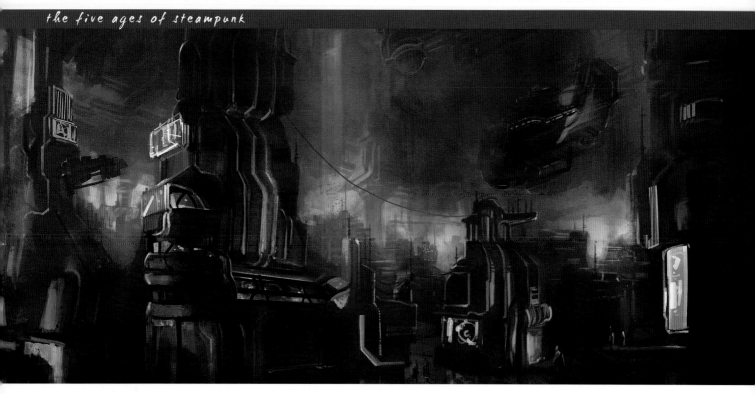

FANTASY
BY CHEE MING WONG

SOFTWARE USED: PHOTOSHOP

D'TOUR

We have now reached the final part of our tour of the inter-realms, which has encompassed different eras and themes within the interconnected districts of Steamworld (D'Automobilis, D'Vinci, D'Metronomus and D'Inginis).

GUILD OF D'MACHINIS

Now that we have travelled the four elements and time zones of the Steamworld, perhaps it is best if we sit back and appreciate the wonders of the telegraphic modern hubris of the D'Machinis metropolis. For underneath a massive time bridge supporting all of these interlocking cities and realms, there lies the D'Machinis vast administrative centre, providing new extensions to new steampunk exhibits and allowing sub-genres to grow. This time bridge spans various cracks in time and space, which are barely noticeable within perceived realities.

Unfettered by the various etheric limitations of the various realms, denizens of D'Machinis employ transports of advanced steam-powered engineering allowing for vertical and horizontal movement through air, water and space-time.

Large or small, there is freedom to move about but at a cost. The spill-off of energy resulting from etheric usage generates toxic gases and, as such, a clean manufactured atmosphere is encased within a atmospheric bubble. Any areas surrounding this bubble are toxic to any living inhabitant.

And thus, we come to our final assignment: The development of a key art illustration for use in production. This entails developing an environment that will provide a lighting, mood, color and textural feel that can also serve as art direction to any artist at a glance.

THE GUILD CITY

The early forefathers decided the Guild City of D'Machinis would be a hub of telecommunications in celebration of the telegraphic ether transmitter. As such, all forms would adopt a sinusoid/wavelength shape as their main inspiration.

Establishing a key feature such as this allows for main and sub forms to reinforce one another from the shape of roofs, elevation of a park, construction of walls, curvature of streets (any excuse to add a curve as opposed to a straight line; this gives the observer a

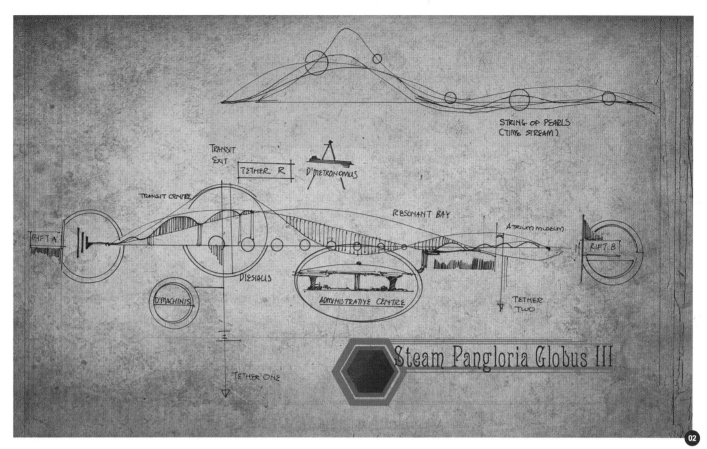

Labels in figure:
STRING OF PEARLS (TIME STREAM)
TRANSIT EXIT
TETHER R
D'METRONOMUS
TRANSIT CENTRE
RESONANT BAY
ATRIUM MUSEUM
RIFT A
RIFT B
DIESIALIS
D'MACHINIS
ADMINISTRATIVE CENTRE
TETHER TWO
TETHER ONE
Steam Pangloria Globus III
02

larger than life/what is around the corner sort of feeling) and placement of public and local lights.

In **Fig.01** we utilize the sinusoid shape to consist of a differential potential gradient. A height difference will allow for a counter current of energy potential versus etheric potential to be generated in relation to the movement of electrons within an electric current.

In addition, there is the design of the main housing unit and a transmission/power generating unit (**Fig.02**). Taking this one step further we have the schematics of the time bridge, a bridge that spans the various cracks in time. Using multiple various sinusoids, these can accommodate for variations in a time phase shift (akin to a earthquake tremor), allowing for people travelling between different realms to remain wholly intact in mid-tremor (without dissipating into a multitude of parts).

THE KEY ART
Sketch
No prior preliminary sketch has been produced in this instance (**Fig.03**). Instead, we will start the composition as if we were painting plein air, on site at the scene. So let's start off by utilizing a simple two-point perspective (2PP), with one visible vanishing point (VP) at the lower third of the canvas and a second invisible VP.

The initial composition in **Fig.03** can consist of a few large shapes upon the canvas. Some artists choose to utilize the main color of the canvas as a backdrop, but in this case we're going to use a faint gray-blue wash to provide a monochromic, cool feel. Once this has been

03

04

established we can move on to adding some secondary elements (sub forms) to reinforce the main shapes in the image. Make sure that you do not go into too much detail as this stage (**Fig.04**).

The design is fairly flexible and by utilizing the sinusoidal/wavelength art direction (see Fig.01) try to establish a good shot of one of the sinusoid structures. A faint suggestion of warmth, perhaps from a local light, can be added to accentuate the aspect of the near structure versus the backdrop. In addition, try and work in the faint suggestion of a generator tower (far right) whilst up above, the underside of the time bridge can be hinted at.

I imagine the underside to consist of floating land pieces, unified by a variety of pipes, struts, landings, gardens and vertical shafts that allow communication between each realm and the administrative centre of D'Machinis.

> " THIS STEAMPUNK METROPOLIS IS POWERED BY ETHERIC GASSES THAT TAKE ON THE NEON GLOW-LIKE APPEAL OF A WIDE GAMUT OF COLORS "

Work-up
Having developed the establishing shot, expand the canvas slightly to adopt a more generic landscape view. The offset of this is that we lose the intimate gesture and feeling of

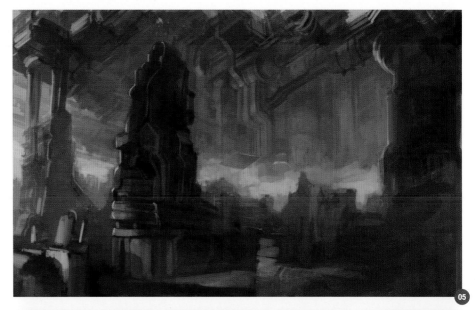

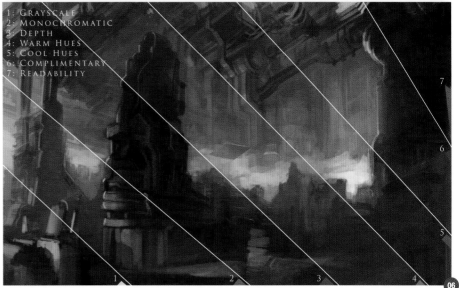

1: GRAYSCALE
2: MONOCHROMATIC
3: DEPTH
4: WARM HUES
5: COOL HUES
6: COMPLIMENTARY
7: READABILITY

this establishing shot. So make a mental note that we may come back to this at a later stage and work more on this establishing shot, or perhaps crop the final image (**Fig.05**).

It's important not to be too fixed on any particular idea, although trying to change a worked-up image later can involve a bit of time and painstaking repainting. The option to re-crop is akin to being an image taker with a photo facsimile device. If it looks and feels good, then it's good to go in that direction.

Next up, we're going to look at the expanded canvas from grayscale towards a color wash. This is sliced into various segments to show the development from an establishing shot towards a colored grayscale. In developing

a grayscale image to a color image, the main challenge that we face is to proceed in a methodical step-by-step fashion, utilizing thin washes of color that eventually build up towards a whole (**Fig.06**).

Lighting and Color
Working the illustration from large to smaller shapes, the next aspect to consider is that of local lighting. Utilizing knowledge and the foundation established from the previous chapters, we can then produce a dramatic shape by up-lighting the buildings (**Fig.07**). This method is used in existing hotels and key buildings across various cities. In this instance, this steampunk metropolis is powered by etheric gasses that take on the neon glow-like appeal of a wide gamut of colors.

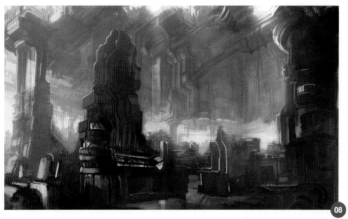

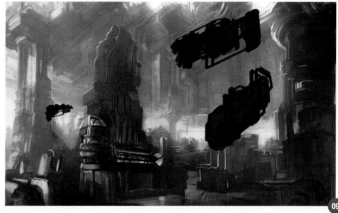

We can take this methodology further and expand various local lighting conditions across the landscape (**Fig.08**). Keep in mind the image is undergoing a lot of WIP reconstruction and as such will invariably look like a bombsite sometimes.

Foreground Objects

We are now two-thirds through this illustration, and need to consider object interest, VFX, atmosphere and global illumination/grading. Let us tackle this in a step-wise fashion. Building upon the various steam trams and transport of the previous realms, there is not much more to go into the final design of the steam hover objects in this realm. The designs are more of an exercise in plausible shapes and so are best blocked in as dark silhouettes (**Fig.09**).

The key to designing without much forethought is to have a good understanding of shapes and relationships. Thus, in this regard, the use of repeating pipes and cylindrical drums attached to a bus/tram-like shape are established. Once the various shapes are developed, be mindful that you can color grade these objects in relation to the foreground, mid-ground or background.

VFX and Final Grade

The next aspect that we can look at is the time of day. Determining what the time of day is in a painting can greatly affect the final finish. In our image, we render three different color modes: day, night and twilight (**Fig.10**):

- Daylight affords a fairly monochromic, reddish-orange feel.
- Night creates saturated strong colors due to the various neon lights employed.

• Twilight allows the best of both worlds – it is fairly light, yet still with elements of strong, saturated neon local lights.

As we're going with a twilight feeling, we need to cover the illustration with painstaking local lights that fit the relative perspective and spatial relationship. For this, it is sometimes useful to paint upside down and flip the view horizontally so that the brain can analyze the image from different views (**Fig.11**).

At this point the overall illustration is becoming quite overwhelmed with color and all the subtle shapes and readability from the establishing value have been lost or nearly obliterated

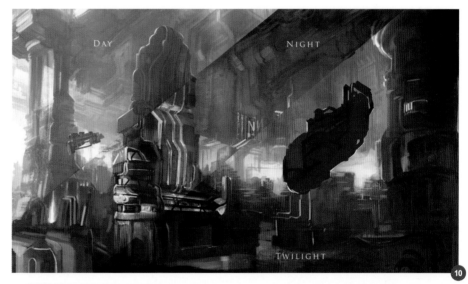

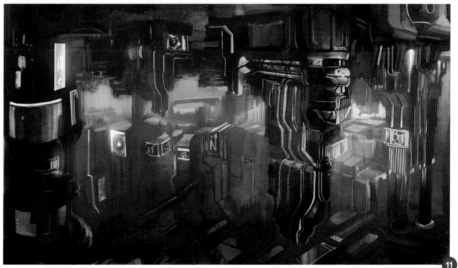

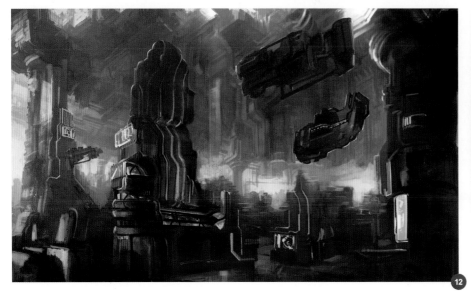

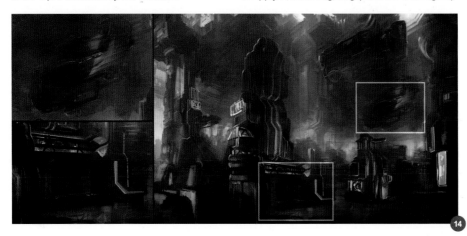

(**Fig.12**). In addition, the more details added, the less improvement there is in the perceived overall finish/value. Keeping to the established hierarchy of values is quite important to ensure readability at all stages, so perhaps it might be easier to abandon this image and restart again from the establishing shot.

This is what I would do in a normal circumstance, on the reasoning that a second or a third attempt would develop a better piece. However sometimes this just isn't possible because of lack of time or deadlines – either you have to move onto another painting/project, your transport is here and you have to go elsewhere (home/work), or the printer says that your painting has to go to print right now. Time's up!

Faced with such a situation, do you:

1. Give up and throw a sickie?
2. Be a pro and remedy the situation.

3. Ask for a miracle.
4. Utilize more manpower (sometimes employ two-five studios to help out to ensure quality – more cooks equals more bandwidth).
5. Take a few moments. Take a walk. Come back with fresher eyes.

In this instance, the image is too well lit and overpowered by a range of colors, and requires a contrast of motion versus static structures. By donning the AD's (Art Director's) hat and providing a brutal analysis of the image, we can formulate an exit strategy (**Fig.13**):

1. Darken the overall image.
2. Allow for more focal lighting (horizon).
3. Punch up the saturation locally and repaint the far distant atmospheric skylight.
4. Apply some motion blur to the steam vehicles (remember to apply these only towards the edges of some vehicles, or all that lovely design is obliterated).
5. Apply reflected lighting (from the local lights).

Having applied all these measures, there is that last 1% to tidy up, in terms of focal details and some slight textural suggestions of various lit planes to suggest different surface materials. Lastly, take a few moments to apply some subtle color grades and faint suggestions of smoke, pollution and steam to allow for overlying elements to add depth to the overall image (**Fig.14**).

When there are no further changes that you feel are required to sell this image convincingly, it is best to stop and keep some element of energy, mood and atmosphere. It's time to call this done!

SKY BLUE, SUN RED AND DEEP BLUE

Global illumination and color lighting is a fascinating subject, and as a final summary let us discuss this subject matter.

In general one finds that in a blue-green atmospheric planet irradiated by a blue-yellow star, the following is true: the sky is blue-violet and the daybreak/evening is golden red within the human visible spectrum of light. Cats, owls and E.T might perceive a shorter or longer spectrum of visible light, and if they could describe to you what they saw, perhaps in their world the sky would be silver green and the oceans cerulean tinged with red...

Thus, light wavelengths are a bit more complicated and are only thus due to perceived visible light by the human eye. Blue (475nm) is

a shorter wavelength than red (longest 650nm) and violet is the shortest (450nm) (**Fig.15**).

Thus, for global illumination it works as follows (but can be slightly confusing): During daytime, the sky is blue primarily due to efficient scattering. In addition, our eyes are more sensitive to blue light, and the sun pumps out more blue light than violet. Whereas during sunrise/sunset, the red wavelength (longest) is less efficiently scattered. The longer wavelengths of red and orange effectively eliminate any blue/violet from the sky and result in a blood red-orange evening/sunrise.

Thus, if red light is longer, how is it that red is the first color to be lost underwater? This can be explained by the amount of visible light absorbed underwater. Longer wavelengths are greatly absorbed underwater, and thus red and yellow wavelengths are lost initially whilst the shorter wavelengths of blue and violet are readily absorbed. This also explains why whitish/pale objects underwater appear blue. Lastly, at 10m depth about a fourth of sunlight is available and almost non-existent at 100m

depth or more. This can affect how one depicts an underwater image accordingly and requires local lighting to depict any colors below 100m depth.

END OF OUR TOUR

Thus, we come to the end of our whirlwind tour of the various aspects of the steampunk sub-genre, of which there are often new and evolving sub-categories popping up that encompass the elements of punk and steampunk in their various incarnations in popular media.

Lastly, as with all things, there isn't any hard and fast rule to producing your own unique take on steampunk. As long as it looks plausible (70:30 rule – 70% based in reality, 30% imagined), and certain aspects can be reasoned to have some function, you are onto a winning ticket.

So have fun! Steampunk your favorite vampire or retrofit your DeLorean of choice and perhaps be as bold as to retrofit your computer and everyday garments with subtle elements of

steam as part of the Neo-Victorian culture. The world is your oyster; you can steampunk that too.

I leave you with an observation. Everyone has within them the power of dreams and imagination. Therefore, I believe anyone can paint and draw; how well is entirely a different matter altogether. Nevertheless, draw to be the best, the best artist living in a generation; draw because it provides therapy and hours of fun; draw because it is a way of life, a lifestyle, and draw because perhaps the secret of the universe lies in those who can dream and bring worlds of imagining to life.

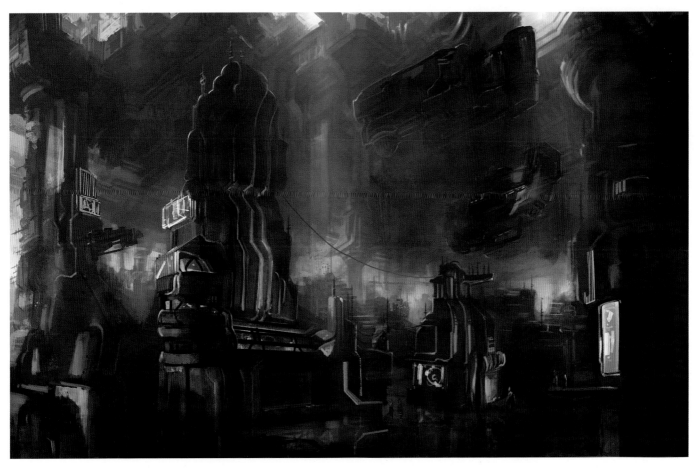

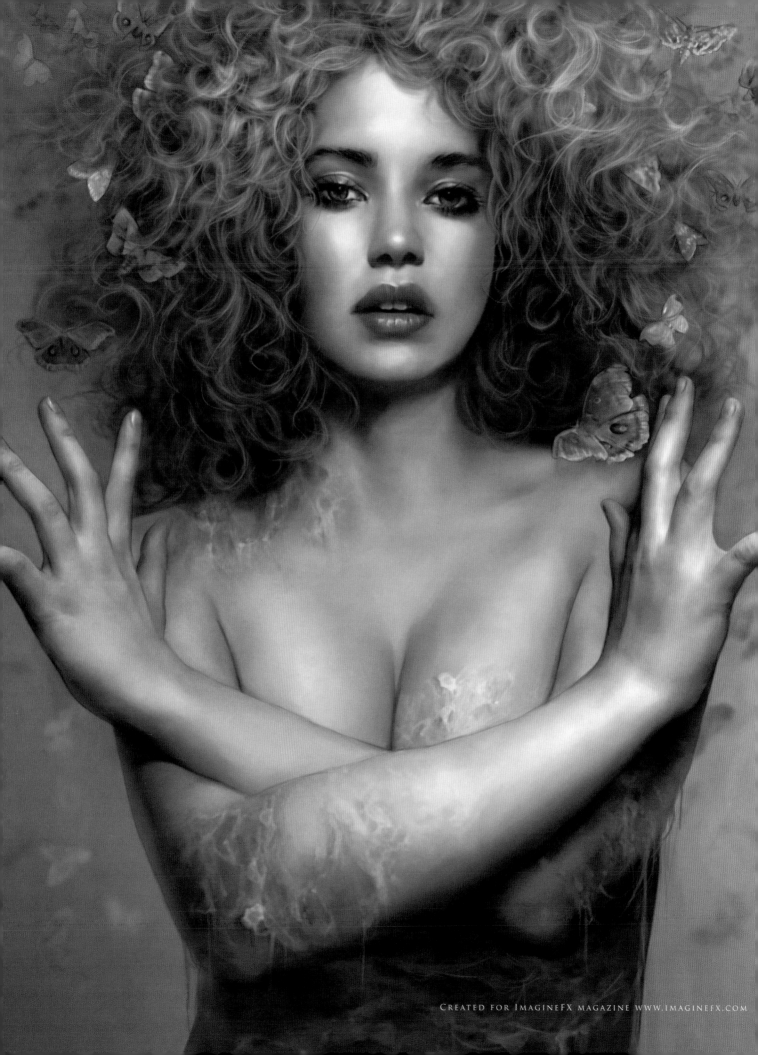

portraiture

People have always been my favorite painting subject. Even though it probably sounds cliché, what I love most about them are their physical imperfections.

Painting perfect people is not really my interest. I like contrasts and boldness. I find beauty canons boring, since there is just not enough mystery in a face that is fully compatible with a common beauty standard.

Instead, I love achieving a harmony between "imperfect" features – it's the balance between beauty and unattractiveness that interests me most. That is why I find a slightly skewed nose or exaggerated cheekbones much more appealing than a fully proportional face. I prefer "interesting" to "attractive" – I want my characters to be fascinating and hypnotic, rather than just pretty.

MARTA DAHLIG
blackeri@poczta.onet.pl
http://blackeri.deviantart.com/

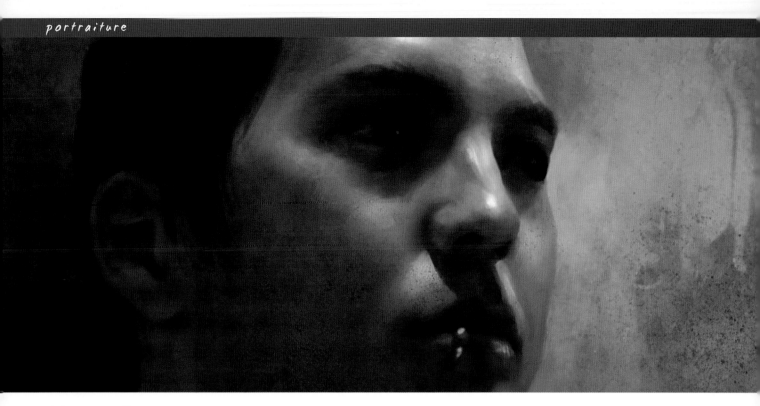

MALE SELF-PORTRAIT
BY DAARKEN (MIKE LIM)

SOFTWARE USED: PHOTOSHOP

GATHERING REFERENCE

The first thing I do when painting a portrait
is to gather my references. Even for concept
work I try and find some type of reference, be
it costume ideas, texture swatches, inspiration
for the color palette – just anything that will
get my mind rolling. Getting the right type of
reference is extremely important if your goal
is to paint someone's likeness. You may think
you know what someone looks like, but do you
know every nuance well enough to paint them
from your memory? I suggest painting from
life whenever possible. Painting from a photo
can flatten out the forms and cause distortion
from the lens. When you have a live subject
you can see exactly how the light interacts with
the planes of their face. That being said, I am
going to paint my portrait from a photo! Make
sure that your subject has some interesting
shadow shapes on their face, so if you are
using a camera be sure to turn the flash off.
The last thing you want is a subject that is all
blown out.

Finding willing subjects to sit for you or
allow you to take their photo can be tricky
sometimes, but you always have yourself
available as a model. May I also suggest that

01

you leave self-portraits out of your portfolio
and only use them for practice. The last thing a
client wants to see when looking through your
portfolio is your face staring back at them!

THE LINE DRAWING

In school they taught us how to paint portraits
in oil by first laying out all of the major
landmarks in line. If I were doing this in oils I
would first draw out the structure using burnt
umber that was thinned out with turpentine. I

would only really need to worry about drawing
in the details for the light side of the face and
for the shadows I could just block in large
shadow shapes. Since I am doing this digitally
I can just open my reference in Photoshop and
paint next to it. I would avoid color picking from
the photo because you want to train your eye
to see colors, plus color picking from photos
can be deceiving because if you zoom in really
close on a photo you can see that there are
many other colors that you can't see zoomed

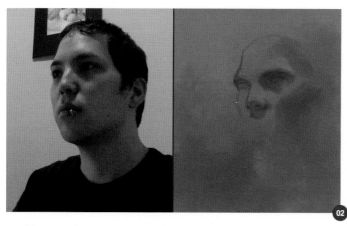

out. You may also want to change some of the colors, depending on what you are going for in terms of mood and style.

The trick to painting a likeness is all in the structure of the face. The little details aren't as important as the overall head shape and structure. If you can get someone's brow right, or their eye socket shape right, you are well on your way to painting a good likeness. If you squint your eyes you can focus more on the large shapes instead of the details.

When I look at my photo, I am looking for the large shadow areas and the shape they create (**Fig.01**). Typically when I start drawing a 3/4 view I will start with the brow of the far eye and work my way up the forehead. I can then come down and block in the large shadow shape for the eye socket and the large shadow area under the cheek on the left side of the face (the viewer's right side). There is a large area of shadow under the nose, so I can knock that out in a few large strokes as well.

Right now I am using a rectangular Chalk brush at 100% opacity. The way I change my opacity is by how hard I press on the tablet. To do this go to Window > Brushes and make sure to click the box next to Other Dynamics. Under other dynamics make sure you have Opacity Jitter set to Pen Pressure. I like using the Chalk brush because it has a little bit of texture and it acts more like an actual paint brush, allowing you to knock in the various planes. When I say "planes" I mean direction changes in the form.

Once I have the large shadow shapes in place I can go in and start blocking in the details, like the shape of the nostril and the shape of the

eye (**Fig.02**). If you notice, I am just blocking in the large overall shape and not all of the details inside the shape. Like the eyes, I don't have the eyeball detailed out or the iris, only the general outside shape. Try to be as accurate as possible when painting these shapes. Really look at the model and try to understand what the forms are doing.

> **Quick Tip:** There are also some general rules that you should be aware of when painting a face. Generally there is one eye width between the eyes; the corner of the eye starts at the edge of the wing of the nostril; the corners of the mouth line up to the middle of the eye, and so on. These are good rules, but they are not always true. I know from painting previous self-portraits that my eyes are actually 1.5 eye widths apart. Also, be sure to check the angles of the individual features (**Fig.03**). Hold your pencil up and measure the angle of the eyes, or the angle of the mouth. Don't worry too much if your painting doesn't look exactly like your subject; it will come together as you begin to add color and value.

TRICKS OF THE TRADE

Working digitally has a lot of perks that you should be sure to take advantage of. The Undo button is your friend, although some might beg to differ. Some argue that having an Undo button so readily available causes artists to become lazy or it might cause them to lose their edge. Sure, not being able to undo causes a person to become more vigilant in their choices and their drawing/painting ability, but it all comes down to the end result. Is your illustration better because you were a

purist and never erased anything, or is your illustration stronger because you recognized your errors and you corrected them? I am sure that subject will be debated until the end of time.

There are also several tools that will allow you to fix your mistakes without having to repaint large areas. The Warp tool allows you to warp areas by pushing and pulling dots that are situated in a 3 x 3 grid, almost as if you were modifying a 3D object (**Fig.04**). Some of my features aren't wrapping around the form as much as I had hoped, so using the Warp tool to wrap them around the form a little more is a quick and easy solution. Don't think that this is a perfect solution though; you can only warp something so much until it starts to look weird.

Once you have things close to where you want them, you can go in and fix your mistakes

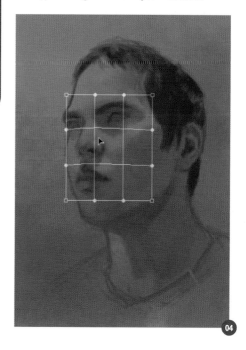

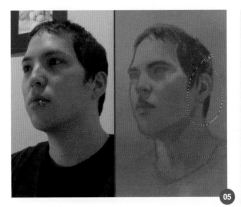

manually. My ear is a little too high compared to the photo (**Fig.05**). Since I have my drawing on several different layers, I need to find a way to move them. Doing a Copy Merged will merge all of the visible layers in your selection and spit them out in one nice, happy layer. Just select the area you want to move with the Marquee tool and then hit Ctrl + Shift + C for PCs, or Command + Shift + C for Macs. You can also find it by going to Edit > Copy Merged. Now, with your selection still selected, hit Paste (Ctrl + V for PCs or Command + V for Macs). This will paste all of the merged layers into a new layer that you can modify. Using the Move tool I can move my ear down. If you just want to make minor changes use the arrow keys to move your selection.

BEHOLD! COLOR!

The single most asked question I receive is how do I add color to a black and white painting. First of all I would like to dispel the belief that adding color in Photoshop is achieved by a simple click of a button. Sure you can add color using a Color layer or an Overlay layer, but chances are it won't look very good. Usually I start by adding color through the use of a Color or Overlay layer, but then I build the color up using several different layer modes, Color Balance, and Levels (**Fig.06 – 07**). Once that is achieved you have a good starting point, but not an ending point. After you have the base colors established you will need to go in and paint opaquely on top of everything the old-fashioned way (**Fig.08**). I throw down big specular highlights on the forehead just so that I can gauge my value range and make sure that my other lights aren't brighter than that highlight. I'll go in later and make it even brighter as well as push the darks so that my painting pops a little more.

In the reference picture you can see a lot of bluish light on the left side of the photo. That light is coming from the computer monitor. After playing around with adding the blue light in the painting, I decide against it and go with a more traditional look. If you are using a reference don't be a slave to the reference. Know when to deviate or when to stick to the reference.

> ❝ THE GREAT THING ABOUT ADJUSTMENT LAYERS IS THAT THEY DON'T ACTUALLY CHANGE YOUR PAINTING, SO IF YOU DON'T LIKE THE CHANGES YOU CAN JUST DELETE THEM. ❞

Right now I am trying to stay pretty loose with my brush strokes. I won't add little details until the very end. I also stay zoomed out so that I can see the entire painting. This allows me to see how each element relates to another and also helps me avoid getting bogged down in the details. Since the face already has a lot of yellows and oranges, I didn't want to keep the background a brownish color (**Fig.09**). I really wanted the face to pop, so I decide to make the background more blue/green. You'll notice that I'm using the background color to carve in on the face. As I paint I do a lot of push and pull with the paint, the same way I would if I

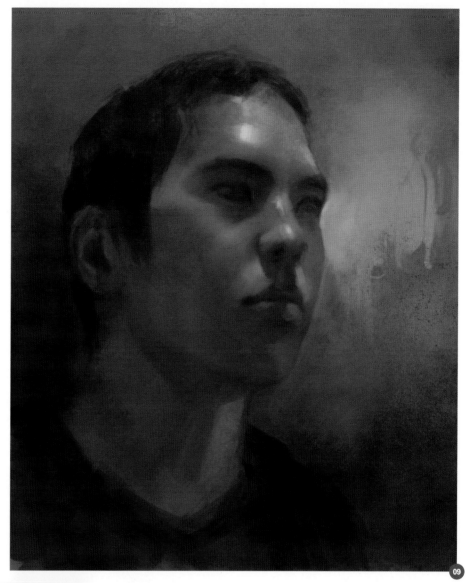

09

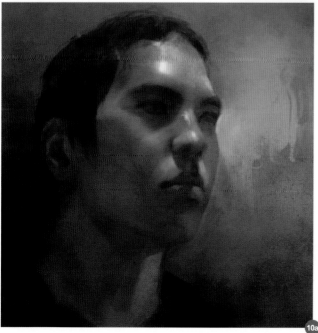

10a

10b

was using oils. The shirt and neck aren't as important, so I make the background darker towards the bottom in order to pull the focus to the face. The face is a little on the green side, so I want to change that by using an adjustment layer (**Fig.10a – b**). On your layer palette click on the half black half white circle near the bottom. This will bring up a number of choices, but we are going to select Color Balance. The great thing about adjustment layers is that they don't actually change your painting, so if you don't like the changes you can just delete them and your painting will be back to normal.

CHIP AWAY

The basic structure and color palette has been established, so all we need to do now is to refine the painting, one step at a time. Using

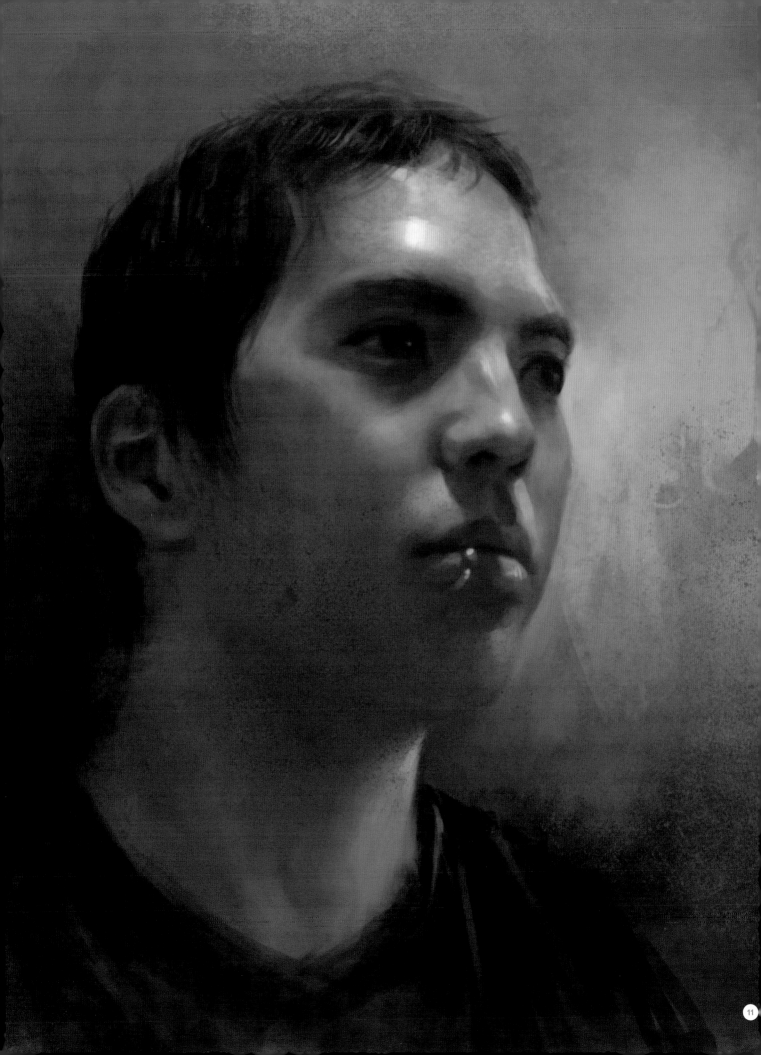

thc Liquify tool and the Warp tool I can pull
the eye sockets and nose out a little bit since
they seem like they are pinched in a little too
much. I also rotate the ear counter-clockwise
and the mouth clockwise. For the facial hair
I use a speckled brush instead of painting in
each hair by hand. Don't go too overboard with
specialized brushes because they can end up
looking "too digital" or they can make repeating
patterns. Usually I will add facial hair on a
separate layer so that I can go back in and
erase out parts that repeat too much (**Fig.11**).

Flipping your image often will help you
recognize your errors more easily and give you
a new perspective on your painting (**Fig.12**).
Taking regular breaks can also give your
eyes a rest so that when you come back you
can see things that need to be fixed. I have
mine bound to Command + F. To make your
own shortcut you can go to Edit > Keyboard
Shortcuts. Click the arrow next to image and
then scroll down to Rotate Canvas > Flip
Canvas Horizontal. You can then enter your
own shortcut and hit Accept and then OK.

My image is also looking a little fuzzy, so I think
I will sharpen it up a little. Make sure that you
have your entire image on one layer. If you
don't, just select the entire canvas by hitting
Ctrl + A (or Command + A) and then do a Copy
Merged (Ctrl + Shift + C or Command + Shift
+ C) and Paste (Ctrl + V or Command + V).
Now go to Filter > Sharpen > Unsharp Mask.
You can play with the settings until you get
something you like. Comparing my painting

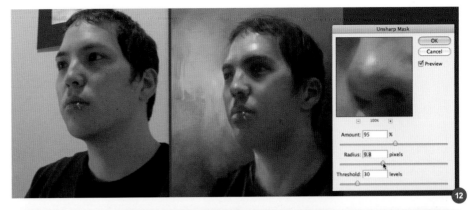

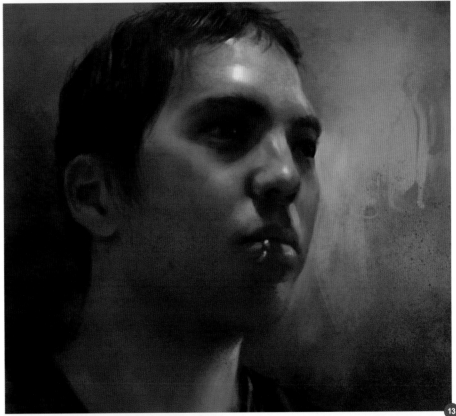

to the reference I can tell that the angle of the
cheeks is wrong. The angle of the bottom of
the nose is a little off too.

Most of the time I only use the default Round
brush, so sometimes my paintings can look a
little "digital" and clean. Whenever possible I
try to use custom brushes to add in little hints
of texture here and there (**Fig.13 – 14**). You
can also add texture overlays over the entire
image. Grab a texture you like and add a new
layer. Paste that texture into the new layer so
that it fills the entire canvas. Next change the
layer mode to Soft Light and drop the opacity
down to 30%. You don't want to overdo the
texture because it will defeat the purpose and

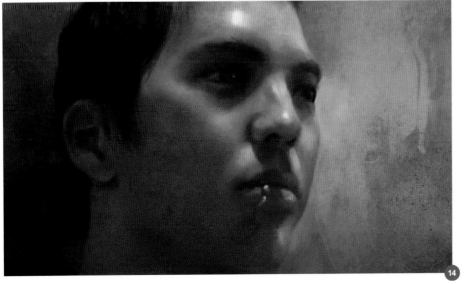

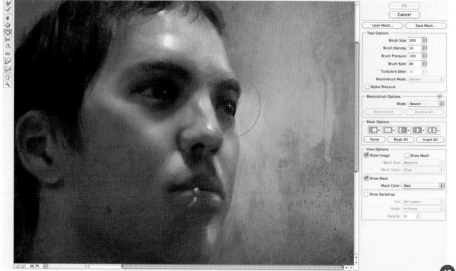

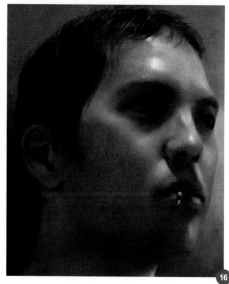

make your painting look fake. My value range isn't quite what I want, so I add a Color Dodge layer and paint into it using a dark gray. Using a neutral color will preserve the colors of your painting. Also, don't pick a gray that is too light, otherwise you will blow out your painting.

The Liquify tool is an awesome tool that will let you change your painting quickly without having to repaint anything. It is a great tool for concept artists that need to make changes quickly (**Fig.15 – 16**). Select the area you want to change and then go to Filter > Liquify. The far eye is too small, so instead of using the Transform tool I can use the Liquify tool to

make a more seamless change. Once you hit Liquify there will be a number of new icons on the left-hand side of the screen. The one we want is the fifth one down. It will allow you to increase the size of things. Once I have that selected I can change the brush size using the Brush Size option to the right. All I have to do is tap down on my tablet to increase the size of the eye. Once I have the changes I want I just click OK.

MAKE IT FAT
After coming back to the image I can see that the face and neck look way too skinny compared to the reference (**Fig.17**). In order to

"fatten" up the face I flatten the image, select everything, and then hit Ctrl + T (Command + T) to transform it. I then pull the side handle bar out and boom, instant fatness added. For the neck I just paint it in the old-fashioned way and add in a little bit of a bluish rim light on the back of the neck. Another important aspect of painting a portrait is knowing when to exaggerate or pull back certain features. If you were painting an upper-class woman, you might want to make her look a little more elegant by lengthening her neck. Again, it just depends on what you are trying achieve with your painting. I guess that sometimes when working on a self-portrait you feel the need to cheat a little and take off a few pounds or edit out some wrinkles. Don't fall into the trap – make it fat!

POKE A STICK IN IT
The hardest part is knowing when you are done. If you feel that you've accomplished everything that you set out to do and you are happy with the result, don't stop, because you still have 5% more to go. Step away again and come back to it later. I can almost guarantee that you will find something you will want to fix or change when you come back to it. When I came back to mine I noticed that the mouth was too far forward and the colors were not where I wanted them to be. I added more blues, reds and purples since the skin tones were still a little too yellow/green. I only put two hours into this painting, but I felt that it was in a place that I felt comfortable with calling it finished (**Fig.18 – 19**).

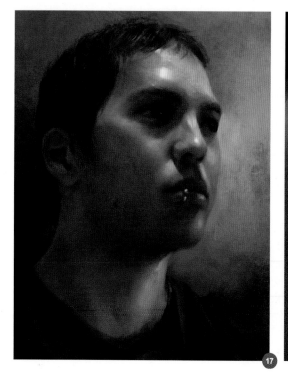

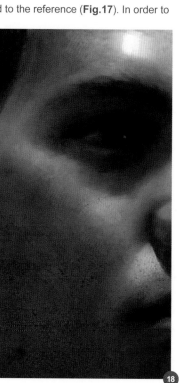

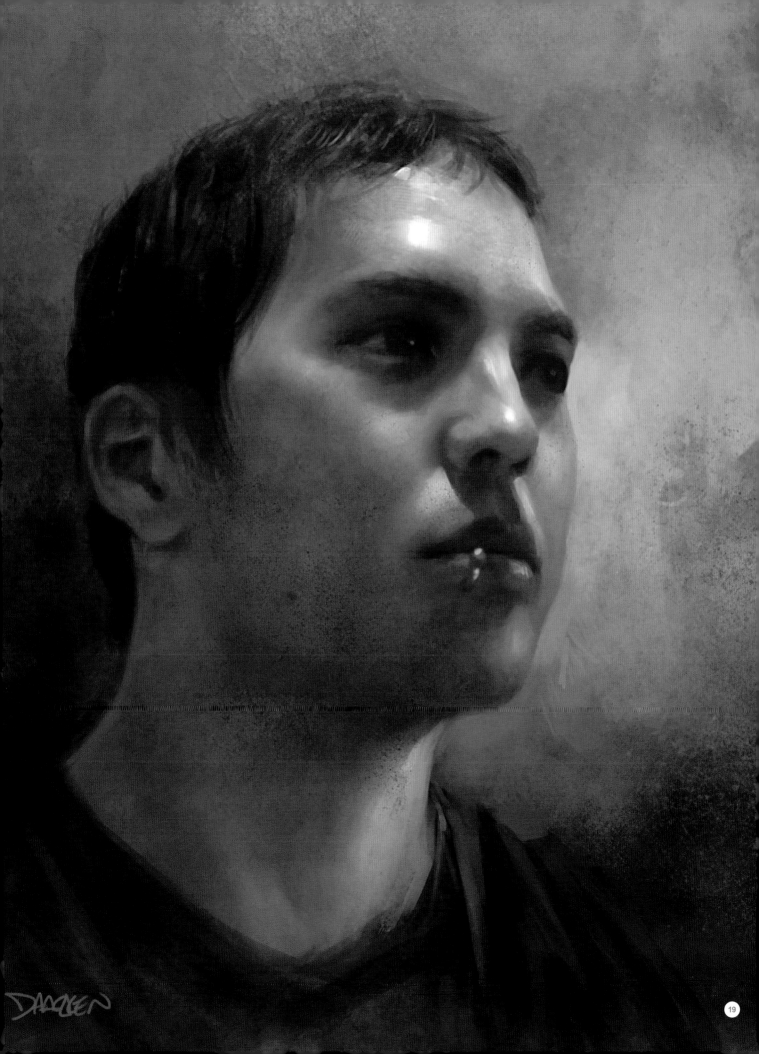

DARREN

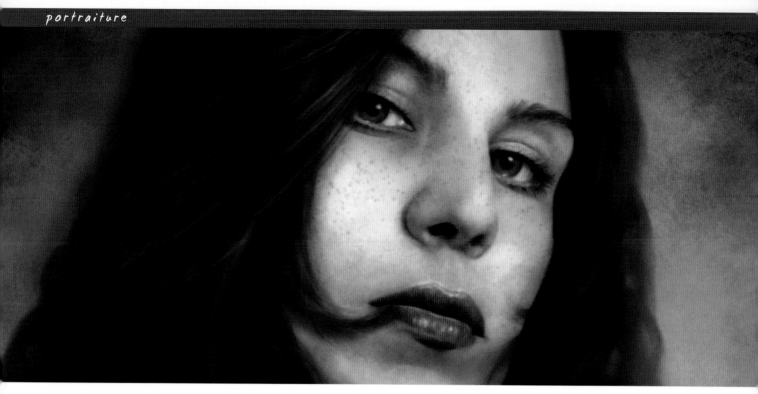

BESTE EREL
BY NYKOLAI ALEKSANDER

SOFTWARE USED: PHOTOSHOP

INTRODUCTION

The skill of portrait painting is about as old as painting itself. Humans have always loved to do portraits and document in pictures what they see around them. And it's no different today, only now we have lots of gadgets and technology to help us capture what we see before committing it to canvas, so to speak.

Painting a portrait from a photo (or life, for that matter) has, first and foremost, nothing to do with art. It's a mechanical skill. It's eye-hand coordination, translating what you see in front of you through your brush onto a surface of your choice. If done well, it becomes an art form, and if you add your own interpretation, it can become art.

That said this workshop will look at the fundamental basics of painting a portrait from a photo. I chose fellow artist Beste Erel (**http:// lllaurore.deviantart.com**) for this, and the particular photo I'll be using as reference is perfect for what I would like to go into. Also, I felt it's from an interesting enough angle to keep me, and hopefully you too, challenged and hooked.

LET'S PAINT!

We have our photo (**Fig.01**), and we have a new canvas open in Photoshop. Now there are several ways to begin with a portrait like this:

Eyeballing – As the name suggests, we can simply sketch out the composition by eye (on

© BESTE EREL ON PHOTO
01

a new layer), frequently looking at the photo reference to make sure we get the likeness right, or at least the proportions of the key features within the face. Measuring has been known to help with this. Some refer to this as "freehand" sketching, but others use that term when there are no references involved at all, so it's a bit of a toss-up to what it actually means. It is good practice to do this on a regular basis to train yourself and keep your hand-eye coordination sharp.

The Grid – It's a great little tool used by old masters and new artists alike. It's said to have helped Rembrandt figure out depth and proportions, and can be seen in various Da Vinci sketches as well, mainly to help with

02

CHAPTER 7 188

perspective. The best thing is that it's really easy to do! All you need to do is place a grid layer over the photo and the same grid over your empty canvas, and off you go – using the grid as a guide for feature placement (**Fig.02**). If your canvas is much bigger than your photo you may want to either reduce the canvas size to match the photo's dimensions, or increase the size of your photo so the grid really will be the same in both. It goes without saying that for the sketch you add a new layer.

Tracing – The magic word that thou shalt not utter lest you want to incite the wrath of various groups of fine artists out there, who believe that even using a reference is sacrilege. Thankfully, they will not be reading this tutorial. Tracing is another one of those very old methods of getting stuff done. In the traditional art world, people use projectors or light boxes to achieve this. Back in the days of the Renaissance candles would be placed so they threw a shadow outline onto the canvas, or the preliminary sketch for a piece was perforated along the lines with a fine needle and then the paper was placed on the canvas and covered in fine charcoal dust, which would go through the holes and stick to the canvas.

In the digital world, you just need to drag the photo onto your canvas, transform its size to however big you want it to be on the canvas and reduce its opacity by half. Then you add

a new layer and trace the photo. Once done, remove the photo from the canvas and you'll be left with a line drawing.

No Sketch – Of course, you can ditch the idea of a line sketch altogether and start straight with color, starting with blocks of it and almost sculpting the features with paint as you go along. I personally find this method easier when I don't have a reference, as I find it's a more intuitive way of working, rather than a precise one. But that's just me.

Whichever method you use, it doesn't matter because when it comes to painting one thing still holds true: if you don't know how to paint, don't know about light and shadows, colors and form, it really makes no difference how you get the sketch done, or how perfect the line art is, you can still screw up the painting.

So, with the sketch done let's start painting!

I like to start in color right away. Some people prefer doing a value painting first then overlaying it with colors later, but it boggles my mind and when I try it, it always comes out looking really dull and flat. Choosing the right colors is important, as they will set the mood as well as compliment (or clash with) your subject.

> **Quick Tip**: Of course, you could just use the colors exactly as you see them in the photo, but that isn't always such a good idea – like in this case. Also, choosing your own color palette will stop the work from being a direct "photocopy", which in most cases is rather boring to do anyway and pointless too, unless it's for practice.

Filling the background of the canvas with a grayish green that I actually picked off the

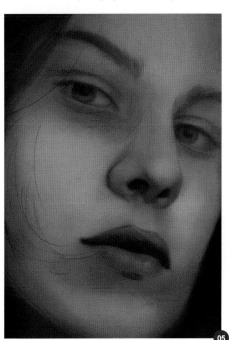

background of the photo, I start to choose the main colors I want to use. I already know what I want to do with Beste, and feel that for now a limited palette of mostly muted dark and cool tones will be a nice base to start with (**Fig.03**). The reason I like to start off with such muted colors is because it's easier to make them pop later through various means than to mute fully saturated colors without losing depth. And as you can see, I've also adjusted the composition of the sketch slightly.

Adding a new layer under the sketch, I start by blocking in everything with a Hard Round brush, with Opacity set to Pen Pressure. I tend to play with the colors in that I use very little pressure as well as manually adjusting the opacity, and thus apply paint thinly layer by layer. It would be the digital version of what's known as glazing. The color variations you get by doing that are usually very interesting.

Once I'm happy with the first approach, I decide to duplicate the layer I've been painting on to get a more solid look and then merge the two layers (**Fig.04**).

I continue as before – same brush, same settings – to refine the features a little more. I found the Smudge tool does the trick when blending and smoothing the colors when used with a speckled or otherwise rough-edged or irregular shaped brush tip, with Strength Jitter set to Pen Pressure, Angle Jitter to 50% and Scattering to around 30%. This prevents it from being smeary, and adds a very subtle texture in places. At this point I can already reduce the opacity of the sketch layer, too (**Fig.05**).

Now comes the part where you just keep refining and refining and refining, while keeping one eye on the photo reference to make sure

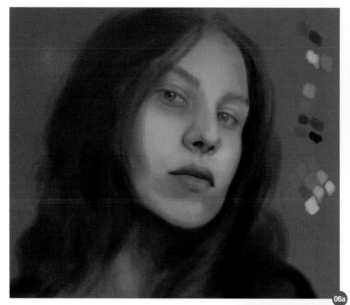
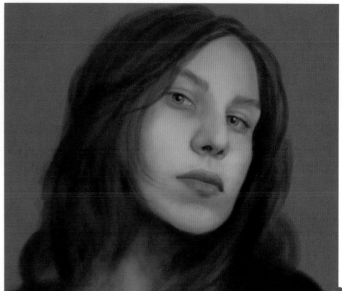

you get it right. Sometimes it helps to flip the canvas (and the photo) to see things that you may have missed before or even leave the work alone for a day. You'll see I'm working on the hair a little bit as well, and at this point I just use the same standard Hard Round brush for this as I am using for the face (**Fig.06a – b**).

Having pulled the face off the canvas a little more, I have a better idea of what I want to do in the background. More often than not portraits don't need elaborate background scenes. Some simple shadows and highlights tend to do the trick, as this keeps the focus nicely on the person depicted. Using a custom brush (my favorite rectangular one) adds instant texture (**Fig.07**).

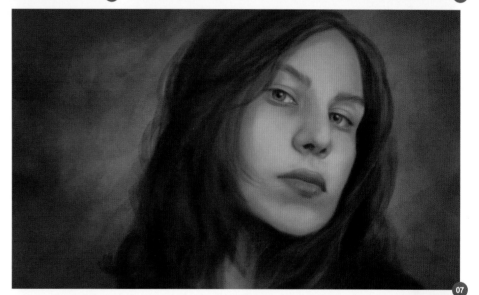

Before I continue refining the details of the face, I want to pop the colors a little. At this stage, I tend to do that using Levels, Variations or Curves, or a combination of the three, depending on what gives me the best results. As I want to see what the whole image would look like if adjusted, I duplicate and flatten it, then do some test adjustments. Once I like one, I apply the same adjustments to the canvas that I'm actually working on, one level at a time. Here I've used Levels as well as Variations to up the contrast and adjust the colors slightly (**Fig.08**).

Next up, I mainly smooth out the hair base and shoulder area, again using the Standard Round brush and Smudge tool. The background gets

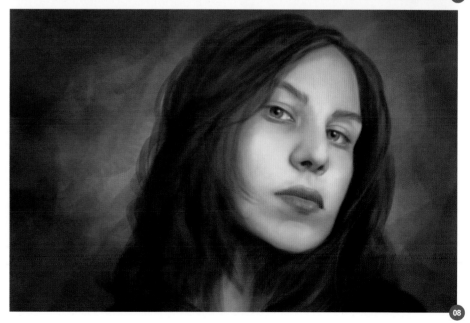

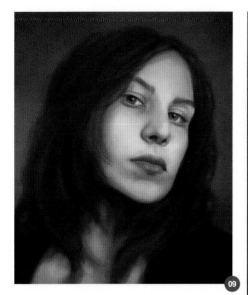

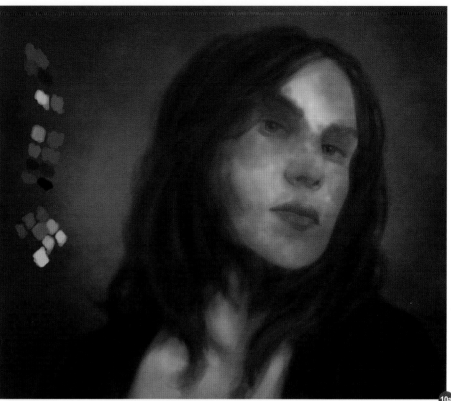

a bit more attention too, this time with a custom brush that's somewhere between speckled and blobby (**Fig.09**).

At this point, the portrait looks decent, but way too smooth, which is due to the Smudge tool usage. Some people like it like that, and that's cool. I don't, so this is not so cool. For me, this is just the perfect base to work from.

> " I CANNOT STRESS
> ENOUGH THAT
> CONSTANTLY
> LOOKING AT THE
> REFERENCE WILL
> REDUCE THE CHANCE
> OF MISTAKES
> HAPPENING "

Before I continue refining things, I'm going to take a big, rough custom brush, add a new layer and go wild with random brush strokes. The reason for the rough-edged brush is it will add some very subtle texture into the mix (**Fig.10a**). You will see that I've mainly used the warm darker colors and there's a reason for this: it will bring life into her face without losing the green and blue tints. Once satisfied with the mess, I set the layer to Soft Light (and adjust the opacity if needed or add some more color), then merge the layer with the portrait layer (**Fig.10b**).

And from here it's back to refining things still using the Round brush with the same settings as before, though when needed I switch the

Size Jitter to Pen Pressure. I cannot stress enough that constantly looking at the reference will reduce the chance of mistakes happening; after all, you are painting a real person and you'll want the person to look like themselves.

I often see eyebrows and eyelashes painted far too precisely, hair by hair. This tends to give a face a plastic look that and unless you're designing a Barbie Doll you may want to try and avoid this. You may be able to see single

hairs in the photo and, of course, in real life, but in a painted portrait what works well is creating the illusion of hair (**Fig.11a**).

For the lashes I add a new layer, as that gives me more freedom to erase bits and soften them as needed with the Smudge tool. And don't be scared of stray lashes! They add realism to the whole. Once happy with it all, I merge the layers with the portrait layer (**Fig.11b**).

Time to move on to the lips and nose now. They don't need that much refining, but I've noticed a few flaws that I want to iron out. You'd be surprised how some small details really change the look of a person (or their expression, for that matter), so paying close attention to this can be very beneficial.

In this case, I just work a bit more on the texture and volume of the lips, still using the Round brush as before (**Fig.12a – b**).

Happy with the face for now, I review the general composition and decide that she needs more space, namely to the right. And I like the fact that the shoulder is cut off in the reference on the left, so I'm going to do the same. Grabbing the Crop tool, I am going to kill two birds with one stone: cropping the part on the left, and extending the canvas to the right. When first applying the Crop tool, it will automatically only let you go as far as the canvas edges (**Fig.13a**). Once you have that, you can adjust the crop on whichever side you want, in and outwards (**Fig.13b**). This process saves you the time of having to use Image > Canvas Size in the main menu. The final crop

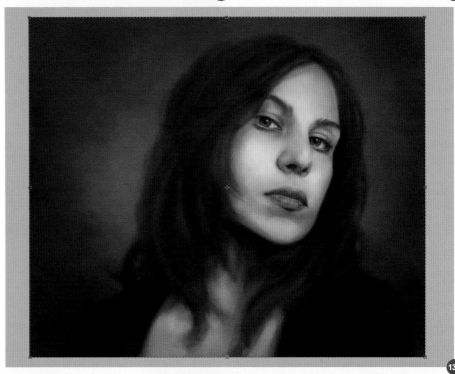

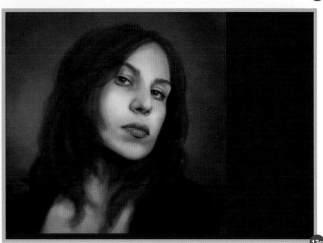

> "HERE IS A PART OF A PORTRAIT THAT MANY PEOPLE SEEM TO STRUGGLE WITH; THEY EITHER PAINT THE HAIR TOO WASHY AND BLURRED, OR FAR TOO DETAILED, HAIR BY HAIR

will use your current background color to fill the new space you've just created (**Fig.13c**). Obviously, the background has to be adjusted now, so I do that first. I fix the hair a little, erasing some of it on the left (**Fig.14**) and then have a look at the shoulders.

Something about the shoulder area still bothers me, probably because most of the definition that would be there, such as collar bones and neck, is hidden by the hair. Now, I don't want to change the hair in any way, as I think it's one of the lovely things about the reference photo – it frames her face beautifully. So I'm going to change her top and get rid of most of the skin that is still visible, while filling in the gap that was left by the cropping at the same time. At this point I also decide to pop the colors some more by adjusting the levels and adding another, stronger shade of green to the background (**Fig.15**).

Right, the hair. Again, here is a part of a portrait that many people seem to struggle with; they either paint the hair too washy and blurred, or far too detailed, hair by hair. Now, if you look at the reference picture you can see how her hair is in bundles or strands and there are only a few stray single hairs floating about. And that is what we'll mimic in the painting.

As I've already painted the base of the hair, I can instantly concentrate on getting some more detail into it. The easiest way to go about doing that is using a speckled brush with Opacity and Flow set to Pen Pressure, and Size Jitter switched off. Adding a new layer, I pick one of the lighter colors from the hair that I've already painted and set about adding the blotchy mass that is going to be the hair, blending it ever so slightly with the Smudge tool here and there (**Fig.16a**).

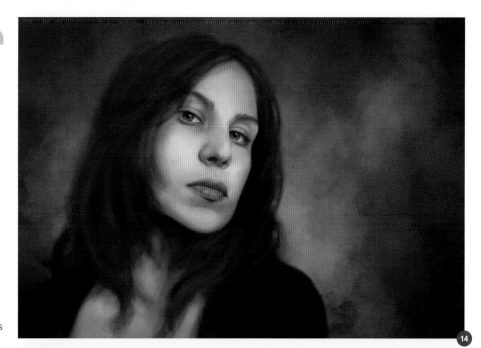
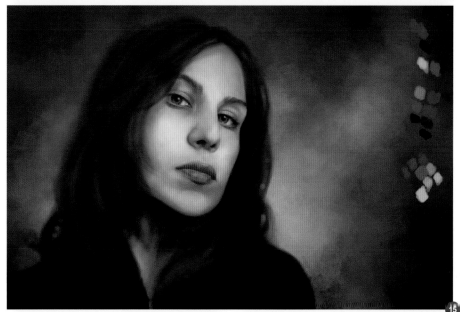
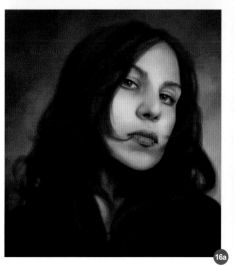
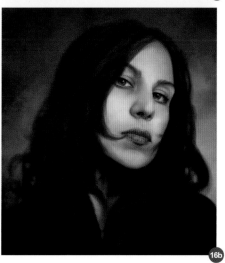

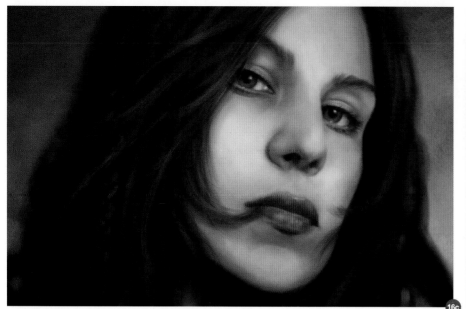

16c

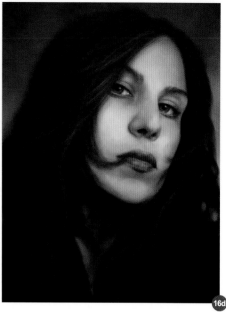

16d

I continue to add some more definition with a speckled brush on yet another layer, but reduce the Opacity and Flow manually as well as leaving it set to Pen Pressure (**Fig.16b**). The layers get merged quite frequently and new ones added, but that's just how I work. If you prefer to keep all the layers separate, that's fine too. Just keep an eye on the file size, as it can increase quite dramatically if you keep adding new layers without merging any of the previous ones.

Now that the basic hairdo is laid down, I can start to really refine some areas. I don't want to go into detail all over, just around the part of the hair that's obscuring part of her face, as well as the small braid. I'm still using a speckled

brush at this point, with settings as before but a much smaller size, as well as another custom rough-edged brush with Size, Opacity and Flow Jitter set to Pen Pressure, and Angle Jitter at 25%. I also employ the Smudge tool quite a bit to soften up some of the strands, giving the illusion of soft flowing hair (**Fig.16c**).

I just keep at it, working on finer and finer sections of the area I selected to refine, while the other parts of the hair get less attention, though I am still working on them too. Sometimes you can get some really nice effects by duplicating a layer, moving it a bit and setting it to Color, Overlay or Soft Light. Also, don't worry about it if you draw a hair "out of line" – hair has kinks and curls and generally

flies off sometimes. Having those irregularities in it makes it look more realistic than a perfectly ordered hairdo (**Fig.16d**).

Happy with the hair, I go back to the face for a few last touch-ups. I feel the lips need a bit more work, so I set about detailing them with a small Round brush, with Size Jitter and Opacity set to Pen Pressure and Hardness to about 50%. Of course, I also use the Smudge tool with the same settings as before to blend, but sparingly (**Fig.17**).

Once that is done, I can look at the skin texture. This is the really fun part, because the effect you can achieve with some simple texturing is amazing. Female faces generally

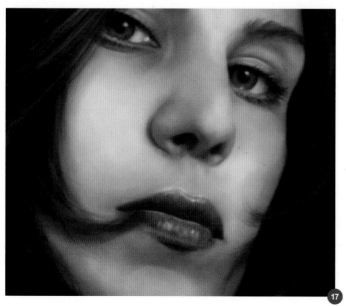

17

1) UNDERLAYING SKIN TEXTURE 2) SKIN TEXTURE
3) SKIN HIGHLIGHTS 4) FRECKLES

18

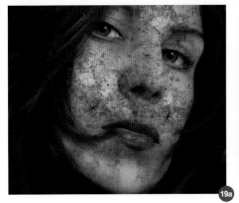

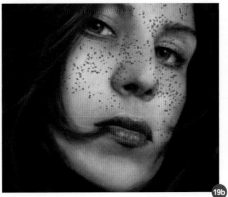

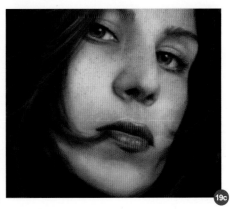

seem a lot smoother than male faces, due to a smaller pore size and the use of make-up, but that doesn't mean they shouldn't have any texture at all. It just should be a lot more subtle than if you were painting a male portrait. Beste told me she likes freckles, even though she doesn't have any, which is great because that gives me some additional texture to work with. First though, just the normal skin texture.

The various brushes I will be using range from several speckled ones to a custom photo texture brush that I've had so long that I don't remember what the original photo was of, but it most definitely was some kind of stone, probably marble (**Fig.18**). If you wonder why I would rather use that than one of the many "skin textures" that are out there, it's quite simple: they may work for 3D characters, but I find that actual skin texture makes painted skin look even faker. But that's just me.

Adding a new layer for each texture, I select the brush and make sure all Pen Pressure settings are switched off, while the Angle Jitter is set to something like 50% – this will ensure that the texture is even all over in intensity to begin with, but doesn't look repetitive. I apply the texture all over the face and then erase the areas that wouldn't have any, such as the eyes and nostrils, and a little on the lips too. Then I set the layer either to Soft Light or Overlay and reduce the opacity as needed. I use an eraser to remove some more of the texture in places, and the Blur tool to soften it where needed, or apply the Gaussian Blur filter. It's the same procedure for each texture layer – sometimes more, sometimes less – until it looks right to me (**Fig.19a – c**).

The last thing I do in any painting is some targeted softened edges, or additional lighting – in this case particularly around the hair on

the right. I add a new layer, pick the color from the background and, using a large Soft Round brush, gently paint over the edge of the hair (**Fig.20**). For additional lighting (if needed) you do the same thing, but set the layer to Overlay or Soft Light to get some nice color popping effects. Playing around with this is usually best, as using different colors and settings for this obviously gives you different results.

And that's pretty much it. All I do now is adjust the background contrast to my liking (usually with Levels), then flatten the image and adjust it some more with Levels and Variations, cropping and adding more additional lighting layers if needed, which of course will be flattened too.

Done!

IN CLOSING
Portraits like these are fun to do, because you can take them as far as you want to take them, and change everything or nothing at all. It's in your hands. Fact is, people love having their portrait painted because it is slightly more special than just having a photo taken, and it provides good practice to keep your observational skills sharp, no matter if you're a beginner or not.

So, grab some photos of your friends and family and get going (**Fig.21**)!

You can download some movies (MOV) files to accompany this tutorial from: **www.3dtotalpublishing. com**.

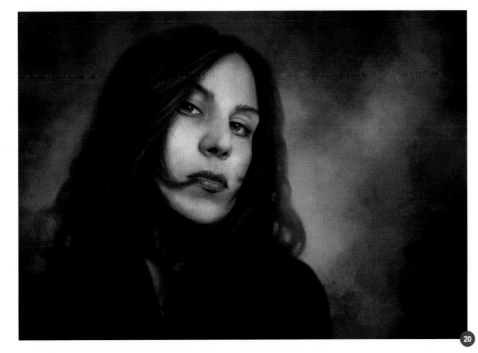

CHAPTER 7

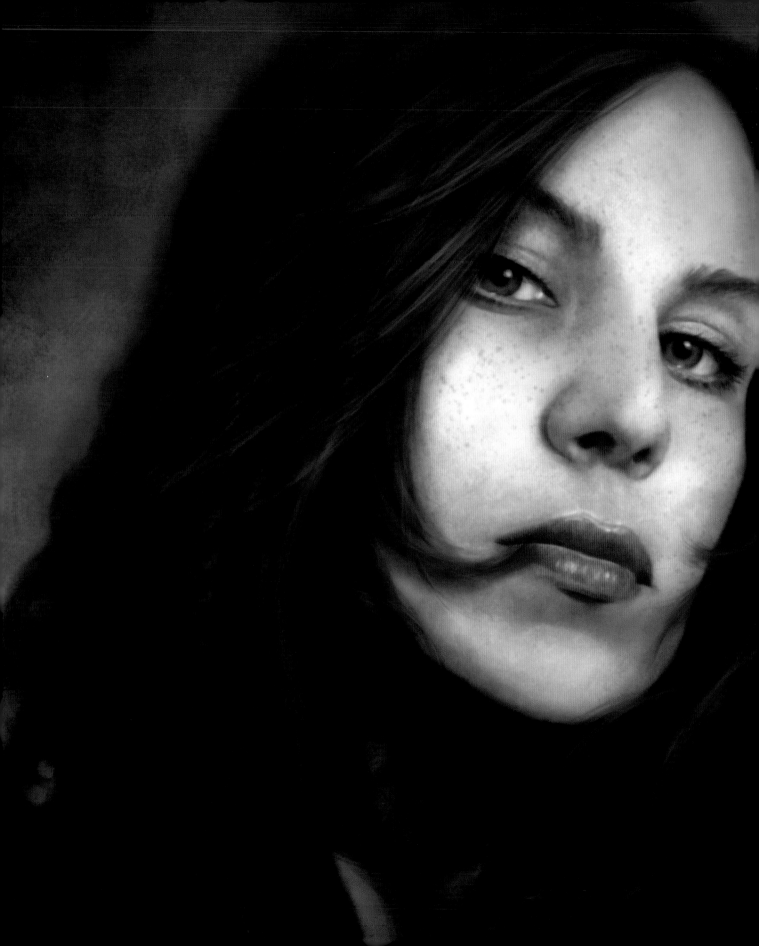

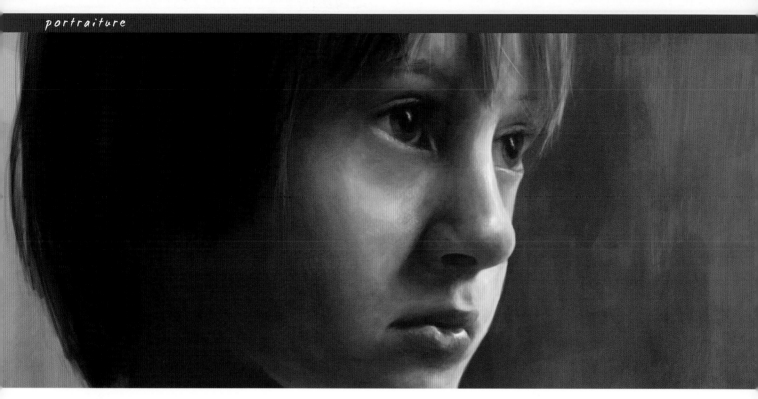

GABRIEL
BY RICHARD TILBURY
SOFTWARE USED: PHOTOSHOP

INTRODUCTION

This tutorial requires a portrait to be painted using a photo as a reference and so the first decision that needs to be made concerns the subject. I've decided to paint my son Gabriel and so pick up the camera and try my best to persuade him to sit still while I take a few pictures. I photograph him from different angles in order to get a variation in the lighting and in the end opt to use the photo that can be seen here in **Fig.01**.

I also photograph him from the opposite side, but most of his face is in direct light and so does not look quite as good as this angle where there is a more interesting play of light and shadow. I like this particular photo compared to the others partly because of the light, but mainly because of his expression which looks strangely melancholic; probably caused in no small part by my asking him to sit still for what seemed like an endless period of time! Anyway after taking a series of photos

and considering them all carefully I'm going to go with this one.

BLOCKING IN

When it comes to digital painting the canvas proportions are not crucial as you can always extend the frame later or alternatively trim it, which is a luxury unavailable in traditional painting without re-stretching. I opt for a traditional portrait ratio and then begin to make a mess on the background to get rid of the white void. I always keep the character separate from the background so that I can experiment with the color schemes independently. I use an array of brushes when blocking in, which range from the standard Hard Round brushes to Chalk ones that incorporate a dual brush.

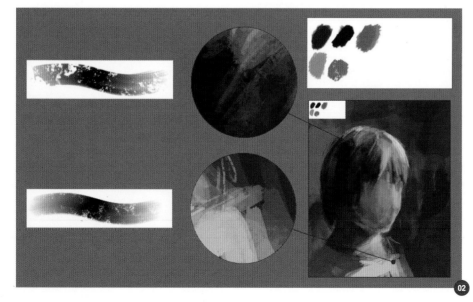

Fig.02 shows two details that use different brushes alongside a color palette in the top left corner. I've created this palette so that I can quickly pick the light, mid and darker tones whilst roughing in the general tones. You could, in fact, use the photo directly to establish your palette, but it will not be good practice for your eye and so I prefer to do it the old-fashioned way; after all we do not want an identical copy.

Whilst working on the initial stages I like to reduce the size of the canvas so that I get a good overall impression of the painting and so I don't get carried away with detailing. **Fig.03** shows the typical view of my workspace with both the photo and the canvas at about the size I use to begin with.

Fig.04 shows the progress from the initial block-in through to putting in the features. I find it is always good practice to work on the image as a whole and develop each area of the canvas at a similar pace. This way it is easier to see which areas may be wrong or need alteration. I can see at this point that the proportions are inaccurate, but I find it is much better to have something on the canvas. After all it is easier to change something when it is in front of you as opposed to existing purely in your head. During this phase I use the color palette to block in the volumes and get a sense of the light in the photograph.

I find the best way of tackling any painting that is based on "real world" observation is to establish early on the key areas of dark and light. In this case there is a distinct shape

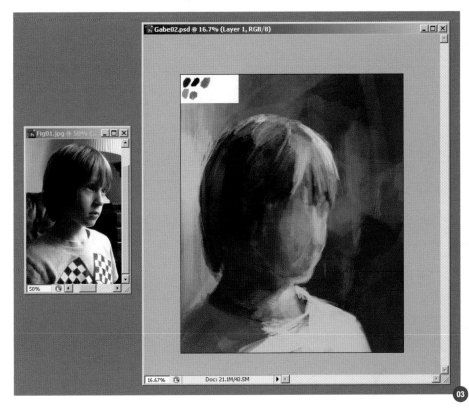

created through the face and hair that marks the boundary between the highlights and shadows (see red lines).

I often squint my eyes and try to get a simplified view of what I am looking at, as this encourages a keener focus on the main structure and proportion of the subject as opposed to any details.

In the middle stage I provisionally add in a value for the white area of the eyes. I also block in the highlight catching the lower eyelid together with the shadow around the eye

socket. This intermediate stage is used to sketch in the eyes, nose and lips so that I have a clearer idea about the overall proportions and their relationships.

If any part of a portrait is wrong it will have an impact on the whole face and how we perceive it, so it is important to balance everything carefully. You can see in the final stage that all the features are now in place and how much more successful the image reads as a result. I find it far easier to see where something may be wrong if all of the components are in place. If you were to paint a perfect mouth

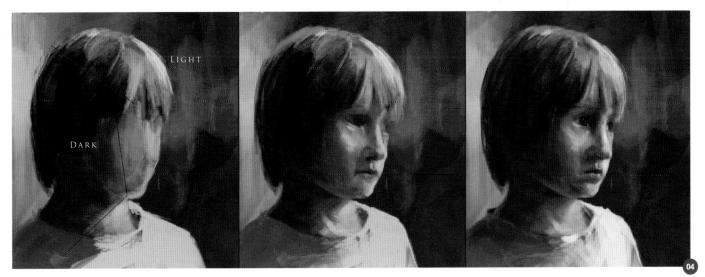

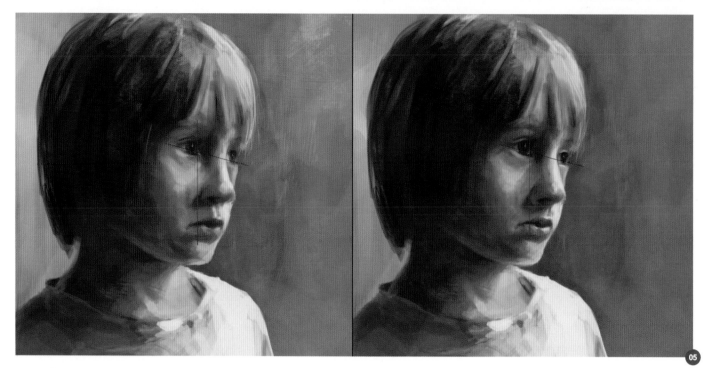

05

and nose they may still look wrong if the eyes were missing. These are what I think of as the essential foundations and from here I usually begin the process of building and refining the painting.

ADJUSTING AND REFINING THE FEATURES

The background looks a little too messy and so I make this look more uniform first of all. I then copy the eyes onto a new layer and use the Transform tool to re-position them and change the scale. **Fig.05** shows the modified version on the right with some guidelines to better show the changes. The angle of the eyes has changed as well as the relationship between the left eye and the nose.

The thing to remember about portraits is that the smallest of changes can have a seemingly big impact on both the likeness and expression. I think the right eye looks a little too small compared to the near one (left image in **Fig.06**) and so I use the Edit > Transform > Scale tool to address this. I can also see that the mouth shape is wrong, with too much shadow between the lips and no curvature to the upper lip.

There are two main ways I change things in a painting and one is by copying and pasting selections and then using Transform tools,

such as Scale and Rotate, before blending these back in using the eraser and some brushwork. The other method is by way of the Warp tool, which is equally useful but I advise doing this on a duplicate layer because if you are not careful you can end up with some obvious distortion.

So far I have been adjusting just the features of the face as these are the more crucial

elements, but the hair and shoulders need to catch up a little. I create a new layer temporarily and then, using a finer brush, paint in some strokes to add some definition. Most of the hair is in shadow when looking at the photo and so can be broadly blocked in, but the transition between this and the highlights requires some finer detail. **Fig.07** shows the image beforehand (left) and the result of this additional layer.

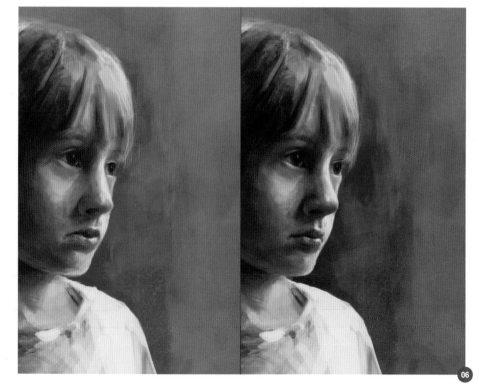

06

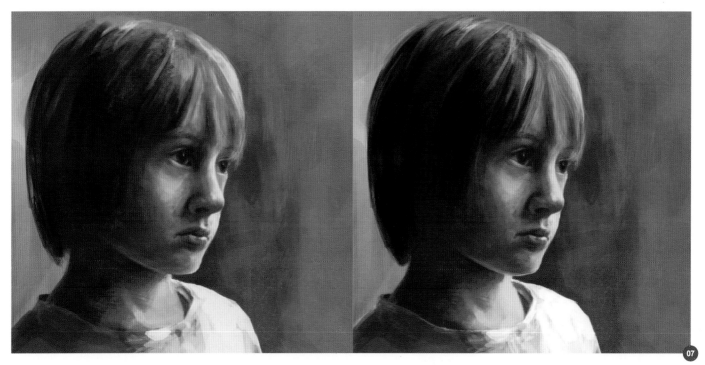

This is generally the pattern I follow from here on in; creating new layers for additional refinements and detail, and then flattening everything once I am happy. **Fig.08** shows one such version with a smoother transition between the light and dark tones.

At this point I also alter the background, which remains as a separate layer. I keep a darker area to the right-hand side and a lighter band behind the head in order to create a contrast and play of light against dark. To reflect the warmer tones of the face and hair I also add in some reddish tones to help balance the portrait with the background.

FINAL STAGES

In some ways I could finish the painting here, but there are still a few improvements that can be made. Although I could have left it alone, I decide to refine the t-shirt as doing something like this often lends a fresher quality to a painting as well as giving the viewer a better glimpse into the processes (**Fig.09**).

Perhaps more significant is the change I make to the angle of the chin, which becomes sharper, and the shape of the right pupil and lens, which are given a more elliptical shape. The nose is also modified slightly with a

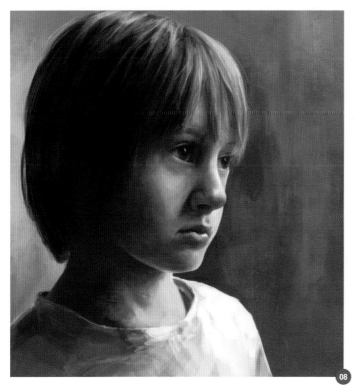

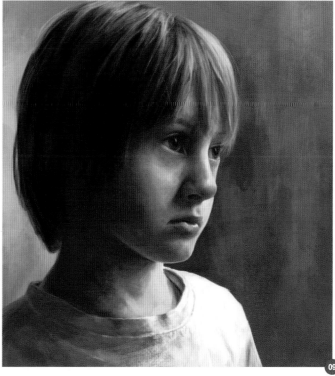

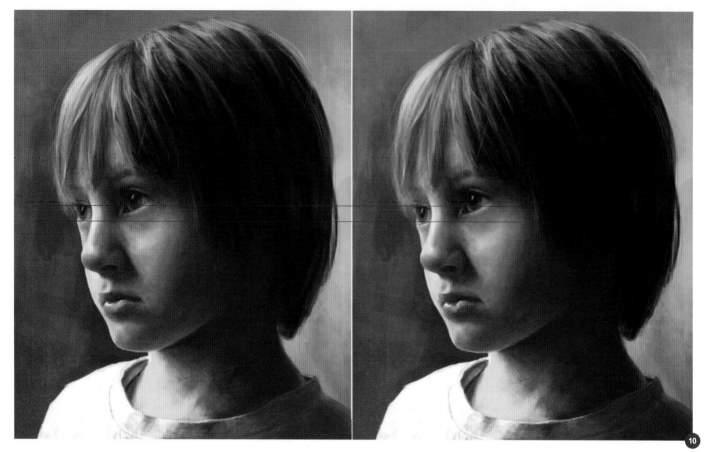

10

more defined change of angle as it slopes up towards the forehead. All of these changes are indeed modest, but collectively create an important difference to the overall portrait.

You will hear many artists say how valuable it is to flip their canvas horizontally from time to time in order to reveal any problems that they feel are there but cannot detect. I am no different in this respect and do this frequently throughout the process. Flipping the canvas reveals that the left eye looks wrong, so I scale up the eye slightly, the result of which can be seen in the right-hand version of **Fig.10**.

One thing to be aware of is that a camera is liable to distort a person due to the lens and so when painting from this type of reference you may need to adjust proportions in order to account for this. I think in the end that you may need to balance what you see with what you know and use a little artistic license if you feel the painting does not look right.

Another aspect which is not wholly accurate is the width of the hair and neck, which look too big. Using the Warp tool I pull in the left

edge, which makes the neck look more slender and the area of hair somewhat smaller. **Fig.11** shows the portrait beforehand (left) alongside the result of this subtle transformation.

This almost concludes the portrait barring a soft highlight below the nose and a slight tilt of the lips. Here is the final version which I hope does my son justice (**Fig.12**).

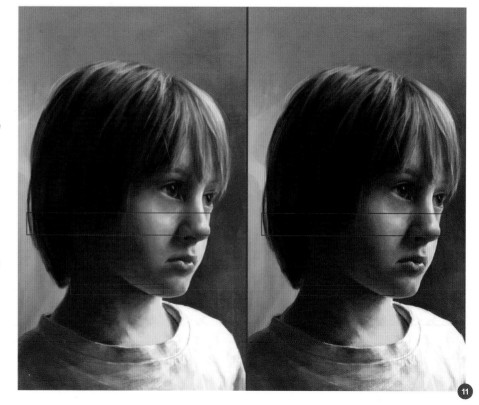

11

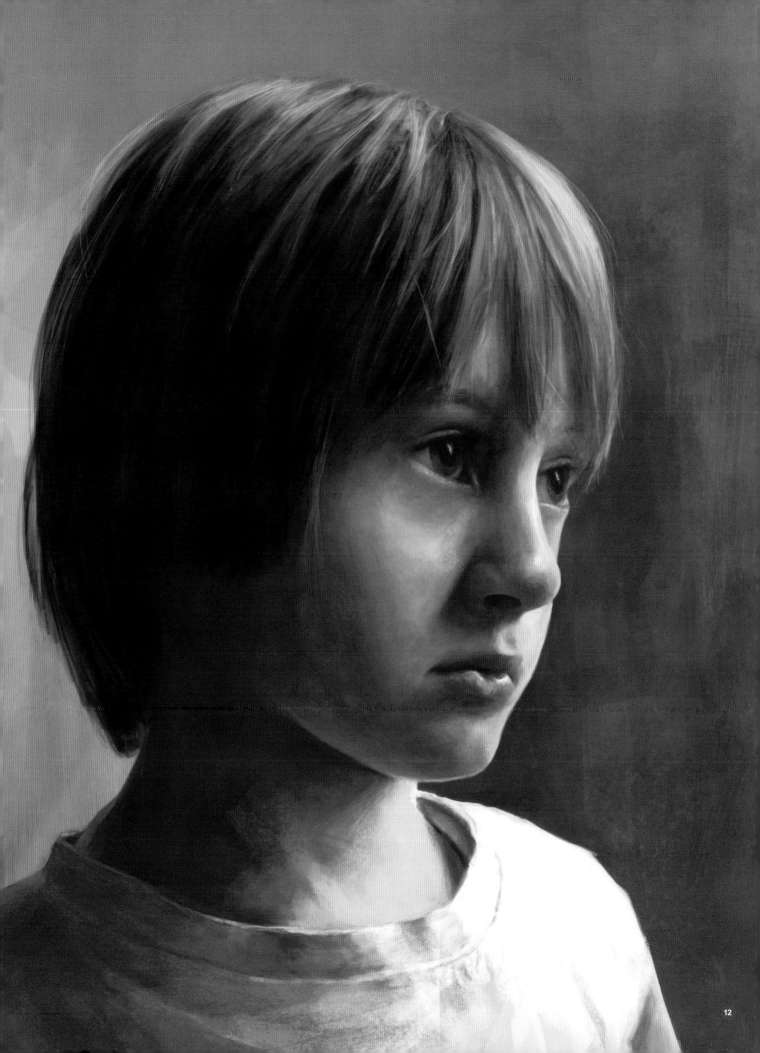

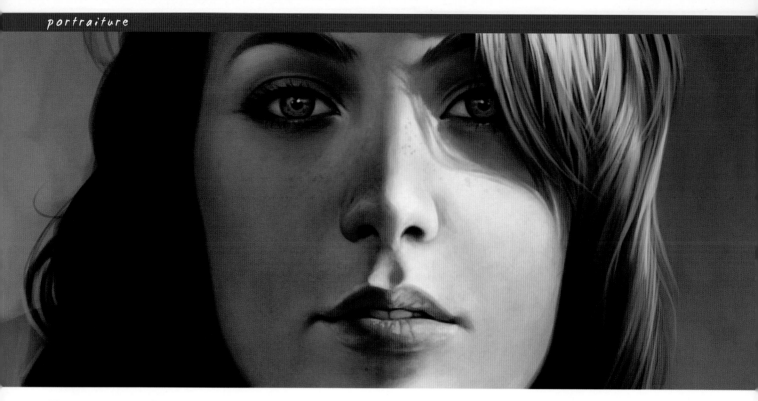

FEMALE SELF-PORTRAIT
BY CHARLIE BOWATER

SOFTWARE USED: PHOTOSHOP

REFERENCE

When tasked with painting from a photograph
I'm opting for a self-portrait. It's always better
to paint from life as and when you can; forms
can become a little distorted in a photograph
sometimes. However, it's not always possible
or convenient to have people sit for you and
photographs are certainly a great aid. I've
tried to pick an interesting photograph; there's
something about this that doesn't quite look like
me, but I love the strong light source enough to
pick it anyway (**Fig.01**)!

SKETCH

I don't always start out with a sketch, but when
painting from a photograph (and a self-portrait
no less) it helps to be a little more accurate.
Sometimes I begin by just blocking in basic
shapes and forms. In this instance, however,
I'm starting with a very simple guide.

This is to help measure out where the main
features should be (eyes, nose, mouth etc.,)
and it's just a layer of lines positioned over the
main features, then duplicated (**Fig.02 – 03**).

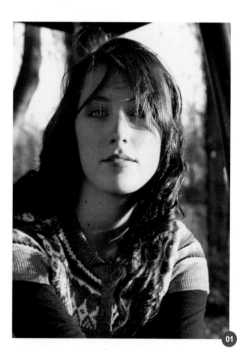

(You can create straight lines simply by holding
down Shift during a brush stroke). After that
I'm roughly sketching the rest by eye. You can
use grid methods if you feel more comfortable
with them, but personally I try not to get too
wrapped up in perfecting a very basic sketch.
It's looking pretty bloody ugly at this stage, but
the basics are covered so I can move onto
coloring!

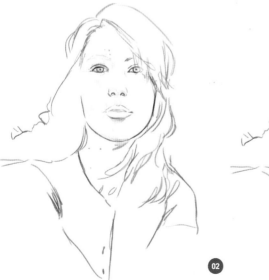

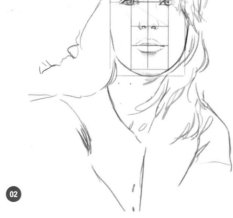

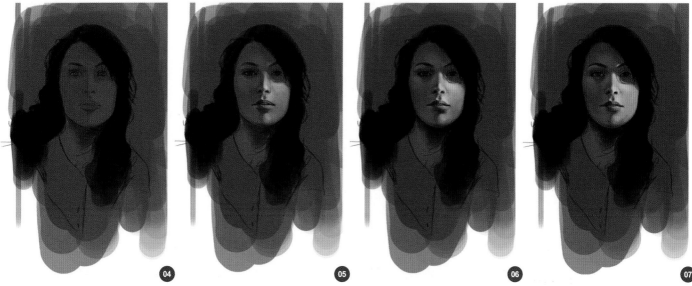

BRUSHES

There is an absolute plethora of different custom brushes available in every corner of the internet and whilst some of them are great, I've always thought you just can't go wrong with a basic Round brush. So that's what I'm using, a basic Hard Round Standard brush that comes with Photoshop.

BASE COLORS

When it comes to choosing your colors whilst painting from a photograph, I think it's best to avoid using the color picker. Photographs can become very pixelated and the colors can be distorted. Randomly picking a color won't give you a true representation of tones, especially with skin, for example! So use your own judgement and try to get as close to a tone as you can; it doesn't matter at all if it's not completely spot on.

Throughout the process of this image I'll be adding in so many different colors it won't matter by the end. The next step is to add some very basic tones on a normal layer below the sketch (the sketch itself is set to Multiply, which essentially makes it transparent) (**Fig.04**).

> ## ONE OF THE QUESTIONS I GET ASKED AN AWFUL LOT, IS HOW DO I 'KNOW' WHAT COLORS TO PICK. IN ALL HONESTLY I DON'T KNOW, I JUST TRY AND PAY ATTENTION TO MY SURROUNDINGS AND PICK COLORS THAT SEEM RIGHT

From this point onwards, everything is painted above the sketch and base colors. My paintings are always flattened eventually so I don't get too cluttered up with layers. A lot of the time, however, I will paint new sections on a new layer. I'm not a purist! If I screw something up, it's not too much of a disaster. As for working with or without lots of layers, it's a personal choice – just go for whatever you're more comfortable with. I'm starting to block in some very crude highlights at this point to help bring out the form of the face (**Fig.05**).

> *Quick Tip:* Try not to worry if your painting doesn't look very much like your subject at this point; it's a very early stage and things definitely come together better later on. Right now, everything looks pretty messy – the stokes are very visible and blotchy – but it's really just about finding the right colors and form so try not to get too wrapped up in making anything perfectly smooth at this point.

COLORS

One of the questions I get asked an awful lot, is how do I "know" what colors to pick. In all honestly I don't know, I just try and pay attention to my surroundings and pick colors that seem right. Working from a photograph

gives me a good guide and is easier than going with intuition. However, 90% of the time chances are I won't be completely happy with the color I've chosen and I'll end up changing it anyway. The color palette at the beginning of a painting and the end result are two very different things. So, if you're not happy with your color choices to start with, don't freak out. Photoshop is your friend and certainly has its perks (**Fig.06 – 07**).

One tool which is pretty much invaluable to me is Color Balance. I normally make a duplicate of the entire painting and then tweak the colors if I'm not happy, which is all the time. It comes in very handy if you want to make very slight or very drastic color changes to a painting. It also really helps to unify the colors if things aren't quite matching up (**Fig.08**).

You'll probably notice the tones of my painting gradually change throughout a painting. Sometimes I'll hop back and forth deciding on the right tones – I'm very indecisive like that!

CHIPPING AWAY

Once I have base colors and light sources established, I spend the rest of my time just chipping away at the details and carrying on with that until everything is refined. During this

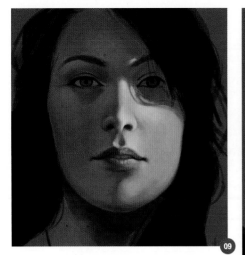

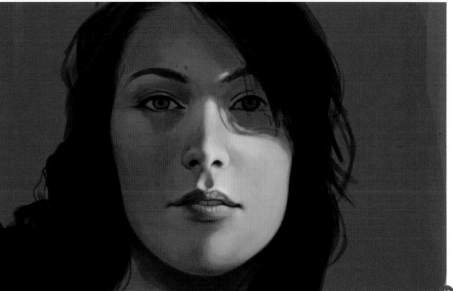

process I rarely stay on one section for too long; I hop between different features just to make sure I don't get too bored working on the same section for too long. It also helps to come back to sections later as you'll notice more mistakes that way. It's also apparent that the painting has a much smoother look now. It was quite blotchy to begin with, but things have gradually smoothed out through the process of refining the painting (**Fig.09 – 11**).

LAYER MODES

Throughout a painting, I end up using a mixture of a couple of different layer types. They're predominately Normal and Overlay. I obviously don't need to explain Normal, but Overlay comes in very handy. It's a great way of really ramping up the contrast. My photographic reference has a very strong light source. So I'm throwing in some overlay layers throughout the painting. I'm painting in a much brighter skin tone on the right side of the face, applying more of the same tone but on an overlay layer. This really helps to bring out the contrast and the glow caused by the sunlight. It also helps to add to that very bright red/orange you can see when skin comes into contact with sunlight. The opacity of the layer varies a lot for me, depending on what looks best. Experiment with layers every now and then and see what looks good (**Fig.12 – 13**).

The darker side of the face is still looking a little flat compared to the sunlit side. To counter this I'm going to use another Overlay layer and gently add in a brighter tone to highlight the structure of the face a little more, such as the cheek, brow, bone etc. I'm using a light green

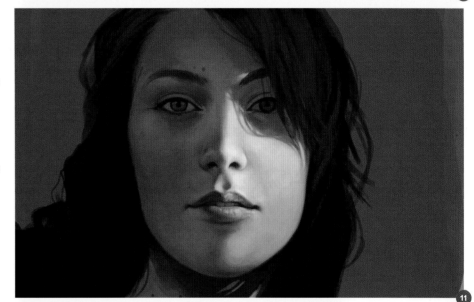

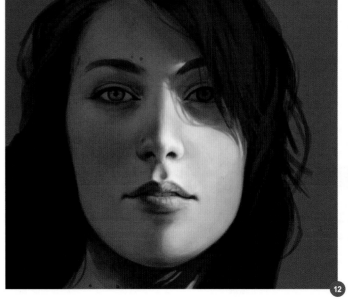

because Overlay can create very saturated colors. If I'd chosen a skin tone, the end result would be bright orange. Green won't cause this effect and generally works very well in skin tones too (**Fig.14**).

FLIP!

Another way of keeping on top of too many slip-ups is to regularly flip your image. Working from a photograph means I know which way my image will end up, but it's still very useful to flip things every hour or so.

Mistakes always stick out once flipped, so it's much easier to fix them throughout rather than reaching the end of painting and realizing it looks awful flipped the other way (**Fig.15**)!

> "I'D NEVER RECOMMEND TRYING TO BLUR COLORS TOGETHER. IN MY OPINION THAT APPROACH COMPLETELY SUCKS THE LIFE OUT OF A PAINTING AND IT ENDS UP LOOKING VERY MUDDY"

BLENDING

I'm pretty sure the one question I'm asked the most is how I blend. I always struggle to answer because I never "actively blend" two colors together. My way of blending is gradually layering up color, stroke after stroke in various tones until they're almost seamless (**Fig.16**). I'd never recommend trying to blur colors together. In my opinion that approach

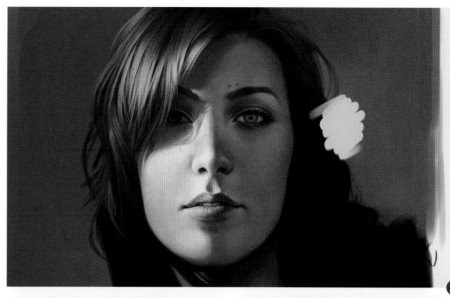

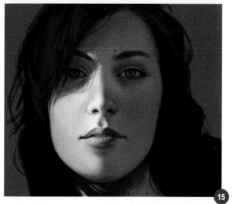

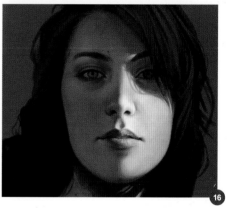

completely sucks the life out of a painting and it ends up looking very muddy, so don't worry if things look a little rough, just keep going! Pick a tone that bridges and compliments the colors you're trying to bring together, keep dabbing on paint strokes and they will naturally blend. If you are struggling, try using a brush with a softer edge. Although I wouldn't suggest using airbrushes (personal choice!) a brush without hard edges may help with the blend. It might

also come in handy to lower the opacity of your brush a little. Sometimes 100% opacity can be too much. Whilst I don't generally alter my opacity from 100% at any time, it's more about finding your own way of working and what produces the best results.

HAIR

Still using the basic Round brush, I block in the basic shape of the hair (**Fig.17 – 19**). Then,

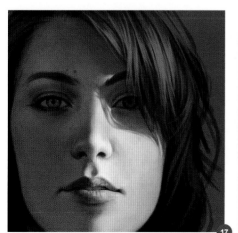

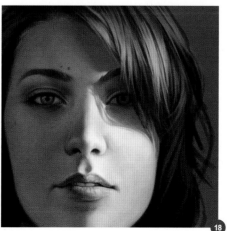

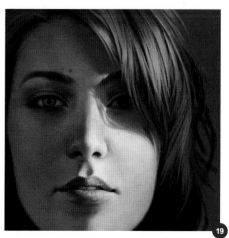

CHAPTER 7

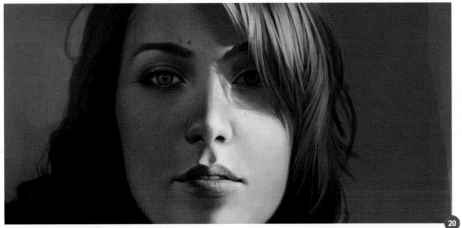

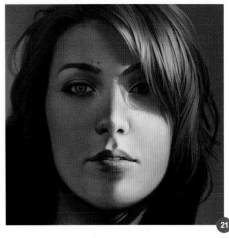

in the same manner as everything else, I start building up the lighter tones. I try not to paint hair as a group of individual hairs entirely, but rather paint it in sections and try to emphasize the way that hair naturally falls and groups together. Then I add in individual hairs just to add to that wispy effect.

I add in another Overlay layer in a light brown, which gives the hair a nice glow on the side being lit by the sun. After that it's a process of rinse and repeat. Just keep adding in sections, highlights and some individual strands until things start to come together.

FINAL TOUCHES AND DETAILS

Adding final touches is something that takes up a major portion of my painting process. It's also something that, in my case, isn't done in the "final" stages. Refining details is something that I do throughout an entire painting. It's a very gradual process for me and also very enjoyable – I love details! This is basically cleaning everything up.

For me refining the details means cleaning up the lines, such as the jaw line against the dark color of the hair. I can also at this point focus a lot more on adding details to the eye, eyebrow, nose and lips etc. I'm still using the same brush, just at a much smaller size. I usually zoom in considerably when working on details. Obviously it's far clearer and much easier when cleaning up the details (**Fig.20 – 21**),

ALTERATIONS

You might notice that certain details are not the same as my reference. One change in

particular is the hair. It was literally a mess! I wasn't too keen on painting it like that so use your artistic license. If you think something will look better another way then paint it like that! It's only a reference at the end of the day, not a script you need to stick to. Here you can see further refining has taken place (**Fig.22**).

You can see the close up detail in **Fig.23 – 24**. The painting is pretty much done at this point.

I've cropped the image a little and tried to add in some brighter colors, pinks and blues to bring out the blue eyes and the pinkish tones in the skin. I don't need to tell you that isn't based on the photo reference, but I'm just going with what I like.

I hope you enjoyed my tutorial and if you learnt anything along the way, excellent. Above all remember: have fun and be creative (**Fig.25**)!

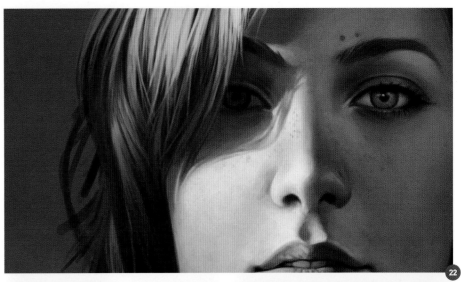

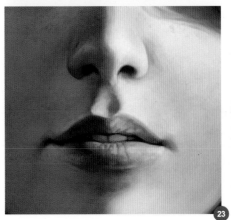

matte painting

Matte painting is limitless! It is the art that transports you magically to unreal times and locations you could never visit in the real life. It's a powerful tool that combines both 3D animation and 2D painting techniques to create the illusion of environments that would be impossible to build or film.

Because of this amazing attention to detail and the great sense of photographic realism, talented matte painters have the ability to convince the viewer that what they are looking at is real. So a good matte painting has to be as close to reality as possible and when it's well executed there are no boundaries but your imagination!

FREDERIC ST-ARNAUD
f.starno@gmail.com
http://www.starno.net

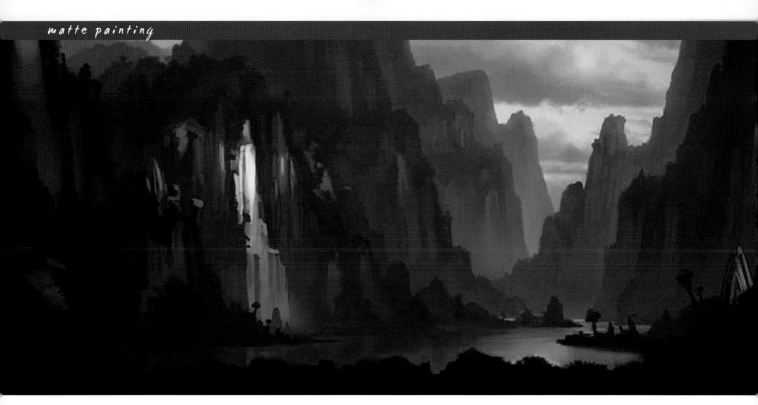

BLOCKING IN AND CONCEPT
BY PIOTREK SWIGUT

SOFTWARE USED: PHOTOSHOP

INTRODUCTION

The inspiration for this image came to me after watching Disney's 1999 animated film *Tarzan*. I wanted to create a jungle landscape with subtle light passing through big mountains that barely touched the mountain tops. I also wanted to use images that I shot during my trip to Vietnam.

BLACK AND WHITE SKETCH

I started with a very small black and white sketch. I usually keep them no bigger than 300 pixels wide as this way I am not tempted to go into details and can focus on the big picture. I heard once that if the painting looks good when it's small then it will look great once we make it bigger. I usually find this to be true.

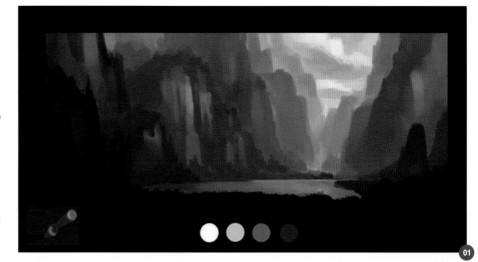

> **Quick Tip :** In the lower left corner I painted an arrow that reminds me of light direction (**Fig.01**). I also placed four round circles with different values in the middle. This way I can quickly use different values without using the color picker.

I used a bit of artistic license here as to where the sun's light hit the mountains. I intentionally painted clouds and placed the mountains in the valley because this way I was able to paint sunlight wherever I wanted without making it look too artificial. This way you can always say that thick clouds are casting the shadows, and if that is not enough you still have mountains that could put the entire valley in the shadow.

I was concentrating on giving good form to the mountains and showing a light side as well as a side in shadow. Also I was trying to lead the viewer's eyes across the painting until their gaze exits at the far mountains and the sky. I chose the waterfall to be the main focal point of the painting and the temple in front of it as a secondary focal point.

COMPOSITION

Here I will try to explain a little bit about the composition. It is good to keep in mind the golden rule (**Fig.02**) although I am not following any rule strictly because I found they limit my creativity. It is, however, very useful to learn them and use them whenever you find yourself in trouble and don't know why your picture isn't working. In this case I was trying to divide the

major masses of the mountains into rectangles. I found the golden rule to be useful not only for the purpose of placing the focal points, but more as a guide to make sure I did not paint any shapes with the equal proportions, particularly in reference to the masses of dark and light colors within my image. If you squint you may find it easier to judge if the balance is correct.

> ## IT IS VERY IMPORTANT TO HAVE THE IMAGE WELL BALANCED. AND BY THAT I MEAN THE RELATIONSHIP BETWEEN THE MASSES

PROPORTIONS

Fig.03 explains more clearly the idea of dividing masses. The left image is well organized. There is no question or uncertainty about whether we see equality or inequality. The major rule here is when creating a good composition you should not confuse the viewer at any stage. The easier it is for the eye to understand the image the better it will be. This particularly applies to motion pictures where the shot will appear on the screen for just a few seconds. It is also good to keep in mind that sometimes the director will want to confuse the viewer, but even in that case it is better to do it intentionally.

BALANCE

At this stage especially (and during the entire process of painting) I flipped the image

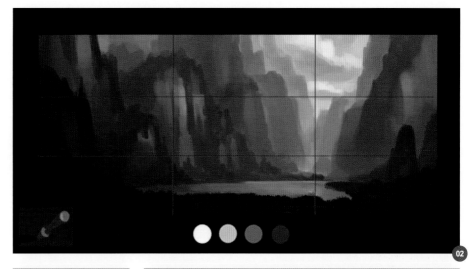

horizontally to check the balance (Image > Image Rotation > Flip Canvas Horizontal). I assigned a shortcut to this operation just to make it more accessible. It is very important to have the image well balanced. And by that I mean the relationship between the masses (visual weight). The left rectangle represents the visual pulling forces. Try to imagine the canvas as a field of energy. If you place an object in that field, for example, a black circle, there are visual forces trying to pull it in one of the directions (**Fig.04**). The closer to the borders of the image the object is, the stronger the forces are. That is why big objects placed

in the corner of images do not create well balanced compositions. The object either needs to be placed closer to the center or balanced by another object. In this example the big circle placed in slightly left of middle is balanced by the smaller circle placed on the right. The rules, as I mentioned, are very subjective and everyone has different tastes. It's a good idea to study paintings that are truly pleasing and develop your own unique style.

There are lots of other useful rules to study and if, like me, you have problems remembering them I would advise printing them out and keeping them close to your monitor.

SKY GRADIENT

When the small scale black and white painting was satisfying enough I re-scaled it to 2000 pixels. Then I started with a color gradient (**Fig.05**). I'm always trying to establish the sky first, as other elements in the painting are dependent on it. I decided to go with a late sunset color pallet.

> **Quick Tip:** It is a good idea to look at photos of the time of day you've chosen or, even better, the real sky.

COLORING THE MOUNTAINS

Then I moved my black and white painting on top of the gradient and erased the portion of it with the sky (**Fig.06**). I color corrected the sketch to roughly match the sky. To do that I selected a color from the sky and set it to Multiply it on top of the sketch.

ADDING DETAIL AND COLOR VARIATION

At this point I started to introduce more color and detail into the painting (**Fig.07**). I was not planning to make a detailed concept simply because almost all of it was going to be replaced by photographs. I also wanted to give it a painterly feel. I wanted this painting to be a decent indication for me later on when I started using photographs. I needed information about the placement of key elements, where to paint

my highlights, how much rock and vegetation, and the color transitions from the warm facing the sun colors and cool shadows. I was mixing the paint straight on the canvas with Opacity Jitter set to Pen Pressure on the Wacom pen. This way I was able to color pick warmer sun

colors and paint them straight onto the painted shadow mountains. I was not using the value circles anymore. Instead I was color picking different colors to add more color variation to the painting.

Quick Tip : If you study similar photographs you will notice that there are thousands of different colors involved in this type of image. I usually bring at least a few different hues to the canvas and that makes the process faster as I can color pick them from there.

BRUSHES AND SETTINGS

During the entire process I used three standard Photoshop brushes:

1. Soft Round brush for haze, waterfall and soft transitions
2. Chalk brush for rocks
3. Chalk brush with Scattering for vegetation (**Fig.08**).

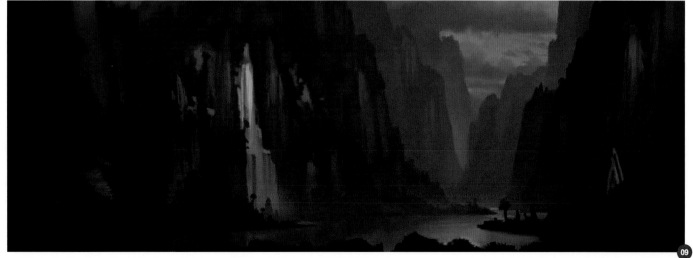

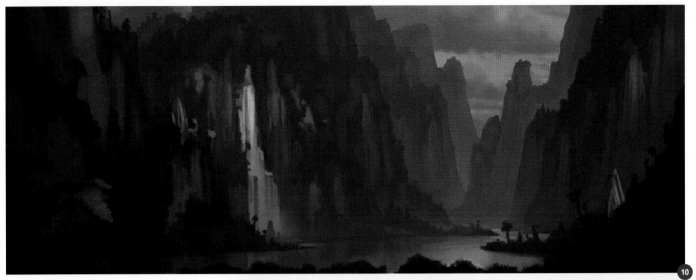

ADDING DETAILS

Then I started to focus a little more on micro composition. I started by adding trees and temples. I placed them in the areas where the contrast was higher as this meant we would see them more clearly. I was trying to add as much depth as I could by overlapping trees in different planes of the painting. Also when painting clouds I made sure to give them depth by placing smaller clouds further in the distance (**Fig.09 – 10**).

FINAL PAINTING

I gave the painting a slightly warmer tone using a Curves adjustment layer. I have also added more haze at the bottom of the mountains by using the Lasso tool and painting in the selection area (**Fig.11**). Finally I squashed the entire painting a little bit because I felt that the mountains were too vertical (**Fig.12**).

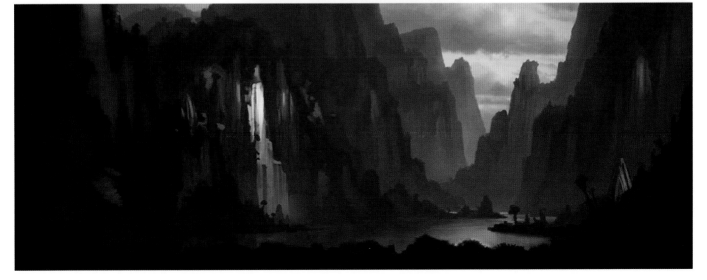

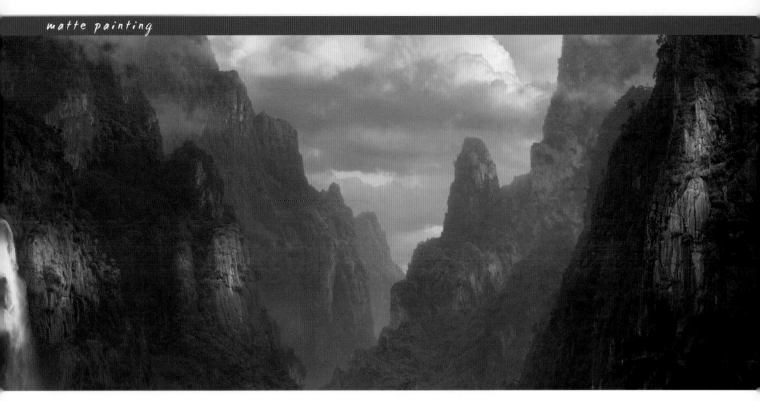

ADDING THE SKY
BY PIOTREK SWIGUT

SOFTWARE USED: PHOTOSHOP

SKY GRADIENTS

Now we can start the creation of the final image. The first step is to re-size the whole painting to a larger size; I decided to go with 4,096 pixels wide. I usually paint in this resolution because it is double the standard film resolution and once it is re-sized to 2,048 pixels all images become consistent. I can also paint in that resolution using standard Photoshop brushes without worrying that it will look too painterly at the end. I actually made the image even bigger than that in the end, because I kept the black borders around it. It is a good habit for you to adopt because sometimes you might want to change the composition or even show parts of the image that are outside of the frame in an animation. This way you still have additional painting space available for you.

I started to create the sky from a basic gradient (**Fig.01**). This way I can keep my work clean and start adding different cloud layers on top of each other. Having all the clouds separately on different layers would help if you were ever to animate the image. The ability to move the clouds independently would make the shot much more believable.

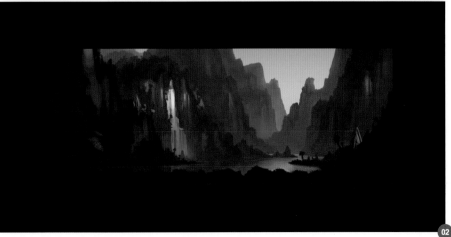

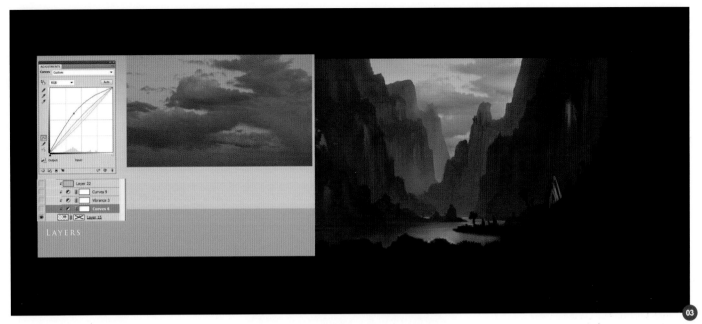

PLACING YOUR CONCEPT SKETCH

On top of the sky gradient I placed our concept sketch to have a better idea of where to place the clouds (**Fig.02**). I also kept the original finished concept on top of all layers and turned it on and off from time to time to compare the progress, and to make sure I was not inventing anything too different from the original idea.

THE FIRST CLOUD LAYER

The key is to place the clouds furthest away first. It is also very important to make sure the lighting direction in the photos matches the lighting in the sketch. As you can see, the horizon line on the photograph did not match the horizon line in the sketch (**Fig.03**). I decided to try this photograph anyway, and it turned out to work okay for me. I color corrected the picture using Curves. To make it look a little more vibrant I placed the layer of haze above the clouds. You will see me using a similar method many times. I regularly color correct pictures to make them match the image, and then on top of that I place a layer the same color as the sky and change the blending modes and tone down the levels. This is so that there is an atmosphere that makes the image more believable.

PASTING CLOUDS FROM THE CONCEPT SKETCH

For the largest cloud I had to do more work because I went through my photo library and

I could not find anything with a similar shape. So I decided to bring the largest cloud from the concept sketch and start from there (**Fig.04**).

COLOR CORRECTING THE CLOUD PHOTO

The photo that you can see in the top right corner of **Fig.05** looked like what I needed

for the bottom part of my large cloud. I color corrected the photograph and then I painted in the layer mask to reveal just the portion that matched the concept. It is valuable at this point to mention a little bit about Curve adjustments. It is a very powerful tool and I use it all the time. I color corrected every channel independently.

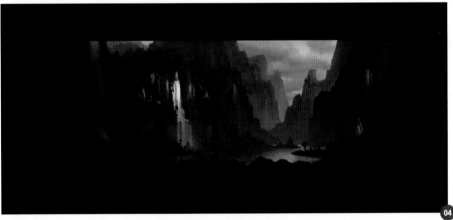

CHAPTER 8

COLOR CORRECTING THE RED CHANNEL

First I color corrected the red channel. I wanted to see more red in the area of the clouds that are lit by the sun and less in the shadows, because our shadows in the concept sketch are more violet and the highlights more red (**Fig.06**).

> **Quick Tip:** This is how Curve adjustments work. You have an X and Y axis. On the X axis is the input of the values in the red channel (first you have to select the channel you want to correct). On the Y axis is the output. You create a dot on the line simply by clicking it. In this case I lowered the red channel values in the darks and increased the values in the high tones.

COLOR CORRECTING THE GREEN CHANNEL

The next step was to decrease the green values in the shadows. I kept the green values for lit areas of the cloud (**Fig.07**).

COLOR CORRECTING THE BLUE CHANNEL

Finally I color corrected the blue channel (**Fig.08**). The cloud as it was didn't match the sketch perfectly, but was there mainly to show the shadowed side of the clouds because if you remember I only used just the bottom of it.

Here is how the images looked during their progression and the image with the clouds in place (**Fig.09 – 11**).

I wanted the clouds to have a puffy look. To achieve this I used another photo of clouds, which I incorporated into the scene (**Fig.12**).

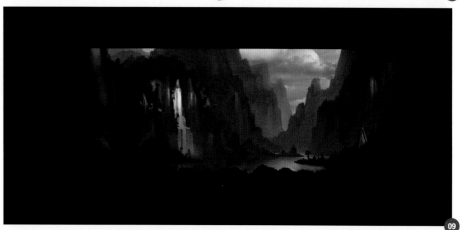

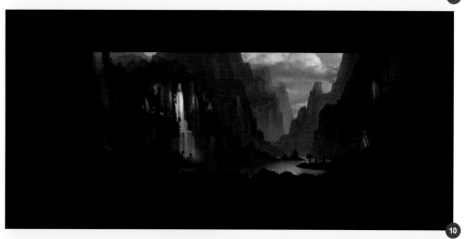

I extracted the cloud using the red channel on the photograph because this channel contrasts most with the color of the cloud and the sky. I made a copy of this channel and then I color corrected it to create a mask for selection. Because the color corrected channel was not perfect I had to paint out the grays and noise with white color (**Fig.13**).

This is the mask I used for selection (**Fig.14**).

And this is how the cloud looked after extraction on the sky gradient (**Fig.15**).

For the left part of the cloud I used another photograph and I followed the same method to adjust the colors as I had done previously (**Fig.16**).

In the meantime I also created the sky's mid-ground cloud, but I decided not to use it because although we have this cloud in the concept, the sky looked too busy and I finally decided not to use it.

CHAPTER 8

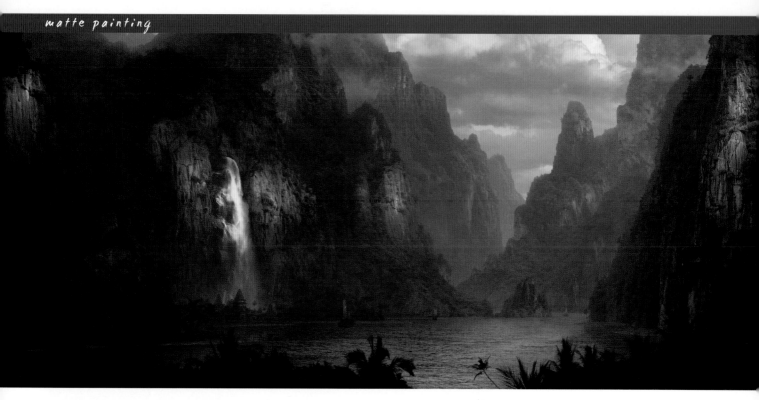

ADDING ELEMENTS
BY PIOTREK SWIGUT

SOFTWARE USED: PHOTOSHOP

With the sky done I focused on the mountains. As you can see it still has the old sky with the cloud in the middle, which I decided to remove later on (**Fig.01**). As I am working on the entire painting at the same time, sometimes it comes to me after a while that something is missing or not working in the way I want it to.

PERSPECTIVE

It is very important to have the correct perspective. I have found that it is little tricky to paint organic landscapes like this and have correct perspective. Perspective, of course, applies to the mountains and any other objects, but because there are many form changes it is harder to determine the correct perspective (**Fig.02**). However this is much easier when dealing with things like architecture. You will

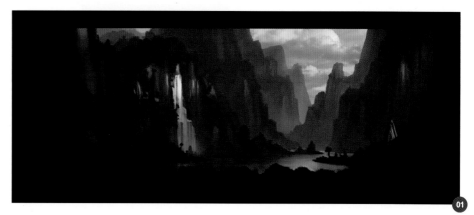

have to use your own eyes to judge whether the perspective in the final version is correct.

VANISHING POINTS

Each mountain has its own perspective with different vanishing points. I created my own

perspective guides for the mountain that has the waterfall on it as an example as to how you can do this. It has two vanishing points (**Fig.03**). One is far to the left and the other is far to the right. Both of them are far outside the frame of the picture. It is useful for everyone

HORIZON LINE

VANISHING POINT 2 (BLUE)

VANISHING POINT 1 (RED)

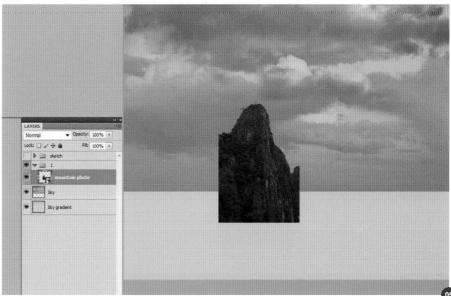

(particularly beginners) to understand how to obtain the correct perspective for the objects in the scene before starting to add the photograph elements. It would be a good exercise to create similar guidelines for all of the mountains. Because each mountain is facing a slightly different direction the perspective will be different for each of them. If I am unsure about the perspective I find it is always helpful to create a simple 3D scene.

The way I developed this painting was to remove details from the original concept sketch bit by bit as I added new elements. This way I kept the entire picture together. Before I start a matte painting I always gather a big library of photographs that I will use. With this painting the process was simple because I already had a good library of photos that I had taken in Vietnam and Thailand. Sometimes I need to spend a whole day searching for the correct pictures.

THE DISTANT MOUNTAIN

I used this photo for the distant mountain because it resembled the mountain I had in concept sketch quite closely (**Fig.04**). You will probably notice later that I also used this photo for the mountain on the right-hand side in the foreground. I really liked the form of the rocks on it and the mix of vegetation. Later on I re-painted the distant mountain to make it look different to the one I added in the foreground as we don't want to have cloned elements in the painting.

At this point I started to think about the scale of the mountains and especially the scale of the trees. As the mountains recede into the distance the trees obviously get smaller and if you show this correctly it will greatly enhance the believability of your image.

THE FIRST MOUNTAIN

The extraction of this mountain was very simple because there was nothing but white sky behind it. I used the same extraction method as described in the previous chapter. I converted the layer to a smart object. It is a method introduced in Photoshop CS4, I believe to preserve the layer detail after transforming it. By doing so I can transform the layer without

worrying about losing the quality if I decide to make the image bigger (**Fig.05**). The drawback is that it increases the size of the Photoshop file. Because of that I convert the layer back to normal mode once I am satisfied with the adjustments I have made.

MULTIPLYING THE SKY COLOR

I find that adding a flat layer of sky color to the image and then setting it to Multiply is the fastest was to color correct a photograph. This method is particularly useful when you want to darken your photograph and then match the color (**Fig.06**). The first step when adding this photograph was to try to make the mountain

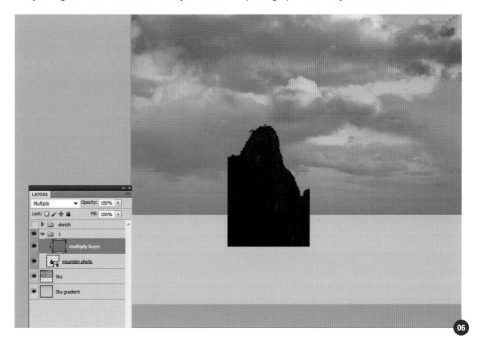

CHAPTER 8

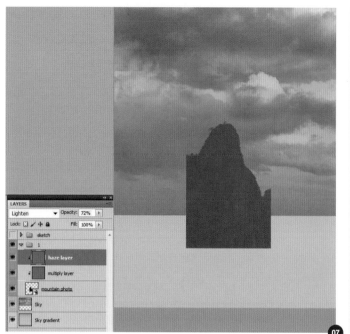

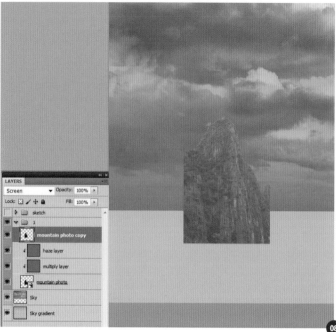

the correct color, and make it look as it would if it was in shadow. However you have to do this without adding the haze or atmosphere as that comes later. At this point I was picking a sky color from the shadowed side of the clouds. I then created a new layer on top of the mountain layer and created a Clipping Mask. You can do this by clicking in between two layers with the Alt key (in Windows). Clipping Masks let you paint in the new layer without affecting any layers below. Often I manipulate the opacity settings of this layer to achieve the desired look and to keep the colors of the original layer. I sometimes find that the multiply layer washes out the colors.

> EVEN IF THE MATTE
> PAINTING IS SET
> IN A SCENE THAT
> IS COMPLETELY
> OVERCAST I WOULD
> STILL PAINT A SLIGHT
> INDICATION OF
> DIRECT LIGHT ON
> THE MOUNTAINS

ADDING HAZE

I created another Clipping Mask using the sky color. This time I used a distant sky color instead of the cloud color. I did this because the haze layer is simply the particles in the sky lit by the sun, so the color should be lighter. I also changed the mode of this layer to Lighten.

This way I kept the highlights, but reduced the black levels (**Fig.07**). I reduced the opacity of this layer to 72%. When it comes to judging the amount you should adjust the opacity it really comes down to your own judgment. You will find after doing it for a while that it becomes second nature and that you will do it without having to think about it.

ADDING THE SUNLIGHT

After the haze levels and overall values were established I started to add sunlight. I duplicated the existing photo from the bottom

of my stash of clipped layers and put it on the top in Screen mode (**Fig.08**). This blending mode allows you to add values that are greater than those in the layer below it. Even if the matte painting is set in a scene that is completely overcast I would still paint a slight indication of direct light on the mountains.

COLOR CORRECTING

I then created a high contrast image to be used as my light layer. I added a warm sun tone to this layer to reflect some of the warm tones in the sky (**Fig.09**).

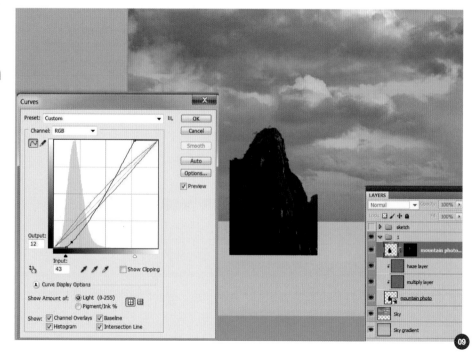

PAINTING THE HIGHLIGHT

Once I had done some minor color adjustments I then set the duplicated mountain layer to Screen mode so that I could see the final effect of the sun on the cliff face. After that I created a layer mask and inverted it to black and painted into it my sunlight. This was to create the sunlight that touches the top of the mountains in my concept (**Fig.10**).

CREATING A LIGHT WRAP EFFECT

The last thing to do was to mimic the effect of a camera lens and show light washing over edges where there is a high contrast. There is a little technique to doing this which I learned while compositing. If you were to animate this shot with an airplane flying behind the mountain, for example, the effect of light bloom would change. In this case I would not add a static painted effect of light distorting the edge of the mountain, but rather incorporate layers behind it. This is why I used the sky layer and painted the light wrap in the mask to reveal it along the edges (**Fig.11**).

FINAL RESULT

Here is the final result showing the first added mountain (**Fig.12**). I proceeded with other mountain layers in a similar way as I did with this one, replacing the concept art with the cropped and adjusted photographs.

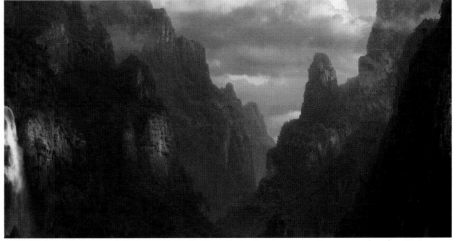

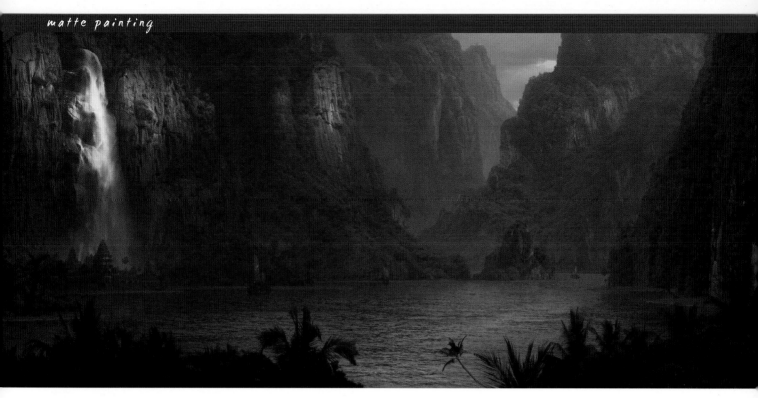

LIGHTING
BY PIOTREK SWIGUT

SOFTWARE USED: PHOTOSHOP

REFINING THE FEATURES

Once most of the concept sketch was covered with photographs I started to work on the form and shape of each mountain individually (**Fig.01**). First of all I added seven different photographs that resembled my concept. I wasn't too concerned about their exact shape, because I knew I would paint on top of them or add more photos at a later stage.

Here I have added more photos to make the main mountain (which will also include the waterfall later) look more like I had intended it to (**Fig.02**). I picked a mountain with a little opening at the bottom of it because it looked like it would be a nice setting for a waterfall. It turned out later on that it was not necessary because it got covered with the splashing water at the base of the waterfall, but it is always good to think about the painting as a real construction with different layers of believability. For example, if you were making this for a film and the director decided he wanted to turn the waterfall off you would need some believable features in place.

Then I worked on the image starting from the farthest layers. At this point I was concentrating

on giving the mountains a nicely defined form. The most important thing to me was the area facing the sun, because the viewer tends to focus there. Because of this I didn't want these parts of the mountain range to look flat and uninteresting. Also it was important to paint or find photos that were very different to each other, particularly in reference to the color value and shape of rocks and trees. I find that it is important to have a lot of contrasting features as it adds interest and keeps your eyes entertained (**Fig.03**).

> "I WORK WITH TWO MONITORS AND I AM ALWAYS LOOKING FOR APPROPRIATE PHOTOS ON THE SECOND MONITOR. WHEN I FIND ONE I BRING IT INTO THE PAINTING AND CHECK TO SEE IF IT IS USEFUL OR NOT

BACKGROUND FEATURES

Here is a little breakdown for the mountains in the background (**Fig.04**). I used four different photos to achieve the desired appearance. I color corrected all four of the photos and painted in the mask channel of each layer to blend them together nicely. I work with two monitors and I am always looking for appropriate photos on the second monitor. When I find one I bring it into the painting and check to see if it is useful or not.

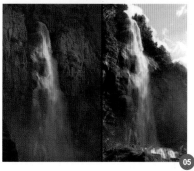

THE WATERFALL

For the waterfall I was fortunate to find one that matched perfectly (**Fig.05**). It rarely happens that I will find an ideal image that requires very little work. In this case I just had to color correct it with Curves to add a warmer tone to the highlights and Multiply it with a dark blue color to shade the bottom and top parts. I shaded the top part of the image specifically to break up the otherwise long and boring shape of the waterfall.

Here is the final result after adding the waterfall to the painting (**Fig.06**). I changed the mountain on the right-hand side, because even though I had part of it covered I was not

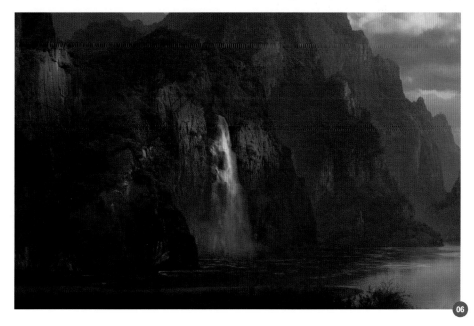

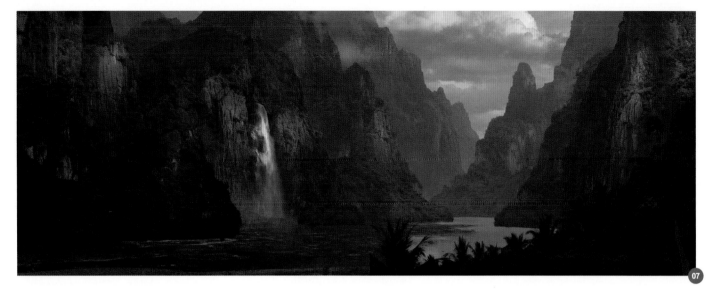

satisfied with the overall shape of it. I also changed the look of the mountain that the waterfall fell from. I gave most of my attention to that part because it is the focal area of the image and I wanted it to look more interesting. I also wanted to have decent looking faces on that mountain as they would be reflecting some sunlight.

I decided to change the shape of the mountain behind the waterfall (**Fig.07**). There was no continuity between these two mountains and by changing the look of the front area I created more space for the nice highlights. By placing clouds in between the mountains I could separate them and add more depth and height to the composition. I didn't add any further clouds in the foreground because I wanted it to appear as if they were only above a certain height and therefore out of sight of the viewer. I often turn the concept on and off to make sure

> " I OFTEN TURN THE CONCEPT ON AND OFF TO MAKE SURE THAT I RETAIN THE ORIGINAL SIMPLICITY AND BEAUTY THAT WAS IN THE CONCEPT. WHEN ADDING IMAGES THINGS CAN GET A LITTLE CHAOTIC SO IT IS DEFINITELY IMPORTANT TO KEEP YOUR CONCEPT NEARBY

that I retain the original simplicity and beauty that was in the concept. When adding images things can get a little chaotic so it is definitely important to keep your concept nearby.

As I progressed with the painting and hopefully added to it, the elements that didn't work well started to show up. For example, the features on the right in the foreground looked strange because the background was looking quite good and clean. By looking at your image carefully you can spot the imperfections. I often see my painting like a living hydra with many heads – as I cut one of the heads off

another one grows up and needs to be taken care off. I suggest saving merged versions on top of your layers and switching them on and off once in a while to see the progress that the image has made, and if any areas are showing up as not looking good. I have heard that traditional artists that use oils sometimes take photographs of their work and the scene they are painting to compare the two alongside each other. Luckily as digital artists we have easy ways around having to do that.

Here I got a little confused about where this painting was going (**Fig.08**). I was not happy

09a

09b

about the overall flow of the piece. It looked too flat and there was no path for the eye to follow. Even though I had concept art to work from I was finding it hard to make the image look real and pretty. Often when I find myself doubting the quality of the image I paint on top of my painting and try to change it to my taste. For this image I painted a little island in the background to add more layers of depth. I also tried to introduce another island in the right foreground, but that idea made the composition look a little complicated.

I then added the small island in the background, boats and many palm trees (**Fig.09a – b**). The purpose of adding boats was to break up the coast line as I found it

really boring and too straight. It also made the image more interesting. The trees added more interest at the edges, as well as more depth. Also, as a final step, I color corrected the entire painting. I graded as well to make it brighter towards the top and right-hand side. I also upped the contrast. I had to take particular care

with the light wrap to make sure the painting didn't look like a photo collage.

If you closely compare all of the pictures you will see that I have been transforming every mountain bit by bit over the course of painting (**Fig.10**).

10

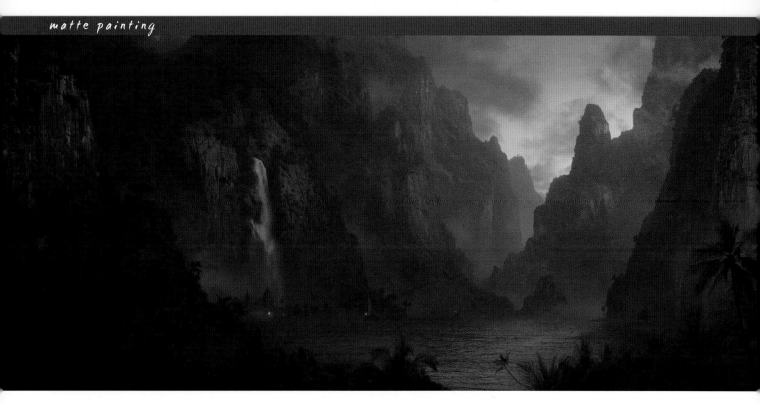

TRANSFORMING THE TIME OF DAY
BY PIOTREK SWIGUT
SOFTWARE USED: PHOTOSHOP

Since I kept all the lighting on separate layers, changing the light condition was not hard. I decided to turn this painting into an early night/dusk shot, basically a few hours later than the original. This is the time of day when the sun disappears completely beyond the horizon and leaves just its warm glow behind (**Fig.01**). It is the perfect conditions for a misty atmosphere with low ground mist, which is great for emphasizing depth.

Like with the previous painting I started by choosing the sky (**Fig.02**). I am always trying to get this element right before moving forward because all the other elements like the mountains are directly related to the sky and the atmosphere it creates.

Since I still had all the layers I was able to easily change their colors and properties to match the sky (**Fig.03**). If I had merged the layers (which I often do to simplify the

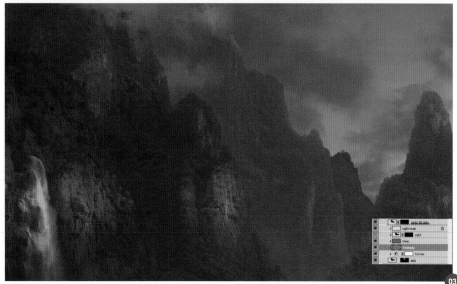

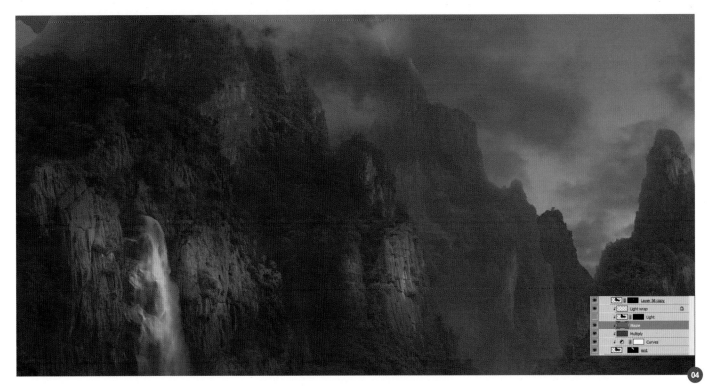

Photoshop file and work more quickly) I would have had to dig out one of my saved work-in-progress images. I usually save lots of work-in-progress files. In fact, I save around every 30 minutes. I do it mainly because in the past I have had to repaint things because I have lost my work, and there is nothing more frustrating then having to repaint.

I then changed the color of the layer set to Multiply (**Fig.04**). The effect is barely visible because the haze layer is still on top of it and is brightening the color of the mountains.

Because it is the haze layer affecting the mountains the next step was to change it to match the new tones we are striving to achieve

(**Fig.05**). I color picked the sky color and filled the haze layer with the color of the sky. By doing this it starts to make the mountains match the atmosphere around them.

I followed the same procedure with the light wrap layer (**Fig.06**). The light layer was switched off and in the end I decided to

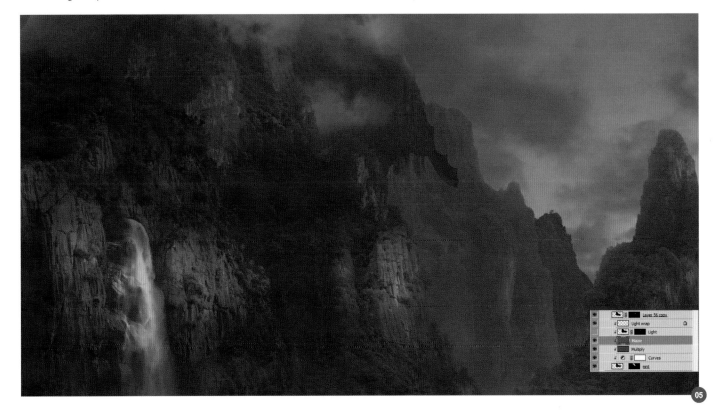

CHAPTER 8

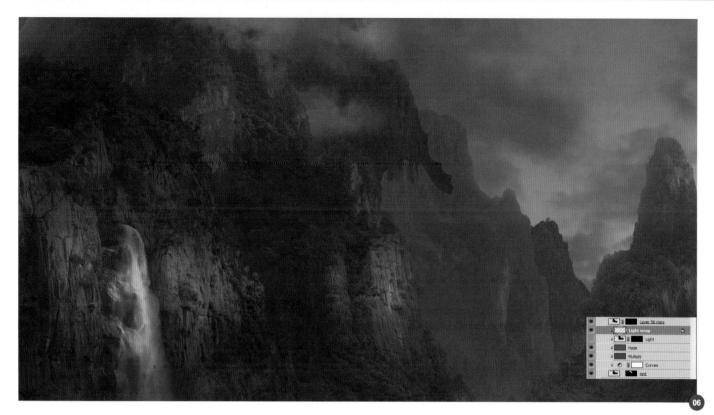

remove it completely. To create the light on the mountains I used the information from the merged layers below and painted it in. The lighting situation here is very different as the sun is now gone and the lighting that is there is mostly atmospheric or from the moon. I still want to reflect the light direction, but it is very important to keep it subtle and diffused.

Here is the effect of color correcting the entire painting (**Fig.07**). I could not remove the lighting from some of the mountain faces because I had already merged the layers

> "EVEN IF YOU HAVE PAINTED SOMETHING SIMILAR IN THE PAST, IT IS STILL WORTH LOOKING MORE CLOSELY AT REFERENCES AND TRYING TO APPLY YOUR OBSERVATIONS TO YOUR PAINTING

together. But as I mentioned I will bring back those layers later from a previous version. The image here is starting here to look like it is at night, but it still needs some work. The mountains look flat and lifeless, and there is not much indication of form change apart from the incorrect lighting on some of the mountains.

I found a really good image on the internet that I could use as a reference. It showed low ground mist on the surface of the water and also showed the lighting effect that I wanted to mimic. Even if you have painted something similar in the past, it is still worth looking more closely at references and trying to apply your

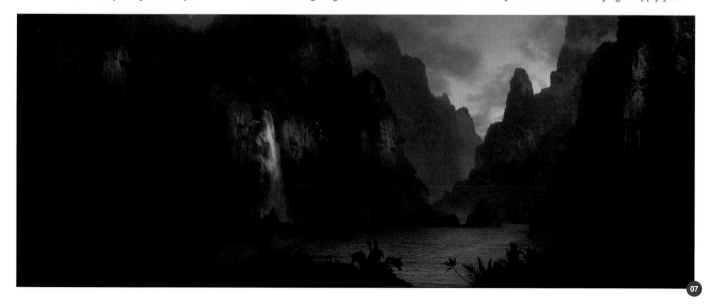

> **I WAS ABLE TO REVEAL THE LITTLE PALM TREES IN THE DISTANCE THAT WERE ALMOST INVISIBLE IN THE PREVIOUS LIGHTING CONDITION**

observations to your painting. The photo was really helpful at this point of my painting.

To mimic the effect of the cloudy mist I used my Cloud brush (**Fig.08**). I made it by using cloud photos that I stuck together. I used the Scattering option so that the clouds spread and rotate randomly whilst I paint. When I paint haze or clouds with this brush I also have the eraser set with the same brush on it and I remove from the painting at the same time as I add to it as it makes the clouds look more random. I find this method very fast, fun and effective.

It was really enjoyable to paint this low ground mist. Because I kept all of my mountain layers separate I could easily paint in between them to create more depth and also make the silhouette of the shapes more prominent (**Fig.09**). You could see that I was able to reveal the little palm trees in the distance that were almost invisible in the previous lighting condition. The work on them really paid off here. You can see that painting the mist in this way really adds depth to the scene, which is very enjoyable.

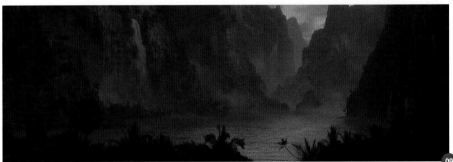

I was trying to give this painting as much life as possible as I was concerned that I would lose a little when the lighting conditions changed. I had to pay special attention to the different ways the rock surfaces and vegetation reflected the sky and moon. The light on the rocks is quite strong whilst on the vegetation it looks more diffused. This adds life to the painting and makes it look more realistic and

more pleasing to look at. The last touch to really bring this scene alive was to add a little light in the temple as well as to the boats (**Fig.10**).

I hope that you enjoyed reading this tutorial and found it useful. I had a lot of fun creating this painting and I hope you have a lot of fun with it as well!

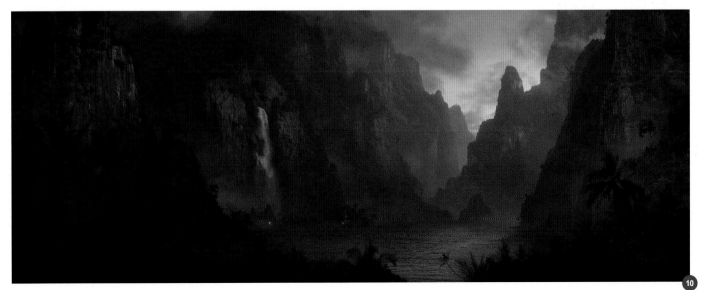

complete projects

CG art has come a long way in the past 15 years in both 3D and 2D, and in both the games and movie industries. As concept artists we have amazing tools on hand with which to create unique and refined concepts. Due to the possibilities the work of a concept artist is made harder and more challenging, and therefore more rewarding. You need to create something authentic and fresh, drawing from real-life influences whilst trying to impress your client and fulfill their brief. I believe that as technology and software advances the art of storytelling and portraying emotion will become more important, leading the way to new, exciting art that has never been seen before.

IOAN DUMITRESCU
jononespo@yahoo.com
http://www.ioandumitrescu.com

THE MAKING OF "DIAPER FAERIE"
BY BRANKO BISTROVIC
SOFTWARE USED: PHOTOSHOP

INTRODUCTION

I tend to paint a lot of images with gruesome and sombre subject matter, and it suffices to say that at times it all begins to sort of feel stale and repetitive. Sometimes there are days when I just feel that I need to bring a little more humor to my work, and this is the result of one of those days.

THE IDEA

The idea of the Diaper Fairy first started to take shape while both a friend and a colleague were expecting new additions to their family ranks. One was adopting, the other going about it the old fashioned way. Discussing their experiences with them, I then found myself weighing up the pros and cons of the two options. Granted, many would immediately point out the obvious psychological predisposition to rearing your own flesh and blood, but playing devil's advocate I looked for the positives in adoption and came up with quite a few good points. After considering this for a while there was only one clear aspect that was chuckle worthy: depending on the age of the child you adopt there could be no diaper changing or potty training! You only have to look into the hollowed eyes of any individual

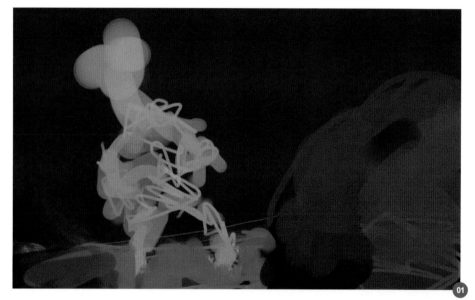

who just changed a particularly gruesome diaper and you will see how right I am...

Now on with it!

THE PAINTING

I pretty much visualized in my head from the get go what I wanted in this piece and having the idea already established allowed me to work at a significantly quicker speed. I immediately made the background dark,

because I wanted to give the impression that the faerie was sort of doing this under the cover of night when no one was around to witness his humiliation. The dark also gave me a sense of claustrophobia, adding to the idea that the duty was unbearable. I then made some quick gestures deciding where I'd place the faerie, the baby and the ground (**Fig.01**).

I continued the block-in, keeping it very loose, giving the faerie its wings and really only

focusing on the silhouettes and placement of the subject matter. An accidental indication of a beard gave me the idea to make the faerie a dwarvish-looking one. Weird and confusing I know, but it made me smile thinking of an old mini grumpy dwarf in diapers with angelic wings changing a kid's stinky diaper while holding back tears. On reflection maybe I should have called the piece "Diaper Dwarf" (**Fig.02**).

Okay, now I started refining the shapes, deciding how big to make the head in proportion to the body, and also the baby in proportion to the whole faerie. I wanted to make it look ridiculous but still somehow feasible; it's a pretty difficult balance mostly because it's so subjective. While working on the piece I actually had someone suggest I make the head bigger, but before I got the chance to do so someone else chimed in that it should be smaller, I suppose in the end (if it's a personal piece) it's most important to go with what you feel works best (unless of course the critique is valid in pointing out something you missed).

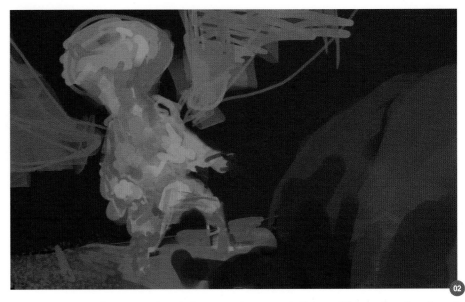

Here I also started to establish the lighting in the mid-ground, although I held off on the foreground mass to the right (baby) just until I knew how bright I was going to go on the faerie (**Fig.03**).

At this point, the direction of the light was pretty much decided upon for the whole piece. So, I added it to the foreground as well and began to clarify everything, such as the wings, foreground baby, shape of the faerie.

At the same time, I was also focusing heavily on the gesture of the faerie. I wanted him cringing and repulsed, as if this is as low as low can get. I knew that the gesture would sell the piece; if it wasn't right then there would be no real impact to the viewer, unless of course

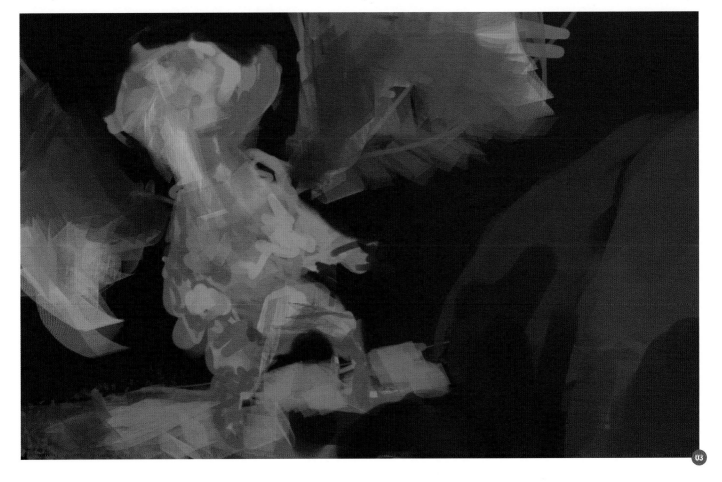

> **I'M LOOKING TO MAKE THE FAERIE CUTE, YET HAIRY AND SORT OF GRIMY. HEY, HE'S GOT A TOUGH JOB TO DO, THE KIND THAT PUTS HAIR ON YOUR CHEST!**

they liked looking at pretty wings and nothing else, in which case I could have just painted the wings pretty and that would have been it. Although, as we all know, "Wing Lovers" are the shallowest of individuals (**Fig.04**).

Well, as you can see I was now near the detailing stage. At this point, I was primarily using the Hard Round brush that comes as stock with Photoshop, varying its hardness between 30-100% depending on the edges I wanted to put down.

Quick Tip: Generally speaking, harder edges demand our focus while softer edges allow for our eyes to take a glance. Although, it's all about contrast of course – if you have a painting with just hard edges and then you introduce a prominent line with a soft edge, that line will jump out at the viewer. Try it yourself. The mind is a funny monkey. It's probably just a painterly convention of mirroring how we actually see. Sharp edges represent things we have in focus and therefore are worthy of our attention, while soft edges either represent things too far off, too close or on the edge of our periphery, to really be discernible and therefore don't grab our immediate attention. That's just a hypothesis; if you know the answer feel free to drop me a line (**Fig.05**)!

Now I went in and added the hopefully adorable detail (**Fig.06**). I was looking to make the faerie cute, yet hairy and sort of grimy. Hey, he's got a tough job to do, the kind that puts hair on your chest! (Not literally of course… otherwise we'd have many scruffy ladies walking around).

Next I tried to focus on anatomy and the facial expression, along with the flow of the hair,

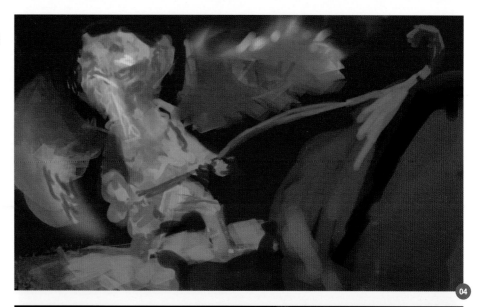

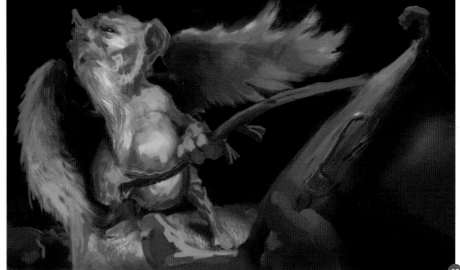

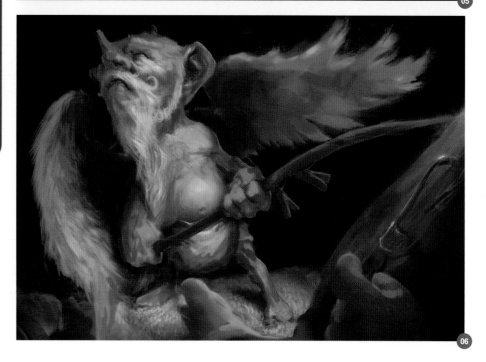

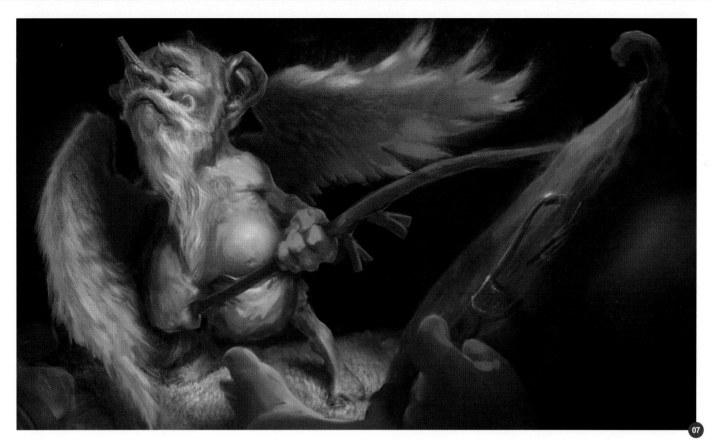

wings and the strands of the towel that covers most of the ground. I made a new brush to use for the hair on the beard and also the wings. It has some texture applied to it, but just lightly so that it breaks up the digital feel.

As always in this final stage, the refining of everything is by far the most time-consuming step and it can be quite demoralizing when things seem done but somehow are not quite where you want them to be (**Fig.07**). At such moments of frustration, my best remedy is to take a step back, get some fresh air (maybe cry a little in some alley) then return to the painting and hopefully discover what is missing.

And here you have it, the finished piece (**Fig.08**)! I zeroed in on the wings and face primarily and then tried to give the piece a sense of motion, even though looking at it now some parts of it feel over rendered. I decided in the end to have him look heavenward with a teary glisten in his eye and multi-colored fishes on his diapers.

Looking back on this piece I can see some serious issues with the anatomy. The pectorals are way off and don't insert properly. The veins

are not great, I really have to practice my veins, but I do like the final expression and the way the ear/beard came out. The wings are okay as well, but they don't seem quite as fluffy as I had intended.

This was pretty much a piece which I whimsically began but then decided to see all the way through. Now that it's done I'm happy to have at least put a foot past the comfort zone of gruesome and sombre. I think at times it's important to vary your subject matter; even

if it isn't something entirely different it'll still challenge you in new and unexpected ways. If anything, it at least refreshed me a little for whatever piece I was going to tackle next!

You can download a custom brush (ABR) file to accompany this tutorial from: **www.3dtotalpublishing. com**. These brushes have been created using Photoshop CS3.

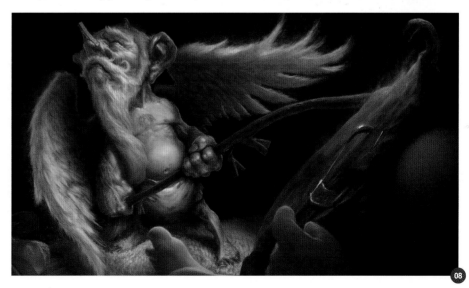

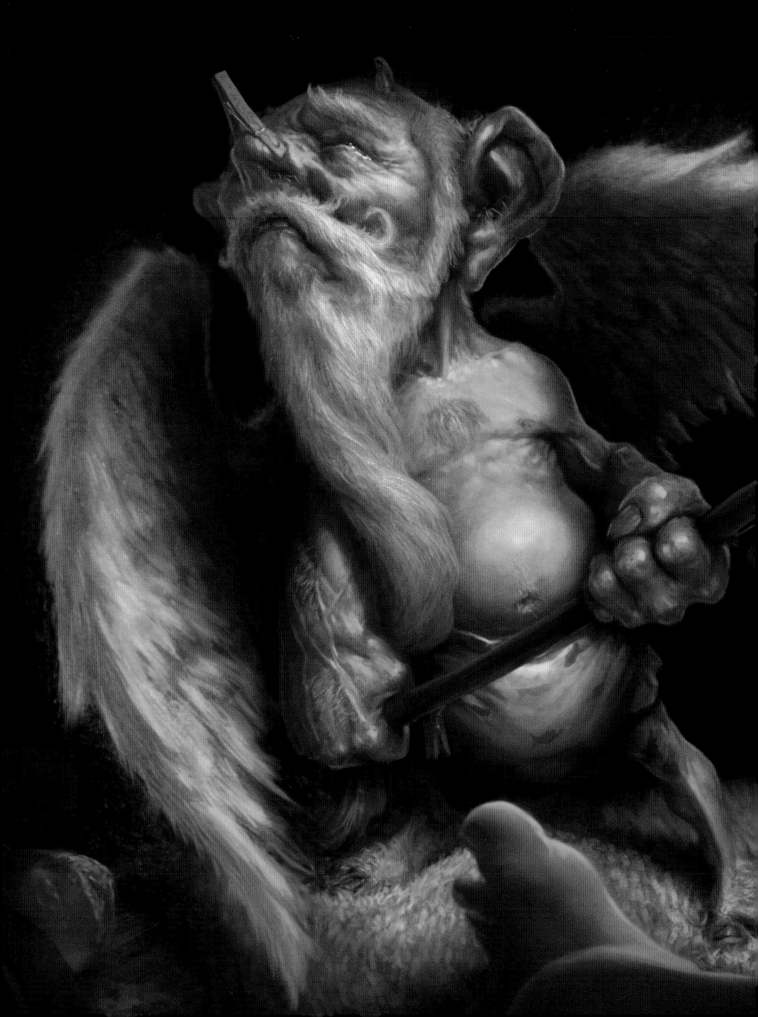

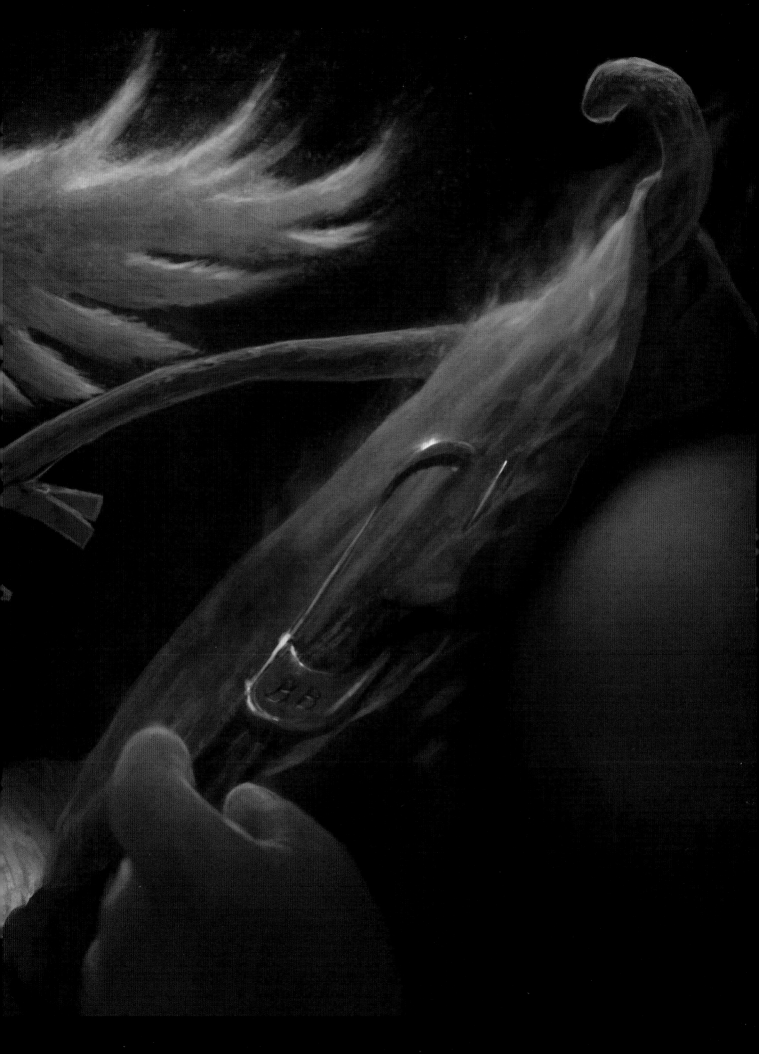

THE MAKING OF "WASP WOMAN RETURNS"
BY GEDIMINAS PRANCKEVIČIUS

SOFTWARE USED: PHOTOSHOP

INTRODUCTION

Hello to everyone who is reading this tutorial. Before we start why don't we go out and enjoy the sun, puffy clouds or even little stars in the sky (if its night outside I'd recommend staying at home).

MY IMAGE

I just came back inside and will do my best to provide some useful and interesting information about my image *The Wasp Woman Returns*. This painting was produced for the CGSociety competition XXV – B-Movie. I was really intrigued by the theme as I was working for a cinema at the time and was greatly interested

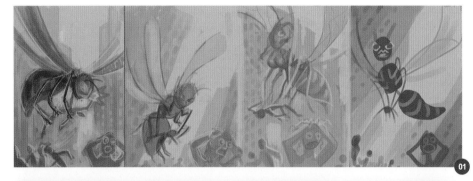

in movie posters. Posters from this kind of film are really impressive, colorful, and bright, and usually have very interesting composition. They are also often quite a lot of fun even when they should be horrible and scary.

To make it slightly easier for myself I didn't create my own film title, instead I found an old poster on the internet and tried to inspire myself with it without deviating from the style of the period. First of all a few little sketches were

done to make the composition different to the way it was in the original piece (**Fig.01**). I used 3ds Max to create realistic perspective in the background and help me create the New York street and buildings. I also used 3D planes to construct the road and added boxes instead of all small details (**Fig.02**). In Photoshop I then painted some simple small windows (**Fig.03**) as a material that can be added and applied to the skyscrapers, shops and houses (**Fig.04**).

> LITTLE BY LITTLE
> WITH THE HELP
> OF THE PEN TOOL
> AND A SOFT ROUND
> BRUSH, I PAINTED
> OUT THE SHADOWS
> AND ADDED SOME
> HIGHLIGHTS

I then created what were soon to be characters. I put them in place according to the rules of Divine Proportion (**Fig.05**). Next I rendered an Ambient Occlusion map for the windows (**Fig.06**) and then the coloring started. I mainly used the Lasso and Gradient tools to apply the color.

After completing this step I started working on the main attraction: the wasp woman. With the Pen tool in Photoshop I carefully drew the face and made a selection and filled it with color (Ctrl + Delete). Then, little by little with the help of the Pen tool and a Soft Round brush, I painted out the shadows and added

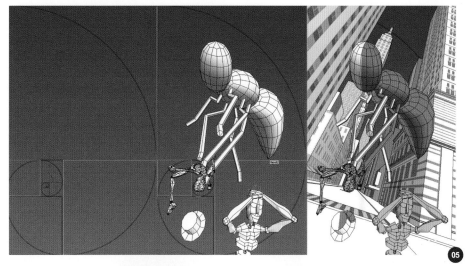

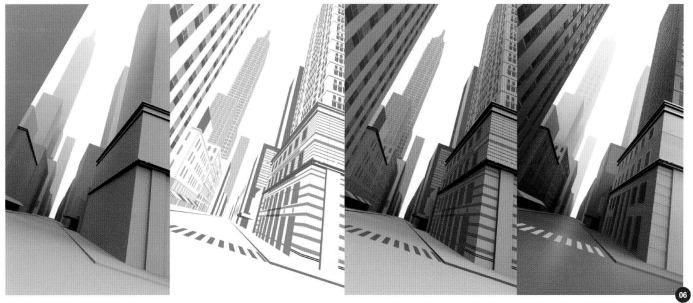

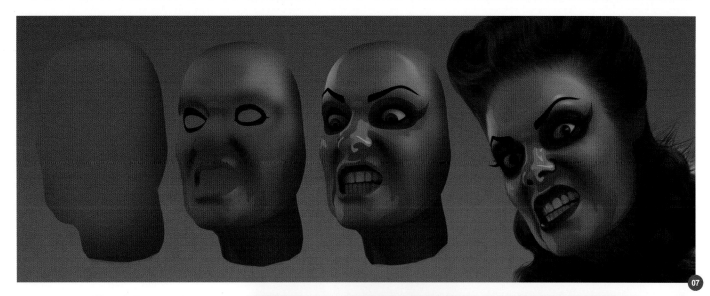

07

some highlights (**Fig.07**). The legs of the wasp woman, the cars and the frightened victims were all done using exactly the same workflow.

Even though I tried to work in the right order, this was quite a big experiment for me, and I spent a lot of time trying to find the correct path. Almost everything evolved in separate pieces. It is also worth mentioning about the first building, the one on the right in **Fig.08**. As it looked quite good and the painting around it was also painted quite well, I decided to create a more detailed model of it in Max. I found a photo reference of a building and created a 3D model. When I had done that I rendered an Ambient Occlusion map and painted it in Photoshop. One other thing is that I had a lot of fun making a custom brush for the body and hair of the wasp, I have given this away with the tutorial (**Fig.09a – c**).

You can download a custom brush (ABR) file to accompany this tutorial from: **www.3dtotalpublishing. com**. These brushes have been created using Photoshop CS3.

08

FREE **RESOURCES** Download from: www.3dtotalpublishing.com

09a

09b

09c

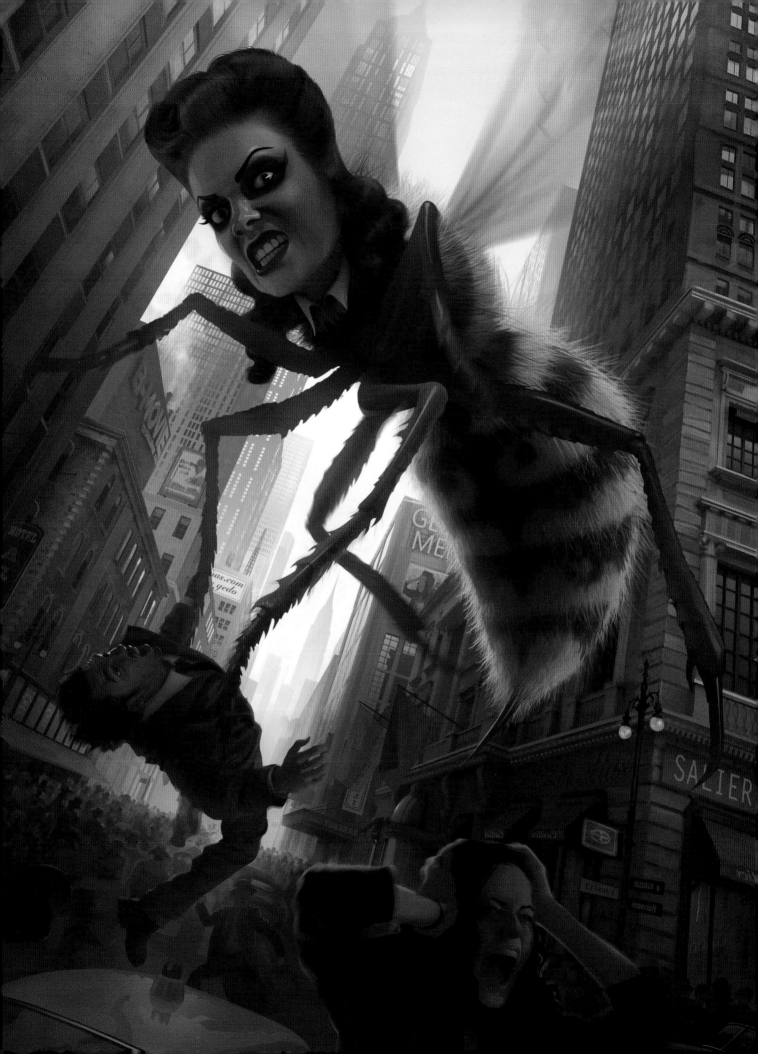

THE MAKING OF "CONCRETE 5"
BY YANG XUEGUO
SOFTWARE USED: PHOTOSHOP

This image was created for a CG exhibition, named "Industrial Impression: Design & Creation Exhibition". I used a lot of industrial elements as fodder for the creation of this image. The purpose was to show the relationship between the development of post-modern industry and the human way of life. There wasn't any clear intention at the start of my creation process, I just blocked in some shapes at random. Then I gathered the interesting parts of them and ultimately created a final concert composition (**Fig.01**).

To make sure the sketch layer was complete before adding color, I looked at pictures of some industrial materials and then blended them into the image. The aim was to keep the style and design bold and interesting, but to

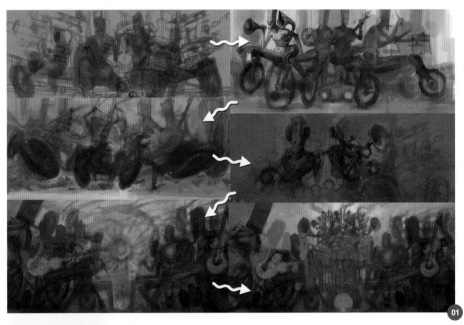

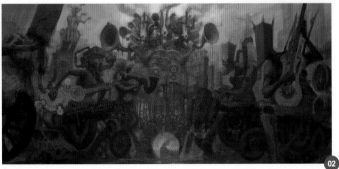

also try and maintain the feel of the scene. I then added more details as I adjusted the composition. As you can see from the sketch, everything in the distance looks lighter and the colors are stronger in the foreground. This gave a good sense of depth (**Fig.02**).

I then selected a large brush to add color to the image in a single layer. I set the brush mode to Multiply and then selected warm colors to paint on it. Multiply mode allows color to be added to the sketch transparently, and will not cover the original sketch layer. It is a commonly used color method, but do not select dark colors or paint over it repeatedly. If you

paint in Multiply mode with darker colors repeatedly in one place, it will make the image black. Making the image a little darker can enhance the tone of the image and also offer a nice base tone for adding all kinds of highlights later (**Fig.03**).

With a basic color set I then began to paint in the details. I started with the tones in the distance. I tried to keep the tone and colors consistent with those in the previous sketch and the strength of the color in the distance low. To do this I decreased the color's saturation. I also kept the whole image in warm tones, making sure there wasn't too much contrast, and made sure that the only light in the scene was diffused (**Fig.04**).

What is "diffuse"? Diffuse is when the environment has no direct light, like on a rainy day, where there is only light reflected from other objects. This usually means there is no obvious direction for this kind of light, so the shadows are not clear. The shadows created by diffuse reflections appear in the close areas between the objects. We can see how the diffuse reflection works in the following picture. If you understand this relationship then you will know where to place the shadow (**Fig.05**).

To demonstrate that a surface is hard I usually use a hard-edged brush with 100% transparency and no feathering edge so that I can portray the solidity of the item. I pay attention to the texture features (like rusted metal, concrete etc.,) and change the brush's size and direction depending on what I am painting (**Fig.06**).

The Smudge tool helps when blending the colors, especially when drawing the background. Here I used the Smudge tool to deal with the edge of adjacent colors. It created soft tones and shadows (**Fig.07**).

There are various ways to define details; you can use the brush to add texture or overlay a photo. I prefer to use a block-shaped brush and paint it in freely, making sure that I portray the highlights when painting. The highlights are very important and the different highlights will determine the final texture of the substance. For instance, in this image the highlight and the strength of color are extremely different, particularly between the smooth and the rusty metal. Normally a high intensity small area highlight will make the subject look smooth and hard, whilst a soft and coarse highlight will do the contrary. It's important to pay attention to the changes of highlight on the subject, whether it is a rough or glossy surface (**Fig.08**).

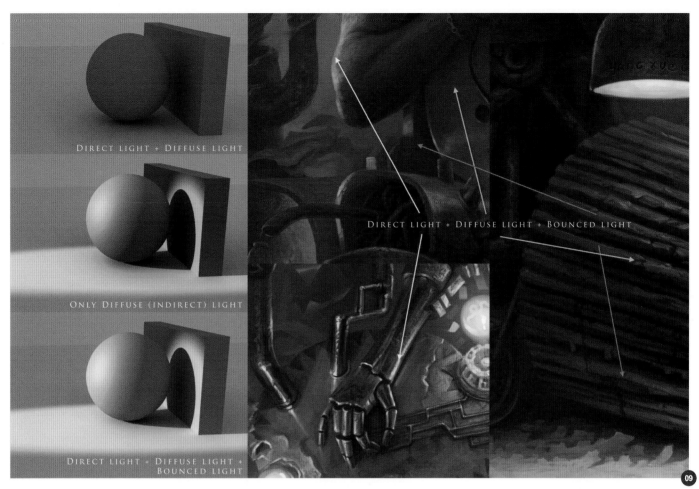

DIRECT LIGHT + DIFFUSE LIGHT

ONLY DIFFUSE (INDIRECT) LIGHT

DIRECT LIGHT + DIFFUSE LIGHT +
BOUNCED LIGHT

DIRECT LIGHT + DIFFUSE LIGHT + BOUNCED LIGHT

With regards to light and shade, diffuse reflection is one of the elements that will set the tone of the image, but there is also direct light and bounce light. In more complex images the portrayal of light on surfaces is very important,

especially the bounce light, and if there is not enough bounce light the whole image will become dull and perspective will be lost. In **Fig.09** you can see the different types of light I used in this image.

The next step was to paint in all of the details, adding highlights as the last steps (**Fig.10**).

Effects were essential for this image, such as light, smoke, fire, lightning, etc. I used custom

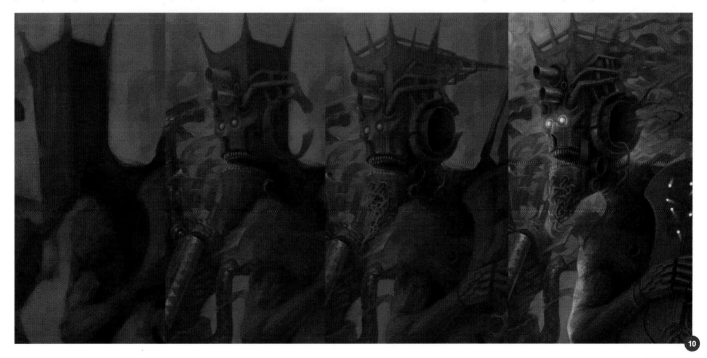

CHAPTER 9

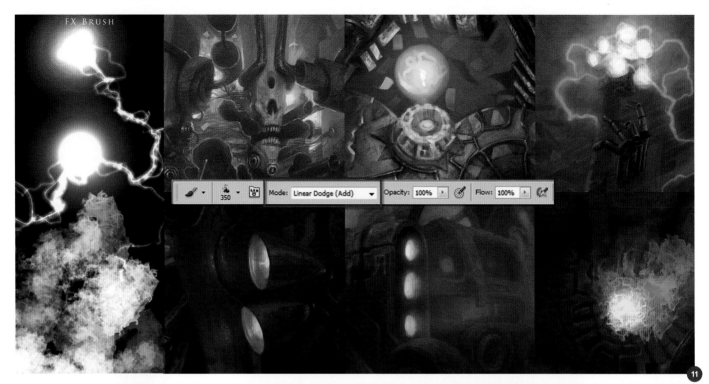

brushes to paint these effects. To paint on the same layer I set the brush mode to Color Dodge. To paint on a new layer, I set the whole new layer to Color Dodge mode. Then I was able to achieve a "transparent light" effect (**Fig.11**).

Here are some tips for how to make a smoke effect brush:

1. Create a new 500 x 500 pixel, 72 dpi, pure white background layer.
2. Draw some black dots (**Fig.12**)
3. Paint a gray girth at the very edge of the dots and then you can create a transparent mist effect
4. Add Ocean Wave filters to it to move it closer towards a cloud effect

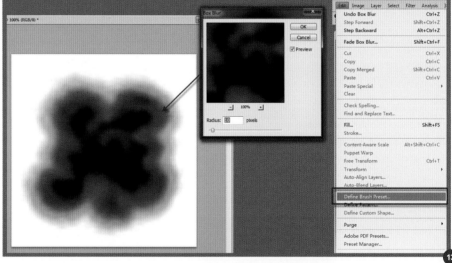

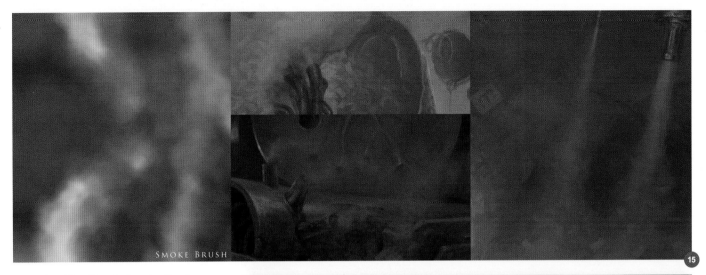

SMOKE BRUSH

15

5. Add Box Blur filters to it and soften the edge (**Fig.13**).

6. Go to Edit > Define Brush Preset and set the parameters as shown in **Fig.14**

Done! I used this brush in many parts of the image. And this technique can be used to create other brushes. If you want these brushes to make a glitter effect, make sure the brush mode is set to Color Dodge (**Fig.15**).

Finally I used a uniform texture layer to enrich the texture and details. I used textures such as paper, cloth or concrete, then placed them on the top layer and modified the layer mode to Overlay. Then there was a delicate texture on the image (**Fig.16**).

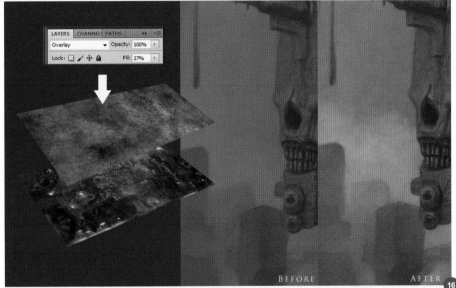

BEFORE AFTER

16

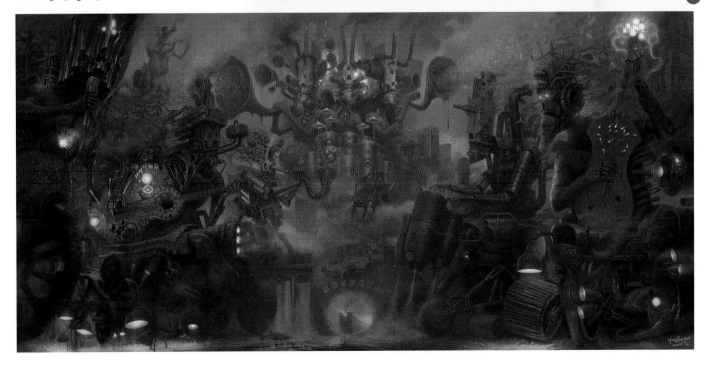

the gallery

© Loïc e338 Zimmermann

© Wei Che Juan

© Maciej Kuciara

LIFE PAINTING 10
Wei Che Juan
(Above)

PEDESTAL
Loïc e338 Zimmermann
(Top Left)

KNIGHTRESS
Maciej Kuciara
(Left)

LIFE PAINTING 06
Wei Che Juan
(Right)

QUANTUM LEAP
LOÏC E338 ZIMMERMANN
(ABOVE)

JACK WHITE
JASON SEILER
(RIGHT)

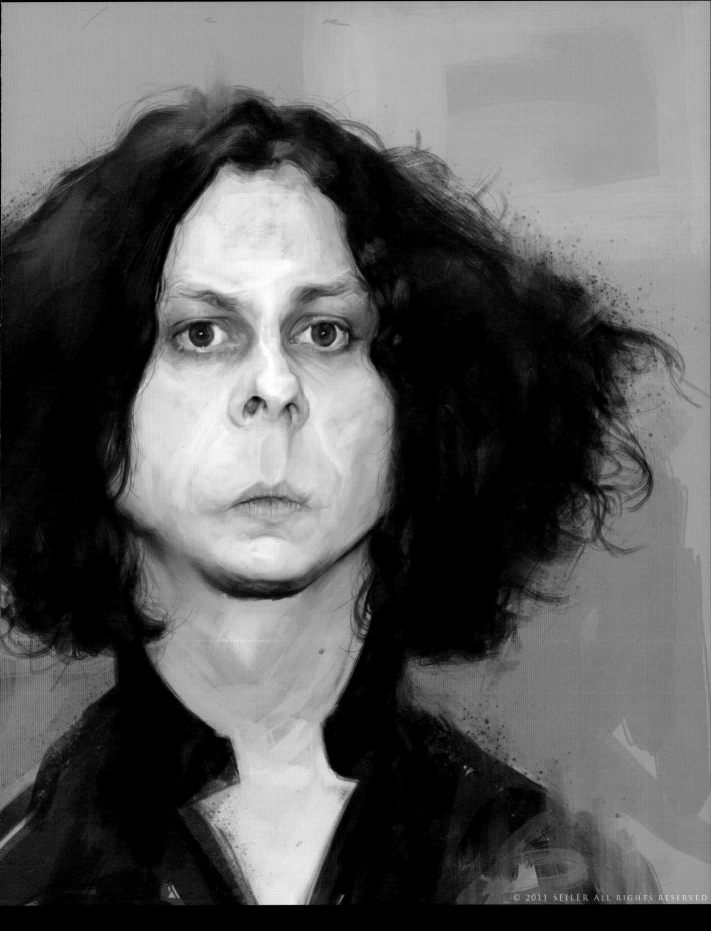

BONNIE AND CLYDE
LOÏC E338 ZIMMERMANN

(ABOVE)

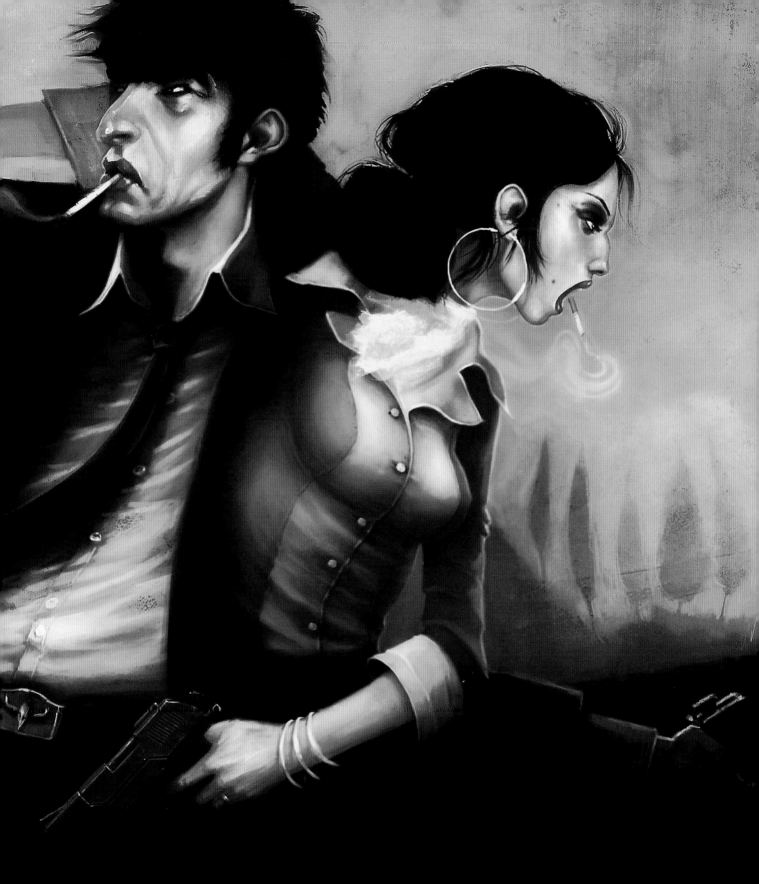

© Loïc e338 Zimmermann

257

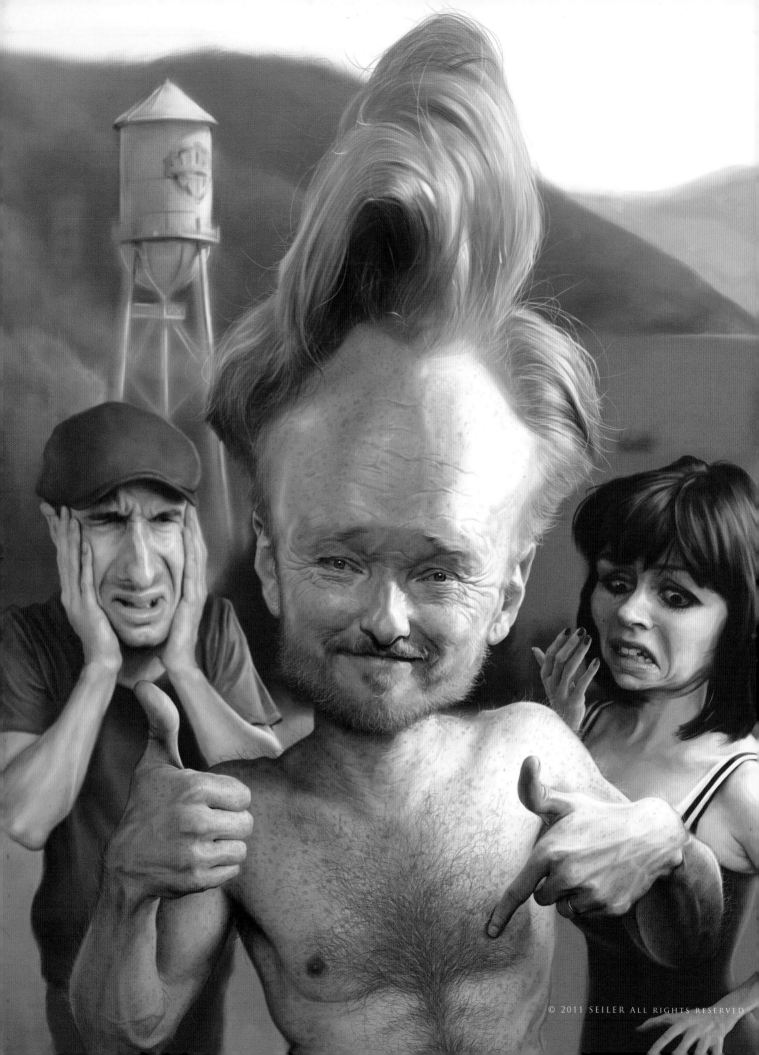

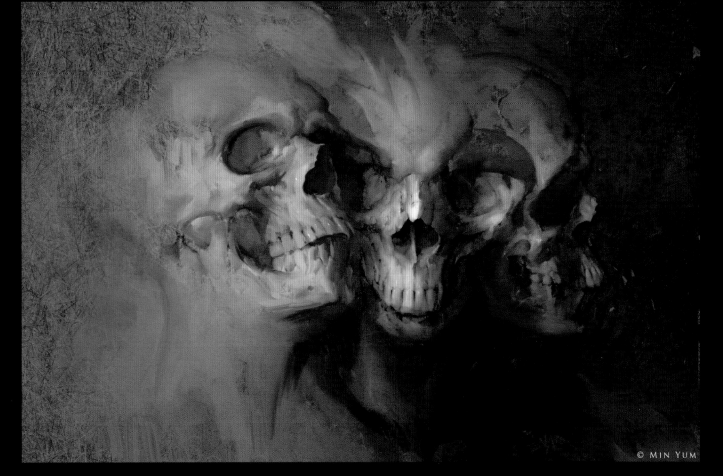

© Min Yum

CONAN
Jason Seiler
(Left)

SKULLS
Min Yum
(Above)

KITCHEN
Min Yum
(Below)

© Me & My Monsters

DREAMSCAPE
Yang Xueguo
(ABOVE)

STILL LIFE
Damien Mammoliti
(LEFT)

CONVERGENCE FINAL
Alex Ruiz
(RIGHT)

FIGHT
Max Revin
(BOTTOM RIGHT)

GANG
MAX REVIN
(ABOVE)

FACTION
GEOFFROY THOORENS
(BELOW)

FINISHED SKETCH 577
JAN DITLEV
(RIGHT)

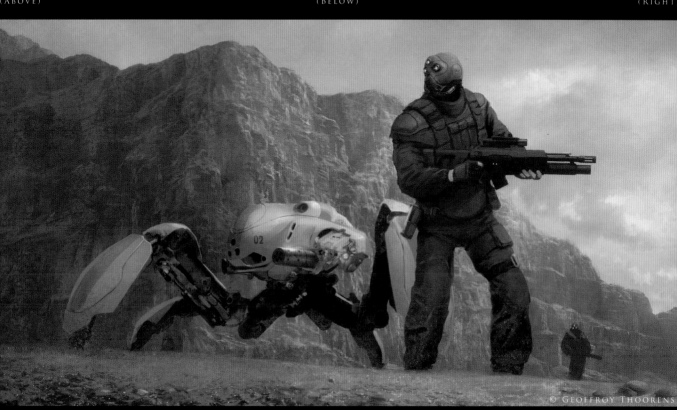

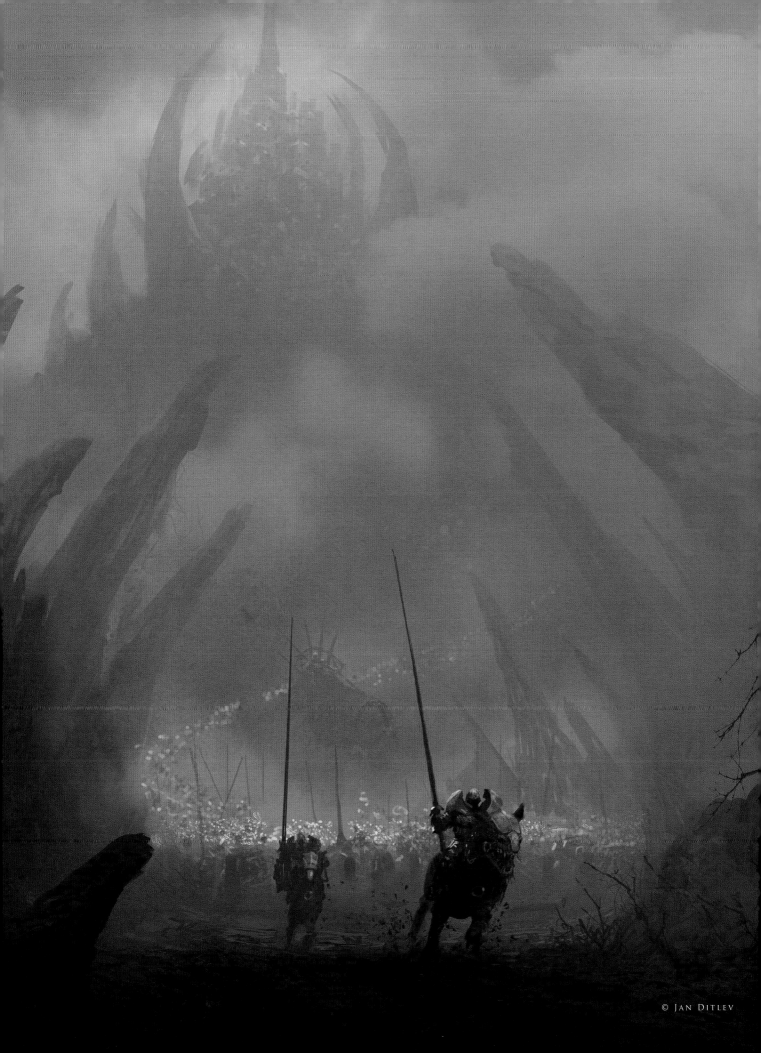

© Jan Ditlev

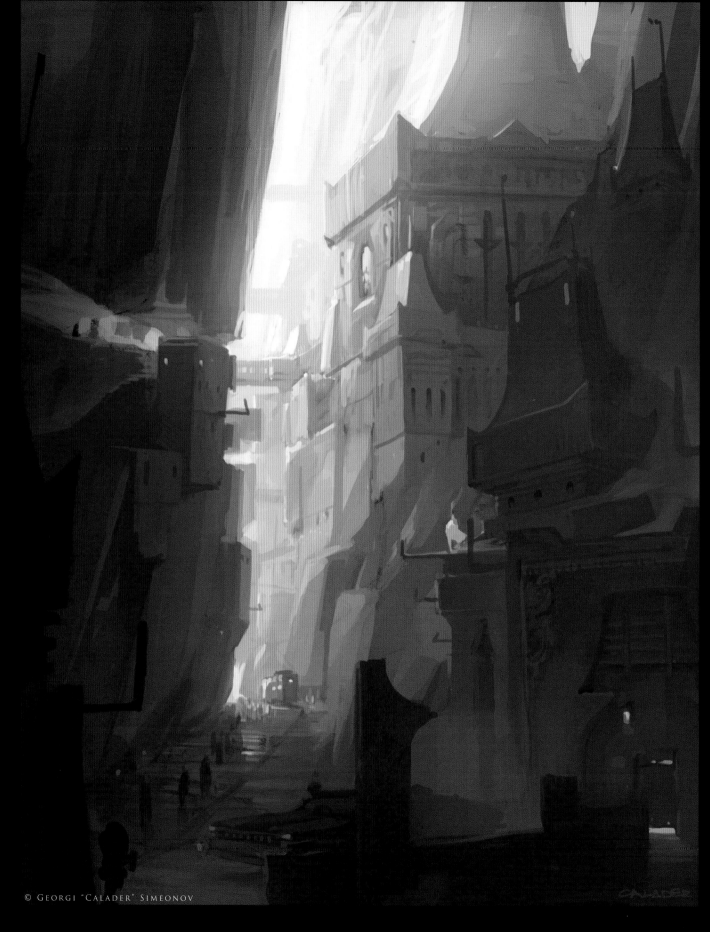

© Georgi "Calader" Simeonov

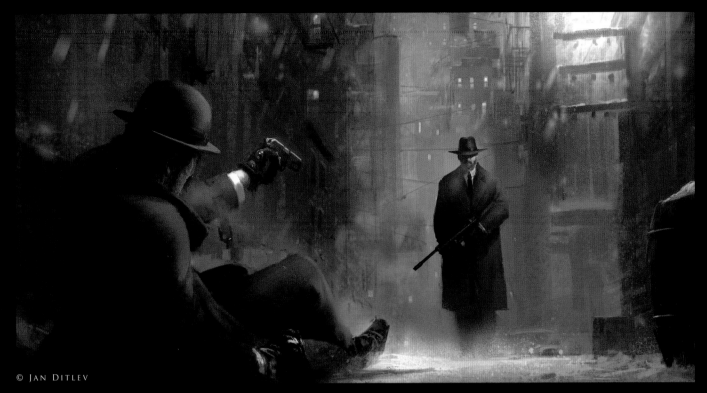

FINISHED SKETCH 570
Jan Ditlev
(Above)

SAND CITY
Georgi "Calader" Simeonov
(Left)

PERSONAL HALO CONCEPT PAINTING
Alp Allen Giovanni Altiner
(Right)

HATERZ
Alp Allen Giovanni Altiner
(Bottom Right)

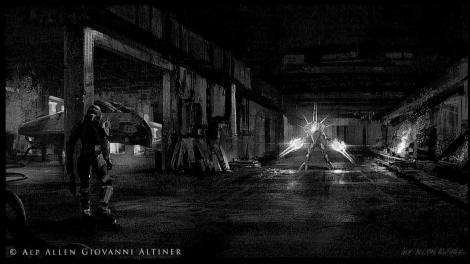

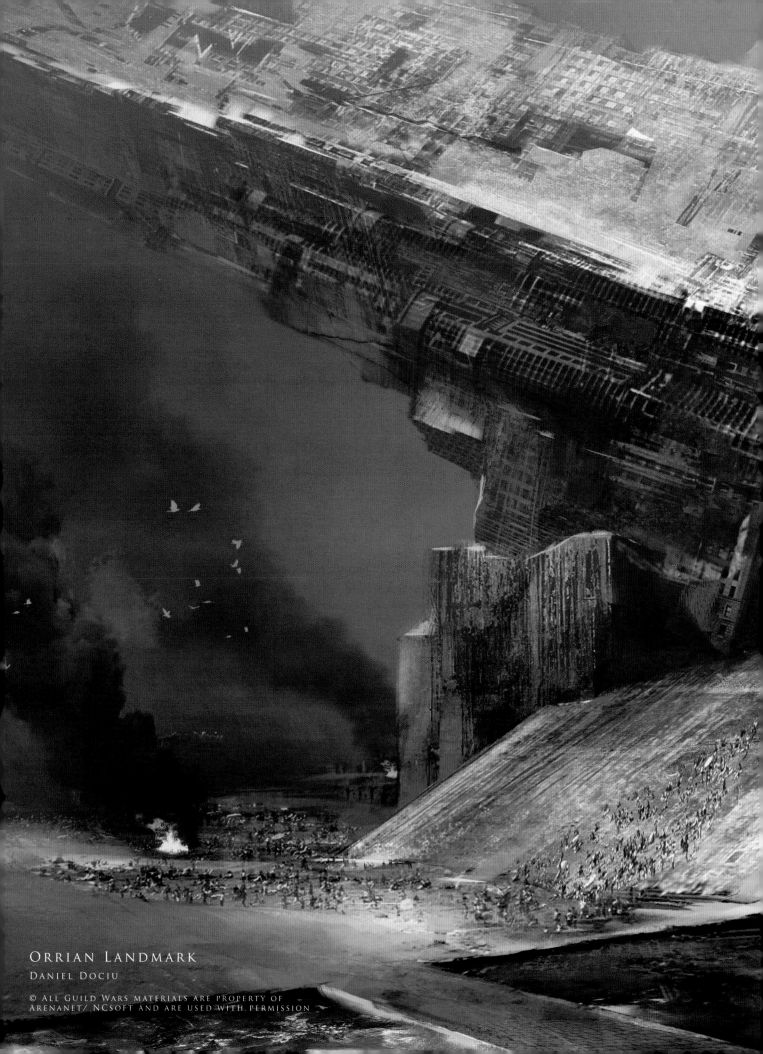

ORRIAN LANDMARK

Daniel Dociu

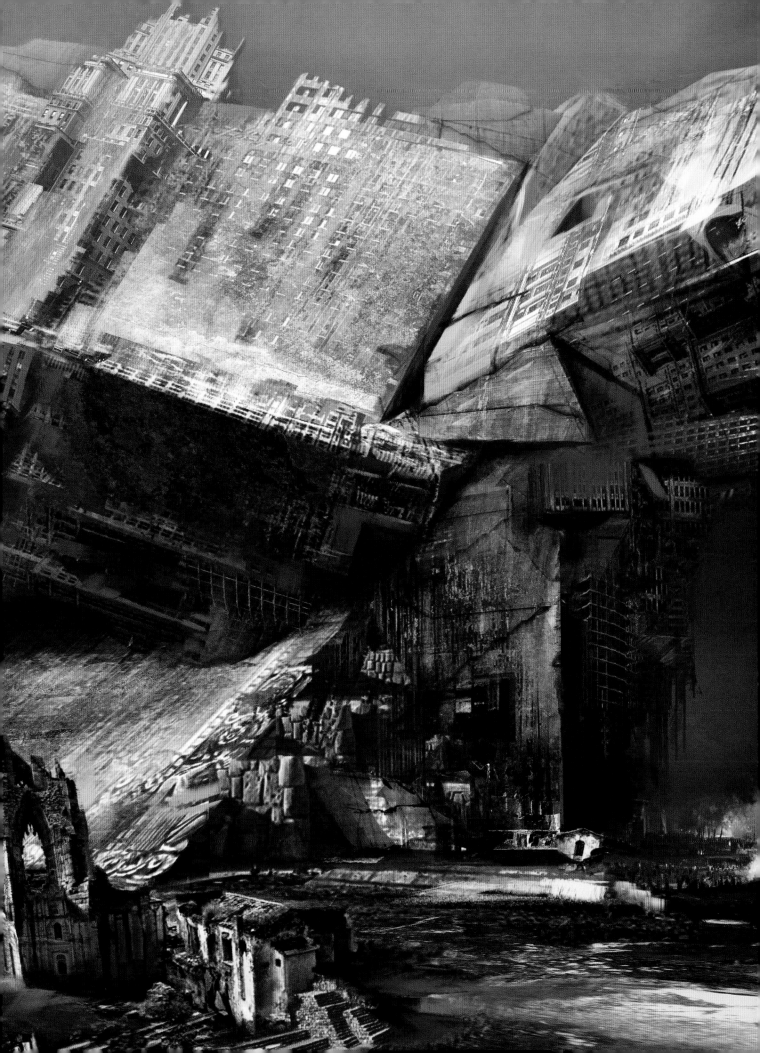

SPACE STATION
Max Revin

GONDOLA
Ian McQue

(Above)

SPACESHIP CONCEPT
Max Revin

(Below)

SPACE SCENE
Daniel Dociu

(Right)

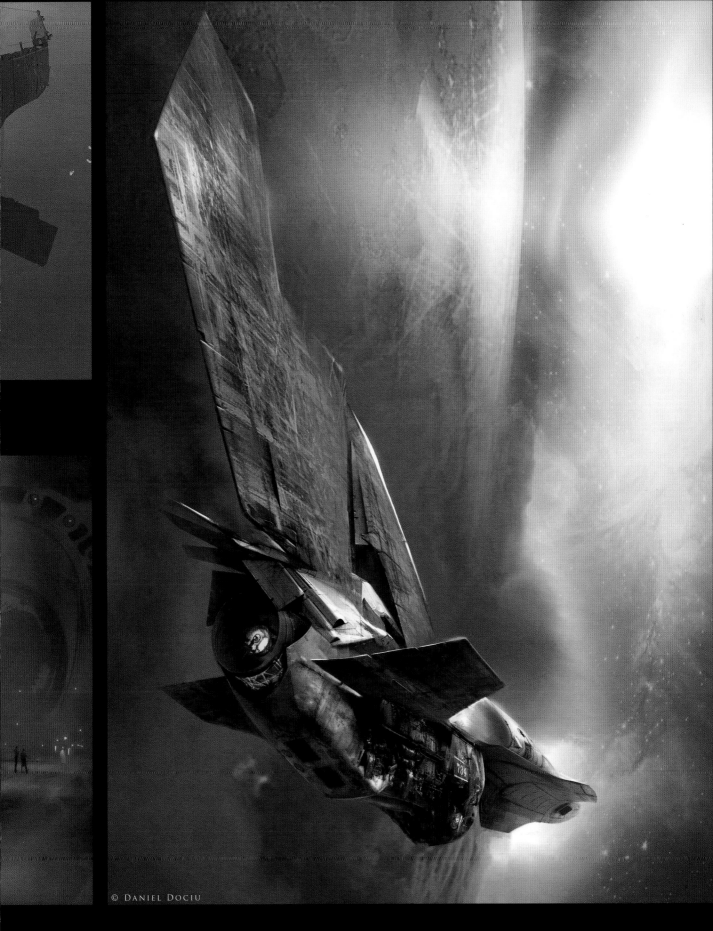

© DANIEL DOCIU

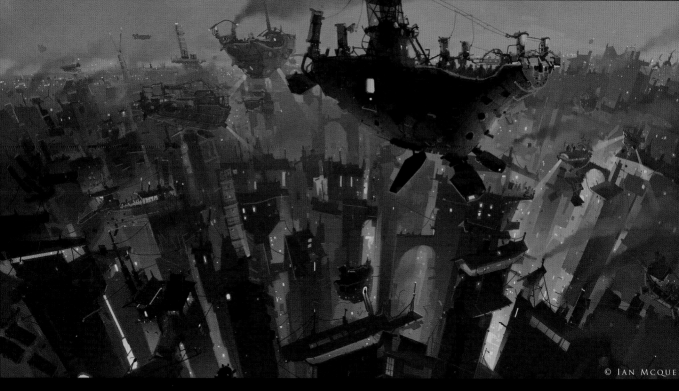

NIGHTBOAT
IAN MCQUE
(ABOVE)

LEAD ZEPPELINS
DANIEL DOCIU
(BELOW)

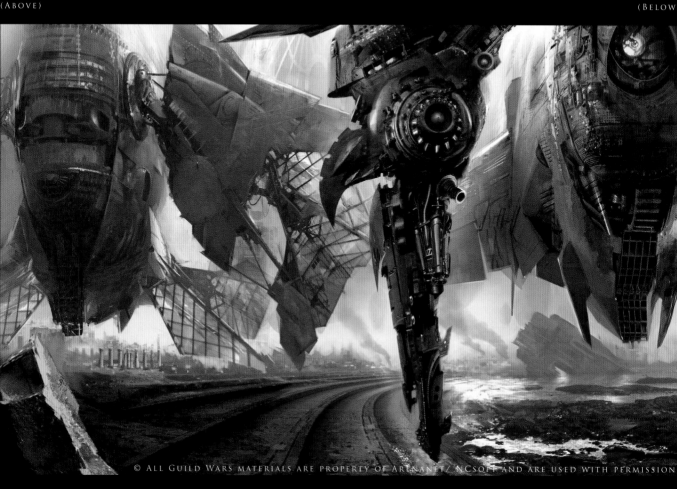

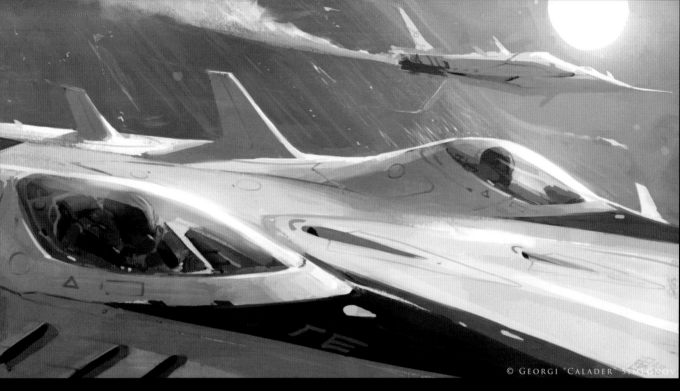

DOUBLE HEADED ARROW
GEORGI "CALADER" SIMEONOV
(ABOVE)

CRASH
DANIEL DOCIU
(BELOW)

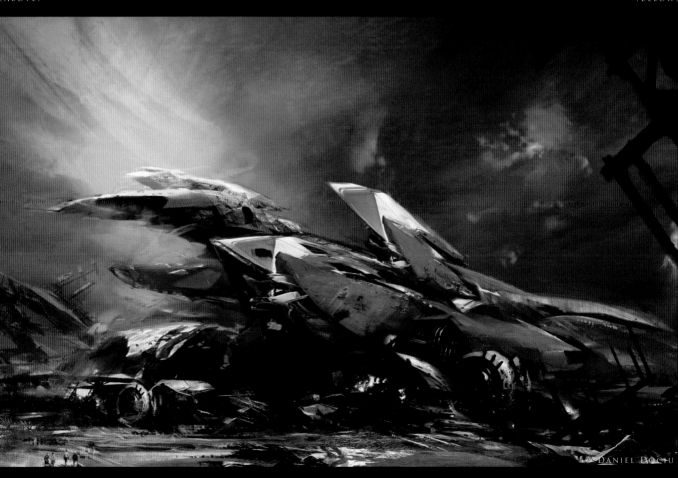

© MACIEJ KUCIARA

DRAGONS LAIR
MACIEJ KUCIARA
(LEFT)

GLADIATOR VS DRAGON
MACIEJ KUCIARA
(ABOVE)

STORMY HORIZON
DANIEL DOCIU
(BELOW)

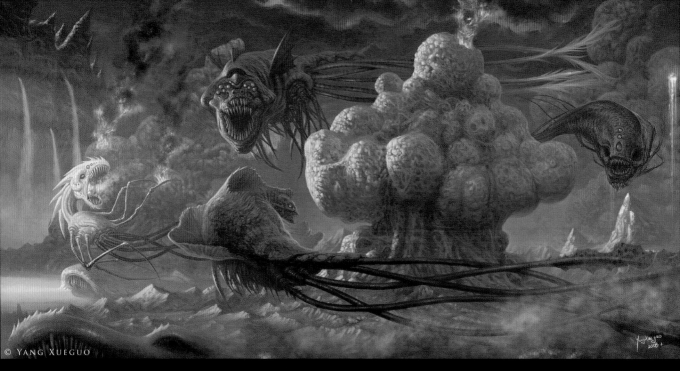

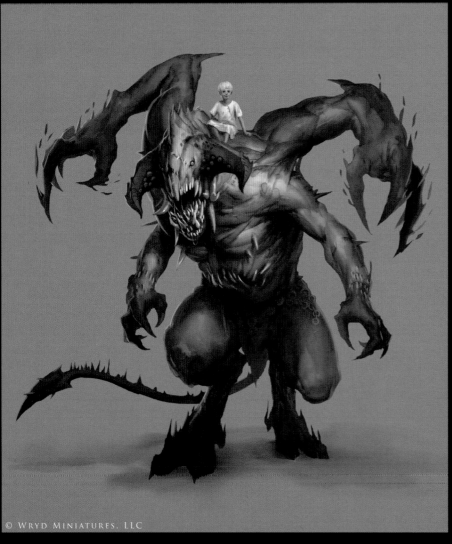

WAR
Yang Xueguo
(Above)

DREAMER AND NYTMARE
Min Yum
(Left)

MONKEY KING
Alex Figini
(Top Left)

SLAVE
Maciej Kuciara
(Top Right)

MORNING MAINTENANCE
Hethe Srodawa
(Bottom Right)

© Alex Figini

© Maciej Kuciara

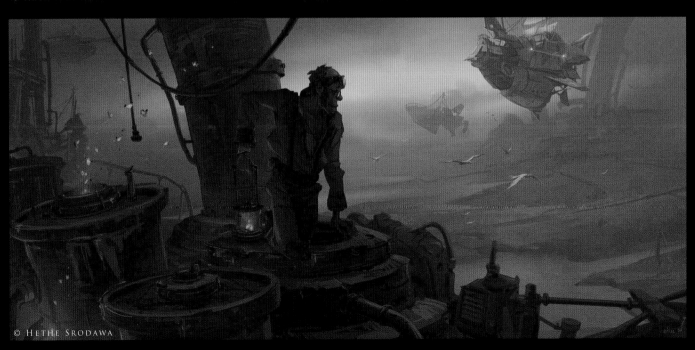

© Hethe Srodawa

THE PRIME MINISTER'S WITCH
HETHE SRODAWA

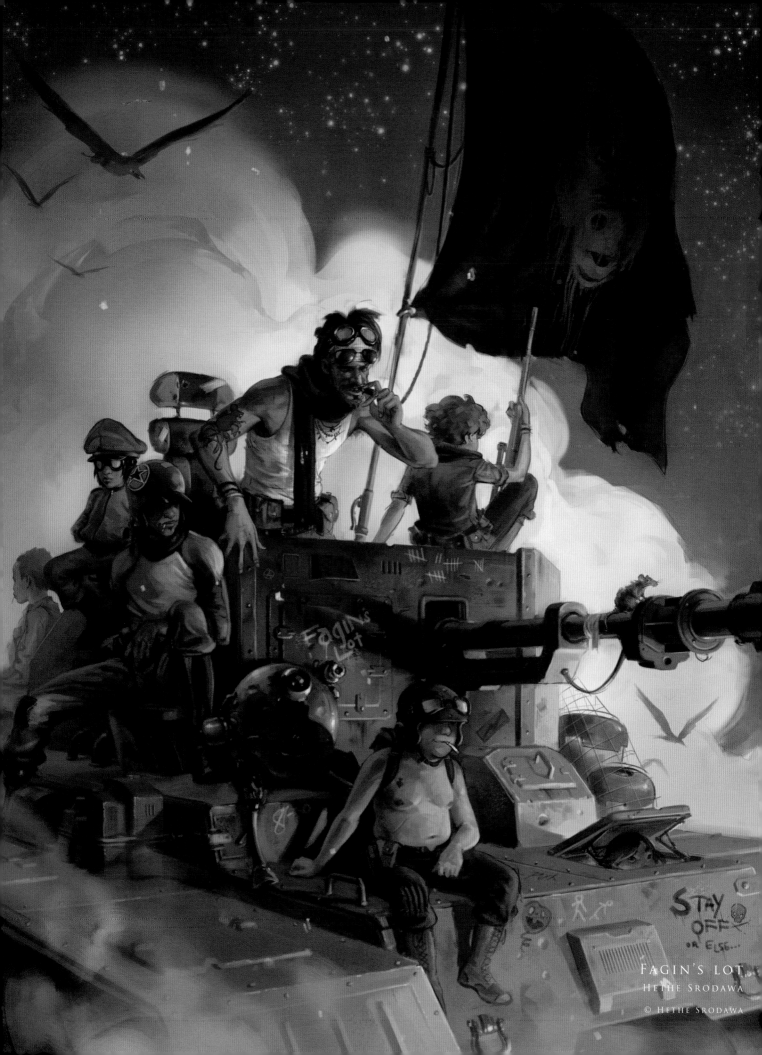

FAGIN'S LOT
HETHE SRODAWA
© HETHE SRODAWA

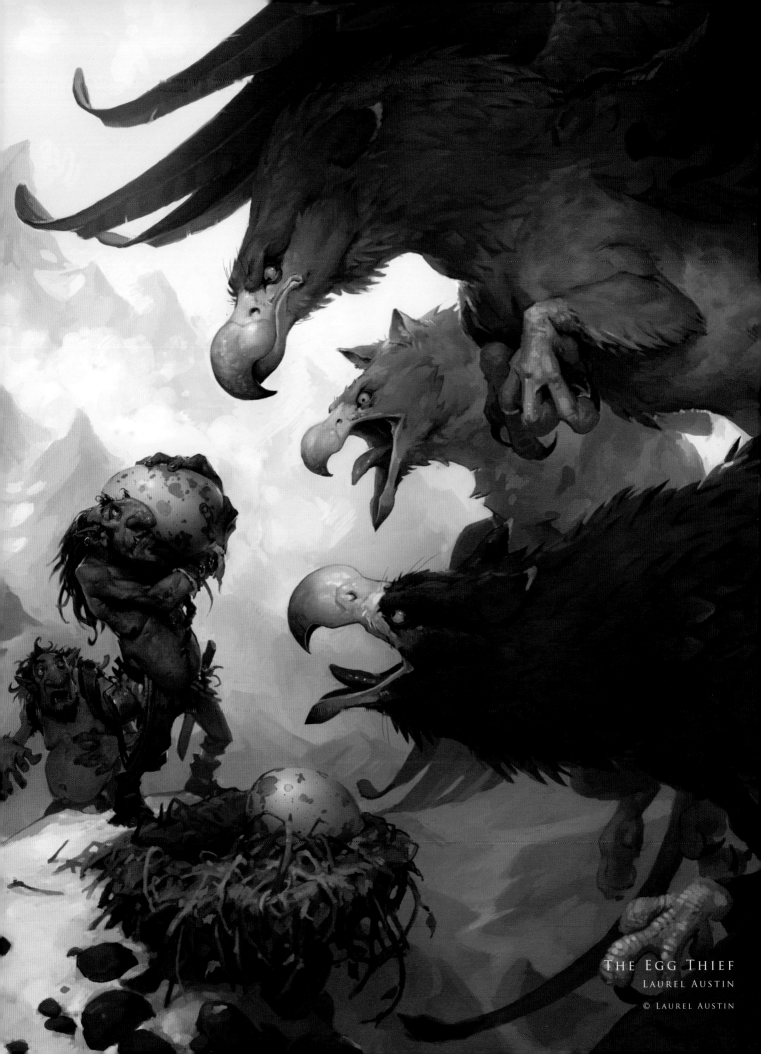

THE EGG THIEF
Laurel Austin

© Laurel Austin

THE TUTORIAL ARTISTS

ALEX
RUIZ
ziurx@earthlink.net
http://www.alexruizart.com

DAARKEN
(MIKE LIM)
daarkenart@daarken.com
http://daarken.com

PIOTREK
SWIGUT
pswigut@gmail.com
http://www.swigut.com

ANDREI
PERVUKHIN
earfirst@gmail.com
http://pervandr.deviantart.com/
gallery

GEDIMINAS
PRANCKEVIČIUS
gediminaspr@gmail.com
http://www.gedomenas.com

RICHARD
TILBURY
ibex80@hotmail.com
http://www.richardtilburyart.co.uk

BART
TIONGSON
BTiongson@Robot
Entertainment.com
http://riceandeggs.blogspot.com

IGNACIO BAZÁN
LAZCANO
i.bazanlazcano@gmail.com
http://www.neisbeis.deviantart.com

ROBH
RUPPEL
robhrr@yahoo.com
http://www.robhruppel.com

BRANKO
BISTROVIC
bisvic@gmail.com
http://www.brushdreams.com/
brankosfurnace.swf

JAMA
JURABAEV
jama_art@tag.tj
http://jamajurabaev.daportfolio.com

SIMON
DOMINIC
si@painterly.co.uk
http://www.painterly.co.uk

CHARLIE
BOWATER
charliebowater@hotmail.com
http://charlie140588.deviantart.
com/

JASON
WEI CHE JUAN
jasonjuan05@gmail.com
http://www.jasonjuan.com

SVETLIN
VELINOV
svetlin@velinov.com
http://velinov.deviantart.com

CHEE
MING WONG
chee@opusartz.com
http://www.opusartz.com

MIN
YUM
minyum@gmail.com
http://www.minart.net

THOMAS
PRINGLE
thomas@pringleart.com
http://www.pringleart.com/

CRAIG
SELLARS
sellarsart@hotmail.com
http://www.greensocksart.com

NYKOLAI
ALEXANDER
x@admemento.com
http://www.admemento.com

YANG
XUEGUO
blur1977@126.com
http://seedsfromhell.blogspot.com

THE GALLERY ARTISTS

**ALEX
FIGINI**

sundragon83@hotmail.com

http://alexf.cghub.com

**HETHE
SRODAWA**

hethebar@gmail.com

hethesrodawa.blogspot.com

**MACIEJ
KUCIARA**

fajny@maciejkuciara.com

http://maciejkuciara.com/

**ALEX
RUIZ**

ziurx@earthlink.net

http://www.alexruizart.com

**IAN
MCQUE**

ian.mcque@googlemail.com

http://mcqueconcept.blogspot.com

**MAX
REVIN**

maxrevin@mail.ru

http://www.celistic.ru/

**ALP ALLEN
GIOVANNI ALTINER**

alpvfx@gmail.com

http://www.alpaltiner.com

**JAN
DITLEV**

janditlev@gmail.com

http://www.janditlev.com/

**MIN
YUM**

minyum@gmail.com

http://www.minart.net

**DAMIEN
MAMMOLITI**

rivmammoli@gmail.com

http://damiem.blogspot.com

**JASON
WEI CHE JUAN**

jasonjuan05@gmail.com

http://jasonjart.cgsociety.org

**YANG
XUEGUO**

blur1977@126.com

http://seedsfromhell.blogspot.com/

**DANIEL
DOCIU**

danieldociu@gmail.com

http://www.tinfoilgames.com

**JASON
SEILER**

seilerillustration@gmail.com

http://www.jasonseiler.com

**GEOFFROY
THOORENS**

contact@djahalland.com

http://www.djahalland.com

**LAUREL
AUSTIN**

tully21@gmail.com

http://www.ldaustinart.com

**GEORGI "CALADER"
SIMEONOV**

calader@caladerart.com

http://www.caladerart.com

**LOÏC E338
ZIMMERMANN**

info@e338.com

http://www.e338.com

DIGITAL ART MASTERS

422338

"Digital Arts Masters 6 once again amazes me with an incredible amount of top quality content. It's an absolute gem amongst other art books showcasing not only mesmerizing images but also the workflow and artists behind them. This is an absolute must for any digital art enthusiast!"

Marek Okoń | http://okonart.com

VOLUME 6

Digital Art Masters: Volume 6 delves into the working practices of some of the world's best digital artists to reveal the creation processes behind their breathtaking images.

Meet some of the finest 2D and 3D artists in the industry today and discover how they created some of the most innovative digital art in the world. More than a gallery book, *Digital Art Masters: Volume 6* takes readers behind the scenes with breakdowns of the techniques and tricks the artists employed to create their stunning imagery.

- New! Additional downloadable video tutorials available from some of the featured artists
- A source of inspiration for artists of all levels: cutting edge imagery showcases the best in today's digital art
- Featuring more than 50 artists and showcasing over 900 stunning color images in five sections: Sci-Fi, Scene, Fantasy, Character and Cartoon

VOLUME 3

The third book in the Digital Art Masters series features 60 of the finest 2D and 3D artists, including Damien Canderlé, James Paick, John Wu, Laurent Pierlot, Marc Brunet, Mathieu Aerni, Matt Dixon & Neil Blevins

VOLUME 4

The forth book in the Digital Art Masters series features 50 of the finest 2D and 3D artists, including Maciej Kuciara, James Paick, Jelmer Boskma, Andrew Hickinbottom, Marek Denko, Craig Sellars & Kekai Kotaki

VOLUME 5

The fifth book in the Digital Art Masters series features 58 of the finest 2D and 3D artists, including Jason Seiler, Chase Stone, Rebeca Puebla, Viktor Fretyán, Daarken, Kekai Kotaki, Andrew Hickinbottom & Neil Maccormack